A PICASSO ANTHOLOGY:
DOCUMENTS, CRITICISM, REMINISCENCES

Published on the occasion of the Arts Council exhibition

7299

31/7

D1423661

Overleaf: Statement about art by Picasso, 1923–4 (*see* p.155).

Vouloir exprimer une notion par le langage de l'art est un détour fort inutile; cela rentre dans cette manière que je blâmais tout à l'heure, de jouer, sans aucun but, avec les ressources artistiques. Aussi ne produira-t-on jamais une œuvre d'art réelle, toutes les fois que sa conception repose uniquement sur des pures notions.

On reconnaît que la conception a cette origine hybride, c'est à dire qu'elle est née des pures notions, à ce que l'auteur, avant de se mettre à l'œuvre, peut exprimer bien exactement et en paroles, le sujet qu'il a l'intention de représenter

A PICASSO ANTHOLOGY: DOCUMENTS, CRITICISM, REMINISCENCES

Edited by Marilyn McCully

The Arts Council of Great Britain
in association with
Thames and Hudson

First published in Great Britain in 1981 by the Arts Council
of Great Britain, 105 Piccadilly, London W1V 0AU
Illustrations copyright © SPADEM 1981
Text and translations copyright © Arts Council of Great Britain,
Marilyn McCully and the original authors and publishers 1981

Arts Council ISBN 0 7287 0293 2
Thames and Hudson ISBN 0 500 27244 1

Produced by Michael Raeburn for the Arts Council of Great Britain
Designed by Dennis Bailey
Printed and bound in Great Britain by Jolly & Barber Ltd, Rugby

1003476941

Contents

3. Picasso's critical reputation outside France 76

4. The war years 102

5. The twenties 136

8. The last twenty years

Acknowledgments

The publishers gratefully acknowledge the following for their kind permission to reproduce copyright material in this anthology:

The Picasso Estate for the letters and statement on pp. 30–1, 32, 35, 38, 41, 51, 130–2, 155.

Dr Jacint Reventós i Conti for the letters from Casagemas and Picasso to Ramon and Jacinto Reventós on pp. 27–31, 51.

The Gertrude Stein Estate for the passage on pp. 65–6.

Pamela Diamond for the passages by Roger Fry on pp. 79, 85–6.

Mme Jean Arp and Dr Lucian Neitzel for the passage by Hans Arp and L. H. Neitzel on pp. 100–1.

Quentin Bell and Chatto and Windus Ltd for the passage by Clive Bell on p. 145.

Caritat Grau Sala Vda. Gasch for the passage by Sebastià Gasch on pp. 170–1.

Benedict Read, on behalf of the Herbert Read Discretionary Trust, for the passage on pp. 209–11.

Sir Roland Penrose for the passages on pp. 211, 265–7, 268–70.

The Sidney Janis Gallery, New York, for the passages on pp. 218–9, 224–5, from Harriet and Sidney Janis, *Picasso: The Recent Years 1939–1946*, Garden City, N.Y., Doubleday.

David Higham Associates for the passage by John Pudney on pp. 225–6.

Françoise Gilot for the passages on pp. 229–33, 240, from her book *Life with Picasso*; copyright © Françoise Gilot 1964; used with the permission of the McGraw Hill Book Company; published in Great Britain by Thomas Nelson and Sons and Penguin Books.

Rosamond Bernier and *L'Oeil* for the passage on p. 249, and *L'Oeil* for the passages on pp. 259–61, 268–70.

Michel Leiris and Galerie Louise Leiris, Paris, for the passage on pp. 255–8.

Pierre Daix for the passage on pp. 274–7.

Edouard Pignon for the statement on p. 277.

John Richardson for the passage on pp. 278–84.

The original of the letter on pp. 66–7 is in the Collection of American Literature, Beinecke Rare Book and Manuscript Library, Yale University.

The publishers also wish to acknowledge the publishers of the works cited below (page numbers refer to this book; page references in the original works are cited at the end of each passage):

J. Sabartés, Picasso: Documents Iconographiques, Geneva, Pierre Cailler Editeur (pp. 21, 38, 41).

J. Palau i Fabre, *Picasso Vivent*, Barcelona, Ediciones Polígrafa; published in English by Phaidon Press, Oxford (pp. 32, 35).

F. Olivier, *Picasso and His Friends* (translated by Jane Miller), London, William Heinemann Ltd (pp. 49–50, 61).

Pierre Daix, Georges Boudaille and Joan Rosselet, *Picasso: The Blue and Rose Periods. A Catalogue Raisonné of the Paintings, 1900–1906*, New York Graphic Society, 1966; translated by Phoebe Pool from the original edition in French published by Editions Ides et Calendes, Neuchâtel, Switzerland (pp. 52–3).

Edward Fry, *Cubism*, London, Thames and Hudson, and New York, Oxford University Press (pp. 55–8).

D. H. Kahnweiler, *The Rise of Cubism* (translated by H. Aronson), New York, Wittenborn-Schultz (pp. 58–60, 69–73).

Gertrude Stein, *The Autobiography of Alice B. Toklas*, New York, Random House (pp. 61–2).

Apollinaire, *The Cubist Painters*, New York, Wittenborn-Schultz (p. 74).

The film *Picasso – A Painter's Diary*, courtesy of Perry Miller Adato, Producer-Director, WNET/Thirteen (pp. 126, 277).

Leroy C. Breunig (ed.), *Apollinaire on Art*, New York, The Viking Press, and London, Thames and Hudson (p. 128).

Claude Frioux, *Maïakovski par lui-même*, Paris, Editions du Seuil (p. 154).

André Breton, *Surrealism and Painting* (translated by Simon Watson Taylor), London, Macdonald and Co. (pp. 155–6, 243–4).

C. G. Jung, *Collected Works*, New York, Bollingen Foundation, and London, Routledge and Kegan Paul (pp. 182–6).

Roland Penrose, *Scrap Book*, London, Thames and Hudson (pp. 211, 265–7).

J. Sabartés, *Picasso*; copyright © 1948 by Prentice-Hall Inc.; published by Prentice-Hall Inc., Englewood Cliffs, N.J. 17632, and W. H. Allen, London (pp. 216–7).

Brassaï, *Picasso and Company*, Garden City, N.Y., Doubleday (pp. 218, 220–1).

Hélène Parmelin, *Picasso Plain*, London, Secker and Warburg (pp. 249–50).

Roberto Otero, *Forever Picasso: An Intimate Look at his Last Years*, New York, Harry N. Abrams Inc. (p. 270).

The publishers have made every effort to contact all authors, literary executors and publishers of copyright works. All copyright-holders we have been unable to reach are invited to contact the publishers, so that a full acknowledgment may be given in subsequent editions.

The publishers also wish to thank the following for permission to reproduce the illustrations in the book and for providing photographs:

Acquavella Galleries, New York: p. 24.

The Art Institute of Chicago: pp. 72, 266.

The Cleveland Museum of Art (Gift of Hanna Fund, CMA 45.24): p. 40.

Fitzwilliam Museum, Cambridge: p. 78.

Fogg Art Museum, Cambridge, Mass. (Bequest of Paul J. Sachs, Class of 1900, a testimonial to my friend W. G. Russell Allen): p. 124.

Mr and Mrs Victor W. Ganz: p. 252.

Françoise Gilot: p. 230.

Stephen Hahn, New York: p. 219.

Hermitage Museum, Leningrad: pp. 103, 105, 108.

Bruce C. Jones, Huntington, N.Y.: p. 219.

Kunstmuseum, Basel: pp. 116, 162.

Galerie Louise Leiris, Paris: pp. 223, 239, 273.

Marlborough Fine Art (London) Ltd: p. 269.

Arquivo Mas, Barcelona: p. 26.

The Metropolitan Museum of Art, New York (Elisha Whittelsey Collection, 1947): p. 89.

Al Mozell, New York: p. 276.

Musées Nationaux, Paris:

Musée de l'Orangerie (Walter Guillaume Collection): p. 147.

Musée Picasso: pp. 39, 75, 131, 167, 179, 198, 260.

Museo Picasso, Barcelona: pp. 20, 217, 256.

The Museum of Modern Art, New York: pp. 204, 230; (Acquired through the Lillie P. Bliss Bequest): pp. 59, 134; (Gift of Mrs Simon Guggenheim): p. 185; (Nelson A. Rockefeller Bequest): pp. 65, 96, 201.

National Film Archive Stills Library, London: p. 263.

National Gallery of Art, Washington, D.C. (Chester Dale Collection): p. 36.

L'Oeil: p. 248.

The Pace Gallery, New York: p. 276.

Bernard Picasso: p. 2.

Marina Picasso Foundation (and Galerie Jan Krugier, Geneva): p. 177.

Eric Pollitzer, Hempstead, N.Y.: p. 252.

The Pushkin State Museum of Fine Arts, Moscow: p. 68.

Jacint Reventós i Conti, Barcelona (and Editorial Gustavo Gili S.A., Barcelona): cover and p. 29.

John Richardson, New York: p. 23.

John D. Schiff, New York: p. 56.

Thames and Hudson Ltd, London: pp. 40, 53, 68, 89, 103, 108, 124, 256.

Eileen Tweedy: p. 210.

Introduction

A Picasso Anthology: Documents, Criticism and Reminiscences *takes in a wide range and variety of responses to Picasso and his work throughout his life, and, in that sense, it constitutes a retrospective of Picasso criticism itself. Picasso's work began to attract attention with his early exhibitions in Spain, and with each new development in his art a new wave of writing followed. The impact of Picasso on twentieth-century art and the path of his creative development are still, since his death in 1973, continuing to be re-evaluated, and their study has been stimulated in part by the recent retrospective exhibitions in Paris, New York, and now London. By considering the nature of both critical and personal reactions to the artist and his work during the different phases of his long life a new level of understanding of Picasso may be achieved, for not only do we gain insight into how he was understood during these periods, but the efforts to explain him also reveal the principal ideas on art of the various times at which they were written.*

One inference, of course, is that the ideas that were held among critics were widespread and therefore must have been in the artist's mind as well. This is probably true to some degree and may help to explain the reasons for some of the artist's choices during a given period. Of more significance, perhaps, is that our approach today to the immense oeuvre left us by Picasso can be enriched by our acknowledgment of the various approaches to his work that have been made in the past. All of them have a certain legitimacy, for even though a particular approach may seem to us outdated, the ideas which were provoked by Picasso's art at the time and the ideas which affected the critical writing of any period may have been overshadowed or missed today because of our own taste and critical criteria.

In addition to criticism, the anthology includes certain documents, letters and statements by the artist and his contemporaries which contribute to our knowledge of specific phases of his development. These, too, particularly the records of his friends, were affected by the same ideas that are found in contemporary criticism. For example, Françoise Gilot's extremely valuable account of the painting of her portrait, La Femme Fleur, *in the 1940s is in some respects typical of a prevailing tendency to record the details of the working methods and habits, and every thought, of the artist, who by that time was in his sixties and regarded as an old master in his own time.*

Picasso was only considered the leader or in the forefront of an avant-garde movement during the years of the development of Cubism, yet his work always seemed new and, for that reason, demanded a critical response. The cubist years were, in fact, the only time Picasso chose to work in close collaboration with another artist, and he and Georges Braque consciously attempted to achieve a certain anonymity in their work at this period. During the rest of Picasso's long career he was generally working alone, without students, and often in a style that seemed superficially to have nothing to do with more recognized contemporary artistic movements.

The question this raises is not whether his work was mainstream or not, but in what ways did the critics, who reflected the taste and preoccupations of their time, explain Picasso's work. The fact that his work continued to change, while his established reputation generated curiosity about anything he did, stimulated a critical response which also drew continually on new ideas, be they from philosophy, psychology, politics or art. Thus, an overall reading of this anthology serves to illuminate the impact of twentieth-century thought and events on critical response to Picasso and, to some extent, on twentieth-century criticism as a whole.

Another dimension to the reading of the selections is that the language or style of the texts themselves may be analyzed with regard both to the work of Picasso's they treat and to the period in which they were written. Some of Picasso's critics, a number of whom were poets, experimented with the form of their writing and, in some instances, produced results that corresponded in literary techniques to the artistic techniques discussed. The surrealist poet Michel Leiris, for example, in his 1959 essay on Picasso's variations on Velázquez's Las Meninas, wrote in a manner that paralleled the working process he described, for he, like Picasso, played the game of theme and variation in his almost circular description of the evolution of that series.

To take another example, André Salmon, in his article 'Picasso' in 1920, summarized Picasso's development and especially the significance of Cubism in a literary form that suggests Picasso's own constructive means. Salmon begins by using simple sentences and one-sentence paragraphs, often more evocative or poetic than descriptive or analytic, as if they were facets of one single theme or object. Proceeding in this way, Salmon constructs his essay as if each sentence or thought were a plane which is related to and overlaps the next. He first asks the question 'Was Stéphane Mallarmé a symbolist?'. His answer begins with an opposing view, then a reference to Mallarmé with a specific identifying detail (L'Hérodiade), then the concept of symbolism, moving to a larger system (the academy) and back to the individual; but instead of returning to Mallarmé, it is Picasso and aspects of his work which he classifies by yet another system (outside the academy) comprised of the poets of Picasso's circle. Picasso emerges from the essay as complex a creator as the argument Salmon himself has created.

The most theoretical and abstract writing concerning Picasso's work also deals with Cubism, and it is important to remember how some of the early studies of the movement affected subsequent writing. D. H. Kahnweiler's

The Rise of Cubism, *first published in 1920 in Germany and in French translation in 1921, set out a theoretical framework to explain the various stages of Cubism. By the time his book appeared there was a greater acceptance of the notion of pure painting, and the 'language' of art, especially Cubism, seemed ideally suited to the directions of modernist architecture and design, which complemented a certain post-war idealism among those who wished to seek a new order in society.*

Amedée Ozenfant, for example, himself a theorist and painter, wrote (using the name Vauvrecy) of the significance of Picasso's break with tradition in 'Picasso and Impressionism' in his own journal, L'Esprit Nouveau *(1921), and attempted to explain Picasso's formal abstraction in an abstract language. Ozenfant claimed that Picasso, from an analytic study of natural phenomena in cubist painting, had invented a new language of expression, a means of creation and not representation. Picasso's 'vocabulary' was composed of what Ozenfant called 'mots plastiques', which were more than just forms and colours, for they conveyed emotions. In this way the juxtaposition of these plastic elements in Cubism resulted in a truly conceptual art, not only linking Picasso to his own time but to all great masters. This vocabulary, in turn, assisted Ozenfant in defining his own theory of art, which he called 'purism'.*

Another type of critical response, one which is surprisingly infrequent in the vast bibliography concerning Picasso, is formalist analysis, and this is best represented in the anthology by the Russian critic Ivan Aksenov. Again, these texts must be read in the light of their historical context, for in the case of Aksenov it is important to remember that he wrote in a period of extraordinary social and artistic change in Russia, and, furthermore, he based his analyses on a selected group of works, principally those available to him in the Shchukin collection in Moscow. The revolutionary nature of Cubism (and important cubist works figured in Shchukin's collection) and of Picasso's role in its development seemed ideally suited to the aims of a new revolutionary Russian art, and Aksenov's book Picasso and his environs, *published in Russia in 1917, was timely for that reason.*

Aksenov begins by expressing his belief that it is the artist who best conveys the complexity of man's experience in the form of an enduring image, and, in so doing, he creates not theories but pictures. Aksenov then proceeds to examine the works themselves and their facture. His analysis of the various layers of paint, the brushwork and colour groupings is the result of careful observation and comparative study. Not only does Aksenov attempt to understand Picasso's expression of depth in his early work through the introduction of sharply defined patches of different colours and textures, but he also considers these techniques in the context of art-historical precedents – turning, for example, to Cézanne and the Impressionists or even to El Greco, who was considered at that time as a forerunner of abstract painting.

Picasso's break with tradition, according to Aksenov, occurred precisely with his questioning of such matters as the expression of depth. It was his radical resolution of painterly problems such as depth that resulted in

Cubism. Aksenov felt in general that the properties of material that the artist used determined the nature of the work of art and hence governed the artist's entire creation. Thus, when he turned to an analysis of Picasso's cubist works in order to explain the nature of the artist's radical vision, he examined the material properties of the work of art. Only in this way could the image which he had created then be read as a summation of the artist's experiences and, in a broader sense, of man's perception and experience of the world.

One of the most consistent reactions to Picasso throughout his lifetime was the myth-making view that he was a living legend, a genius in his own time. Not only was this a result of his strong, magnetic personality, but also of his extraordinary breadth of techniques and styles. In fact, in his earliest critical reviews, he was sometimes faulted for his failure to develop a single characteristic style. Later, his shift from Cubism to a classicizing tendency in drawing and volumetric forms, and to some extent in subject matter, baffled his critics, who were just getting used to the revolutionary nature of Cubism. Either Picasso's decision was explained as a retreat, having exhausted the geometry of forms he had invented in Cubism, or as a renewal, turning to the artistic resources he had at hand that would inspire a new direction.

Picasso's extraordinary, almost magical capacity to work with a variety of materials and transform them into art has continued to dazzle his critics to the present day. The 1980 Museum of Modern Art retrospective, for example, made it clear once again that whatever Picasso's subject matter or style during any particular period of his life, his greatest gift was an exceptional sensitivity to his materials and an enormous capacity to create out of them new and compelling forms; and, in part, this view of Picasso reflects present attitudes towards art, its conception and its practice.

The anthology ends with one critic's response to the Museum of Modern Art retrospective exhibition. John Richardson's article 'Your Show of Shows', in The New York Review of Books, not only calls attention to the enormous variety and exceptional quality of Picasso's work, but reiterates the importance of its autobiographical nature for a meaningful reading of his iconography. This view has itself stimulated debate among critics and art historians about the validity of the autobiographical approach in dealing with the history of modern art in general. The detailed recording of an artist's everyday activities (other than the deliberate use of this technique by conceptual artists themselves in recent years) is indeed less appropriate for the explanation of the work of most major artists of the last hundred years; but, with the possible exception of Van Gogh, no other artist has chronicled his own life, particularly since the twenties, so directly and with such care as Picasso has done in his art. Thus Richardson's method, even in its singularity, is a valuable tool in explaining the meaning and autobiographical nature of Picasso's great oeuvre. Moreover, this approach confirms the contemporary critical evaluation that no other artist has occupied a comparable position in the history of twentieth-century art.

The use of autobiography for the understanding of personal iconography, in the sense that Richardson has proposed, is one valuable way of explaining

the phenomenon of Picasso, and clearly an important one. It is hoped that this anthology, in its retrospective view of how Picasso's critics saw him, will open new or forgotten avenues of approach to the work of an artist whose position as a major force in twentieth-century art was (as we have seen) firmly established from the very beginning. His work has undergone a variety of interpretations reflecting not only changes in his life and vision but in our own.

Since the anthology is intended both to provide the interested reader with a representative survey of criticism and unusual documents relating to Picasso's life and work, and to serve the scholar as a handbook of sources in translation, the selections have been organized chronologically. Some texts, especially reminiscences, have been placed in the section which covers the period during which the particular events recollected occurred. The eight chronological sections have been determined in general by important events in Picasso's life or because of the nature of the material itself. Thus, for example, the early period ends with the last major critical piece written in Spain in 1904, preceding Picasso's move to Paris, which is the starting point for the next section. The landmark studies of the development of Cubism tend to shape this section, which concerns Picasso's activities in France until 1913. Reviews of his shows outside France during the same period, which are, in general, less known, are presented in a separate section. The two sections following one on the war years are divided at 1931, the year of Picasso's fiftieth birthday. In the period of World War II and after attention is given to his personal activities and to his experiments in various media, and the final section is concerned with the last twenty years of his life.

Even with the somewhat arbitrary nature of this organization, the material in each section tends to suggest a shared point of view, which reflects the time if not the country in which the pieces were written. Most writers in a specific period also tend to cite the same aspect of Picasso's work (or to cite each other, with or without acknowledgment) in their discussions. In the first twenty-five years or so, the French generally attempted to situate Picasso in art-historical tradition, particularly linking his cubist development to Cézanne, and also to measure him against Matisse. The English, on the other hand, tended to frame their response in philosophical terms, in contrast to the romantic style of the Spanish critics. The analytic approach of the Russians in the teens suggests a certain distance from western European criticism, particularly when considered alongside the expressionist and later psycho-analytic approaches of German writing. From time to time, critics of various nationalities wanted to claim the Spanish artist from Málaga as their own: in Barcelona he was (and often still is) considered a Catalan; in France, where he lived most of his life, he was thought to have best embodied French painting; Italians credited his brief visit to Rome and Naples in 1917 as a significant step in his development and as evidence of his connection with Italian sources (his mother's surname, Picasso, may have been of Italian

origin); and in 1926 one Russian critic even claimed that Picasso's potential was stifled in the west and that only Russia could offer him real creative freedom.

The principal criteria of selection in this anthology were that documents, criticism or particularly informative reminiscences from all periods of Picasso's life be, in general, little known, difficult to find, or, as is the case with most non-English sources, never before translated into English. An attempt was made to gather material that referred principally to works produced within approximately the decade preceding the date of the particular article. A few well-known works have been included by authors such as Gertrude Stein, Apollinaire or Brassaï, either to give a more balanced view of criticism or to provide relevant information concerning Picasso's activities, which in turn complement the less familiar material or put it into a better framework.

An effort was made not to duplicate material in several key books which contain Picasso documentation in translation, including: Dore Ashton, Picasso on Art: A Selection of Views *(London and New York, 1972)*, the most comprehensive collection of statements by the artist, who did not leave a large body of writing or correspondence *(Jerome Seckler's account of his visit to Picasso is included here in full)*; Gert Schiff, Picasso in Perspective *(Englewood Cliffs, N.J., 1976)*, which includes both historical pieces *(Herbert Read's essay on* Guernica *has been reprinted here as well as in Fry)* and recent retrospective articles; and Edward Fry, Cubism *(New York, Toronto and London, 1966)*, which covers a wide selection of writings on Cubism *(Salmon and Kahnweiler are represented in this anthology as well as in Schiff)*. Other publications which contain documents in translation include: Pierre Daix, Picasso: The Blue and Rose Periods *(London and Greenwich, Conn., 1966)*, Alfred H. Barr Jr, Picasso: Fifty Years of His Art *(New York, 1946)*, Wilhelm Boeck and Jaime Sabartés, Picasso *(New York and London, 1955)*, and Domenico Porzio and Marco Valsecchi, Picasso: His Life, His Art *(London, 1974)*. A list of abbreviations used for works frequently cited will be found on p. 285.

The most important bibliographic sources that were consulted are Juan Antonio Gaya Nuño, Bibliográfia crítica y antológica de Picasso *(San Juan, Puerto Rico, 1966)* and Ray Anne Kibbey, Picasso: A Comprehensive Bibliography *(New York, 1977)*. Although neither is exhaustive, these two volumes are absolutely essential to bibliographic analysis. Eunice Lipton's thesis Picasso Criticism 1901–1939: The Making of an Artist Hero *(New York and London, 1976)* is a useful survey of the critic's role in the development of Picasso's image. Her analysis of general currents in French, German, American and English criticism during the period she considers is particularly helpful. Finally, a valuable source of documentation that was often consulted is Jane Fluegel's chronology in the Museum of Modern Art catalogue, Pablo Picasso: A Retrospective *(New York, 1980)*.

Because of the length of some of the articles, it was necessary to excerpt passages, which sometimes meant changing a few introductory words for

clarity. A team of translators worked on these texts, and I would like to express my thanks and appreciation to David Britt, P. S. Falla, Ewald Osers, Francesc Parcerisas, Michael Raeburn, Josep Miquel Sobré and Christine Thomas for their careful attention to the nuances and problems of translation.

The decision to commit the time and effort of many people to realize this project was made by the Arts Council of Great Britain and the organizers of the exhibition Picasso's Picassos: An exhibition from the Musée Picasso, Paris *at the Hayward Gallery in London. I wish especially to thank Joanna Drew, Sir Roland Penrose, John Golding, Andrew Dempsey and Susan Ferleger Brades for their untiring and willing support of this undertaking.*

In order to assist me in giving shape to the varied sources that comprise this anthology and to put it into a form that will not only present new material but also stimulate new thinking in the fields of Picasso studies and twentieth-century criticism, I have relied on the expertise of the editor Michael Raeburn. His knowledge, care and help throughout the editing of the book are deeply appreciated.

There have been many individuals whose assistance in the research phase of this project were invaluable, and I wish to mention some of their names here: Dominique Bozo, Michèle Richet and Laurence Marceillac of the Musée Picasso in Paris; Rosa Maria Subirana of the Museo Picasso in Barcelona; Dominique Moyen at the Centre Georges Pompidou in Paris; Janette Rozene at the Museum of Modern Art in New York; and the staffs of the libraries of the Metropolitan Museum of Art, New York Public Library, Casa de l'Arcadiaca in Barcelona, and Marquand Library at Princeton University.

The contributions of my colleagues have been extremely helpful in the selection of some of these documents, and I wish especially to thank John Richardson for his generosity and enthusiastic support. Others who gave helpful suggestions whom I wish to thank include Claude Picasso, Angelica Rudenstine, Perry Miller Adato, Robert McVaugh and Ron Johnson. Throughout the project the help of Evie Chondros in the duplication of materials and in the many details of organization has been invaluable. Finally there are my friends, Vita Vileisis-Sherwin, Jackie and Panas Anastasis, Maria Teresa Conill, Joanne Dresner, Eileen Guggenheim and Francesc Parcerisas, who gave their help and support in so many ways, and I wish to express my gratitude to them here.

I.
The early years

1897–1904

The selections that follow cover Picasso's early exhibitions and activities in Madrid, Barcelona and Paris. Critical notices, letters and a major 1904 essay concerning the artist by his friend the Barcelona critic Carlos Juñer Vidal reveal the somewhat controversial response to Pcasso's work by that date. Early criticism faults the artist for departing from an expected realism and for his association with Catalan modernismo, a style and subject matter loosely characterized as confused and decadent. The suggestion that Picasso was still too young to have developed a strong personal quality in his work is a reflection of the prevalent symbolist (or late romantic) tone of Catalan criticism at the end of the nineteenth century, which emphasized the important role of the expression of the artist's temperament in the face of modern society as well as nature. However, praise is given for Picasso's exceptional drawing ability, and the success of the characterization of his portraits (although the subjects seemed unworthy bohemians to some) is noted by reviewers both in Barcelona and in Paris. The Barcelona reviews, in general, also reflect a certain journalistic style of criticism, which contrasts with a tendency towards theoretical and philosophical exposition in the explanation outside Spain of Picasso's work towards the end of the decade. Established critics, such as Raimond Casellas, who had championed the new modernista art in the 1890s, failed, however, to notice Picasso's work.

1900 was a significant year for Picasso, beginning with his February exhibition at the café Els Quatre Gats in Barcelona, where he showed a sizeable group of charcoal portraits of his friends, in addition to three oil paintings. One of these, Derniers Moments, was also exhibited at the Exposition Universelle in Paris later in the year. In October Picasso made his first trip to the French capital for that occasion in the company of his friend, the poet and painter Carles (whom Picasso referred to on at least one occasion as Charles) Casagemas. Their letters to Ramon Reventós, written on that visit, are important not only as documents of their activities in Paris, but as evidence of the close and often humorous nature of their friendship.

The events of this period, some of which refer specifically to Casagemas, are intimately linked to many of the major themes of Picasso's paintings and drawings of the early years. Casagemas's suicide in 1901, which was directly related to his unsuccessful love affair with Germaine (who is mentioned in the

11 November 1900 letter and was living with Casagemas and Picasso along with another woman called Odette), prompted several paintings by Picasso, the most famous of which was La Vie, *which he painted in 1903 over his 1900 canvas* Derniers Moments.* *The sale of* La Vie *to a Parisian collector in 1903 was recorded in the Barcelona newspaper* El Liberal, *and although the symbolic significance of the painting was not mentioned,* La Vie *was considered as Picasso's major work by that date.*

At the time of Casagemas's death, Picasso was in Madrid along with another poet friend from Barcelona, Francisco de Asis Soler. In an effort to generate new artistic activity in the Spanish capital, they had founded a little artistic-literary journal, Arte Joven, *which they modelled upon the Barcelona art journal* Pel & Ploma. *Public reception to their efforts was apparently indifferent in Madrid (although the journal warranted notice in* Pel & Ploma *in Barcelona), and after only four issues the venture was terminated and Picasso returned first to Barcelona and then to Paris for the preparation and exhibition of his works in both cities that year.*

Picasso's June 1901 exhibition of pastels at the Sala Parés gallery in Barcelona prompted the well-known biographical sketch by Miquel Utrillo that appeared in Pel & Ploma *(see Daix, p. 333), in which Utrillo summarized the short but dazzling career of the young Andalusian artist. As sponsors of the exhibition, the editors of* Pel & Ploma *(Utrillo and the artist Ramon Casas) thus pay tribute, and, in a sense, initiate the legend of the young genius Picasso, the 'petit Goya' of the circle of young artists from Barcelona.*

During the same month in Paris, Picasso's works were exhibited at Vollard's gallery and discussed by several French critics. These reviews have been republished in translation in several publications (such as Daix, pp. 333–5). Two lesser-known reviews of the Paris show, Gustave Coquiot's article in Le Journal *and Pere Coll's review for the Barcelona newspaper* La Veu de Catalunya *are included here and are especially noteworthy for their generous praise. Picasso's work in 1901 showed the direct influence of the art he had seen in France the previous autumn, and reference to his expressive use of colour suggests the influence of Gauguin and Van Gogh. Picasso's preference for subjects of modern life also linked his work at that time to Toulouse-Lautrec and Steinlen.*

Finally, Picasso's important and influential friendships in Paris with writers and poets are referred to in the affectionate letters to his friend Max Jacob and in the poet's recollection of their first meeting. This section ends with the last major Barcelona article concerning Picasso until his work was exhibited there once again in 1912.

**See Marilyn McCully and Robert McVaugh, 'New Light on Picasso's* La Vie', *Cleveland Museum Bulletin, February 1978, pp. 67–71. Note that in this article* Derniers Moments *is referred to as* Dying Woman.

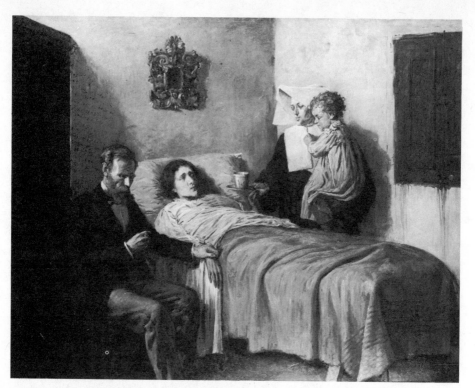

Science and Charity, 1897. Museo Picasso, Barcelona.

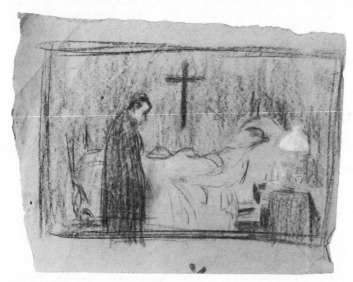

El lecho mortuorio (Study for Derniers Monuments), 1899. Museo Picasso, Barcelona.

(1897) Jaime Sabartés
On *Science and Charity*

At that time Pablo had a studio in the Calle de la Plata, which his father had rented for him and which was the first he ever had. There he painted *Science and Charity*,[1] which received an honourable mention at the national fine arts exhibition at Madrid in 1897. The studio was, of course, close to the family home, Don José having discovered it one day on the way to school.

The picture, the subject of which was suggested by Don José himself, represented a sick woman lying on a pallet. In the background a nun, holding a baby in her arms, offers a cup of soup to the patient, while a doctor in the foreground takes her pulse. Pablo's father was the model for the doctor; the baby belonged to a beggar-woman who used to take it with her when begging alms in the street. The nun's habit was lent by Sister Josefa González of the order of St Vincent, born in Málaga and brought up by the Blue Nuns there, who was living at the time at the nuns' hostel of La Granja in Barcelona.

A Madrid critic wrote a facetious verse in a newspaper column: 'I am sorry to laugh callously at such grief, but I cannot help it, for surely the doctor is feeling the pulse of a glove?'[2]

From Jaime Sabartés, *Picasso: Documents Iconographiques*, Geneva, 1954, pp. 299–300; translated from French by P. S. Falla.

[1] z. xxi. 56
[2] Jaime (also known as Jaume) Sabartés first met Picasso in Barcelona, where both were frequenters of the café Els Quatre Gats. Sabartés, who would become Picasso's biographer and personal secretary until his death in 1968, was first known in Barcelona as a poet.

1900 (Manuel Rodríguez Codolà)
Els IV Gats: Ruiz Picazzo Exhibition

A young man, almost a child, Ruiz Picasso [*sic*] has organized an exhibition of drawings and colour sketches at Els Quatre Gats.

In all the works exhibited he shows an extraordinary ease in the handling of pencil and brush; he is master, too, of that fundamental quality, gracefulness of executin, a useful trait, but one that may become damaging when it dominates all other traits, rather than being the result of long and steady practice.

This is the cause of the imbalance one notices in Picazzo's drawings and canvases. If at first glance they make a good impression (although it is apparent that the artist is strongly affected by outside influences), as one examines the work carefully one notices mistakes, lack of experience

(which the artist's age makes understandable) and, mostly, hesitation about which path to follow.

True, it is not easy to find one's way; few are the chosen who put their abilities to good use right from the start; but it is equally true that in order to achieve personality in art one must not base it on that of others, following their tracks;[1] on the contrary, one must take a different direction in order to avoid gathering the masters' crumbs, for that is the trap into which most fall and perish.

This reflection is suggested by the series of charcoal portraits drawn by our young painter; these portraits doubtless suffer by their very origin, which highlights the artist's inexperience.

One must nevertheless confess that many of these portraits have *character*, which is saying a lot, and that some of them have been executed with conviction and economy. In all of them, as we have suggested, the ease of pencil-work is noteworthy; this quality is characteristic of the rest of the sketches and studies.

The only painting which Ruiz Picazzo has in Els Quatre Gats portrays a young priest standing with a prayer book in his hand, looking at a woman on her death-bed. The light of a lamp radiates weakly and is reflected in patches on the white bedcover over the dying woman. The rest of the canvas is in shadow, which dissolves the figures into indecisive silhouettes.[2]

There are qualities in this work, painted with natural ease which we appreciate; qualities which we hope will reach maturity the day when Señor Ruiz Picazzo frees himself of prejudice and brings to his work richer experience and study than he shows today, when he reaches the age when one dares all and produces typically personal works.

Attributed to Manuel Rodríguez Codolà, 'Els IV Gats: Exposición Ruiz Picazzo [*sic*]', *La Vanguardia*, Barcelona, 3 February 1900, p. 7; translated from Spanish by Miquel Sobré.

[1] Sabartés (in *Picasso: Portraits & Souvenirs*, Paris, 1946, p. 60) recalled that Picasso's exhibition of charcoal portraits of his friends was intended to rival the older Catalan artist Ramon Casas, who in 1899 had exhibited a large number of charcoal portraits of Barcelona intellectuals and various representatives of Catalan society at the Sala Parés gallery. Rodríguez Codolà is undoubtedly warning Picasso in this review to avoid imitating the work and drawing style of the popular Casas.

[2] This painting, although unidentified by Rodríguez Codolà, is undoubtedly *Derniers Moments*, the work Picasso exhibited later in 1900 at the Exposition Universelle in Paris. It has been identified (see note p. 19) as the painting that lies beneath *La Vie* (z. 1. 179); it is not, as has often been supposed, an alternative title for *Science and Charity*.

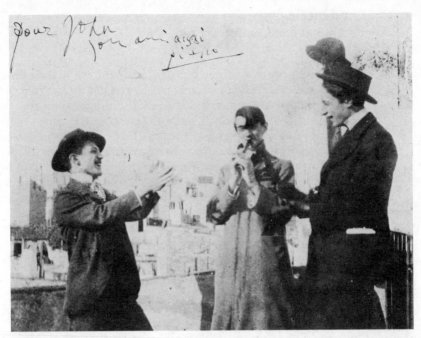

Picasso, Angel de Soto and Carles Casagemas on the roof of Picasso's studio at Calle de la Merced 3, Barcelona, c.1900; photograph inscribed for John Richardson by Picasso.

1900 (Sebastià Trullol i Plana)
Picasso at Els Quatre Gats

Currently on exhibition in the salon of the Quatre Gats are several drawings and colour sketches by D. R. Picassó [*sic*], a youth who enters the world of art obsessed with the most extreme *modernismo*. One cannot deny that Señor Picassó has talent and feeling for art; he proves this in three oils which appear in the exhibition, in which there is intuition and knowledge of the expressive potential of colour; but in contrast to this, the exhibition reveals in the painter, as in many others who have preceded him and are madly in love with the *modernista* school, a lamentable confusion of artistic sense and a mistaken concept of art.

In the collection of pencil portraits, which form part of the exhibition, several stand out for the confidence of drawing, but it is only necessary to glance at them as a whole to recognize that this is a gallery of melancholy, taciturn and bored characters that produces in the spectator an impression of sadness and compassion for their unsympathetic portrayal.

From 'Barcelona' (attributed to Sebastià Trullol i Plana), *Diario de Barcelona*, Barcelona, 7 February 1900, p. 1610; translated from Spanish by Marilyn McCully.

23

Having been cordially invited by our good friend Pablo Ruiz Picasso, we went to see his exhibition in the big hall of the Quatre Gats. We went with the assurance of seeing something good, because we know the artist and we were delighted to look at more than 150 works, each one of them worthy of being a passport to the realm of art. We had never seen so rich an exhibition, and seldom one with so many good things. Picasso is an artist from head to toe. He has a genuine feeling for art and he knows how to project his feelings with good taste, which is a rare quality in our artists. In painting he is a revolutionary and an enthusiastic campaigner for the new school.

All his paintings are full of great strength and ease and, down to the most insignificant drawings, they convey a deep philosophy, a need to unite the psychological aspect of the work to the materiality of the craft. In each stroke of the pencil or of charcoal, in each brushstroke, one can

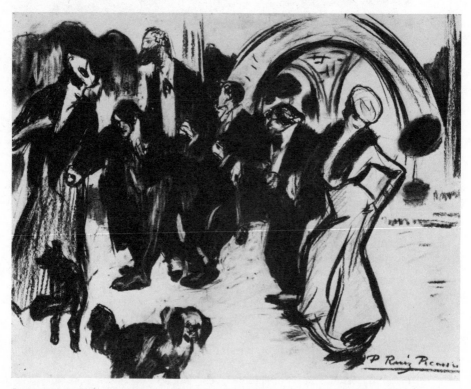

Leaving the Exposition Universelle, 1900. From left to right: Odette, Picasso, Ramon Pichot, Miquel Utrillo, Carles Casagemas and Germaine. Private collection.

see a profound faith in the art he is making, and a kind of inspired fever reminiscent of the best works of El Greco and Goya, the only indisputable masters or divinities for Picasso. His portraits can be rated as masterpieces; they are all true embodiments of those pipe-smoking characters we have seen walking down the Ramblas,[1] but this collection presents more than personalities, it is a portrait of the present age. The exhibition may become a special testimonial and historical document. In the same way, in the Casas exhibition one saw a gallery of personalities, who are, with a few exceptions, representatives of intellectual society.

Manuscript in Museo Picasso, Barcelona (MAB. 110.286/110.286R); translated from Spanish by Miquel Sobré.

[1] *Modernista* artists were often caricatured in contemporary publications as pipe-smoking bohemians in contrast to the upper middle-class personalities portrayed by Ramon Casas in his charcoal-portrait exhibition of the previous year.

1900 Charles Ponsonailhe
Derniers Moments at the Paris Exposition

Spain is a poor country, even in the field of art.[1] Señor Sorrolla-Bastida, the only representative of his country to win the *grand prix*, has to his credit many important paintings full of sincere vision and depth of feeling. I admire unreservedly his *Fisherwomen Making a Sail*, with its warm, sunny atmosphere, and a picture of *Crippled Children Bathing* on a June day with a fresh sea breeze under the care of a group of religious brothers. There is a true sense of grief in Ruiz Picasso's *Derniers Moments*, and this is also found in the *Salus infirmorum* and the *Leader of the blind* by Luis Pidal Menender. *The Pool* by Eliseo Meifrén is an excellent picture very badly hung.

From Charles Ponsonailhe, 'La peinture étrangère', *L'Exposition de Paris* vol. III, Paris, 1900, pp. 202–3; translated from French by P. S. Falla.

[1] In his description of the various rooms of the painting section at the Paris Exposition of 1900, Charles Ponsonailhe gave this small survey of the Spanish works. The reference, although brief, to Picasso's contribution, *Derniers Moments* (see note 2 p. 22), has been completely overlooked in Picasso literature, and I wish to thank Robert McVaugh for pointing it out to me.

In Casagemas's and Picasso's letters of 1900 to Ramon Reventós mention is made of many friends from the circle of artists and writers who gathered at Els Quatre Gats in Barcelona. There were two Reventós brothers, Ramon (known as Moni and also referred to on one occasion by Casagemas as Baltasar), who was a humorist and writer, and Jacinto (known also as Cinto or Cintet), who later became a physician. Others mentioned include the critic

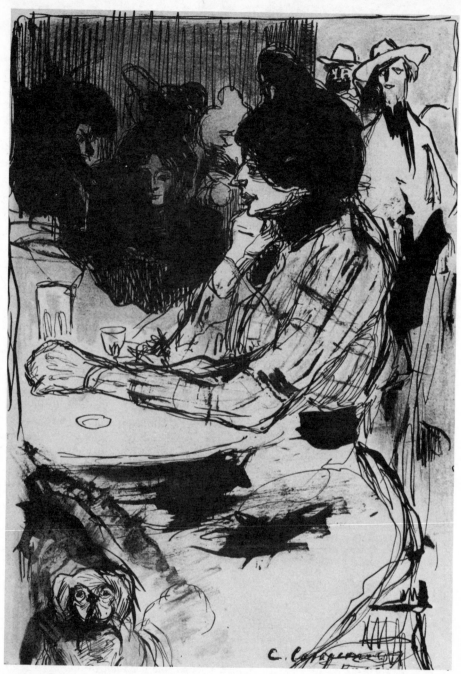

Casagemas, *At the Café*, Paris, 1900. Private collection.

Miquel Utrillo, Pere Romeu, the proprietor of Els Quatre Gats, the writer Eduard Marquina, the artists Santiago Rusiñol, Isidre Nonell, Ramon Pichot (also spelled Pitxot) and Ricard Opisso, the sculptor Manolo Hugué, the collector Alexandre Riera and the writer Pompeo Gener (Peio). The Basque painter Francisco Iturrino, with whom Picasso exhibited in Paris at Vollard's in 1901, is also mentioned. Indirect reference is made in the letter of 25 October 1900 to the architect Antoni Gaudi and to the designer and painter Alex Clapés.

1900 Carles Casagemas
 Letter from Paris (25 October) to Ramon Reventós

25 October 1900

Friend Ramon: On our return from accompanying Pitxot to his house the concierge gave us your letter. Although it might have more substance than mine, we found it short. And what's Cinto up to? Why doesn't he write? We have already launched into work. Now we have a model. Tomorrow we'll light the heater and we'll have to work furiously for we're already thinking about the painting we're going to send to the next Salon. Also we're painting for exhibitions in Barcelona and Madrid. We're working hard. Whenever there is light (daylight, because you can find the other kind of light everywhere all the time) we are in the studio painting and drawing. So *you'll see if we make it!* Peio is here and the day he arrived he sent us a *pneumatique* giving us an appointment for midnight at Ponset's tavern, without armour. We spent an hour there and he invited us to a beer and sandwiches and when we were about to leave Utrillo and Riera turned up and it all lasted until the early hours of the morning. The following day we got together at *petit-Pousset*, which is not the same as Ponset's place, and we all got drunk. Utrillo wrote nursery rhymes, Peio sang bawdy songs in Latin, Picasso made sketches of people, and I wrote verses of 11, 12, 14 and more syllables. We sent it all together to Marquina in an envelope and it needed at least five *real* stamps. Tomorrow there's going to be a meeting of Catalans and non-Catalans, illustrious and not so illustrious. We'll eat at the brasserie. There's a Catalan guy here with fig-leaves called Cortada, loaded with millions and a miserly bastard. He often eats with us and considers himself an intellectual, but he's an arse. The intellectuals around here seem to have more little deals going than in Barcelona. They are pompous bachelors and not even Christ will have anything to do with them. But even so, there's not a single one who can outdo us in gossiping seriously about people. Have you met Nonell yet? He's a nice guy, and he and Pichot are the only two decent ones around here. Today we met Iturrino who also seems to be a good guy. I think that Rusiñol is dying and maybe

when you get this letter he'll be dead. We'll be very sorry. What about Perico? Is he very bored? Tell him to come to Paris, and Manolo too, because there's room for everybody and money for whoever works. Our studio is going along well. Some nights we go to cafés-concerts or theatres *idem*. It's pretty nice but it usually ends up a mess. Sometimes they think they're doing Spanish dancing and yesterday one of them came up with a fart of *ollé ollé caramba cagamba* which left us cold and made us doubt our origins. The military style is also very much in vogue everywhere. Tell Romeu that he's crazy not to come here to open the shop – he must get the money in any way possible – rob, kill, assassinate, do anything to come because here he'd make money. The boulevard de Clichy is full of mad places like Le Néant, Le Ciel, L'Enfer, La Fin du Monde, Les 4 z'Arts, Le Cabaret des Arts, Le Cabaret de Bruant and a lot more which don't have the least bit of charm but make lots of money. A 'Quatre Gats' here would be a mine of gold and muscles. Pere would be appreciated and not insulted by the passing mob like in Barcelona.

There's nothing as good as that nor anything like it. Here everything is fanfare, full of tinsel and cloth made of cardboard and papier mâché stuffed with sawdust. And above all, it has the other advantage of being of a deplorable taste – *cursi, vaja, bunyol, carquinyol*. The Moulin de la Galette has lost all its character and l'idem Rouge costs 3 francs to enter and some days 5. The theatres too. The cheapest places and cheapest theatres cost one franc.

At any rate, there's nothing left to do but adapt to circumstances: do what you can because everything turns out as the Lord wants it. You Cinto, let's see if you'll write a long letter with lots of good philosophy. Last night we saw Cucurny and we said hello to him and he asked where Pichot lived – he was with *Rusiñol petit* and another idiot – I don't know who he was. If it hadn't been for Nonell's trip we wouldn't have written you such a long letter because a letter like this is just extra baggage.

If you see Opisso tell him to come as it's good for saving the soul – tell him to send Gaudi and the Sagrada Familia to hell and the simpleton Clapés too. Here there are real teachers everywhere. Soon the Exhibition will close and we still haven't seen more than the painting section.

Yesterday we saw a horror drama at the Théâtre Montmartre. There was a lot of death, shots, fires, beheadings, thefts, rapes of maidens, and other evil deeds, and then there was an announcement in huge letters of a scene superior to all the others – a poor man, the Marquis of *Siete Iglesias*, a Spaniard who died by being crushed by a roof that was coming down, down . . . Those words you have put into Lord Byron's mouth (I have his picture just in front of me), and in Castilian too, have reached my heart. I don't know whether this letter will affect you like the last one; but, if so, I'll have no alternative but to believe it's a chronic illness with me. I think in the other one I told you about the furniture, but if it amuses you to know where we sit, lie down, write, paint, and what we look at, here is a little inventory without a notary's signature.

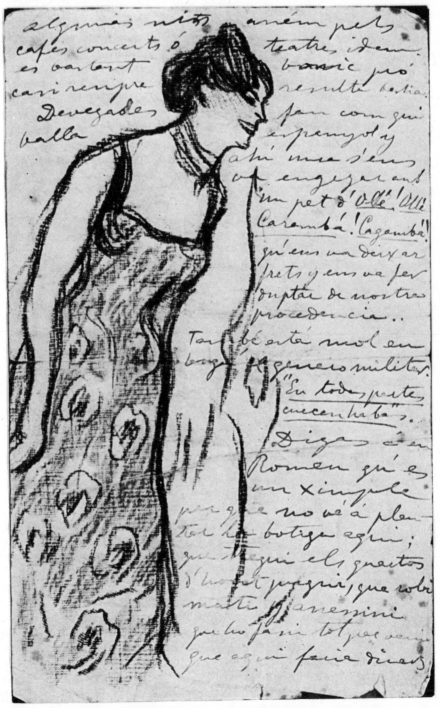

Drawing of a woman by Picasso, from the letter of 25 October 1900 from Casagemas to Ramon Reventós. Collection Jacint Reventós i Conti, Barcelona.

One table, one sink, two green chairs, one green armchair, two chairs that aren't green, one bed with extensions, one corner cupboard which isn't in a corner, two wooden horses that make a trunk, one oil lamp, one mat, a persian rug, twelve blankets, one eiderdown, two pillows and a lot of pillowcases, four more pillows without cases, some cooking utensils, glasses, wine-glasses, bottles, brushes, a screen which just arrived from the theatre of war which Waldersee[1] knows so well, flowerpots, W.C., books and a pile of other things. We even have a mysterious utensil for private use *by ladies only*. I don't know what it's called but I believe it's used to clean oneself where one gets dirty *in coitus* and in addition I believe it's used *to prevent having babies* – that is to say, if you put it in your cunt it's the opposite of putting your head in the pot of Nuria.[2]

In addition we have a kilo of coffee and a can of peas. Goodbye, and another day I'll be more lengthy.

Carles Casagemas
P. Ruiz Picasso

Letter (25 October 1900) from C. Casagemas to R. Reventós with drawings by Picasso; translated from Catalan by Francesc Parcerisas and Marilyn McCully. Property of Jacint Reventós i Conti. Published in Josep Palau i Fabre, *Picasso Vivent (1881–1907)*, Barcelona, 1980, appendix 8, p. 513 (and also reproduced in part in Jacint Reventós i Conti, *Picasso i els Reventós*, Barcelona, 1973, pp. 45–9).

[1] General Alfred von Waldersee was appointed commander-in-chief of the German forces in China in 1900, but arrived there after the Boxer Rebellion had already been crushed.
[2] In Nuria (in Catalonia) there is a sanctuary where couples who want children go. They put their heads in a cavity, and legend has it the woman will become fertile.

1900 ## Pablo Picasso and Carles Casagemas
Letter from Paris (11 November) to Ramon Reventós

[From Picasso]

Friend Ramon Reventós
So you want me to tell you something now after what Charles has already written to you – if you were to see us you wouldn't recognize us because we've finally become such hard workers. All this about women, as seen through our letters and as Utrillo must be telling you, seems or must seem to take all our strength, but no! Not only do we spend our lives 'fondling', but I've almost finished a painting – and, to be frank, I think I have it just about sold [*vendido*]. Because of this, as lovers of the traditions of our beloved (!) country, which few are, we are saying goodbye to the bachelor life – as of today we are going to bed at 10 and we're not going out anymore to *calle de Londres*. Today Pajaresco has written a notice in the studio that we'll get up early and that we'll even try to 'fondle' at regular hours. It's not that I'm drunk, in spite of the fact that Casagemas says that

vendido is spelled with B and not with V as I've written tonight in front of the red lobster that I have in front of me. I feel I could write you a whole book without stopping which he couldn't! At the moment Casagemas Charles is dividing up the goods. When the lobster saw herself being stripped, she seemed to get redder from blushing. 'Waiter, another,' says Casagemas at this very moment and I say 'another one' too.

[From Casagemas]

Paris 11 November 1900

Friend Ramon

Forgive us for not writing for so long, but there has been a heap of circumstances that has prevented us from writing. Bear in mind that we've been on the brink of running out of money, or, more accurately, we've been without money for a whole day. But there are always good friends who might lend you ten francs in case of urgent necessity. Germaine, who is for the time being the woman of my thoughts, was determined to give me thirty francs she had saved. We didn't accept them because as you can understand, an *hidalgo* cannot do certain things when there's no necessity. In addition we're working a lot and we don't have enough time to distract ourselves. Tell Pere we thank him for his latest advice but just for now we can't think about it nor should we. Family life is heaven. In the coming week, which begins tomorrow, we're going to fill our lives fully with peace, tranquillity, work, and other things that fill the soul with well-being and the body with strength. This decision has been reached after having a formal meeting with the ladies. We've decided that we've been getting up too late and eating at improper hours and everything was going wrong. On top of this one of them, Odette, was beginning to get raucous because of alcohol – she had the good habit of getting drunk every night. So we arrived at the conclusion that neither they nor we will go to bed later than midnight and every day we'll finish lunch by one. After lunch we'll dedicate ourselves to our paintings and they'll do women's work, that is, sew, clean up, kiss us, and let themselves by 'fondled'. Well, this is a kind of Eden or dirty Arcadia. The proof that we are beginning to reform is that I'm writing to you from the Montmartre tavern at 2.30 while eating *Roastbeef-Froid-avec-pikles* and who knows what else and I leave the last word to Picasso.[1] Tell Jacinto to write.

<div align="right">Yours Carles</div>

Letter (11 November 1900) from Picasso and C. Casagemas to R. Reventós; translated from Spanish (Picasso) and Catalan (Casagemas) by Francesc Parcerisas and Marilyn McCully. Property of Jacint Reventós i Conti. Reproduced in Jacint Reventós i Conti, *Picasso i els Reventós*, Barcelona, 1973, p. 43.

[1] Picasso wrote a few more words at the bottom of the page, which are illegible.

1901 (Miquel Utrillo)
 On *Arte Joven*

Arte Joven: Ruiz Picasso, who recently arrived in Madrid, has not slept for a moment, and has been studying, running around, painting and sketching in all the streets and alleys of the land of the *chulos*. The principal fruit of his activity which has seen the light of day in Madrid is a new periodical, supported by good friends, *Arte Joven*. It has had a good start, particularly on the graphic side.

From the article attributed to Miquel Utrillo, 'Revistas Novas', *Pel & Ploma* no. 72, Barcelona, 15 March 1901, p. 7; translated from Catalan by Marilyn McCully.

1901 Pablo Picasso
 Letter from Madrid to Miquel Utrillo

Friend Utrillo: I'm writing to ask you a favour. We're doing a magazine and we want to dedicate almost all of the second issue to Rusiñol. If it is not too much trouble and you would like to, could you send us some of the plates of the gardens that you reproduced.[1] Needless to say, we will reciprocate.

Write to us immediately giving us an answer about what you decide.

You must know about poor Carlos. You can imagine the shock this has given me.

Goodbye, our best, sincerely,

 P. Ruiz Picasso

Letter (1901) from Picasso to M. Utrillo; translated from Spanish by Francesc Parcerisas and Marilyn McCully. Published in Josep Palau i Fabre, *Picasso Vivent (1881–1907)*, Barcelona, 1980, p. 216.

[1] Rusiñol's paintings of gardens were reproduced in *Pel & Ploma* in no. 45 (7 April 1900) and no. 65 (1 December 1900).

1901 Gustave Coquiot
 Review of the exhibition at Vollard's gallery, Paris

Once a week a little Salon blossoms and disappears. Tomorrow we are invited to Vollard's gallery to see a group of paintings and drawings by Pablo Ruiz Picasso.[1]

This very young Spanish painter, who has only recently come among us, is a passionate lover of modern life. We think of him as a lively, inquisitive person, a keen observer of street scenes and human adven-

tures. After a brief glance at his work we are bound to imagine him covering the canvas in furious haste, impatient that he cannot wield the large, colour-laden brushes any faster.

Here we have a new harmonist of bright tonalities, with dazzling tones of red, yellow, green and blue. We realize at once that P. R. Picasso wants to see and express everything. An artist is often called a 'painter of modern life' when he is fascinated by only two or three of its aspects, but Picasso fully deserves this title, as his paintings of women, landscapes, street scenes, interiors, workmen, etc., etc., represent life precisely as we are living it today; while tomorrow, we can be sure, he will give us all the other things, which, being now little more than a child, he has not yet had time to accomplish.

Here, to begin with, are his street women, the whole range of them, with fresh or with ravaged faces. We see them at the café, in the theatre, in bed even, before or after the shock. For the high-class ones he chooses seductive tones with nuances of pink or mother-of-pearl flesh, while the pickpocket and murderess is seen lying in wait for her prey or reducing him to exhaustion in some sordid garret. P. R. Picasso is extremely versatile at painting the fine arch of an eyebrow or the curve of a leg. The whole thing is very prettily observed, without mawkishness or brutality, but expressed with a constant searching, in contrast to the grey and the bright colours. One can admire with real pleasure, in the way one does admire children nowadays, the unusual, expressive children that this artist still delights to paint.

Here are all the happy, mischievous little girls in exquisite pink and grey, with their wild dances and fluttering skirts; and here are the little boys crouching forgotten beside a sandpit, playing gravely and clumsily, with comical faces like seminarists in dog-collars, or with cunning, wide-awake expressions like monkeys. Then again you will see them solemn and dressed-up, swelling with pride in lace and fine linen, these wonderful and extraordinary little Sun Kings parading in their heavy perukes and furbelows.

Summer comes and the families are off to the seaside, looking like red, green and blue mushrooms. P. R. Picasso has expressed all the humour of this, as he has brought out the beauty of lively dance-halls, cafés-concerts and racecourses with their excited crowds. Here for instance is a dance at the Moulin Rouge, with the boys gyrating in front of girls who dance a frenzied cancan, legs wide apart, fixed on the canvas like agile butterflies as they swirl around in a flurry of skirts and underwear. Here is the café-concert, all lights and folly, and here are the races with flowers and girls in bloom, the horses parading smartly, the grandstand elegantly overlooking the well-kept grass.

Such, at the present time, is the work of Pablo Ruiz Picasso – an artist who paints all round the clock, who never believes that the day is over, in a city that offers a different spectacle every minute. A passionate, restless observer, he exults, like a mad but subtle jeweler, in bringing out his most

sumptuous yellows, magnificent greens and glowing rubies. In land-scape, we can easily imagine the joy with which he paints greenery, fences, cheerful or gloomy houses, blue cabbages hidden under the snow.

But this is not all, for other drawings depict gestures of love, beggars turned out of town, colloquies of dumb shapeless figures at dark cross-roads. Old men and women in their second childhood, goitrous children with lacklustre eyes and feeble limbs, are seen coming and going, or seated in doorways; but beside them we see once again with joy the tender flesh of little blue-eyed prostitutes with wheedling smiles of gentle melancholy.

Tomorrow we shall celebrate the works of Pablo Ruiz Picasso.

Gustave Coquiot 'La vie artistique: Pablo Ruiz Picasso', *Le Journal*, Paris, 17 June 1901; translated from French by P. S. Falla.

[1] Picasso's exhibition at Vollard's in 1901 was organized by the journalist Gustave Co-quiot. His own review, which has been neglected in Picasso literature until its recent publication in Catalan translation by Palau i Fabre (*Picasso Vivent (1881–1907)*, Barcelona, 1980, p. 514), is interesting for the full description of subject matter and painterly technique of several works in the exhibition. Many of these have been identified by Pierre Daix (see Daix, p. 156).

1901 Pere Coll
Review of the exhibition at Vollard's gallery, Paris

The exhibition that Picasso has at Galerie Vollard on the rue Laffitte is attracting collectors who are in search of the latest thing and are dying to discover the artists of the future.[1]

Picasso is very young (19 years old), and at his age I doubt if there are many who have done what he has. He has very great qualities but also great defects. The portrait of his companion Iturrino and one of another friend of his, Manyac,[2] and one of himself are done with great courage and great confidence, indicating the genius of the painter. On the other hand, I do not think much of the painting that is listed as No. 13, *La Fille du Roi d'Egipte* – I do not know why it is called that. It is a pity that a boy like him, who can do so well, should want to do strange things. I am told that he feels like this. I do not believe it. I am more inclined to believe that he has been talked into doing this. If I were Picasso I would be deaf to whatever other people told me and I would trust myself. The praise I would put in my pocket, and I would follow the path of my own in-spiration. The man who makes the drawings and colour sketches that we see here can do much, but it is a great mistake to think that he can handle every genre. The accurate touches of colour that are found in the *Races at Auteuil*[3] ought to be seen in other works. The sketch of the woman is first-rate, and it would be better for art and for himself that he should go straight ahead along this path leaving aside any other preoccupations. All

these observations are made only out of the goodwill and fondness I have towards him, and in my judgment it is better to say openly what one thinks than to say one thing to his face and another behind his back. I also know that this can cause much trouble and make enemies. But I think it is better that way.

Pere Coll, 'L'Exposició d'en Picasso', *La Veu de Catalunya*, Barcelona, 10 July 1901; translated from Catalan by Francesc Parcerisas and Marilyn McCully.

[1] Coll's review has also been overlooked in Picasso literature until its republication by Palau i Fabre (*Picasso Vivent (1881–1907)*, Barcelona, 1980, pp. 514–5).

[2] Z. VI. 1459

[3] Either *At the races* (Daix v. 31) or *Enclosure at Auteuil* (Daix v. 32/Z. I. 71).

1901 Pablo Picasso
Letter from Paris (13 July) to Vidal Ventosa

Dear Friend Vidal:[1] you don't know how happy your letter made me and I thank you for remembering me.

I can imagine the reaction of the illustrious bourgeois upon seeing my exhibition at the Sala Parés, but that ought to be as important to us as applause, that is to say, as you already know: if the wise man doesn't approve, bad; if the simpleton applauds, worse. So, I'm content.

My exhibition in Paris has had some success. Almost all the papers have treated it favourably, which is something.

I must ask you a favour; could you get hold of *Joventut*[2] for me, which you say deals with me. I'd appreciate it very much. If you see the Sotos[3] tell them to write to me.

At your disposition,

P. Ruiz Picasso

130[ter] Boulevard de Clichy – Paris

Answer me soon if it's no trouble.

Letter (13 July 1901) from Picasso to J. Vidal Ventosa; translated from Spanish by Francesc Parcerisas and Marilyn McCully. Published in Josep Palau i Fabre, *Picasso Vivent (1881–1907)*, Barcelona, 1980, p. 258.

[1] Joan Vidal Ventosa, a friend of Picasso's from Barcelona, was an art restorer and also worked in photo-gravure. In this letter, Picasso refers to the summer 1901 exhibition of his pastels at the Sala Parés.

[2] Picasso's work was first published in the Barcelona journal *Joventut* in the 19 July 1900 issue.

[3] The Catalan sculptor Mateu de Soto and his younger brother Angel were both friends of Picasso's from the circle at Els Quatre Gats.

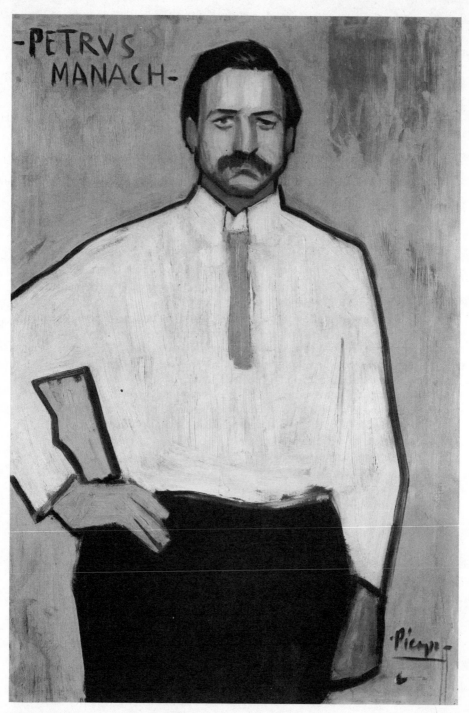

Portrait of Mañach, 1901. National Gallery of Art, Washington, D.C.

The poet Max Jacob (who was born in Brittany in 1876 and died in a concentration camp in 1944) first met Picasso in Paris in 1901 and shared a studio with him for a while in 1902 on the boulevard Voltaire. In 1915, when Jacob converted to Catholicism, he asked Picasso to act as his godfather. Picasso contributed illustrations to editions of Jacob's poetry on several occasions, including Saint Matorel *in 1911 and* Le Siège de Jérusalem *in 1914.*

(1901) Max Jacob
 Meeting Picasso in Paris

When he arrived in Paris, Picasso led the turbulent life of an apprentice. Thanks to the son of a high official of the Museum of Natural History, he and some other Spaniards used to go at night to the Jardin des Plantes to see the animals. He frequented the Moulin Rouge, the Casino de Paris and other music-halls that were fashionable at that time. He met fashionable ladies: Liane de Pougy, Otero and Jeanne Bloch, and he made very faithful portraits of them.

Picasso had a top hat that he later gave to me which was magnificent; for although he always had a taste for cheap clothes, which he bought in workmen's stores, this was the last touch of refinement: he is very fastidious and matches his drawers to his socks with as much love as he makes a painting. . . .

As soon as he had arrived in Paris, he had an exhibition at Vollard's, which was a veritable success. He was accused of imitating Steinlen, Lautrec, Vuillard, Van Gogh etc., but everyone recognized that he had a fire, a real brilliance, a painter's eye. I was an art critic at that time; I expressed my admiration and I received an invitation from a certain M. Mañach,[1] who spoke French and who managed all the affairs of this eighteen-year-old boy.

I went to see them, Mañach and Picasso; I spent a day looking at piles and piles of paintings! He was making one or two each day or night, and selling them for 150 francs on the rue Laffitte.

Picasso spoke no more French than I did Spanish, but we looked at each other and we shook hands enthusiastically. This happened in a large studio in the place Clichy, where some Spaniards were sitting on the floor, eating and conversing gaily. . . . They came the following morning to my place, and Picasso painted on a huge canvas, which has since been lost or covered over, my portrait seated on the floor among my books and in front of a large fire.

I remember having given him a Dürer woodcut, which he still has. He also admired my *images d'Epinal*, which I think I was the only person collecting at that time, and all my Daumier lithographs; I gave him everything, but I think that he has lost it all. That night all the Spaniards

went away, except for Mañach, who went to sleep in an armchair, while as for Picasso and me, we spoke in sign language until morning. One day he left for Spain.

From 'Souvenirs sur Picasso contés par Max Jacob', *Cahiers d'Art* no. 6, Paris, 1927, p. 199; translated from French by Marilyn McCully and Michael Raeburn.

[1] Pedro Mañach (also spelled Pere Manyac), a Catalan businessman, whom Picasso met on his first trip to Paris in 1900, was the artist's first dealer and arranged shows for him during the early years at Berthe Weill's gallery. Mañach also represented other Spanish artists, including Isidre Nonell, Ricard Canals, Ramon Pichot and Manolo.

1902 Pablo Picasso
Letter from Barcelona (13 July) to Max Jacob

My dear Max, it's a long time since I've written to you. It's not that I've forgotten you, but I'm working very hard. That's why I haven't written to you at all.

I'm showing what I'm doing to the *artists* here, but they think there is too much soul and no form. It's very funny. You know how to talk to people like that; but they write very bad books and they paint idiotic pictures. That's life. That's how it is.

Fontbona[1] is working very hard, but he's getting nowhere.

I want to do a picture of this drawing I'm sending you. It's a picture I'm doing of a St. Lazare whore and a nun.[2]

Send me something you've written for *Pel & Ploma*.

Goodbye my friend. Write to me.

<div align="right">Your friend Picasso</div>

rue de la Merced 3, Barcelona, Spain.

Letter (13 July 1902) from Picasso to Max Jacob; translated from French by Marilyn McCully and Michael Raeburn. Reproduced in Jaime Sabartés, *Picasso: Documents Iconographiques*, Geneva, 1954, p. 70.

[1] Picasso probably met the sculptor Emili Fontbona in 1900 in Paris, where the Catalan artist had resided for some two years.
[2] *Les Deux Soeurs* (z. I. 163). There are a number of preparatory drawings (e.g. z. VI. 435, 436 and z. XXI. 369; see also note 2 p. 79).

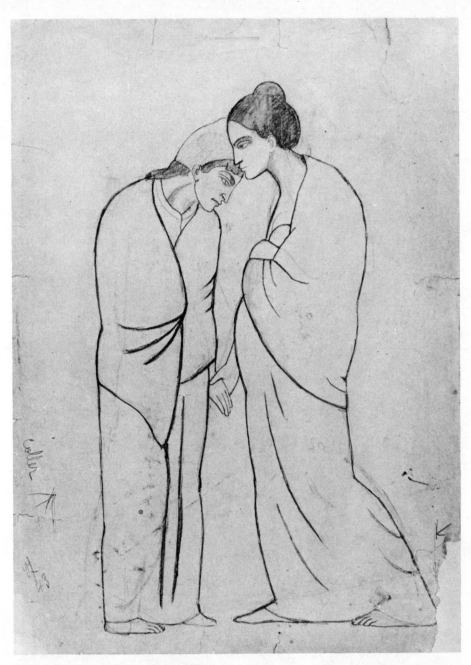

Les Deux Soeurs, 1902. Musée Picasso, Paris.

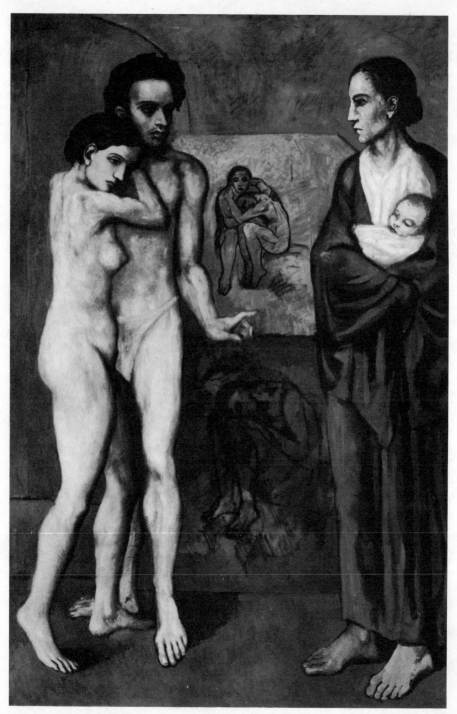

La Vie, 1903. The Cleveland Museum of Art.

1903 Pablo Picasso
Letter from Barcelona to Max Jacob

My dear Max, I'm writing to you facing what I've drawn for you first of all. It's a long time since I've written to you and it really isn't because I'm not thinking about you. It's because I'm working, and when you're not working either you enjoy yourself or you go crazy. I'm writing to you from the studio. I've worked here all day.

Do you get any holidays from *Paris-Sport* or *Paris-France*? If so, you ought to come to Barcelona to see me. You can't imagine how happy that would make me.

.

My dear old Max, I think about the room on the boulevard Voltaire and the omelettes, the beans and the brie and the fried potatoes. But I also think about those days of misery and that's very sad. And I remember the Spaniards from the rue de Seine with disgust. I'm thinking of staying here next winter to get something done.

I embrace you.

Your old friend Picasso

Letter (1903) from Picasso to Max Jacob; translated from French by Marilyn McCully and Michael Raeburn. Reproduced in Jaime Sabartés, *Picasso: Documents Iconographiques*, Geneva, 1954, pp. 84–5.

1903 *El Liberal*
On *La Vie*

Pablo Ruiz Picasso, the well-known Spanish artist, who has had so many triumphs in Paris, has recently sold one of his latest works, for a respectable price, to the Parisian collector M. Jean Saint-Gaudens. This belongs to the new series which the brilliant Spanish artist has produced recently and to which we will devote ourselves soon with the attention it deserves.

The painting which Jean Saint-Gaudens has acquired is entitled *La Vie*[1] and is one of those works which, even considering it apart from the rest, can establish the reputation and name of an artist. The subject is, besides, interesting and suggestive, and the work of the artist is of such strength and intensity that one can say for certain that it is one of the few truly solid works that has been created in Spain for some time.

'Pablo Ruiz Picasso', *El Liberal*, Barcelona, 4 June 1903, p. 2; translated from Spanish by Francesc Parcerisas and Marilyn McCully.

[1] z. I. 179

Carlos Juñer-Vidal (also spelled Junyer-Vidal) was an art critic and collector in Barcelona. His brother Sebastià was a painter who worked at the Sala Parés gallery and was a great friend of Picasso's, particularly during the 1903–4 period in Barcelona and Paris.

Carlos Juñer-Vidal's March 1904 El Liberal article was written just prior to Picasso's permanent move to Paris that spring, and it is the earliest full-length study of Picasso's work and the nature of its development to be written in Spain. The more well-known article by Miquel Utrillo that appeared in Pel & Ploma in June 1901 (translated in Daix, p. 333) is principally a biographical sketch.

1904 Carlos Juñer-Vidal
Picasso and his work

Pablo Ruiz Picasso! Here is an artist hardly known to anyone, since even most of those who 'know him' do not know him enough to understand and judge him.

Picasso is still young; he has not lived a long life yet, but his work is rooted in tradition. It is old and it is modern: old in the impulsive strength which gives his work the completeness of the idea of Art; and modern in its insatiable appetite for the new, an appetite to destroy outmoded prejudices and to overcome former trends which have still survived, though as brittle as glass.

It is my view that in order to evaluate Picasso it is necessary to have a deep understanding of all those artists whose work is transcendental and bears the mark of moral grandeur in the development of the human spirit.

Picasso is more, infinitely more than what many think – even those who seem to know him. He is the beginning of an end. And I do not mean to say that his is an art in embryo. On the contrary, through his manifold evolutions he has marked a solid and straight path, securely defined. He is the beginning of an end, not in any one independent work, but in his whole production, in his artistic temperament and feeling. For although he is still young, his work is never premature. It is precisely this original quality which signals to us what Picasso is today and what he will become in the future. He is young, and because he is young he feels a penetrating perception, a mixture of profundity, vision and 'burning' poetry: this spiritual directness, united with the fire in his heart, is admirably defined in those two beautiful lines:

'Droit comme un rayon de lumière,
et comme lui vibrant et chaud.'
(Straight as a beam of light, and like it vibrant and warm.)

For these reasons Picasso's work has charm and a beautiful suggestiveness. This is the aspect of strength, of joy or sadness, of serenity, easy

elegance, which is shown so freely in each one of his works, in a manner capable of expressing the most powerful lamentations, the subtlest dreams, the most intimate songs, and the completeness of a serious soul, which in its perceptions and solitary broodings discerns an 'infinite' and a 'beyond'.

The deep and refined perception one finds in his work leads him, in his insatiable desire for investigation, for scrutiny, for discovery, to probe far deeper than the visible. Form is the object and the medium, it is not subordinated to likeness, to expression, to gestures, to situation, even to action. His work is at once pictorial and, to an even greater degree, artistic and intensely philosophical. It combines the supreme Art – for this is transcendental philosophy – of living, feeling, expressing . . .

In this sense Picasso is triumphant: the very conception of his figures expresses everything. They are admirably drawn and are marvellously well balanced, without relying on line or the correctness of their proportion. Indeed, almost all his figures could be cast by a goldsmith or a sculptor; his hands have touched the contours of muscles, they have followed the curve of lines, they have felt the form of bones. This is what first appears to our eyes: a natural human type, in all its natural attitudes.

If one considers, knowing him well, how he understands Art, Beauty, Love, Morality . . . if one observes how his work develops naturally, impulsively, if one comprehends his way of life, his feel for life, one can see an infinity of expression, radiating from the source of his imagination and spirit, which breathes throughout all his work.

Thus we see how, starting from the harmonious form, he develops his inflexible, penetrating strength. For this reason, and in spite of it, he pays less attention to the external than to the internal, preferring intimate life to external decoration. He is more religious than idolatrous, more philosophical than picturesque, more beautiful and handsome than pretty and pleasing.

In his eagerness never to bow to any demand of any kind – not even those born of his own inclinations – he will never conceive anything to please others, but only himself. He thus shuns the unexpected, the eruption of spontaneous unconscious forces. Equally, in his development, he appears invulnerable to the ultimate danger, triviality, the absolute negation of the idea of Art.

Picasso has always conserved his strength: he has always known how to develop, leading the force of his genius through new paths, never descending to triviality.

His figures, whose strength some may consider short-lived, have always been strong. There is a background of palpitating beauty and truth in each one of the objects he describes – and thus he has averted deviousness, error, atavism. The object attains firmness both because it conforms to the idea and because it responds entirely to the ideal, presented and defined with all clarity.

Whether he interprets his chosen themes in one way or in a way directly

opposite, or in any way in between, they always have the same strength, the same power of suggestion, the same enchantment.

Since artists have such different talent, intelligence, learning and education, it is clear that the same object will impress each one differently. Each finds a distinct character in it, each conceives an original idea from it, which, manifested in a new work, suddenly reveals a new ideal form.

It is also clear that the most deeply felt, the most beautifully conceived, the most genuinely artistic idea will be the one that is most transcendent in the face of experimental reality.

There are many examples. Plautus brought Euclion, an impoverished miser, on to the stage; later Molière took the same character and created Harpagon, the wealthy miser. Two centuries go by and we have Grandet, not stupid and grotesque like his ancestors, but terrible and triumphant; and the same miser, removed from the provinces and turned Parisian, a cosmopolitan, a salon poet, reappears as Gobseck the usurer, created by the same Balzac.

This means that Picasso's work contains in some sense the strength of the works of some of the great men on whom posterity has set the seal of immortality. He has drunk wisely from these fountains and has thus formed his personality, as his work clearly indicates. The objects he describes externalize, as did the ancients, the consequences of psychological temperament, as well as all other temperamental types: melancholic, choleric, phlegmatic, or sanguine.

All this is identified not through external details but through the psychological tension of themes and things . . .

The effect of this is a strong and convincing emotion. It forms a link, a direct relationship established voluntarily by the artist's vision in this chain of influence.

This can be described with fine names: inspiration, genius or sentiment. But if you want to define it precisely, you will have to perceive clearly the real feeling, which is made up of ideas, perceptions, sentiments and the metamorphosis that transforms them into a work of art.

It is not a question of looking at one painting, one drawing, one or another topic. One must contemplate the work as a whole and plot its course.

Picasso is one of the few spirits in Spain who has collaborated in the work of faith.

His artistic temperament is free, strong and impulsive, it recognizes no school and kneels before no idol; the beauty of his temperament derives from the vitality of his thought and the supreme strength of his spirit. Consequently we realize all the time that his vision is honest, forceful, intrepid and audacious; it is loving, human and just, and desires the sublime ideal of Beauty.

Each new product of the young artist is a step further from the beginning towards the end; an example of superior life, an ascendant life. Although Picasso hates stupidity, routine and indifference – the negative

aspects of social consciousness – he replaces these with positive statements. He works with faith, enthusiasm and devotion, his convictions deepening every day, and his forces manifest their explosive, shocking strength through to the day's end.

Few, very few, have such honesty in Art. His ability is astonishing and, if he so wished, he could produce and sell many works. But he sacrifices himself and refuses to please the philistines, unlike all the others who, cynically, consider that Art is just a trade or a pastime which anyone can do.

Remember that Picasso's work cannot be compared to anything else produced in this country. It stands apart; let this be understood by everyone, both novices and experts.

Picasso will return very shortly to Paris. There he will be properly judged.

Carlos Juñer-Vidal, 'Picasso y su obra', *El Liberal*, Barcelona, 24 March 1904, p. 2; translated from Spanish by Miquel Sobré.

2.
Picasso moves to Paris and the development of Cubism

1904–1913

In 1904 Picasso decided to move permanently to Paris and took up residence on the rue Ravignan, no. 13, at the 'Bateau-Lavoir' (so nicknamed by Max Jacob because of the building's resemblance to a wash-boat), where an unusual circle of artists, writers, and art collectors soon gathered around him. After exhibitions in 1905, critics began to notice Picasso's work, which was, within a short period of time, regarded as a new direction in modern painting. The other major figure at this time was the older Henri Matisse, whose position of leadership among young artists was firmly established in 1905 with his participation in the 'fauve' room of the Salon d'Automne of that year. Although Matisse's paintings were considered radical, particularly in his choice of colours and in his use of colour rather than drawing in compositional arrangement, his work was generally discussed in relation to its connection with the French painting that preceded him. Picasso, on the other hand (until he was linked to Cézanne with Cubism), represented a new departure. Even in his 1905 harlequins, a familiar subject in French painting and literature, Picasso's expression of the haunting mystery of the saltimbanques through ambiguous spatial relationships and evocative drawing seemed to some critics, such as Apollinaire, to derive from a combination of Picasso's Spanish origins and his very personal approach to form and colour that set him apart from everyone else.

By 1906 Picasso began to concentrate more on the formal problems of his work, to give less attention to a specific subject matter. In a spirit of research and experimentation, he worked simultaneously on paintings, drawings, prints and sculpture, and in contrast to the relative ease with which he worked in almost every other period of his life, this was a time in which Picasso was struggling. André Salmon, in the description that follows of the months preceding the Demoiselles d'Avignon of 1907, suggested that Picasso had resolved pictorial problems by turning from painting to other media, especially drawing. Salmon's explanation is in fact one of the earliest attempts to account for Picasso's choosing to work in a variety of media at the same time, a habit that characterized his work in general and often perplexed his critics.

After 1907 Picasso also began to work more closely with Georges Braque, in an effort (as Braque recalled, see p. 64) to create a new art which would

reflect the spirit of scientific research they brought to their work rather than the individualism or personal temperament that was associated with a romantic notion of art. The result, of course, was Cubism. The major documents of Cubism are well known,* and excerpts from three of the principal studies, André Salmon's 'Anecdotal History of Cubism' (1913), D. H. Kahnweiler's The Rise of Cubism (1920, written during the war) and Apollinaire's The Cubist Painters (1913) follow. Although Picasso figures as one of the founders of Cubism in critical writing, it should be remembered that his cubist work was actually little known in France, and others, such as André Derain or Albert Gleizes and Jean Metzinger (who wrote Du Cubisme, in which Picasso is not discussed, in 1913), were perhaps, more widely known at the time, even though they might in retrospect seem like 'academic' Cubists.

Picasso's Demoiselles d'Avignon of 1907 (Z. II. 18) and his concurrent interest in Oceanic and African sculpture have been the basic points of departure in the discussion of the origins and problems of Cubism that have followed in much of Picasso scholarship since that time. The debt of Picasso and Braque to the work of Cézanne, discussed for example by Apollinaire, is another major factor. In his 'Anecdotal History of Cubism' André Salmon gave the Demoiselles d'Avignon (in which he described six figures rather than five) a generally mathematical rather than iconographic interpretation: 'They are naked problems, white numbers on the blackboard.' In this way the 'picture-as-equation' became emblematic in the conceptual development of Cubism, which was popularly called 'geometric' art.

In The Rise of Cubism Kahnweiler placed the Demoiselles at the beginning of Cubism, 'the first upsurge', for in it Picasso had challenged the basic problem of painting, the representation of three dimensions on a flat surface. According to Kahnweiler, the key years for both Braque and Picasso were 1909 and 1910, when their work, particularly landscapes, represented the final break with traditional perspective and the representation of closed form. Several documents concerning those years follow, including a selection from Gertrude Stein's Picasso (written in 1938), in which she captures the spirit of Picasso's ongoing struggle and commitment during that time in her own special style.

One aspect of Picasso's working technique that Stein mentioned, which has been recognized but not yet fully studied, is his use of photography. In 1909 Picasso had written in a letter dated 24 June (Beinecke Library) to Gertrude and Leo Stein from Horta, where he and Fernande Olivier spent the summer of 1909, that not only had he painted two landscapes but that he intended to photograph the town. A comparison of one of his photographs and a painting of Horta from that summer (Z. II. 161, reproduced in Fry, fig. 14) suggests that photography did play a part both in his consideration of compositional space and in his choice of a limited palette. A striking planar quality and

* Edward Fry's excellent study of Cubist documents should be consulted for other critical writing of the period (see Cubism, New York-Toronto-London, 1966).

shifting geometry is produced by the shapes of the houses and walls of this little hill town, complemented by the narrow range of golden hues of the earth, sandstone and stucco structures, and the rocks beneath them. Picasso's black-and-white photographic image emphasized those geometrical relationships and tended to crowd the spatial reading of the overall view. ⋆

This section ends with Apollinaire's perceptive discussion of the import-ance of papier collé *and collage from* The Cubist Painters *of 1913. In this year Picasso's witty, sometimes poetic, and expressive nature strongly re-emerged from the less personal analytic phase of Cubism, through his choices of materials and the juxtaposition of elements in synthetic works, such as* Still life with chair caning (z. ii. 294), *which Apollinaire described. This 'syn-thetic' phase of Cubism signalled the end of the idea of an anonymous personality that Braque and Picasso had championed in the preceding years, and thereafter they worked apart.*

⋆ *Picasso's use of photography is usually associated with works from a later date; for example, two drawings of Russian dancers of 1919 (z. iii. 355 and z. iii. 353) are known to be based upon a publicity photograph (see MOMA catalogue, p. 199).*

The Frugal Repast, 1904.

48

Fernande Olivier, the woman who shared Picasso's life from 1904 to 1912, wrote of first meeting Picasso at the Bateau-Lavoir and her impressions of his studio in the selection that follows from her well-known book Picasso and his Friends *(first published in 1933). Her comment about the painting of a cripple (now lost) is particularly noteworthy, for she refers to the intellectual conception of the work rather than its potentially sentimental interpretation. (The red harlequin that, according to Olivier, covered the painting of the cripple has not been identified.)*

Beginning with the move to Paris, Picasso had shifted from the so-called Blue Period subjects of beggars and other unfortunate or marginal types to his Rose Period harlequins and female figure studies. Not only did Picasso thus abandon the symbolist overtones of the earlier works but the artistic problems of form and composition began to predominate in his canvases, particularly in 1906. These works were often painted with a limited range of tones of rose, the pink of flesh, the red of clay (of sculpture and pottery) and the earth itself. Picasso's activity in printmaking, also noted on Olivier's first visit to the studio, and in sculpture in the following year contributed to an increasingly formal approach in his painting.

(1904) Fernande Olivier
Picasso at the 'Bateau-Lavoir'

As I lived in the same house as he did I often bumped into him. At this period he seemed to spend all his time on the little Montmartre square, and I remember thinking: 'Whenever does he work?' I learned later that he preferred painting at night, so as not to be disturbed. During the day he was visited by a constant stream of Spaniards. I met Picasso as I was coming home one thundery evening. He was holding a tiny kitten in his arms, and he held it out to me, laughing and blocking my path. I laughed, too, and he took me to see his studio.

This was the introduction into the world in which I was to live for so long; the world I came to know, love and respect.

I was astonished by Picasso's work. Astonished and fascinated. The morbid side of it certainly perturbed me somewhat, but it delighted me too. This was the end of the 'Blue Period'. Huge, unfinished canvases stood all over the studios, and everything there suggested work: but, my God, in what chaos!

· · · · ·

Picasso was working at the time on an etching, which has become famous since: it is of a man and a woman sitting at a table in a wine-shop.[1] There is the most intense feeling of poverty and alcoholism and a startling realism in the figures of this wretched, starving couple.

One painting particularly struck me – I think Picasso has since painted over it – of a cripple leaning on his crutch and carrying a basket of flowers

49

on his back. The man, the background, everything in the picture, was blue, except the flowers, which were painted in fresh, brilliant colours. The man was haggard, gaunt, and miserable, and his expression told of his hopeless resignation. The effect was strange, tender and infinitely sad, suggesting total hopelessness, an agonized appeal to the compassion of mankind.

What was at the bottom of this kind of painting? Was the work completely intellectual in conception, as I've come to understand it since, or did it reveal a deep and despairing love of humanity as I thought then?

Picasso painted over that canvas. He frequently had too little money to buy materials, and I'm fairly sure that the blue cripple with the basketful of flowers was covered by the large red harlequin with the pointed cap, which was later bought for the Rouart collection.

From Fernande Olivier, *Picasso et ses amis*, Paris, 1933; translated from French by Jane Miller as *Picasso and his Friends*, London, 1964, pp. 27–8.

[1] *The Frugal Repast* (G. 2)

Until Picasso moved to a new studio on the boulevard Clichy in the autumn of 1909, the Bateau-Lavoir (which he gave up finally in 1912) was a popular meeting place for poets, writers, collectors, painters and all the other characters Olivier called 'la bande à Picasso'. Undoubtedly, Picasso's contact with writers such as Guillaume Apollinaire, André Salmon, Max Jacob, and Gertrude Stein, among others, stimulated his curiosity in both contemporary and older literary works. Specific evidence of that interest is found in a letter to his friend Jacinto Reventós that follows, where Picasso named several books he was reading; and in Max Jacob's recollections, where Jacob described their experiments in amateur theatre production. Moreover, André Salmon noted in his 'Anecdotal History of Cubism', that Picasso's fascination with the subject of saltimbanques, wandering performers often dressed in harlequin's costume, was also shared by Apollinaire. In connection with the subject of saltimbanques, a brief comment (that follows), attributed to the writer Ramon Reventós by Pasarell, links the earthen tones of Picasso's harlequins to the autumnal colours of the vineyards of Tiana. This suggests that Picasso's visits to this Catalan village, which have been generally overlooked in Picasso literature, must have taken place before or during 1905.

1905 Pablo Picasso
 Letter from Paris to Jacinto Reventós

Paris Wednesday [22] February 1905

Dear friend Jacinto
You cannot imagine the happiness you gave me yesterday when I read your letter, because I have thought of you often and it has been a consolation for me to talk with you – you already know how lonely I am, always in the middle of a commotion and in the midst of a crowd which irritates me, but I am forced to deal with them because of interest and necessity – one has to eat – but if it were only that! When you have to arrange things with other people and when you want to do something, it's terrible to be obliged to waste so much time, sometimes scrounging for the last *peseta* to pay for the studio or restaurant – and believe me all those struggles and all this trouble isn't worth it – it's wasted time. This only teaches you a practical and stupid moral, identical in everything to that of the last bourgeois of Barcelona. But, anyway, I continue working and in a few days I'm going to have a small exhibition.[1] God willing people will like it and I'll sell all I'm sending. Charles Morice is in charge of organizing it. He tries to cover whatever is in his hands in the *Mercure de France* – we'll see about the results of all this. Another day I'll write you more. This letter is only so you know I received yours.
 A hug from your friend

 Picasso
 13 rue Ravignan

Tell me if you know Rabelais *(Gargantua)* – Gargantua you might know in Spanish, but what a difference. . . . *La Bruyère* and all these other classics from here. One of these days I'll send you a book by Pascal that you might not know.

Letter (22 February 1905) from Picasso to J. Reventós; translated from Spanish by Francesc Parcerisas and Marilyn McCully. Property of Jacint Reventós i Conti. Reproduced in Jacint Reventós i Conti, *Picasso i els Reventós*, Barcelona, 1973, pp. 50–1.

[1] This exhibition was held at the Galeries Serrurier from 25 February to 6 March. Daix (*Picasso: The Blue and Rose Periods*, pp. 335–6) reproduces Charles Morice's introduction to the catalogue, his review that appeared in *Mercure de France* (15 March) and two reviews by Guillaume Apollinaire, in *La Revue Immoraliste* (1 April) and *La Plume* (15 May, which follows). He also gives a list of works in the exhibition (pp. 254–5) and identifies many of the paintings exhibited.

The Young: Picasso, Painter

The harlequins go in splendid rags while the painting is gathering, warming or whitening its colours to express the strength and duration of the passions, while the lines, delimited by the tight curves, intersect or flow impetuously.

In a square room, paternity transfigures the harlequin, whose wife bathes with cold water and admires her figure, as frail and slim as her husband, the puppet. A stove warms a nearby gypsy caravan. Fine lilts mingle, and elsewhere passing soldiers curse the day.

Love is good when it is set off, and the habit of spending one's time at home redoubles paternal feeling. The child brings the woman Picasso wanted glorious and immaculate closer to the father.

Primiparous mothers no longer expect the baby to arrive, perhaps because of certain ill-omened, chattering ravens. Miracle! They give birth to future acrobats in the midst of pet monkeys, white horses, and dogs like bears.

Adolescent sisters, treading in perfect balance the heavy balls of the saltimbanques, impose on these spheres the radiant motion of worlds. These still adolescent youngsters have the anxieties of innocence; animals instruct them in the religious mystery. Some harlequins match the splendour of the women, whom they resemble, being neither male nor female. The colour has the flatness of frescoes; the lines are firm. But placed at the frontiers of life, the animals are human, and the sexes are indistinct. [1]

Hybrid beasts have the consciousness of Egyptian demigods: taciturn harlequins have their cheeks and foreheads paled by morbid sensibility.

You cannot confuse these saltimbanques with actors. The spectator must be pious for they are celebrating silent rites with a difficult agility. It is this that distinguishes this painter from the Greek vase painters although his drawing sometimes approaches theirs. There, on the painted earthenware, bearded, garrulous priests offered in sacrifice animals, resigned and powerless. Here, virility is beardless, but shows itself in the sinews of thin arms, in the flat planes of the face, and the animals are mysterious.

Picasso's taste for the elusive line transforms and penetrates, and produces almost unique examples of linear drypoints in which the general appearance of the world is not altered by the light which modifies forms as it changes colours.

More than all the poets, sculptors and the other painters, this Spaniard scathes us like a sudden chill. His meditations are laid bare in the silence. He comes from afar, from the opulence of composition and brutal decoration of the Spaniards of the seventeenth century.

Those who have been acquainted with him remember transient manifestations of ferocity which already were more than just experiments.

His insistence on the quest of beauty has governed his path. He has found himself more of a Latin in morals, more of an Arab in rhythms.

From Guillaume Apollinaire, 'Les jeunes: Picasso, peintre', *La Plume*, Paris, 15 May 1905; translated and included in Pierre Daix, *Picasso: The Blue and Rose Periods*, London and Greenwich, Conn., 1966, p. 336.

[1] Apollinaire refers to a number of works in the series of saltimbanque subjects exhibited at the Galeries Serrurier (see note p.51).

The Harlequin's Family, 1905. Private collection.

(1905) Jaume Pasarell
Picasso in Tiana

What the residents of Tiana don't know – and now the opportune moment has arrived to tell this – is that the painter Pau Picasso was also a guest in Tiana.[1] Those who know about this strange circumstance are the Reventós family. What I know is only that he spent some time there and, as the deceased humorist Ramon Reventós used to say whenever Picasso was discussed, the ochres of his harlequins were stolen from the golden colour of the vineyards of Tiana in the autumn.

From Jaume Pasarell, 'Una tarda de maig a Tiana', *Meridia*, **Barcelona, 1 July 1938, p. 7; translated from Catalan by Francesc Parcerisas and Marilyn McCully.**

[1] Tiana is located some 17 kilometres north-east of Barcelona in the wine-producing region known as the Maresme.

(1905–7) Max Jacob
Picasso, Apollinaire, Salmon and Jacob

The art dealers who today are so proud of having discovered Picasso thought he was mad. 'Your friend has gone mad!' M. V . . . said to me. One day, when Picasso was sick and I had tried to sell this same M. V. a landscape, he said to me disdainfully 'The bell tower is crooked!' and turned his back on me.

Picasso sold some drawings for ten *sous* to a junk shop on the rue des Martyrs,[1] and those ten *sous* were welcome.

In the evenings we acted out plays by the light of an oil lamp, as we were not able to see other people's performances. We took all the parts in turn, including that of the producer, the stage manager, the electricians and the stage hands, and brought them all into the play. (Pirandello did not invent anything.)

We used to go to a restaurant which gave us credit and we always paid in the end. Later we took all our friends there, and the place was full, if not rich. Père Vernin deserves a chapter in a book. . . .

One morning, when I arrived as usual from my lodgings on the boulevard Barbès, Picasso, whom I had not seen the previous evening, told me he had spent the evening in a bar on the rue d'Amsterdam with an extraordinary man, Guillaume Apollinaire, and that he would introduce me to him that same evening. I then met Guillaume Apollinaire, who was impressive. He was seated on a leather bench, surrounded by a thousand little books which he brought out from everywhere, and by a group of rather common people. He gave me his hand, and from that moment a triple friendship started, which lasted until Apollinaire's death. This all

54

happened in 1905. Picasso and Apollinaire understood one another marvellously. Picasso painted harlequins and saltimbanques; Apollinaire put them in his poems. The figure of Apollinaire was often repeated in his paintings; mine too. We were never apart: we used to wait for Apollinaire at the entrance to the bank where he was employed on the rue Lepelletier. We had lunch and dinner together. Our literary opinions were summed up in the words that were so important at the time: 'Down with Laforgue! Long live Rimbaud!' The 'Long live Rimbaud' was prophetic, as we all know.

One winter morning, when I arrived in the corridor which led to the studio, a tall thin young man asked me where Picasso lived. I said to him 'Are you André Salmon?' And he replied 'Are you Max Jacob?' A minute later we were seated on the garnet-red mattress with no feet which served as the studio divan. Salmon became Picasso's friend.

At the time he also knew Derain, Vlaminck and Matisse. For a while, we used to go on Thursday evenings to Matisse's for dinner, Picasso, Salmon, Apollinaire and myself. I think it was at Matisse's that Picasso saw Negro sculpture, or at least that he was struck by it, for the first time. Picasso has never confided in me at all about the invention of Cubism, so that I have to rely on guesswork, and I will venture to say this: Cubism was born from Negro sculpture. Picasso began some large figures (in 1906 or 1907) with their noses attached to their eyes. He absorbed himself in deep meditation, simplifying animals and objects and arriving at a single stroke at drawings of a kind that recall those in prehistoric caves. I doubt that any still exist.

From 'Souvenirs sur Picasso contés par Max Jacob', *Cahiers d'Art* no. 6, Paris, 1927, p. 202; translated from French by Marilyn McCully and Michael Raeburn.

[1] This was Père Soulier's shop, where Picasso purchased a painting by Douanier Rousseau, which was offered to him as a second-hand canvas to paint over.

(1907) André Salmon
On *Les Demoiselles d'Avignon*

After a fine series of acrobats that were also metaphysicians, of ballerinas that were attendants of Diana, of sorcerer clowns and figures like Apollinaire's *arlequin trismégiste*,[1] Picasso had painted without a model the extremely pure, simple image of a young Parisian workman, beardless and dressed in blue. Very much as the artist himself looked when he was at work.

One night Picasso deserted the group of friends deep in intellectual discussion: he went back to his studio and, taking up this picture, which he had left untouched for a month, gave the young artisan in it a crown of

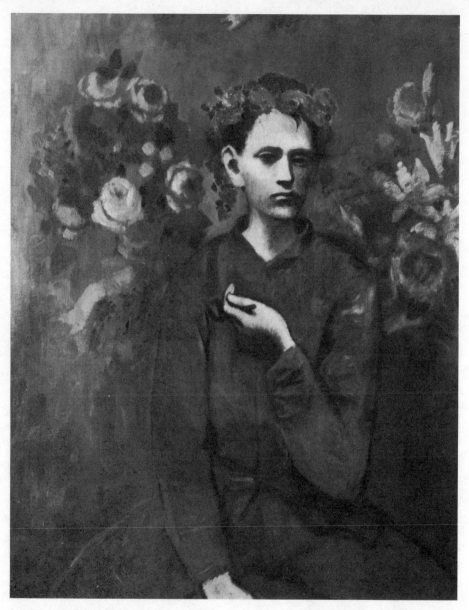

Boy with a pipe, 1905. Private collection.

roses. By a sublime stroke of caprice he had turned his picture into a masterpiece.[2]

Picasso was able to live and work in this way, happy, justifiably satisfied with himself. He had no ground for hoping that some different effort would bring him more praise or make his fortune sooner, for his canvases were beginning to be competed for.

And yet Picasso felt uneasy. He turned his pictures to the wall and threw down his brushes.

Through long days – and the nights as well – he drew, concretizing the abstract and reducing the concrete to its essentials. Never was labour less paid with joys, and it was with none of his former juvenile enthusiasm that Picasso set to work on a major picture which was intended to be the first application of his researches.

Already the artist had taken ardently to the sculpture of the Negroes, whom he placed well above the Egyptians. His enthusiasm was not based on any trivial appetite for the picturesque. The images from Polynesia or Dahomey appeared to him as 'reasonable'. Renewing his work, Picasso inevitably presented us with an appearance of the world that did not conform to the way in which we had learned to see it.

The familiars of the strange studio in the rue Ravignan, who put their trust in the young master, were for the most part disappointed when he gave them the chance of judging his 'new' work in its first form.

This canvas has never been exhibited to the public. It contains six huge female nudes; the drawing of them has a rugged accent. For the first time in Picasso's work, the expression of the faces is neither tragic nor passionate. These are masks almost entirely freed from humanity. Yet these people are not gods, nor are they Titans or heroes; not even allegorical or symbolic figures. They are naked problems, white numbers on the blackboard.

Thus Picasso has laid down the principle of the picture-as-equation. *serene Beauty with widenly up Mouter*

One of Picasso's friends spontaneously christened the new canvas 'the philosophical brothel'. This was, I think, the last studio joke to cheer the world of the young innovating painters. Painting, from now on, was becoming a science, and not one of the less austere.

DIRECTION OF LIGHT

The large picture, with its severe figures and its absence of lighting effects, did not long remain in its original state.

Soon Picasso attacked the faces, whose noses were for the most part placed full-face, in the form of isosceles triangles. The apprentice sorcerer was still seeking answers to his questions among the enchantments of Oceania and Africa.

After no great while, these noses became white and yellow; touches of blue and yellow added relief to some of the bodies. Picasso was composing for himself a limited palette of succinct tones corresponding rigorously to his schematic design.

At length, dissatisfied with his first researches, this Neronian attacked

other nudes – which he had so far spared, kept in reserve – seeking a new statics, and composing his palette of pinks, whites and grisaille tones.

For a rather short time Picasso seemed satisfied with this gain; the 'philosophical brothel' was turned face to the wall, and it was at this moment that he painted those pictures with their fine harmony of tones and very supple drawing – nudes for the most part – which made up Picasso's last exhibition in 1910.

This painter, who had been the first to find a way of restoring a certain nobility to the discredited subject, here returns to the 'study' and to the studies of his first manner: *Woman Dressing, Woman Combing her Hair*.[3] He seemed content for the moment to draw no further upon the researches for which he had voluntarily sacrificed his original gift of immediate attractiveness.

It is necessary to follow, step by step, the man whose tragic curiosity was to produce Cubism. A holiday interrupted his painful experiments. On his return, Picasso took up again the big experimental picture, which, as I have said, lived only by its figures. — *no other subject matter*

He created its atmosphere by a dynamic decomposition of light values; an effort which left the attempts of neo-impressionism and 'divisionism' far behind. Geometrical signs – belonging to a geometry that was both infinitesimal and cinematic – came on the scene as the principal element in a kind of painting whose development, from now on, nothing could stop.

Never was Picasso to become again – for inevitably he could not – the fertile, ingenious, skilful creator of works filled with human poetry.

From André Salmon, *La jeune peinture française*, Paris, 1913 (from chapter 'Anecdotal History of Cubism'); reprinted in translation from French in Edward Fry, *Cubism*, New York-Toronto-London, 1966, pp. 81–3.

[1] See note p. 144.
[2] Boy with a pipe (z. I. 274)
[3] Picasso exhibited twice in Paris in 1910, at the Galerie Notre-Dame-des-Champs in May and probably at Vollard's in December. The series of nudes to which Salmon refers were perhaps included in the later show (with no catalogue), which he also reviewed in *Paris Journal* on 22 December 1910.

(1907) Daniel-Henry Kahnweiler
On *Les Demoiselles d'Avignon*

Early in 1907 Picasso began a strange large painting depicting women, fruit and drapery, which he left unfinished. It cannot be called other than unfinished, even though it represents a long period of work. Begun in the spirit of the works of 1906, it contains in one section the endeavours of 1907 and thus never constitutes a unified whole.

The nudes, with large, quiet eyes, stand rigid, like mannequins. Their

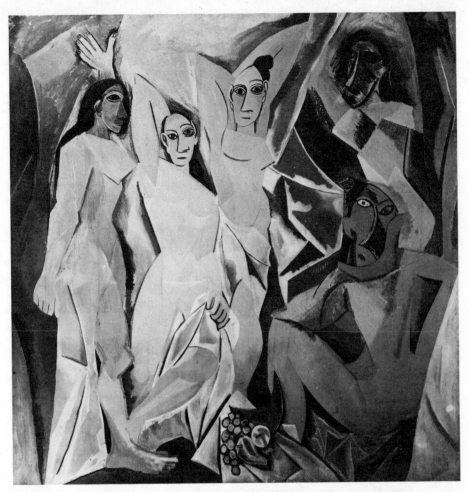

Les Demoiselles d'Avignon, 1907; oil on canvas, 243.9 × 233.7cm. The Museum of Modern Art, New York.

stiff, round bodies are flesh-coloured, black and white. That is the style of 1906.

In the foreground, however, alien to the style of the rest of the painting, appear a crouching figure and a bowl of fruit. These forms are drawn angularly, not roundly modelled in chiaroscuro. The colours are luscious blue, strident yellow, next to pure black and white. This is the beginning of Cubism, the first upsurge, a desperate titanic clash with all of the problems at once.

These problems were the basic tasks of painting: to represent three dimensions and colour on a flat surface and to comprehend them in the unity of that surface. 'Representation', however, and 'comprehension' in the strictest and highest sense. Not the simulation of form by chiaroscuro, but the depiction of the three-dimensional through drawing on a flat surface. No pleasant 'composition' but uncompromising, organically articulated structure. In addition, there was the problem of colour, and finally, the most difficult of all, that of the amalgamation, the reconciliation of the whole.

Rashly, Picasso attacked all the problems at once. He placed sharp-edged images on the canvas, heads and nudes mostly, in the brightest colours: yellow, red, blue and black. He applied the colours in thread-like fashion to serve as lines of direction, and to build up, in conjunction with the drawing, the plastic effect. But, after months of the most laborious searching, Picasso realized that a complete solution of the problem did not lie in this direction.

At this point I must make it clear that these paintings are no less 'beautiful' for not having attained their goal. An artist who is possessed of the divine gift, genius, always produces aesthetic creations, whatever their aspect, whatever their 'appearance' may be. His innermost being creates the beauty; the external appearance of the work of art, however, is the product of the time in which it is created.

From Daniel-Henry Kahnweiler, *Der Weg zum Kubismus*, Munich, 1920; translated by Henry Aronson as *The Rise of Cubism*, New York, 1949, pp. 6–7.

Two separate accounts follow of the well-known banquet organized by Picasso and his friends for the painter Henri Rousseau in November 1908. In Fernande Olivier's description of the after-dinner speeches and tributes mention is made of some of those in attendance, including the artists Auguste Agero and Ramon Pichot, Pichot's wife Germaine (who had been Casagemas's girlfriend, see pp. 18–19), and the writers André Salmon Max Jacob, Maurice Cremnitz and Gertrude Stein. The account given by Gertrude Stein in her Autobiography of Alice B. Toklas in 1933 prompted an attack by André Salmon, which was published in Transition in 1935. Comments by Georges Braque in the same number of Transition concerning further inaccuracies in Gertrude Stein's book are also given here.

(1908) Fernande Olivier
 The banquet for Douanier Rousseau

In 1908 Picasso decided to organize, at his own expense and in his studio,
a banquet in honour of Henri Rousseau. The project was received en-
thusiastically by the gang, who were overjoyed at the prospect of pulling
the *Douanier*'s leg.

They planned to invite thirty people, and all those who wanted to come
after dinner would be allowed to.

.

After dinner there were speeches and songs composed especially for the
occasion; then a few words from Rousseau, who was so moved that he
spluttered with pleasure. Indeed, so happy was he that he accepted with
the greatest stoicism the regular dripping of wax tears on to his brow from
a huge lantern above him. The wax droppings accumulated to form a
small pyramid like a clown's cap on his head, which stayed there until the
lantern eventually caught fire. It didn't take much to persuade Rousseau
that this was his apotheosis. Then Rousseau, who had brought his violin,
started to play a little tune.

What a colourful evening that was! Two or three American couples,
who had got there by accident, had to make the most excruciating efforts
to keep a straight face. The men in their dark suits and the women in pale
evening-dresses seemed a bit out of their element amongst us.

The wives and mistresses of the painters were wearing simple little
dresses of undeniable originality. Madame Agero looked like a schoolgirl
in a black smock. Her husband hadn't a care in the world, and though he
probably imagined he was taking it all in he seemed to be oblivious of
everything. There were the Pichots, the Fornerods, André Salmon and
Cremnitz, who at the end of the evening did an imitation of *delirium
tremens*, chewing soap and making it froth out of his mouth, which
horrified the Americans. Jacques Vaillant, Max Jacob, Apollinaire and
Leo and Gertrude Stein were there, and many, many others.

From Fernande Olivier, *Picasso et ses amis*, Paris, 1933; translated from French
by Jane Miller as *Picasso and his Friends*, London, 1964, pp. 68–70.

(1908) Gertrude Stein
 The banquet for Douanier Rousseau

The ceremonies began. Guillaume Apollinaire got up and made a solemn
eulogy, I do not remember at all what he said but it ended up with a poem
he had written and which he half chanted and in which everybody joined
in the refrain, La peinture de ce Rousseau. Somebody else then, possibly
Raynal, I don't remember, got up and there were toasts, and then all of a

sudden André Salmon who was sitting next to my friend and solemnly discoursing of literature and travels, leaped upon the by no means solid table and poured out an extemporaneous eulogy and poem. At the end he seized a big glass and drank what was in it, then promptly went off his head, being completely drunk, and began to fight. The men all got hold of him, the statues tottered, Braque, a great big chap, got hold of a statue in either arm and stood there holding them while Gertrude Stein's brother, another big chap, protected little Rousseau and his violin from harm. The others with Picasso leading because Picasso though small is very strong, dragged Salmon into the front atelier and locked him in. Everybody came back and sat down.

Thereafter the evening was peaceful. Marie Laurencin sang in a thin voice some charming old norman songs. The wife of Agero sang some charming old limousin songs, Pichot danced a wonderful religious spanish dance ending in making of himself a crucified Christ upon the floor. Guillaume Apollinaire solemnly approached myself and my friend and asked us to sing some of the native songs of the red indians. We did not either of us feel up to that to the great regret of Guillaume and all the company. Rousseau blissful and gentle played the violin and told us about the plays he had written and his memories of Mexico. It was all very peaceful and about three o'clock in the morning we all went into the atelier where Salmon had been deposited and where we had left our hats and coats to get them to go home. There on the couch lay Salmon peacefully sleeping and surrounding him, half chewed, were a box of matches, a petit bleu and my yellow fantaisie. Imagine my feelings even at three o'clock in the morning. However, Salmon woke up very charming and very polite and we all went out into the street together. All of a sudden with a wild yell Salmon rushed down the hill.

Gertrude Stein and her brother, my friend and I, all in one cab, took Rousseau home.

From **Gertrude Stein**, *The Autobiography of Alice B. Toklas*, **New York and London, 1933, pp. 106–7.**

(1908) André Salmon
Response to Gertrude Stein

The scandalous part of the book took us somewhat by surprise. After all we were all young at that time and had no thought of possible later echoes of our actions. I am not angry but I think Gertrude Stein went too far when she made all these things public. Furthermore, there is great confusion of dates, places and persons in her book.

For instance, the story of the Rousseau banquet is very badly told. There is no respect for details, as we might have had the right to expect

from Gertrude Stein since she enjoyed our friendly confidence, and the way she recounts this banquet is very flighty, to say the least. I am all the more astounded for I had thought, along with all our friends, that she had really understood things. It is evident that she had really understood nothing, except in a superficial way.

Her description of my drunkenness on this occasion is entirely false. Madame Fernande Olivier, in her book, *Picasso and his Friends*, tells it much better. 'Salmon pretended delirium tremens in order to frighten the American ladies present.' It was exactly that. Guillaume Apollinaire and I had spent the afternoon together writing the poems that were read. The banquet was not given just for the fun of it either, as Miss Stein seems to have thought, but because we sincerely admired Rousseau. The spectacular features of it were intentional and after the joke of drunkenness I simply went back to my own studio in order to make it seem more plausible. It is evident that Miss Stein understood little of the tendency that we all had, Apollinaire, Max Jacob, myself and the others, to frequently play a rather burlesque role. We made continual fun of everything. When we dined together, for instance, Jacob would often pretend that he was a small clerk, and our conversations in a style that was half slang half peasant amused everybody in the restaurant. We invented an artificial world with countless jokes, rites and expressions that were quite unintelligible to others. Obviously she did not understand very well the rather peculiar French we used to speak. Furthermore, we saw 'The Steins', as we used to call her and Miss Toklas, very rarely, and I was at her house only once.

It is true that Apollinaire recited one of his poems at the Rousseau banquet but it was not he who sang a song afterwards. It is also true that I recited a poem in honour of Rousseau but I did not climb on to the table, as Miss Stein would have had me do. It would be better to refer the reader to the above mentioned book by Madame Fernande Olivier which tells the story of the Rousseau banquet with much more charm and veracity.

Miss Stein's account of the formation of Cubism is entirely false. I was constantly with Picasso, who was nothing of a doctrinaire, soon lost interest in it and left its further development to others. Miss Stein often mentions people whom she never knew very well, and so irresponsibly, in fact, that the reader is astounded. Monsieur Princet, for instance, was not at all as she described him, but a man of distinction. Germaine Pichot was not Spanish but a native of Montmartre. Vaillant, who is spoken of with a certain disdain, was a man entirely without pretentions but who had many excellent qualities. Apollinaire did not use the familiar 'tu' with any and everybody. After all!

And what confusion! What incomprehension of an epoch! Fortunately there are others who have described it better.

From 'Testimony against Gertrude Stein', *Transition* no. 23, Pamphlet no. 1 (Supplement), The Hague, February 1935, pp. 14–15.

Georges Braque
Response to Gertrude Stein

Miss Stein understood nothing of what went on around her. I have no intention of entering into a discussion with her, since it is obvious that she never knew French really well and that was always a barrier. But she has entirely misunderstood Cubism which she sees simply in terms of personalities.

In the early days of Cubism, Pablo Picasso and I were engaged in what we felt was a search for the anonymous personality. We were inclined to efface our own personalities in order to find originality. Thus it often happened that amateurs mistook Picasso's painting for mine and mine for Picasso's. This was a matter of indifference to us because we were primarily interested in our work and in the new problem it presented.

Miss Stein obviously saw everything from the outside and never the real struggle we were engaged in. For one who poses as an authority on the epoch it is safe to say that she never went beyond the stage of the tourist.

Among other fallacies, she insists that Marie Laurencin and I 'painted each other's portraits'. I have never painted Marie Laurencin's portrait.

But while she was gossiping about the little things that happened it is a pity that she should have neglected to tell further details of her visit to me during the war. I was convalescing when she and Miss Toklas arrived in their Red Cross Ford. They looked extremely strange in their boy-scout uniforms with their green veils and Colonial helmets. When we arrived at Avignon, on the Place Clemenceau, their funny get-up so excited the curiosity of the passers-by that a large crowd gathered around us and the comments were quite humorous. The police arrived and insisted on examining our papers. They were in order all right, but for myself, I felt very uncomfortable.

We in Paris always heard that Miss Stein was a writer, but I don't think any of us had read her work until *Transition* began to make her known in France. Now that we have seen her book, *nous sommes fixés*.

From 'Testimony against Gertrude Stein', *Transition* no. 23, Pamphlet no. 1 (Supplement), The Hague, February 1935, pp. 13–14.

In the late spring and summer of 1909, Fernande and Picasso spent several months in the Catalan village of Horta de Ebro, where the landscapes Picasso painted are discussed by Gertrude Stein in her book Picasso *as significant steps in the development of Cubism. In addition, Stein emphasized the importance of Picasso's artistic heritage in that development. Not only were the landscapes painted in Spain but Picasso had written to Gertrude and her brother Leo that summer that he intended to travel to see Spanish paintings in*

Madrid and Toledo. In a letter (in the Beinecke Library), probably written in May 1909, he wrote: 'The doctor says that Fernande can make the journey to Madrid and Toledo and Fernande also feels better. I would be very happy to go – it's been a long time that I've wanted to see Greco again in Toledo and Madrid.' This trip, however, was apparently cancelled.

(1909) Gertrude Stein
Concerning Cubism

Once again Picasso in 1909 was in Spain and he brought back with him some landscapes which were, cer~ ~ly were, the beginning of cubism. These three landscapes[1] were e~ ~narily realistic and all the same the beginning of cubism. Pica~ ~nce taken some photographs of the village that he had pai~ ~mused me when every one protested against the far~ ~ to make them look at the photographs which m~ ~ pictures were almost exactly like the photographs

.

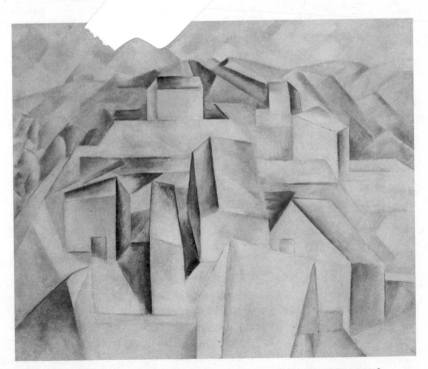

Houses on the Hill, Horta de Ebro, 1909; oil on canvas, 65 × 81cm. The Museum of Modern Art, New York.

After his return from Spain with his first cubist landscapes in his hand, 1909, a long struggle commenced.

Cubism began with landscapes but inevitably he then at once tried to use the idea he had in expressing people. Picasso's first cubist pictures were landscapes, he then did still life but Spaniard that he is, he always knew that people were the only interesting thing to him. Landscapes and still lifes, the seduction of flowers and of landscapes, of still lifes were inevitably more seductive to Frenchmen than to Spaniards, Juan Gris always made still lifes but to him a still life was not a seduction it was a religion, but the ecstasy of things seen, only seen; never touches the Spanish soul.

The head the face the human body these are all that exist for Picasso. I remember once we were walking and we saw a learned man sitting on a bench, before the war a learned man could be sitting on a bench, and Picasso said, look at that face, it is as old as the world, all faces are as old as the world.

And so Picasso commenced his long struggle to express heads faces and bodies of men and of women in the composition which is his composition. The beginning of this struggle was hard and his struggle is still a hard struggle, the souls of people do not interest him, that is to say for him the reality of life is in the head, the face and the body and this is for him so important, so persistent, so complete that it is not at all necessary to think of any other thing and the soul is another thing.

The struggle then had commenced.

From Gertrude Stein, *Picasso*, Paris, 1938; English edition, London, 1938, and New York, 1939, pp. 8–9, 13–14.

[1] *Houses on the Hill, Horta* (z. II. 161) and *The Reservoir, Horta de Ebro* (z. II. 157) were originally purchased by Leo and Gertrude Stein; a third painting, *Factory at Horta de Ebro* (z. II. 158), was purchased by Shchukin.

1910 Fernande Olivier
Letter from Paris (17 June) to Gertrude Stein

My dear Gertrude

17 June 1910

I wanted to write to you but I wasn't sure that you would be receiving mail at Fiesole. I waited and *here I am*. We have received the American newspapers. Thank you. I don't know if I told you that we are definitely going to Spain. I think this plan was decided upon after your departure. There are sure to be too many painters going to Collioure, like Marquet, Manguin, Puy etc. So Pablo decided not to. We shall go to Cadaqués, where the Pichots go every year. It's on the other side of the border just about the same distance from the French border as Collioure is from the

Spanish border. We shall be there till September and then we shall certainly go to Barcelona. Braque, Derain and Alice should be coming with us to Barcelona.

.

Pablo has received that American magazine for which a reporter came two years ago, who took his picture and photographed several canvases. You probably remember that we talked about this little American who visited the studios of several painters (the fauves) and who gave out little boxes to light cigarettes. There is a very long, very *American* article with portraits of Braque, Derain, Friesz, Herbin, Pablo, and with photographs of paintings. The rather large red painting you have of *Three women* is reproduced there. It's an architecture magazine. If you haven't received it, maybe you could get hold of a copy for us?[1]

Pablo is working on the Portrait of Vollard[2] at the moment. As for me, I am doing nothing as usual and you ought to write me a letter.

We have made great friends with some clowns, acrobats, circus riders and tightrope-walkers, whom we met at the Café and spend all our evenings with.[3] One of them is an American from San Francisco and sings and dances Negro songs very well.

Write to me. Marie Laurencin has received some offers for her etchings from Sainsère.[4] Hello to Leo and my best regards

<div align="right">Fernande</div>

Letter (17 June 1910) from Fernande Olivier to Gertrude Stein; translated from French by Marilyn McCully and Michael Raeburn. Yale University, Beinecke Library.

[1] The May 1910 issue of *The Architectural Record*, which included Gelett Burgess's article 'The Wild Men of Paris' (reprinted in Schiff, pp. 30–1). Photographs reproduced in the article, which were taken in 1908, when the 'little American' made his rounds of artists' studios in Paris, distributing souvenir matchboxes, include: p. 403, Picasso's *La Femme* (a study or early version of the *Dryad*, z. II. 113); p. 404, *Meditation* (z. II. 68); p. 407, Picasso in his studio in front of *Three Women* (z. II. 108, here called *La Femme*); p. 408, *Les Demoiselles d'Avignon* (called 'Study by Picasso'); as well as photographs of Braque, Derain (two), Czobel, Herbin, Friesz and Chaubaud.

Picasso's own amusement at the article was expressed that same summer in a postcard (in the Beinecke Library) written to Leo Stein in Florence. He tells him that if he can find a copy of it, Burgess's article will give him a good laugh.

[2] z. II. 214

[3] Picasso's friendship with circus performers may also be associated with a renewed interest in the subject of harlequins in 1909.

[4] Olivier Sainsère, a counsellor of state, was one of the earliest French collectors of Picasso's paintings and helped protect him against the police, who considered any bohemian young Spaniard to be an anarchist.

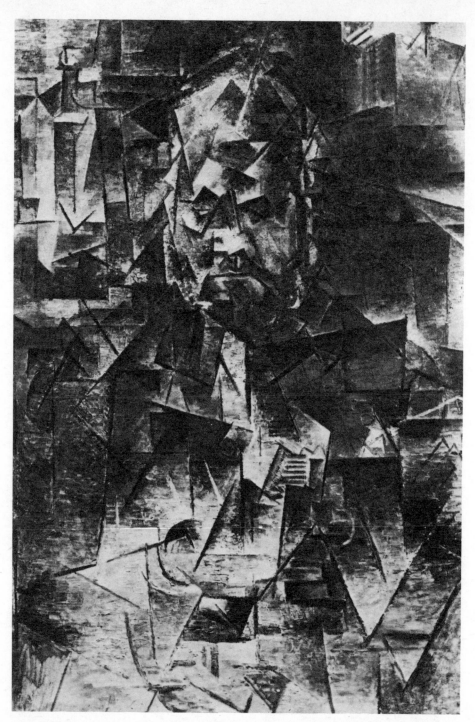

Portrait of Ambroise Vollard, 1910. The Pushkin State Museum of Fine Arts, Moscow.

Picasso first met Manolo (Manuel Martínez Hugué) at Els Quatre Gats in Barcelona, where the Catalan sculptor assisted with the production of puppet theatre at the café. Manolo and the painters Ramon Pichot and Ricard Canals were Picasso's closest Spanish friends in Paris during the period preceding the First World War. Manolo's recollections of his life, and in particular his activities during those years, were later recounted to the Catalan writer Josep Pla, who collected these anecdotes to form a biography of the sculptor in 1930.

(1910) Josep Pla
Manolo on Cubism

I saw the birth and death of many literary and artistic schools, and I saw many fashions go by, expiring soon after their much vaunted first appearance. In Picasso's studio I witnessed the birth of Cubism. If my memory does not fail me, Picasso used to talk a lot then about the fourth dimension and he carried around the mathematics books of Henri Poincaré.[1] Cubism, to be honest, I have never understood and I do not know what it is. Looking at one of the earliest cubist portraits of Picasso's I asked him what he would say if the next day – let us suppose – when he went to the railway station to welcome his mother, she appeared in the form of a cubist figure. At any rate, Picasso is such a great painter that he is good even doing Cubism, and he is a thousand kilometres ahead of his imitators and camp followers.

From Josep Pla, *Vida de Manolo contada por el mismo*, Madrid, 1930, p. 161; translated from Spanish by Miquel Sobré.

[1] For discussion of the relationship of Cubism to contemporary science, especially Henri Poincaré's *La Science et l'Hypothèse*, 1902, see Linda Dalrymple Henderson, 'A new facet of Cubism: the "fourth dimension" and non-Euclidean geometry reinterpreted', *The Art Quarterly* vol. xxxiv no. 4, Detroit, Winter 1971, pp. 411–33.

(1910) Daniel-Henry Kahnweiler
On Cubism

During the summer, again spent in L'Estaque, Braque took a further step in the introduction of 'real objects', that is, of realistically painted things introduced, undistorted in form and colour, into the picture. We find lettering for the first time in a *Guitar Player*[1] of the period. Here again, lyrical painting uncovered a new world of beauty – this time in posters, display windows and commercial signs which play so important a role in our visual impressions.

Much more important, however, was the decisive advance which set

Cubism free from the language previously used by painting. This occurred in Cadaqués (in Spain, on the Mediterranean near the French border) where Picasso spent his summer. Little satisfied, even after weeks of arduous labour, he returned to Paris in the fall with his unfinished works. But he had taken the great step; he had pierced the closed form. A new tool had been forged for the achievement of the new purpose.

Years of research had proved that closed form did not permit an expression sufficient for the two artists' aims. Closed form accepts objects as contained by their own surfaces, viz., the skin; it then endeavours to represent this closed body, and, since no object is visible without light, to paint this 'skin' as the contact point between the body and light where both merge into colour. This chiaroscuro can provide only an illusion of the form of objects. In the actual three-dimensional world the object is there to be touched even after light is eliminated. Memory images of tactile perceptions can also be verified on visible bodies. The different accommodations of the retina of the eye enable us, as it were, to 'touch' three-dimensional objects from a distance. Two-dimensional painting is not concerned with all this. Thus the painters of the Renaissance, using the closed form method, endeavoured to give the illusion of form by painting light as colour on the surface of objects. It was never more than 'illusion'.

Since it was the mission of colour to create the form as chiaroscuro, or light that had become perceivable, there was then no possibility of rendering local colour or colour itself. It could only be painted as objectivated light.

In addition, Braque and Picasso were disturbed by the unavoidable distortion of form which worried many spectators initially. Picasso himself often repeated the ludicrous remark made by his friend, the sculptor Manolo, before one of his figure paintings: 'What would you say if your parents were to call for you at the Barcelona station with such faces?' This is a drastic example of the relation between memory images and the figures represented in the painting. Comparison between the real object as articulated by the rhythm of forms in the painting and the same object as it exists in the spectator's memory inevitably results in 'distortions' as long as even the slightest verisimilitude in the work of art creates this conflict in the spectator. Through the combined discoveries of Braque and Picasso during the summer of 1910 it became possible to avoid these difficulties by a new way of painting.

On the one hand, Picasso's new method made it possible to 'represent' the form of objects and their position in space instead of attempting to imitate them through illusionistic means. With the representation of solid objects this could be effected by a process of representation that has a certain resemblance to geometrical drawing. This is a matter of course since the aim of both is to render the three-dimensional object on a two-dimensional plane. In addition, the painter no longer has to limit himself to depicting the object as it would appear from one given viewpoint, but

wherever necessary for fuller comprehension, can show it from several sides, and from above and below.

Representation of the position of objects in space is done as follows: instead of beginning from a supposed foreground and going on from there to give an illusion of depth by means of perspective, the painter begins from a definite and clearly defined background. Starting from this background the painter now works toward the front by a sort of scheme of forms in which each object's position is clearly indicated, both in relation to the definite background and to other objects. Such an arrangement thus gives a clear and plastic view. But, if only this scheme of forms were to exist it would be impossible to see in the painting the 'representation' of things from the outer world. One would only see an arrangement of planes, cylinders, quadrangles, etc.

At this point Braque's introduction of undistorted real objects into the painting takes on its full significance. When 'real details' are thus introduced, the result is a stimulus which carries with it memory images. Combining the 'real' stimulus and the scheme of forms, these images construct the finished object in the mind. Thus, the desired physical representation comes into being in the spectator's mind.

Now the rhythmization necessary for the coordination of the individual parts into the unity of the work of art can take place without producing disturbing distortions, since the object in effect is no longer 'present' in the painting, that is, since it does not yet have the least resemblance to actuality. Therefore, the stimulus cannot come into conflict with the product of the assimilation. In other words, there exist in the painting the scheme of forms and small real details as stimuli integrated into the unity of the work of art; there exists, as well, but only in the mind of the spectator, the finished product of the assimilation, the human head, for instance. There is no possibility of a conflict here, and yet the object once 'recognized' in the painting is now 'seen' with a perspicacity of which no illusionistic art is capable.

As to colour, its utilization as chiaroscuro had been abolished. Thus, it could be freely employed, as colour; its application on a small scale is sufficient to effect its incorporation into the finished representation in the mind of the spectator.

In the words of Locke, these painters distinguish between primary and secondary qualities. They endeavour to represent the primary, or most important qualities, as exactly as possible. In painting these are: the object's form, and its position in space. They merely suggest the secondary characteristics such as colour and tactile quality, leaving their incorporation into the object to the mind of the spectator.

This new language has given painting an unprecedented freedom. It is no longer bound to the more or less verisimilar optic image which describes the object from a single viewpoint. It can, in order to give a thorough representation of the object's primary characteristics, depict them as stereometric drawing on the plane, or through several repre-

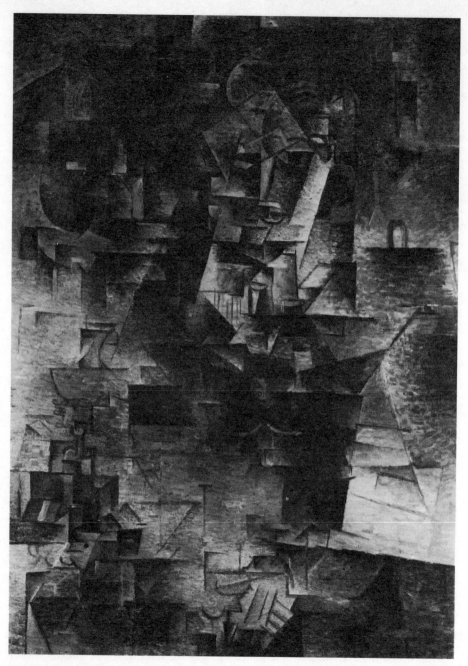

Portrait of Daniel-Henry Kahnweiler, 1910. The Art Institute of Chicago.

sentations of the same object, can provide an analytic study of that object which the spectator then fuses into one again in his mind. The representation does not necessarily have to be in the closed manner of the stereometric drawing; coloured planes, through their direction and relative position, can bring together the formal scheme without uniting in closed forms. This was the great advance made at Cadaqués. Instead of an analytical description, the painter can, if he prefers, also create in this way a synthesis of the object, or in the words of Kant, 'put together the various conceptions and comprehend their variety in one perception.'

Naturally, with this, as with any new mode of expression in painting, the assimilation which leads to seeing the represented things objectively does not immediately take place when the spectator is unfamiliar with the new language. But for lyric painting to fulfil its purpose completely, it must be more than just a pleasure to the eye of the spectator. To be sure, assimilation always takes place finally, but in order to facilitate it, and impress its urgency upon the spectator, cubist pictures should always be provided with descriptive titles, such as *Bottle and Glass, Playing Cards and Dice* and so on. In this way, the condition will arise which H. G. Lewis referred to as 'preperception' and memory images connected with the title will then focus much more easily on the stimuli in the painting.

From Daniel-Henry Kahnweiler, *Der Weg zum Kubismus*, **Munich, 1920; translated from German by Henry Aronson as** *The Rise of Cubism*, **New York, 1949, pp. 10–13.**

[1] Braque, *The Portuguese*, Kunstmuseum, Basel.

(1912) Gino Severini
On *Souvenirs du Havre*

When I painted *Ricordi di Viaggio* in 1911 I showed it to Picasso, and shortly afterwards he painted *Souvenirs du Havre*,[1] of course in a quite different style.

I was in his studio in the rue Ravignan when he showed the picture to Braque. The latter was taken aback and said in a rather sarcastic tone: 'So we're changing our tune,' to which Picasso did not reply. He could hardly be impressed by such a criticism, given the limited importance he attached to 'subjects', and the spiritual independence that he showed more and more firmly as time went on.

I quote the incident by way of showing how admirably Picasso maintains his freedom of action, which enables him to 'change his tune' whenever he wants or needs to, while making his presence strongly felt in whatever direction he goes.

If anyone among modern painters has succeeded in fully expressing and completely realizing that poetry of form which comes from secret and

hidden correspondences and from the profoundest depths of being, that one is certainly Picasso, the most inventive, metaphorical and poetic of us all.

From *Cinquanta Disegni di Pablo Picasso (1903–1938) con scritti di Carlo Carrà,* *Enrico Prampolini, Alberto Savinio, Gino Severini, Ardengo Soffici,* **Novara,** **1943, p. 22; translated from Italian by P. S. Falla.**

[1] z. II. 367

1913 Guillaume Apollinaire
Picasso, Cubist painter

This *Malagueño* bruised us like a brief frost. His meditations bared themselves silently. He came from far away, from the rich composition and brutal decoration of the seventeenth-century Spaniards.

And those who had known him before could recall swift insolences, which were already beyond the experimental stage.

His insistence on the pursuit of beauty has since changed everything in art.

.

Then he sharply questioned the universe. He accustomed himself to the immense light of depths. And sometimes he did not scorn to make use of actual objects, a twopenny song, a real postage stamp, a piece of oil-cloth imprinted with chair caning.[1] The painter would not try to add a single picturesque element to the truth of these objects.

Surprise laughs savagely in the purity of light, and it is perfectly legitimate to use numbers and printed letters as pictorial elements; new in art, they are already steeped in humanity.

It is impossible to envisage all the consequences and possibilities of an art so profound and so meticulous.

The object, real or illusory, is doubtless called upon to play a more and more important role. The object is the inner frame of the picture and marks the limits of its profundity just as the actual frame marks its external limits.

Representing planes to denote volumes, Picasso gives an enumeration so complete and so decisive of the various elements which make up the object, that these do not take the shape of the object, thanks to the effort of the spectator, who is forced to see all the elements simultaneously just because of the way they have been arranged.

From Guillaume Apollinaire, *Les Peintres Cubistes,* **Paris, 1913; reprinted** **in translation from French in** *Documents of Modern Art vol. 1: The Cubist* *Painters,* **New York, 1949, pp. 21–2.**

[1] *Still life with chair caning* (z. II. 294)

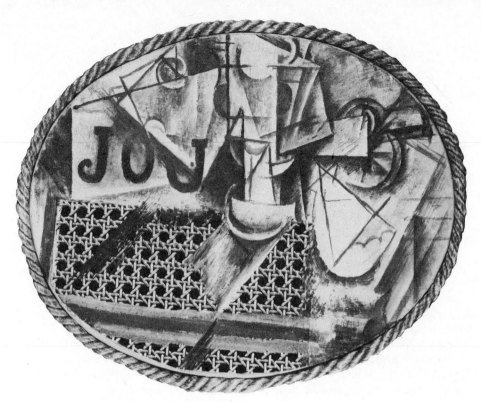

Still life with chair caning, 1912. Musée Picasso, Paris.

3.
Picasso's critical reputation outside France

1910–1913

Picasso preferred to exhibit his work outside France during the years 1910–13 (few works were exhibited in Paris during that time). Critical reaction to exhibitions in New York, London, Barcelona, Cologne, and Munich was mixed, but recognition of Picasso as the leader of a new force in painting stimulated debate about the new art and consequently made his name more widely known than ever before. For the most part, the great difficulty expressed by critics in understanding Cubism was a result of their association of Cubism with mathematics, and in this way 'geometric' art became almost synonymous with abstract art. However, several important critics, including Roger Fry in England and Josep Junoy in Spain, pursued the more challenging connection between philosophical and perceptual inquiry and Cubism.

Although Roger Fry preferred Picasso's earlier work, his willingness to defend Picasso's cubist investigations helped establish the artist's reputation as a painter of the new age. Fry argued that the modern artist must reject his old role as imitator of visible reality, as the Impressionists had been, and that instead he must seek formal means of conveying deeper meaning. Thus, in 1912 Fry described Picasso's 'purely abstract language of form – a visual music'. Basic to this notion is the expression of the essential or intrinsic character of things, which derives in part from late nineteenth-century symbolist theory and, connected to it, a concept of neo-platonism. In fact, the correspondence of the arts (art and music, for example) refers to the expression of essential (corresponding) ideas through various means – in painting, through pictorial form, which in turn evokes poetry, for example.

A less sophisticated yet related argument, framed by a reference to classical art, is found in the article by Huntly Carter, written for The New Age *in 1911, concerning a 'Plato-Picasso idea', citing John Middleton Murry's notion that Picasso's art was related to Plato in that he was seeking an 'art of essentials', which went beyond the superficial or photographic. Murry's somewhat guarded response, published a week later, resulted (probably unintentionally) in a defence of avant-garde art, art that 'sandpapers the brain'.*

In New York, Picasso exhibited at Alfred Stieglitz's Photo-Secession Gallery at 291 Fifth Avenue in 1911. Marius de Zayas's well-known pamphlet from the exhibition was published in the Photo-Secession journal Camera Work *in 1911 (see Schiff, pp. 47–9). Gertrude Stein's short*

literary portrait of Picasso also appeared in Camera Work *in 1912 (see Fry, pp. 55–6). Lesser-known responses to the New York show are included here, and they offer a sample of the baffled if not negative popular response Picasso's work produced in America at this time.*

In March 1912 the Dalmau Gallery in Barcelona mounted an exhibition of Picasso's work, and in the same year the Catalan critic and writer Josep Junoy devoted a chapter of his book Arte y Artistas *to Picasso, in which he discussed the spectator's dilemma in approaching cubist works. Junoy connected the conceptual basis, the idea of the artist, to what he called 'the laws of the imagination', which subject ideas to deformation and result in new harmonies expressed by the artist in their external form. The perceptual role of the spectator is introduced most emphatically in Picasso criticism by Junoy, who says that the viewer like the artist must have a perspective that 'allows him to consider as a whole the series of ideas which are given plastic form by means of simultaneous formulae and continuously modified motifs and ways of seeing.' The ability of the spectator to follow the painter's 'deductive rhythms' on each succeeding surface thus allows him to discern not only a total image but separate aspects of his working technique. For example, Picasso's use of chiaroscuro, which links him to older Spanish masters like Zurbarán, is freed from its traditional role and given independence in cubist composition.*

In contrast to English criticism, which tended to measure Picasso's work against philosophical criteria, and the rather naïve and literal response of American journalists or painters such as Arthur Hoeber, German critical writing in general reflected a prevalent taste for expressionism. For that matter, German critics decidedly preferred Picasso's Blue Period works, which corresponded more closely to the psychological aims of expressionist painting than did the more intellectual cubist canvases of 1910–13. M. K. Rohe, for example, in response to Heinrich Thannhauser's first retrospective show of Picasso's work at the Moderne Galerie in Munich in 1913, spoke of a 'trace of neurosis' in Picasso's early work and claimed that this 'nervous hypersensitivity' was both Picasso's strength and downfall, for his more recent tendency towards exaggeration of forms had resulted in the 'pseudo-science of absolute painting', that is, Cubism.

Some of the better-known German critics who dealt with Picasso's work and Cubism during this period, including Meier Graefe and Max Raphael (with the notable exception of his 1912 open letter to Max Pechstein included here), have been discussed and reproduced in translation elsewhere (see Schiff, pp. 27, 106). Ludwig Coellen's little-known chapter 'Romanticism in the New Painting', which appeared in his book Die Neue Malerei *in 1912, has been chosen here for, in some ways, he shows better in this piece the seriousness of the German point of view and the emphasis on romantic or expressionist interpretation. Coellen defines 'romantic' with regard to Picasso not in the sense of exploring temperament, but in the sense of breaking new ground (as opposed to resorting to classic formal organization and returning to known artistic sources).*

Coellen (whose essay preceded publication of Kahnweiler's theoretical

essay by several years) discusses as the most salient and challenging feature of Cubism Picasso's treatment of space. If space is defined as a function of the human mind, according to Coellen, and space is the operation of principles which generate objects, then the abstract technique of creating form through geometric principles (which are the result of intellectual processes) is a fundamental and important aspect of Cubism. He adds, however, that it is only in this regard that Picasso's technique is abstract, for Picasso was still concerned with the object, and therein lay a danger. Coellen argued that the relation of the object to Picasso's conception of space is similar to the process of arriving at ornamental form, 'which gradually loses all visible connection with natural forms from which it is derived, even though it could not exist without them.' Because of the process of abstraction, the danger Coellen saw in the direction of Picasso's work was that it would become ornamental.

It was the Alsatian artist Hans Arp (who knew Apollinaire's writings on Cubism) who saw that the danger of an ornamental end to Cubism was unwarranted. Like Coellen, Arp saw Picasso as a ground-breaker who turned his back courageously on a 'rich and beautiful body of work', but who, instead of becoming a 'history painter of the object', sought to eliminate the object in the synthetic phase of Cubism by turning to the material of painting itself.

Salome, 1905. Fitzwilliam Museum, Cambridge.

1910 Roger Fry
The Post-Impressionists: Picasso

Picasso is strongly contrasted to Matisse in the vehemence and singularity of his temperament. In his etching of *Salome*[1] he proves his technical mastery beyond cavil, but it shows more, a strange and disquieting imaginative power, which comes at times perilously near to the sentimental, without, I think, ever passing the line. Certainly, in the drawing of the *Two Women*[2] one cannot accuse him of such a failing, though its intimacy of feeling is hardly suspected at first beneath the severity of its form. Of late years Picasso's style has undergone a remarkable change. He has become possessed of the strangest passion for geometric abstraction, and is carrying out hints that are already seen in Cézanne with an almost desperate logical consistency. Signs of this experimental attitude are apparent in the *Portrait of M. Sagot*[3] but they have not gone far enough to disturb the vivid impression of reality, the humorous and searching interpretation of character.

From Roger Fry, 'Art: The Post-Impressionists – II', *The Nation*, **London, 3 December 1910, p. 403.**

[1] G. 17
[2] Catalogued as *Les deux soeurs* (probably z. VI. 435 or z. XXI. 369; see note p. 38).
[3] z. II. 129

1911 Arthur Hoeber
Review of Photo-Secession exhibition, New York

Over at the little galleries of the Photo-Secession on Fifth Avenue and Thirtieth Street, Mr. Stieglitz still holds out with his show of the work of Pablo Picasso, which, save to the extra high-browed in art, remains still an unfathomable mystery. Men and women come and go, and still the wonder grows. Here and there, Mr. Stieglitz manages to make a convert, and there are those who, refusing to accept these weird things, yet maintain they are stimulating! An enormous crowd of visitors have trailed down to these galleries, however, though very few have remained to pray. There are astonishing travesties on humanity here, that, unless you be of the cult, appear sublimely ridiculous, with faces and forms twisted out of all recognition, while two or three efforts appear to be the design of some ill-balanced brain for a fire escape, and not a good fire escape at that. Yet we are informed seriously that these emanations are representations of the human figure. There is a watercolor of a tin cup over which the informed grow enthusiastic, and there is a charcoal drawing of a dish of

bananas that seems a possible effort for a first-year kindergarten pupil, though bad for that youthful age.

Arthur Hoeber, 'Art and Artists', *The Globe and Commercial Advertiser*, New York, 21 April 1911, p. 12.

1911 *The Craftsman*
Review of Photo-Secession exhibition, New York

The Photo-Secession Gallery under the very able and executive management of Mr. Alfred Stieglitz, has recently had two noticeable exhibitions, one of Cézanne, who has dominated art in Paris for some years, and one of the much talked about Spanish modern worker, Pablo Picasso, who has a large following in Paris and who has certainly piqued the interest of the younger generation of artists in New York. It is impossible to write of anything so revolutionary as Cézanne and Picasso without being perfectly frank. The minute one pretends an interest or an understanding greater that one possesses, the result is to stimulate the already well-developed sense of humor of the American public toward phases of art as yet more or less alien to it.
.
As for Picasso, he is up to the present moment a sealed book to the writer. Of course, it is very possible to repeat the very interesting things said about him, to quote, in fact, what especially De Zayas, the caricaturist, said about him, and what he undoubtedly has sincerely said. 'I have studied Picasso,' he writes, 'both the artist and his work, which was not difficult, for he is a sincere and spontaneous man. He makes no mystery of his ideals or the method he employs to realize them. He tries to produce with his work an impression, not of the subject, but the manner in which he expresses it. Picasso receives the direct impression from external nature, which he analyzes, develops and translates, and afterwards executes it in his own particular style, with the intention that the picture should be the pictorial equivalent of the emotion produced by nature.' In other words, he does not want you to see nature, but how he feels about nature; all of which is extremely interesting and what more or less every artist should do. No one wants a chart, but rather the emotional side which a phase of nature has succeeded in imparting to an interesting mind. But if Picasso is sincerely revealing in his studies the way he feels about nature, it is hard to see why he is not a raving maniac, for anything more disjointed, disconnected, unrelated, unbeautiful than his presentation of his own emotions it would be difficult to imagine. When the writer visited the Gallery where these drawings were shown he found the audience pretty well divided between the art students hysterical with bewilderment and the grave critics hiding their bewilderment and utter-

ing banal nonsense. There were one or two men who honestly seemed, if not to enjoy the exhibition, sincerely to be interested in it.

Of course it is important and interesting and significant that every artist should work out his own impressions, work them out to the limit of his susceptibility, to the limit of the development of his imagination, but until he has achieved through these manifold and confusing impressions some beautiful straight line connecting his own soul directly back to the truth of things, it would seem that all his efforts and worries should not be made public, except in relation eventually to his achievement. Of course, this is a very humble point of view of a layman, without pretence and without illumination.

'The Revolutionary Artists', *The Craftsman* vol. XX no. 2, New York, May 1911, p. 237.

1911 Huntly Carter
The Plato-Picasso Idea

The New Age represents the new age. Picassoism is not of the new age, but in the new age. Accordingly there is presented with this week's issue a reproduction of an advanced study by a painter who is one of the most advanced spirits in Paris today. *The New Age* is the first journal in this country to show an intelligent appreciation of the latest stage in M. Picasso's remarkable development, that is at present generally misunderstood and derided, just as the comparatively commonplace early work of the Pre-Raffaelites was jeered at and spat upon. The work of M. Picasso and his followers has been so associated by the ignorant ha'penny critics with cubism that it has become the constant habit of these persons to discuss everything produced by these painters in terms of geometry. This is how the famous Mr. Lewis Hind lets himself go in the *Daily Chronicle*: 'The Cubists, those drear, reviled folk, who are *geometricians* first and painters second, arouse interest with their figures and architecture, and still-lifes emerging from canvases that look like coloured, symbolical frontispieces to editions of Euclid.' Here Mr. Hind develops his cube-root in a manner of which only Mr. Hind is capable. In another of his outbursts he asks whether any lover of the old masters can avoid feeling 'displeasure before a geometrical, cubical landscape by Picasso?' He is apparently quite ignorant of the fact that the old masters at least saw light reflected at angles just as Mr. Hind's cubists do, but they were not intelligent enough to give their vision the Picasso wideness of expression. Picassoism is thus summarily brushed aside to the satisfaction of Mr. Lewis Hind, whose efforts during recent years to make board and lodging in the daily press out of the advanced movement in painting has probably done that movement more harm than he (Mr. Hind) will ever be able to repair.

As a clue to what Picassoism really is and to what little extent it is related to geometry, I may quote from a letter which Mr. Middleton Murray [*sic*] sent me while in Paris. It seems that Oxford, no less than Paris and New York, is greatly impressed with the profoundly intellectual character of the French painter's work, and during a discussion on the subject Mr. Murray was led to put forward the following Plato-Picasso idea: 'It will be remembered that Plato, in the sixth book of the Republic, turns all artists out of his ideal state on the ground that they merely copy objects in Nature, which are in their turn copies of the real reality – the Eternal Idea. Plato, who was a great artist and lover of art, did not turn artists out because he was a Philistine, but because he thought their form of art was superficial, "photographic" we should call it now. There was no inward mastery of the profound meaning of the object expressed, so that the expression was merely "a copy of a copy". The fact is, Plato was looking for a different form of art, and that form was Picasso's art of essentials.' Mr. Murray's contention is that Picassoism is the first intelligent advance upon Platoism, seeing that it is a practical application of Plato's theory. Thus the study submitted to the readers of this journal and chosen for the purpose by M. Picasso from the Galerie Kahnweiler,[1] demonstrates that painting has arrived at the point when, by extreme concentration, the artist attains an abstraction which to him is the soul of the subject, though this subject be composed only of ordinary objects – mandoline, wine-glass and table, as in the present instance. It indicates, too, that painting is at the point of its greatest development. It is on the threshold of the will, and not at a halting-place of men sick with inertia.

Huntly Carter, 'The Plato-Picasso Idea', *The New Age*, London, 23 November 1911, p. 88.

[1] *The Mandolin and the Pernod*, Spring 1911 (z. II. 259)

1911 John Middleton Murry
The Art of Pablo Picasso

Mr. Huntly Carter has quoted some words of a letter of mine on the subject of Picasso's work; and as I read them again I am struck by a suspicion of intellectual arrogance and assumed finality from which I wish to clear myself.

At the outset, modernist, ultra-modernist, as I am in my artistic sympathies, I frankly disclaim any pretension to an understanding or even an appreciation of Picasso. I am awed by him. I do not treat him as other critics are inclined to do, as a madman. His work is not a blague. Of that I am assured; and anyone who has spoken to him will share my assurance. Picasso has to live by his work, and a man who depends for his bread and

butter on his work in paint does not paint unsellable nonsense for a blague. That his later work is unsaleable confirms my conviction that Picasso is one of those spirits who have progressed beyond their age. As with Plato and Leonardo, there are some paths along which pedestrian souls cannot follow, and Picasso is impelled along one of these.

Picasso has done everything. He has painted delicate water-colours of an infinite subtlety and charm. He has made drawings with a magical line that leaves one amazed by its sheer and simple beauty – and yet he has reached a point where none have explained and none, as far as I know, have truly understood. Yet he declares 'J'irai jusqu'au but.' It is because I am convinced of the genius of the man, because I know what he has done in the past, that I stand aside, knowing too much to condemn, knowing too little to praise – for praise needs understanding if it is to be more than empty mouthing.

A great friend of mine, a leader of the Modernists in Paris, a woman gifted with an aesthetic sensibility far profounder than my own, said once as she was looking at a Picasso, 'I don't know what it is – I feel as though my brain had been sandpapered.' And some such feeling as this is what affects me in his pictures. I feel that Picasso is in some way greater than the greatest because he is trying to do something more; when Plato speaks in transparent and wonderful terms of the Idea of the Good; when Leonardo speaks of the serpentine line; when Hegel makes toys of the categories, I stand aside, unconvinced because I am not great enough to be convinced.

I recognise fully that a speculation such as mine on the relationship between the art of Picasso and the aesthetic of Plato is perhaps of no great value in itself; but to those who have read and wondered at the seeming contradiction in the greatest of all philosophers, to those who have a living interest in living art, the work of Picasso offers the suggestion of vistas through which we can never see. I am still convinced that for men who endeavour to think at all profoundly Plato will always be found to be of all philosophers and artists most valuable in the attempt to appreciate and understand the developments of modern art. I would suggest for the curious in such speculations who have some knowledge of the development of Egyptian art, through the most realistic realism the world will ever know, to an intellectual art which is so near to many of the finer modern developments, that his travels in Egypt may suggest the reason for his condemnation of the 'realistic' art of contemporary Greece. I feel that thence came a new attitude: he looked for a closer approach to essential realities in art, and the art he saw seemed to him to take him further away from the eternal verities. Hence my tentative suggestion that Plato was seeking for a Picasso. Not for one moment do I wish to suggest that these two artists are on the same plane. But in each of them there is so much that I understand and value that I feel convinced that it is but my weakness that prevents my following them to the heights they reach.

They who condemn Picasso condemn him because they cannot under-
stand what he has done in the past, and are content to assume that all that
is beyond their feeble comprehension is utterly bad. All that I can say for
myself is that I understand too much to be guilty of that crime. In the
meanwhile Picasso must needs wait for another Plato to understand; but
the world will never have the strength to follow.

John Middleton Murry, 'The Art of Pablo Picasso', *The New Age,* **London,
30 November 1911, p. 115.**

1912 *The Art Chronicle*
 Review of Stafford Gallery exhibition, London

A remarkable example of criticism from two different points of view was
published last week. Pablo Picasso's drawings at the Stafford Gallery
have been judged by the *Times* and Mr. P. G. Konody in the *Observer* on
almost the same day. In a long past age the great daily used to be known as
the 'Thunderer', but there is no thunder in its appreciation of Picasso.
Here are the critic's remarks:
 'M. Picasso, the leader of the most advanced school of French painting,
has been called an incompetent charlatan. The exhibition of drawings by
him, now to be seen at the Stafford Gallery in Duke Street, proves that he
is not that. . . . There are many drawings shown which, though slight and
fragmentary, are vivid and also rhythmically beautiful. We believe M.
Picasso to be an accomplished and sincere artist possessed by an insati-
able love of experiment and discovery and haunted by an incessant fear of
the commonplace. . . . No living artist, perhaps, is so much troubled by
this extreme fastidiousness as M. Picasso. He will not be literal, he will
not be facile, he will not be a virtuoso. He is so determinedly artistic that
he seems to see real objects as if they were already works of art before he
begins to draw them. Thus his *Vieux miséreux* seems to be drawn from a
statue, and a very fine one; and other drawings seem to be taken from bas-
reliefs. . . . In the pen-drawing of a woman seated, there is an extra-
ordinary sensitiveness of line combined with a rhythmical beauty the more
remarkable because it is not at all fluent. The donkey's head,[1] also a
pen-drawing, is extraordinarily delicate and precise in character; the ani-
mal is treated in it with the imaginative seriousness of the great Chinese
artists. . . . We acknowledge his profound artistic seriousness, a serious-
ness which is shown by his attitude towards everything which he draws,
by his desire to discover and express its essential character rather than
to use it as rough material for his art.'
 This is Picasso translated into words by an evidently intelligent per-
sonality. Mr. Konody's reputation as an art critic exacts attention for any
note he signs. In the *Observer* he expresses himself with vigour.

'The drawings shown by M. Pablo Picasso at the Stafford Gallery in Duke Street belong to the region vaguely described as "the limit". . . . What can be pleaded in excuse of M. Picasso? He shows, it is true, one brilliant gouache study of a young man with a horse . . . a rather commonplace pastel portrait . . . and an early water-colour, *L'Apéritif*.[2] But the rest is merely an impertinent display of fumbling incompetence, which reaches its apogee in the water-colour amusingly catalogued as *Nature morte à la bête* (sic!) *de mort*.[3] "Bête" is indeed the only term that can aptly describe this kaleidoscopic jumble, in which it is just possible to distinguish a skull that has obviously been under a steam roller. "Expression, not impression", has been claimed to summarise the aims of the modern group of which M. Picasso is a leading member. His childish pen-scribbles, *Tête de vieille femme*, *Femme nue debout*, *Femme accoudée*, and similar scraps that should never have been rescued from the waste-paper basket, have not even the expressiveness of a talented infant's drawings. To exhibit them as works of art is simply *fumisterie*, or, to use the popular slang term, "spoof".'

With such criticisms covering the ground, we feel that it is unnecessary to add our own. Everything has been said. The only cry can be: 'Under which king, Bezonian? Speak or die!' So with the singularly appropriate drawing by M. Picasso, which the Stafford Gallery has kindly allowed us to reproduce, we leave the matter.

From 'Picasso's Drawings', *The Art Chronicle* **vol. 8 no. 1, London, 3 May 1912, pp. 270–1.**

[1] This drawing (z. XXII. 343) is illustrated with the article, entitled *Fête d'Âne* [*sic*].
[2] Catalogued as no. 26 *L'Apéritif (Portrait de Salmond)*, probably z. XXI. 163.
[3] z. XXVI. 193 [?]

1912 Roger Fry
The Second Post-Impressionist exhibition

Most of the art here seen is neither naïve nor primitive. It is the work of highly civilised and modern men trying to find a pictorial language appropriate to the sensibilities of the modern outlook.

Another charge that is frequently made against these artists is that they allow what is merely capricious, or even what is extravagant and eccentric in their work – that it is not serious, but an attempt to impose on the good-natured tolerance of the public. This charge of insincerity and extravagance is invariably made against any new manifestation of creative art. It does not of course follow that it is always wrong. The desire to impose by such means certainly occurs, and is sometimes temporarily successful. But the feeling on the part of the public may, and I think in this case does, arise from a simple misunderstanding of what these artists set out to do.

The difficulty springs from a deep-rooted conviction, due to long-established custom, that the aim of painting is the descriptive imitation of natural forms. Now these artists do not seek to give what can, after all, be but a pale reflex of actual appearance, but to arouse the conviction of a new and definite reality. They do not seek to imitate form, but to create form; not to imitate life, but to find an equivalent for life. By that I mean that they wish to make images which by the clearness of their logical structure, and by their closely-knit unity of texture, shall appeal to our disinterested and contemplative imagination with something of the same vividness as the things of actual life appeal to our practical activities. In fact, they aim not at illusion but at reality.

The logical extreme of such a method would undoubtedly be the attempt to give up all resemblance to natural form, and to create a purely abstract language of form – a visual music; and the later works of Picasso show this clearly enough. They may or may not be successful in their attempt. It is too early to be dogmatic on the point, which can only be decided when our sensibilities to such abstract form have been more practised than they are at present. But I would suggest that there is nothing ridiculous in the attempt to do this. Such a picture as Picasso's *Head of a Man* would undoubtedly be ridiculous if, having set out to make a direct imitation of the actual model, he had been incapable of getting a better likeness. But Picasso did nothing of the sort. He has shown in his *Portrait of Mlle. L.B.* that he could do so at least as well as any one if he wished, but he is here attempting to do something quite different.

From Roger Fry, 'The French Group', *Second Post-Impressionist Exhibition*, London, Grafton Galleries, 5 October–31 December 1912, pp. 26–7.

The Dalmau Gallery in Barcelona was the principal space devoted to avant-garde artistic activity in the teens and twenties, and was run by Josep Dalmau, whom Picasso had known at Els Quatre Gats. Not only did Dalmau first exhibit Duchamp's controversial Nude Descending a Staircase *in May 1912, but in 1917 many foreign artists living in exile in Barcelona gathered there, including Picabia (whose journal* 391 *came out in 1917 from Dalmau's) and Marie Laurencin. Josep Junoy's experimental journal* Troços *was also published by the Dalmau Gallery in 1917.*

Picasso's show at the gallery in March 1912 included works from his earlier (and still favoured) Barcelona period. The little artistic-literary journal Picarol *included this review, which was probably written by Picasso's friend Ramon Reventós.*

1912 (Ramon Reventós)
Review of Ca'n Dalmau exhibition, Barcelona

As we mentioned in the last issue, Dalmau has succeeded in bringing together a small, but important collection of works by Picasso. The fact that Picasso was involved not long ago in the Cubist affair makes the study of his works more interesting, and there are many intelligent people who from one day to the next visit these nice little rooms where Dalmau has installed the exhibition so well.

The drawing which we reproduce[1] with the permission of its owner (our friend Oleguer Junyent) is a beautiful demonstration of the art Picasso produced some seven or eight years ago. All Barcelona is interested in the youth of this intrepid artist and fighter, who, coming out of the Quatre Gats with a fury of enthusiasm, has triumphed in Paris after kidnapping Nature herself in cubes. Having found something by Picasso which could win over the intelligent public of Barcelona, we are very pleased to illustrate it, for we believe that Picasso deserves the admiration that the sight of his drawing will certainly awaken in our readers.

Attributed to Ramon Reventós, 'Exposició d'obras d'en Picasso a Ca'n Dalmau', *Picarol* no. 5, Barcelona, 9 March 1912; translated from Catalan by Francesc Parcerisas and Marilyn McCully.

[1] *Begging woman nursing a child* (z. VI. 403)

1912 Josep Junoy
Picasso's Art

Il aime les choses parce que, de les comprendre, il les domine.

JACQUES RIVIÈRE, *Baudelaire*

(He loves things because, understanding them, he dominates them.)

Wherever Picasso sets his hand he leaves the imprint of his genius. He has a gift of assimilation unlike that of any other artist, and we can give the most characteristic periods in his art the name of the influence or suggestion which provoked them. But Picasso has seldom subordinated himself to these influences. On the contrary, many of them have raised themselves to his level. His talent and instinctive strength have always stood erect like a healthy plant, sustained by its own sap.

In no other artist have I seen so much complexity nor such an irresistibly magical strength. Picasso understands things without loving them; he interprets them ruthlessly. His love is dominance.

Picasso's intelligence is consumed by his inner fire. He is a mystic, in the manner of the Spanish masters. His beliefs, even if they are more exotic and wildly cynical, are equally pious.

In his art, all is strength; but he lacks the necessary plenitude, the full realization that marks the great creators of immortal forms. Picasso's destiny, like that of the legendary character, is to brush with his lips the fruits and the fresh waters of the fountain without ever attaining them or being satisfied. I mean that his achievement is not full and definitive.

With each new attempt he loses his eyes, his understanding, his heart. Only his hands, beautifully skilful, obey him. He embraces new ideas with both laughter and sorrow. With a furious, sadistic passion. For he knows that soon, in spite of himself, they will flee from him, they will disappear forever before he has managed to realize himself in them. . . .

Picasso is predestined to the glorious torment of constant renewal.

Like a new *wandering Jew* . . . He does not even have the time to rest upon the stone he has just placed by the roadside. He cannot even lie in the shade of the tree he himself has planted! An irresistible force pushes him relentlessly towards new unknown horizons. Picasso must suffer much. Nobody can imagine the torture experienced by any true artist when he knows that he will not realize his ideal as fully as a human being can. Abstinence and harsh penance are imposed on his soul when he sees himself surrounded by the smallest manifestations of nature, bursting with feeling and fully able to realize their allotted ends. . . .

Picasso, who has drunk from all the goblets, who has kissed all the lips, has never slept once in the same bed. Rest, the natural repose of the Sabbath, created in the image of divine repose, is forbidden to him.

But Picasso has the consolation of seeing Art's dawn every day before anyone else.
.

About the brilliance and fecundity of Picasso's Cubism:

A conceptual art, a spiritual abstraction.

'Since he knows the most impenetrable and hidden aspects of reality he can surrender to his imagination without fear of sterilizing objects with an excessive, immaterial, absurd, and absolute abstraction.

Picasso does not paint the image reflected in his own eyes. He is not interested in representing objects more or less – as he says – *photographically*, but rather in representing the idea of those objects his imagination has formed.

For Picasso all representative forms of nature are not things in themselves, governed and determined by the law of *causality*, but hypotheses and imaginary conceptions that obey the laws of the imagination – which are malleable and therefore susceptible to being transfigured, twisted, deformed and harmonized anew, in his own way, with the rhythm he deems necessary to suit the expression of his ideas.

In order to appreciate one of his works, the spectator must form in his imagination a proper perspective, one that allows him to consider as a

Portrait of Ambroise Vollard, 1915. The Metropolitan Museum of Art, New York.

whole the series of ideas which are given plastic form by means of simultaneous formulae and continuously modified motifs and ways of seeing. Once the total system in the painting has been acknowledged, it is easy slowly and carefully to appreciate the interesting and reasoned way in which his fantasy unfolds the multiple relationship of planes: flat, iridescent, of indeterminate tonalities, opposing each other with mutual support, and determining, through reflexive accumulation, a new centre: a new irradiating axis from which one will gradually form the rich and real fantasy of the *total Image*.

Each plane is the energetic compensation for the next. It is interesting to observe, in his major works, the magic and rhythmic reduction with which the artist constructs his figures and landscapes and still lifes. The planes become accentuated or attenuated according to the will of the painter. Picasso is a master of classical chiaroscuro, applied in the schematic and geometric form of the new style. Picasso knows how to model planes with the elemental hardness of a Zurbarán and arrange them in sculptural dependence. The annihilation of the planes of a figure implies no omission, as it would in photographic painting, because the planes that are sacrificed in the luminous relief of a figure become, in the penumbra of the background, along with other planes retained by an orderly rhythm, a new nucleus of geometric relationships. Those empty spaces, those cuts, those square incisions, so surprising in Picasso's figures, present the figures' members as cut out, truncated, mutilated. Yet they are the multiple result of the geometrical annihilation of some planes by others, of the schematic application of a vigorous and solid chiaroscuro which is peculiar to the classical Spanish masters.[1]

Josep Junoy, 'L'Art d'en Picasso', *Arte y Artistas*, Barcelona, 1912; reprinted in *Vell i Nou* vol. III no. 46, Barcelona, 1 June 1917, pp. 452–5; translated from Spanish by Miquel Sobré.

[1] This short essay, which has been generally overlooked in writings concerning Cubism at this time, was reprinted in 1917 in the Catalan journal *Vell i Nou*, illustrated with Picasso's 1915 portrait of Vollard (z. II. 922) and a little-known portrait of Picasso by the Spanish artist Gustau de Maeztzu (p. 453).

Picasso's reputation in Germany was steadily growing prior to the outbreak of the First World War. His art dealer Kahnweiler was an important contact for him, and his works were included in several exhibitions there during these years: in Düsseldorf in 1910; in three exhibitions in Berlin in 1911–12; in Cologne in 1912, where a room was reserved for Picasso's works; and in Munich, at the Galerie Goltz in 1912 (the second Blaue Reiter exhibition) and 1913, and at Heinrich Thannhauser's Moderne Galerie in 1910 and in 1913, which was the artist's first large retrospective. The preface to the catalogue of this exhibition is given below.

One of the most illuminating German critics of Picasso was Max Raphael,

an authority on art history and political economy, and a philosopher as well,
whose well-known study Von Monet zu Picasso *was published in 1913. His*
reply to Max Pechstein (which has been overlooked until its publication here)
is an important early statement of his ideas concerning the response to Cubism
among German artists, that were later incorporated in his more widely read
art-historical studies.

1912 Max Pechstein
What is Picasso up to?

Tonal values in painting vary between black and white; hues between
yellow and violet. But Pechstein uses black and white as hues too – just as
he puts earthy and metallic colours on his palette, so long as they, like
black and white, give him a particular resonance. Cézanne had a colour
harmony all his own, in which the cold and warm colours cancel each
other out: e.g. ochre-orange-cinnabar on the one hand, blue-green-black
on the other. This kept the picture *truer to its materials,* a painted
rectangle, a painted canvas, which did not give an illusion of depth. Call it
tapestry-like, but not in a pejorative sense; a tapestry is a good pheno-
menon in art.

In so far as the cubic content of a picture consists in the illusory
perspective effect of a recession in depth, Pechstein dismisses it. He uses
linear perspective, which leads out of the picture at the sides. But the
further cubic content of a picture consists in the cubic lines which make
up its constructional framework.

If one sets out to remove from a picture its last traces of cubic content,
one must take into account that tonal values are also the bearers of colour.
The new Cubism therefore consists in the extraction of the last vestiges of
cubic content, brought down flat to the surface; without any regard to
hue, which is regarded only as a superficial layer.

A logical Cubist like Picasso must have been attracted by the idea of
completely *dispensing* with hues; setting forth his exemplar purely in
black and white, in rhythmical lines and planes. And this is what Picasso
has done, as an intellectual, ruminating over the language of form. And so
the Cubist paints the cubic content (as a sculptor fits planes together),
through rhythmically juxtaposed and superimposed planes. Example:
the *Pont Neuf*[1] at the Secession. Picasso took his cue from Cézanne here –
and went far beyond him.

**From Max Pechstein (interviewed by Walther Heymann), 'Was ist mit dem
Picasso?'** *Pan* **no. 23, Berlin, 25 April 1912, pp. 668–9; translated from German by
David Britt.**

[1] z. II. 248 (1911), exhibited at the Berlin Secession in 1912.

Vive la bagatelle! – SWIFT

1 place du Pantheon, Paris

Dear Herr Pechstein,

It is a pity that you have given currency to the view, disseminated by ignorant commentators, that Picasso's art and his significance consist in having figured out a new way of rendering cubic space. *Cubism and Futurism might be produced by the intellect alone; but a picture by Picasso is a vision.*

Cubism is an attempt, on the part of creatively impotent but ambitious persons, who have learned to 'hawk and spit' from Picasso, to mobilize the press and exhibitions with a view to getting publicity and gaining business for themselves. Americanism in art. They say to themselves: 'I've been painting as a Neo-Impressionist up to now. It hasn't worked, because people knew Signac. Now Picasso has the direct cube. Perhaps this will work better. Picasso doesn't exhibit his work, and if he were to get known, then I, Monsieur Me-tzin-ger, will curse him out of existence.'

They are all the same. They stand outside and rack their brains and can never find the way inside. But you, as an artist, know that only the giving of form to experience is art.

And as for *Futurism*: a purely national, Italian concern. The imbecility of feeble nerves, etiolated by centuries of culture, and over which the whole mighty turmoil of the modern world surges without finding a trace of a genuine capacity for response. Theft from everywhere; academicism; and the total arbitrariness of utter creative impotence.

Picasso, on the other hand, is the creator of a new world. He has produced it from within himself as a woman bears the fruit of her womb: with enormous generative power, and amid the pain of struggle. This is the ultimate inwardness: the vision of the experience of self. And at every instant this vision is created anew, in growth and in the logic of its own potentialities. Its wealth is huge. And the few who will be able to see it will embark on a new life.

The fact that a thing is so in nature – and psychological experiences or inner sensations are part of nature in this sense – does not automatically give it the right to be painted in a picture.

The world of art is pure creation, and its degree of detachment from nature is immaterial: Poussin and Corot stand at the same level. It comes into being through the mental transformation of experience, through the concentration of individual sensations under the rule of law, and ultimately through that inner *élan* which no psychology and no aesthetics will ever explain to us. *Here art and metaphysics meet.*

It is Picasso's task to lend shape to this world of art. Again, this is not a task for the pure intellect, coldly gauging one form against another and deducing the necessity of one from the other; but the work of his own individual life, the work of the creative individual, who grasps the potentialities inherent in every vision and expresses them in ever richer plastic forms. To endow vision with a plastic form which is constantly enriched, and at the same time constantly becomes more finished and defined; in which nothing is left to arbitrary decision, chance or whim – such is Picasso's imperious will. Think of Rodin's ink drawings, which were praised for the beauty of the chance runs of the Master's ink down the paper. Perhaps Picasso would say to that: 'It's a cheat. Art is the giving of form; form is necessity.' His inner self and his profoundest experiences impel him to do as he does. His creative power has led him to find *one* method of working in the direct representation of cubic space. Just one, my dear Herr Pechstein. It constitutes one form of cement in a structure such as no other modern artist has built: free of reminiscences of tradition, free of the anecdotal, and not only free in the literary or the painterly sense (for what is 'Winter Morning by the Seine, 10 o'clock', if not an anecdote?) but also free of the anecdotal rendering of psychic experience. . . .

It will take us a long time to understand the laws by which he operates, and the vast world that he rules in accordance with them. Let us tread this path in reverence. It is a lofty and a pure one. Let us not speak of cubes; let us leave that to thoughtless critics, those who write for the coffee-tables of the bourgeoisie. Let us not speak of tonal value and hue. *What will you say if I tell you that Picasso has shown me recent pictures in which he has used pure blue and red as the pure matter of painting – not the colour of Matisse, of course, but pure matter in its full force?* Let us try to master, as he has done, the turmoil of inner experience, which presses and mounts within us and tends to impose equality on everything it presents to us – by drawing from within the turmoil itself the laws by which we master it. . . .

That is a little of what a Picasso painting says to me. Because he does not only seek the cubic element but builds a whole world, the message even seems rather moralistic. It is my firm conviction that *Picasso's art must have as its consequence a new aesthetics and a new attitude to life*. We had long ago buried Impressionism. To us younger people it was unintelligent, facile and a cheat. We have the task of making our world visible.

Let us create form with all our strength and not speak of the means we use. For the important thing is our world!

Yours in long-standing sympathy and appreciation,

M. R. Schönlank[1]

M. R. Schönlank (Max Raphael), 'Lieber Herr Pechstein!', *Pan* no. 25, Berlin, 9 May 1912, pp. 738–9; translated from German by David Britt.

[1] The article, written in Paris, is signed M. R. (Max Raphael) Schönlank, the town in west Poland (Schönlanke) where he was born.

Romanticism in Picasso

The pure lyricism which Matisse achieved in the wake of Gauguin is the first and most direct form of visual experience that could satisfy, through a direct link with nature, the new aspiration towards a reality of the Mind: this essential reality had to be discovered through the states and the values in which it is visible in objects: in other words, as a realm of feeling which serves as the vehicle for the object. The modern artist has inevitably discovered this reality in the guise of a transcendent, objectivized realm of emotion, manifold in its qualities because objects are manifold. It was consequently in painting – in the imposition of form on external space – that this realm of feeling found its first artistic expression. But this remained only the superficial aspect of the manifestation of Mind in the world; and the Romantic is impelled to plumb the depths. He seeks not merely to explore the momentary state of things, but to manifest the underlying principle – as Van Gogh penetrated to the origin of the powers within – the principle of the origin of Mind-in-matter, its innermost essence; he sets out to grasp and formulate the living activity in which this realm of feeling is created.

This artistic impulse – manifested, of course, as a way of seeing – is the origin of Pablo Picasso's work. And with astounding consistency and logic this work has taken on the form known as Cubism. Nowhere in the evolution of this new form of painting can the true function of Romantic art, that of laboriously breaking new ground – as opposed to the classical formal organization of wealth already gained – be seen so clearly as it can in Picasso.

Phenomena have their origin in the living operation of a mental principle, and for a *painter* this comes to fruition in the purest and most generalized mental conception of space. For Matisse, colours had furnished the means for the presentation of pure feeling; Picasso's sphere was pure space and its differentiation. Space creates the colours which express states of feeling; only the creation of spatial form articulates the law which governs the origin of matter. Van Gogh had atomized space in terms of dynamic colour; it remained for Picasso to press onwards to the *pure* perception of space as a function of the human mind. The pure perception of space, in this sense, is governed by the principle of *geometrical* creation of form; and so the geometrical articulation of pictorial space has become the fundamental technique of Cubism.

This remains, however, only the abstract element of the technique. Its true artistic meaning, and its relationship to the stylistic task in hand, emerges only from the union of this element with the other imperatives of the style. These are present in embryo from the outset of its evolution. The principal imperative is that of 'planar' painting: the individual significance of the object must be held in suspension in such a way that its

familiar forms no longer give rise to a perspectival, three-dimensional conception of the space in the picture; the picture becomes a flat surface, a 'picture' in every sense of the word. Even so, the nature of the object still remains the raw material of the formal process: the vitality of the human form, in particular, must so permeate the whole that it appears suspended and enshrined as in a higher, objective existence. It is these imperatives that provide the framework within which the primary imperative, that of a pure operation of the spatial principle, must be fulfilled. This leads to the total fragmentation of human or other forms into geometrical shapes abruptly juxtaposed. But it also leads to a degree of reinvention of the 'planar' manner of painting, without violating its essential nature, but bringing it to full and logical expression. Space, defined as the operation of principles which generate objects, can never be identified with two-dimensional surface as such, but only with physical, three-dimensional space; it is only through the functioning of this space that an object is produced. The imperative of 'planar' painting is therefore simply to generate this three-dimensional space, no longer through the means of everyday experience, or the old artistic method of individual perspective, but through the imparting of physical presence to those same geometric figures through which the picture as a whole is organized. The geometric figures must become stereometric – they must become pyramids and cubes – and give rise to a two-dimensional picture surface which to a certain extent still shows signs of a third dimension. Thus, Cubism emerges as the primitive manifestation of a new principle of artistic space, and previous works of 'planar' painting take on the historical role of a transitional stage.

It is this impulse towards the mystic vision that has led Picasso the Romantic, step by step, out of the old way of painting, towards the pure enunciation of principle: from the *Poor People by the Sea*,[1] by way of *The Actor*,[2] in which the inner meaning is ultimately nullified by an unpleasant element of melodrama, to the cubist heads, and finally to those last visionary possibilities which yield only the pure operation of spatial principle.

The 'woman with violin' or the 'mandolin player', who before Picasso would have been the beholder's main concern, are now successfully disposed of. As we have seen, it is impeccably logical that the everyday forms of objects should be dissolved and reintegrated into the organization of the pictorial space; and so it is beside the point, in the presence of such pictures, to seek in them for the object. One looks at such a work in order to experience the spatial vision in which it was created. Of course, Picasso's pictures carry this logic to an ultimate conclusion; but they do not violate the fundamental principle which underlies all artistic creation. The object in its everyday form is, to the artist, merely raw material. It is customary to say that the artist re-creates the object, but this is true only up to a point. The object, for him, is no more than the experiential prerequisite; the artistic process is the creation of a new artistic form in

which the experience of the object is dissolved and absorbed. This dissolution of the object takes place to varying degrees: the everyday form of the object may be faithfully preserved, together with its individual significance, or it may disappear altogether. However, even in the latter case, which is Picasso's, that form still remains the raw material, the

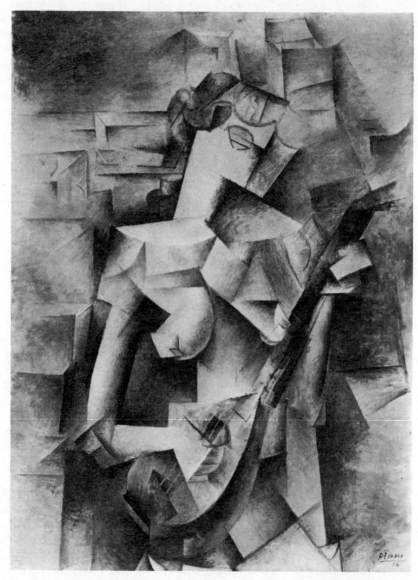

Girl with a mandolin (Fanny Tellier), 1910; oil on canvas, 100.3 × 73.6cm. The Museum of Modern Art, New York.

logical precondition of the work of art. This is analogous to what happens to an ornamental form which gradually loses all visible connection with the natural forms from which it is derived – even though it could not exist without them.

It is not for me to pass judgment on the artistic value of Picasso's achievement, because I know only the few works that were in the Cologne exhibition,[3] and there were hung there, alongside much that was suspect, a number of works of bold originality and outstanding quality. However, the essential thing with this painter is his place in history, and this is an extraordinarily significant one: through the creation of Cubism he has provided an entirely new formal method of attaining, within the stylistic preconditions set by the present age, an appropriate embodiment of pictorial space; *he has replaced mechanical spatial perspective with a dynamic principle whereby a mental space is created within the picture.* It remains to be shown how this new formal resource is subsequently exploited. Picasso has arrived at his new principle through a one-sided emphasis on the dissolution of objective materiality, through an essentially Romantic process of abstraction; and it is more than likely that the quality of his works will suffer in absolute terms as a result. But the first duty of the individual artist is to carry out his historical mission, and the Romantic, in particular, is all too often the victim of that mission.

A systematic working out of artistic principle, such as Picasso has undertaken, necessarily leads to the decorative, to *ornament*. The value of ornament lies in stylization – which means, in perceptual terms, that individual life is subordinated to the prevailing artistic law of the age, and thus transcended. Ornament has the function of creating and maintaining an attitude of consciousness appropriate to the prevailing emotional temper, and consequently requires to be purely formal in character. In the work of art, concrete reality remains the logical starting point and the source of the significance of the work, however much stylization takes place. In ornament, on the other hand, the relationship to the original object has become inoperative: the ornament may well bear signs of its origin in natural or mechanical forms, but its function, and its effect, are matters of pure form. Ornament is thus clearly a product of the Romantic phase of any stylistic evolution; for the Romantic, by virtue of his impulse to pass always from the individual phenomenon to the general essence, is always in a position to formulate a style in isolation. The ornamental patterns of Thorn-Prikker, Heckel and Kirchner, in the 'Chapel' on view at the exhibition, showed how a new style of ornamentation, of great beauty, has evolved out of Cubism.

From Ludwig Coellen, 'Die Romantik der neuen Malerei', *Die Neue Malerei*, **Munich, 1912, pp. 61–7; translated from German by David Britt.**

[1] z. I. 208
[2] z. I. 291
[3] Sonderbund exhibition (1912) which devoted a special room to Picasso's work.

1913　Heinrich Thannhauser
Moderne Galerie exhibition, Munich

It is widely believed that Picasso's works stand at the origin of the whole Expressionist, Cubist and Futurist movements. In fact, Picasso has nothing to do with any of these, except that he did provide the initial artistic impulse; nor does he want to have anything more to do with them. What distinguishes him from all these movements, even at first sight, is that unlike them he has never expressed his artistic intentions in programmes, manifestos or similar pronouncements; that he has never sought to explain his own new departures either psychologically or psychologistically; but that he has just painted. He has stood still in his studio and produced his paintings and smiled at the others, who were meanwhile out on the streets talking their heads off about the necessity of a renewal in painting and the like. And if asked why he is painting in a particular way, he has never found any other answer than that he does so because he has to. And at a time when there were exhibitions everywhere, of young artists from every country: France, Germany, Italy, Russia, Norway, etc., all of them directly or indirectly fertilized by the artistic personality of Picasso, this young Spaniard has himself never sent a picture to an exhibition, and his works have been seen only here and there, in a few art-dealers' galleries and in the homes of private collectors. So this is the first time there has been an opportunity, thanks to an exhibition at the Moderne Galerie, to see works from every stage of his development thus far; and if any spectator who generally gives more than a superficial view leaves the gallery with the conviction that he has before him the work of a serious artistic will, a consistent artistic character and a whole man – then this exhibition will not have failed in its purpose.

Heinrich Thannhauser, *Ausstellung Pablo Picasso*, Moderne Galerie, Munich, February 1913, pp. 1–2; translated from German by David Britt.

1913　M. K. Rohe
Review of Moderne Galerie exhibition, Munich

Picasso began quite normally; which means that like every competent turn-of-the-century Impressionist he first of all pursued the reproduction of concrete natural impressions – and like all energetic beginners he had a fairly haphazard tussle with subject matter and materials. His most remarkable natural gift is an extraordinarily powerful and subtle capacity for emotion, not without that characteristically modern trace of neurosis which is detectable nowadays in many sensitive natures, and whose prevalence shows that we have not yet transmuted our aspirations and

our endeavours into organic growth. This nervous hypersensitivity is Picasso's strength, or has been so hitherto; but in my opinion it has also been his downfall. For it was this quality which in his early works, fascinating though their expressiveness may be, often led him astray into an exaggerated formal emphasis. Later, when he no longer had the strength to maintain his creative progress in a healthy and natural way, this same hypersensitivity led him into the pseudo-intellectualism and pseudo-science of 'absolute painting'. Even now, what still charms us in the most recent Picassos is the subtly ordered arrangement of tones; but of course this cannot blind us to the sheer nonsensicality of these works as a whole.

A remarkable example of the expressiveness that Picasso could command in his early period is his *Youth*,[1] of 1903, in the Thannhauser exhibition. This portrait of a young man in a blue suit with a clay pipe in his hand and a garland of flowers in his hair – almost perverse in its delicacy – is not easily forgotten. In its simple but expressive line there is something of a truly Greek feeling for beauty, which is reinforced by the ingratiating colour scheme. In this piece Picasso is already a totally modern Expressionist, exploiting the heritage of Cézanne and the achievements of a Gauguin or a Matisse while remaining far removed from any superficial imitation.

Picasso's transition from Impressionism to Expressionism was very sudden – as indeed all the shifts in his development to date have been: another confirmation of the highly nervous nature of the artist. He has meanwhile always absorbed every possible external stimulus – but it speaks for the genuine spontaneity of his gift that he has succeeded in animating every outside impulse with an inner life that is all his own.

From M. K. Rohe, 'Pablo Picasso', *Die Kunst für Alle 1912–1913*, **Munich, 1913, pp. 380–2; translated from German by David Britt.**

[1] *Boy with a pipe*, 1905 (z. i. 274)

1913 Wilhelm Bode
The new art of Futurists and Cubists

This 'new art' displays in a particularly repulsive way the tendency of our democratic age to destroy the irksome barriers of religion and morality, to bring everything to a dead level, to suppress originality and independence of character, to abolish the sense of quality and replace it with the triumph of mediocrity and brutality. Aesthetics are cast aside. The search for beauty in art is declared to be nonsensical: a 'new beauty' is constructed, which is sought in ugliness and vulgarity. This is actually turned into a new religion, of which the 'new art' is supposed to be the supreme artistic and moral expression.[1]

From Wilhelm Bode, 'Die "Neue Kunst" der Futuristen und Kubisten', *Neues Wiener Journal* no. 7163, Vienna, 2 October 1913, p. 4; this extract republished in French in *Documents* vol. 2, no. 3, Paris, 1930, p. 183; translated by P. S. Falla.

[1] This passage from an article by Wilhelm Bode, the connoisseur and director of the Kaiser-Friedrich Museum in Berlin, was republished in 1930 in *Documents* (see p. 173), together with a passage (see p. 172) by his assistant Max J. Friedländer, as examples of 'official opinions in Germany'.

1913 Hans Arp and L. H. Neitzel
The Cubists

And now what of the artists who fight under the banner of Cubism? Are they the right protagonists of this lofty problem of form? Have they logically followed the arduous path which opened before them?

Let us take as characteristic examples its 'inventor', André Derain, and its co-founder, Pablo Picasso, who is also its strongest and richest representative. They both passed through the stage of the dematerialization (mentalization) of form. But then came the parting of the ways.

André Derain, the softer, gentler of the two, deserted in the face of the Absolute. His tender nature pined for the interplay of phenomena – which now that he had attained insight and had seen its outer limits, appeared doubly desirable. In travelling thus far he had become aware of the unavoidable compromises that adhere to every step a human being takes. He turned back, though not as a penitent.

But proudly and boldly Pablo Picasso went on to coin new forms. He fought with such implacable ardour, such *élan*, as to ignore the boundaries set for him as a painter. A fanatical will held him to the course on which he had embarked.

When he first set out on that course, he turned his back on a rich and beautiful body of work which for him was exhausted. New horizons, new unbounded potentialities, opened before him.

Work that had previously seemed to grow of its own accord, in rapt, lyrical simplicity, now cost him a dramatic struggle; and this has led, through the resistance and the conquest of forms, to an undreamed-of richness and multiplicity of life. His knowledge of the forms of an object is constantly enriched and leads him into ever more imaginative and fantastic trajectories. And yet he barely strays from the object. He is turning into the history-painter of the object. And that is the most dangerous compromise that he has made with the Absolute.

Picasso must have sensed this. But he has not looked for the compromise within himself: he has sought to eliminate it through the material of painting itself, which – as far as colour is concerned – has nothing to do with form at all. . . . He has sought to still the unresolved harmonies of his inner life, the unsatisfied longing for absolute form, by pursuing a greater authenticity in the use of materials. This authenticity was at first an apparent one – the use of tools appropriate to his materials. It then became absolute – the use of authentic materials.

But what of the new creation that sprang from this? Does it bear witness to a sublime, purified artistic creativity – a superhuman creativity? Are these the forms, swelling with individual quality, idealism and deep emotion, which come close to the absolute, spiritual form of the Creator?

Perhaps they are. . . . And yet they might also be the expression of a courageous nature who is afraid to turn back; of one who renounces, with a grandiose gesture, the house in which he has spent a happy youth.

And the house stands wide open to welcome anyone who wants to live in it.

From Hans Arp and L. H. Neitzel, *Neue französische Malerei*, Leipzig, 1913, unpaginated; translated from German by David Britt.

4.
The war years

1914–1919

With the outbreak of war in 1914, Picasso's circle of friends in Paris broke up; nevertheless, he decided to stay in France, while Braque, Derain, Apollinaire and many others left for the war. At this time Picasso was living with Eva Gouel (Marcelle Humbert), who accompanied him to Avignon in the summer of 1914. From there he wrote (letter in Beinecke Library) to Gertrude Stein, who was in England, that he had been present in Paris several days before the mobilization to attend to his business affairs, and had looked after her apartment on the rue de Fleurus prior to his departure. The following year Eva became ill and eventually died in Paris late in 1915. Picasso worked on alone, for the most part, until he was approached by Jean Cocteau to collaborate on Parade, a project which took him to Italy in 1917 and is discussed later in this section.

Some of the most significant formalist criticism and least-known writing concerning Picasso during this period comes from Russia. Picasso's work was known there by 1914, and his influence was beginning to be felt among Russian artists by that time. His work had been included in the 'Jack of Diamonds' exhibitions in Moscow in 1912 and 1913, and after the Russian artist Tatlin visited Picasso, he introduced radical ideas about constructions and reliefs based upon his study of Picasso's synthetic constructions in 1913. Moreover, the most important collection of Picasso's paintings, which critics knew, belonged to Sergei Shchukin, who had been introduced to Picasso in Paris some years earlier by Henri Matisse. Shchukin's collection, which included works by many other artists as well, was arranged in galleries in his home in Moscow, and once a week, prior to the Russian Revolution, the galleries were open to the public.

Russian critical response to Picasso's work generally followed one of two approaches: one, as is the case with Nikolay Berdyaev, is to consider Picasso as a mystical creator, whose move in the direction of pure painting could be discussed as an outward expression of an inner spiritual search; the other, and more perceptive, approach was formalist analysis, brilliantly represented by Aksenov's study of 1915, published two years later, based on works he had seen both in Shchukin's collection and in Paris. Rather than attempting to place Picasso in the context of art-historical tradition, and particularly French tradition, the Russians tried to explain why Picasso's works looked so

different from, for example, works by Gauguin, and why the effect they produced on the spectator was so disturbing. Aksenov rejected Berdyaev's mystical interpretation of Picasso's intentions and turned to the works themselves. His analysis of planar relationships, the play between foreground and background space and the use of poster lettering and transparent planes in Cubism is the first of its kind in cubist criticism in general, and reflects the mathematical tendencies in Russian constructivist art of that time.

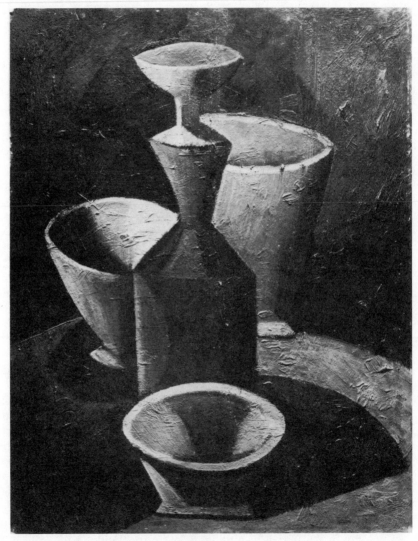

Carafe and three bowls, 1908. The Hermitage Museum, Leningrad.

Picasso is pursued insistently by two mysterious voices which urge him in different directions. That is why the figures in his paintings seem to be listening to voices. This is not done obviously, however, and one has to look at a picture long and carefully before realizing it. How tiresome it is for the poet, or the woman, or the figure seated in front of a glass of absinth, to be pestered by a voice whispering and by another voice, equally persistent, which contradicts the first.

Picasso makes his statements reluctantly, with restraint and caution. He is not yet certain that the rival voices are real, or that they exist independently of himself. But his doubts are short-lived. We have a still life[1] by him, showing earthenware bowls and a carafe on the edge of a table. The ascetic severity of colour, the absolute simplicity of drawing, the resolute absence of premeditation coexist with an unbelievable and surprising expressiveness of form, through which can be clearly sensed an unusual strength of feelings that are completely adequate to that form in its masterly inventiveness.

I know no more frightening picture than this still life by Picasso. It is no longer a work of lyrical sadness, of soft romantic blue or melancholy that the world may not feel; no more soft lines or approximate drawing; what was intimate and subjective is now unexpectedly objectivized, generalized, hard, precise and obligatory for all. Picasso's earthenware bowls are the darkness of an ultimate despair that has already been revealed to us, like a universal sign marking a stage in cultural history. We are already in the domain of collective psychology. Matisse's nihilism is an innocent amusement compared to the cultural and religious abyss that Picasso has here revealed to us with gloomy sincerity. Matisse consoles himself with 'pleasant' tints of undeniable intensity and piquancy; Picasso seeks no consolation.

What fearful anguish emanates from that dark table pushed into a corner.

Picasso's work reaches its culmination in his monumental pictures, drawn and painted with extraordinary conviction, precise as geometrical axioms despite the unexpectedness of their nightmarish forms. The famous *Woman with a fan*,[2] or *La Fermière*,[3] who appeared to him in a dream in 1908, the *Buste de Fermière*, the melancholy *Seated woman*,[4] or the sinister *Friendship*,[5] each of these bears witness to some important, extraordinary artistic vision. Picasso's conversations with his demon in those days were remarkable indeed.

The surprising appropriateness of Picasso's artistic forms to the emotions that have arisen in him enables us to judge with assurance those conversations between man and devil. Satan himself suggested to Picasso that woman is not a mechanism as Degas thought, or a doll as Renoir felt

her to be, but an idol – and what an idol. Here she is in the shape of a farmer's wife, the incarnation of fertility. Elsewhere she is a seductress, as the *Woman with a fan*; or again, mournfully unsatisfied, a ravishing monster inclining her desperate head; or a woman in the bosom of nature, presented with savage cynicism as an embodiment of lust. Always and everywhere the 'eternal feminine', as the devil slanderously would have it, stands before us as a dead, conventional principle, deified by man, exalted as a superior being and suddenly revealed in her true infamy. The

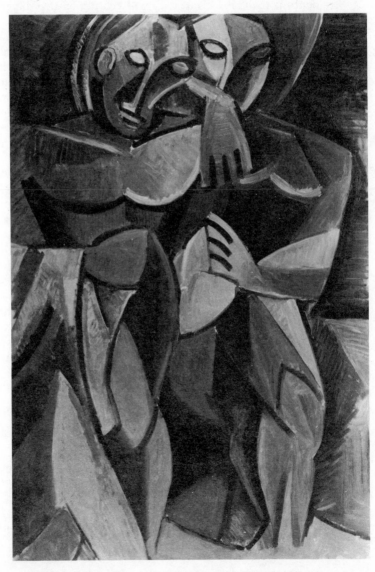

Two nudes (Friendship), 1908. The Hermitage Museum, Leningrad.

goddess that was once an idol collapses and crushes man under a senseless weight of rock. Picasso could not guess that this was not woman, but the devil that had appeared in his dream. He could not guess that he had painted Satan's portrait and that these prophetic signs would preserve us from great danger. Picasso sacrificed himself so that his fearful experience might be of use to others. His fate is tragic; but how blind and naïve are those who think we must imitate Picasso and follow his teaching. What would be the use? – since, outside Hell, there are no emotions corresponding to these forms. But to be in Hell is to anticipate death, and I doubt if the Cubist fraternity will venture on that experiment and that ultimate knowledge.

I am not a painter, and it was my modest design to put forward some thoughts on the psychological basis of Picasso's painting, but I cannot forbear to express my admiration for his skill. Anyone who examines his preliminary studies carefully will be filled with profound confidence in his artistic honesty. The two studies for *Friendship* [6] in the Shchukin collection are extremely convincing from this point of view. In Picasso's monumental paintings nothing is accidental. The distribution of masses corresponds strictly to the other aspects of the picture, namely drawing and colour.

Some, even of Picasso's admirers, maintain that his strength lies in drawing and that his work lacks colour. I do not agree. His colours are always intense and full of meaning, despite their apparent poverty. 'One can recognize the czar even in rags' – such is Picasso's masterly skill, despite the austerity of his yellows and browns.

In my opinion two tendencies are at work in contemporary Western art, a nihilistic optimism and a demonic pessimism. The first of these is of course predominant, and by seeking to justify it painters reject the idea of responsibility.

The conclusion, it seems to me, is as follows. Unless there is a cultural revolution and a world-wide renascence, European artists have a frightful fate in store for them: either to serve the petty, complacent demons of mechanical technology or to sacrifice themselves as Van Gogh and Picasso have done.

From Georgy Chulkov 'Demons and modern life', *Apollon* **no. 1–2, Petersburg, 1914, pp. 73–5; translated from Russian by P. S. Falla.**

[1] *Carafe and three bowls* (z. II. 90)

[2] z. II. 137

[3] Although Picasso did not generally give his works of this period other than descriptive titles, two of the paintings purchased by Shchukin have specific reference: *La Fermière* (z. II. 91) and *Buste de Fermière* (z. II. 92) refer to a neighbour of Picasso's, Madame Putman, at la Rue-des-Bois, where he spent the summer of 1908.

[4] *Meditation* (z. II. 68)

[5] z. II. 60. This work, which was bought by Shchukin in 1913, may well have been titled by the collector.

[6] z. II. 58, 59

Picasso's nudes look as if they were made of blocks of stone joined by cement, which shows as a black line. This is true of *Three women*,[1] painted in brick-red, in which we feel the weight and the contours of a monument. It would be impossible to react more completely against the nudes of Renoir and Degas, or the whole pictorial sensibility of the Impressionists: what we see is the triumph of the chisel over the brush, of tactile over visual qualities. One may make fun of these Three Graces in brick, but it cannot be denied that they are an original monument of our time in its quest for what is organic and sculptural – an age of unsteady intellectuals, attracted by muscle and sport but themselves, alas, a puny race.

For, despite their powerful appearance, Picasso's women have an inner weakness: monumental beauty is not achieved by the arithmetical cohesion of separate blocks. His stone females are not, after all, intact monoliths, at least not always. Certainly, at first glance there is close kinship between the schematic expressiveness of Picasso's women and some massive prehistoric Venus, or the marvellous wood-carvings from the Congo or Madagascar of which Picasso is so fond and which can be seen in the same room as his other works in the Shchukin collection. But if we look first at these African female idols and then at Picasso's women we realize that the latter's construction is inorganic and their geometrical expressiveness is lacking in foundation. They reflect no metaphysical preference for one part of the body rather than another; all the volumes are in equilibrium. But if they are not inwardly cemented there can be no external balance. The African idols are like weighted dolls; you may try to overturn them, but they remain firmly based on their legs like pillars. By contrast, in Picasso's *Female nude in a landscape*[2] the legs seem to give way; the soul does not inspire the body, which collapses under the weight of its own limbs.

Thus when Picasso interests himself in the art of African savages with its schematization based on the creation of communal idols, he is really concerned only with external form and neither can nor wishes to give it a new content. In this sense, 'what is frightening is not that Picasso's monsters resemble the religious art of savages' (A. Benois[3]), but rather that they do not resemble them enough. The Union of Youth are beside the mark when they talk of a 'dark, contorted Apollo' replacing the Apollo of light: Picasso is not concerned to create any Apollo, he does not possess the necessary standard. There is no idol and no ideal to be seen here, even in the realm of pure form. For Apollo symbolizes total achievement, whereas Picasso's world perpetually falls short of that condition.

Consider his picture *Factory at Horta de Ebro*[4] in the Shchukin collection, dating from 1909, with its combination of stone surfaces and shimmering facets. This marks the beginning of the second and latest

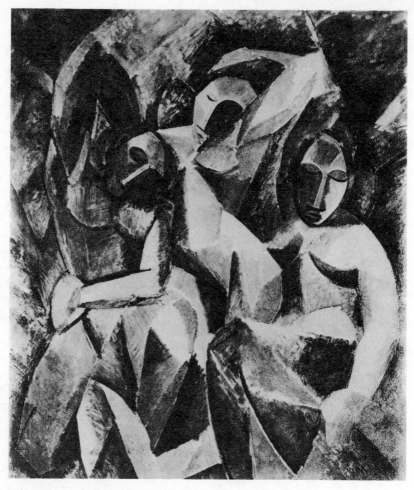

Three women, 1908–9. The Hermitage Museum, Leningrad.

period of Picasso's work, and the ultimate conclusion of Cubism in total contrast to his earlier Spanish cycle. Instead of centripetal rhythm we now have a centrifugal force. The lines of the factory walls and roof do not converge towards the horizon as Cézanne prescribed, but spread out in all directions. There is no vanishing-point, no horizon, no human perspective; no beginning or end, only the cold insanity of absolute space. And even the reflections of the shimmering walls repeat themselves time without number; their reflection in the sky turns the factory into an enchanted labyrinth of mirrors in which men lose their reason. For one might indeed be driven mad by this idea and this temptation, worthy of Ivan Karamazov. There is no end, no unity, no human person as the measure of all things: only a cosmos, an infinite subdivision of volumes in

infinite space. The lines formed by objects diverge into measureless distance, the forms break up into innumerable components.

This is the starting-point of the search for a plastic dynamism as opposed to the static condition of Picasso's stone females: the search for a fourth dimension, 'the dimension of the infinite', for whose sake he ignores the three-dimensional depth of Cézanne. For Cézanne spoke of knowing the world in terms of the sphere, cone and cylinder, while the only geometrical forms Picasso now recognizes are the circle, the triangle and the parallelogram. He is no longer fascinated by the mass of objects, as with the stone women, but by the dynamics of their development. There is no object as such, only a law whereby the object develops from its smallest beginnings. All parts of the object are equal to his objective eye; he examines them from all sides, enumerates their aspects and repeats them to infinity, studying the object 'as a surgeon dissects a corpse' (Apollinaire); he takes musical instruments to pieces as if they were clockwork, and tortures them like an inquisitor. A fetishist of quantitative plurality, he ceases to realize that his picture is no more than a catalogue or a mechanical drawing. He does not represent the dynamic aspect of objects like a painter, Van Gogh for instance, but describes their successive positions one after the other as a writer would do, that is to say in time.

In Picasso's re-examination of musical instruments, as in the principle of the equality of parts and the plurality of viewpoints, we can perceive the same lack of intrinsic criteria as I mentioned when comparing his women to the African idols. Early Renaissance miniaturists and painters also depicted not the object itself but an *a priori* idea of it, independent of perspective, and among all its surfaces and proportions they selected what they needed for a given subject. Picasso, however, does not know where to take his stand, as the qualitative necessity does not exist for him. 'A bottle on a table,' he said to me once, 'is as important as a religious painting.' The guitar does not suggest to him any sentimental or human analogy as it did to Mallarmé *('Une dentelle s'abolit . . .')*, and he presents all its aspects in a centrifugal chaos. Here again we see the absence of an organizing principle, an organic intuition, such as is expressed in Hellenistic bas-reliefs with their combination of full-face and profile, or in Heraclitus's *'panta rhei'*, the anticipation of Futurism. Does not this formula apply to Picasso's *Violin*,[5] the oval shape of which in itself suggests that it can be hung either way, and thus gives the idea of perpetual rotation? This is Picasso's last word, and indeed one cannot go further towards dematerializing the world and breaking it into fragments.

In the series of musical instruments [6] Picasso seems to turn from the monotony of the stone women towards polychromy, the irruption of radiant glimpses of green, pink and sky-blue. But in this new polychromy of his there is a certain diabolical mischief. Picasso uses paint merely to indicate the natural properties of his raw material (the colour of a yellow veined tree, of wallpapers, marble or newspaper lettering) and in so doing

to emphasize and glorify the abstract purity of his design. His green wallpaper is reproduced with such precision that it seems real; his pieces of wood and marble, plaster and newspaper (I have seen pictures in his studio with bits of newspaper stuck to them) are there for the sake of contrast. The irruption of a coarse material world is intended, by its piquancy, to enhance the supramaterial quality of the remainder of the picture. In the same way Mallarmé sometimes used 'everyday words, the kind that honest bourgeois read in their *Petit Journal*', but he did so in such a way that they resembled charades.

It is not by chance that Mallarmé comes to mind: there is some analogy between the creative drama of the symbolist poet, who dreamt of 'reducing the whole world to a single magnificent book' but lost himself in the labyrinth of narrowly subjective analysis, and the art of the Spaniard Picasso who aspires to turn the world into a monolith but has lost the sense of unity thanks to the fetishism of quantitative plurality.

Once again I remember Picasso's studio, the laboratory of his creative experiments, a dungeon in which he tortures objects and plucks out their insides. I have already said it was not an amusing place, and I will now add that there was something tragic about it. Tragedy presides over the work of this intrepid Don Quixote, this knight errant of the absolute, this champion of mathematics doomed to an eternal and hopeless quest. For art, which is essentially dynamic, cannot be everlasting; it only touches eternity when man, in love with the world, 'implores the fleeting instant to remain'.

From Yakov Tugendhold, 'French pictures in the Shchukin collection', *Apollon* **no. 1, Petersburg, 1914, pp. 33–6; translated from Russian by P. S. Falla.**

[1] z. II. 108
[2] *The Dryad* (z. II. 113)
[3] Aleksandr Nikolayevich Benois, author of *The Russian School of Painting* and himself a painter.
[4] z. II. 158
[5] z. II. 358
[6] *Musical instruments* (z. II. 438)

1914 Nikolay Berdyaev
Picasso

When you enter the Picasso room in S. I. Shchukin's gallery, you are overcome by a sense of terror that relates not only to painting and the future of art but to the whole of cosmic life and its destiny. The room before Picasso contains a delightful Gauguin, which makes us feel that we have for the last time tasted the joy of natural life, the beauty of a world that is still incarnate and crystallized, the rapture of sun-drenched nature.

Gauguin, the child of a refined and degenerate culture, had to escape to Tahiti to find exotic nature and exotic people, to discover in himself the strength to create the incarnate crystalline beauty of sunny natural life. From this golden dream we awake in the Picasso room, where all is cold, gloomy and terrifying. Gone is the joy of incarnate sunny life. A wintry cosmic wind has torn off one veil of foliage after another – all flowers and leaves are stripped away, objects are deprived of their outer covering; all flesh, displayed in images of imperishable beauty, has disintegrated. We feel that there will never again be a cosmic spring – there will be no leaves, greenery, beautiful veils or incarnate synthetic forms. If there is any spring it will be a new, different one never known before, with leaves and flowers that are not of this world. It seems that after Picasso's terrible winter nothing will ever blossom as before – that this winter will not only destroy the veils of foliage but that the whole objective, physical world will be shaken to its foundations, in a mysterious disintegration of the universe.

Picasso is an inspired interpreter of the dislocation and atomization of the physical, bodily, incarnate world. From the point of view of the history of painting we can see why Cubism came into being in France. For a long time, since the Impressionists, French painting had developed in the direction of softening and abandoning rigid forms, while concentrating on the purely pictorial. Cubism is a reaction against that softening, a search for the geometrical quality of the objective world, for the hard underlying structure of things. It is an analytical search, not a synthetic one. The synthetic-integral approach to artistic creation becomes more and more impossible: everything is decomposed and dismembered analytically. By this process the artist seeks to reach through to the inner structure of things, to the rigid forms concealed by the softening veils. The material protective layers of the world have begun to dissolve and disintegrate, uncovering the hard substrata that were previously blurred and softened. In his search for the geometrical forms of objects and the skeletons of things, Picasso has arrived at the Stone Age; but it is a transparent Stone Age. The gravity and fixed rigidity of his geometrical figures is only apparent. In reality his geometrical figures, skeletons of the physical world composed of cubes, fall apart at the slightest touch. The innermost layer of the material world that reveals itself to Picasso the artist after all veils have been torn off is transparent and unreal. What meets the artist's gaze is not the substantiality of the material world – that world proves to be insubstantial. Picasso mercilessly lays bare the illusions of personified, material, synthetic beauty. Behind captivating, fascinating female beauty he sees the horror of disintegration and decomposition. Like a clairvoyant he sees through all veils, outer garments and intervening layers to the depths of the material world, where he perceives his composite monsters. These are the demonic grimaces of the pent spirits of nature. If we go any deeper there is no longer any materiality but already the internal harmony of nature, the

hierarchy of spirits. The crisis of painting inevitably leads to the aban-
donment of physical, material flesh and entry into another, higher sphere.
.

What we are now faced by is not an artistic crisis, of which there have
been many, but a crisis of painting and art in general. It is a crisis of
culture, an awareness of its failure, of the impossibility of instilling into it
any creative energy. The cosmic dislocation and atomization leads to a
crisis of all art and threatens to obliterate its boundaries. Picasso is a
manifest symptom of this morbid process, but there are many others.
When I look at his pictures I think that something is going wrong with the
world, and I feel pain and sadness at the loss of the old culture, but I also
feel joy that it is being born anew. This is a great tribute to Picasso's
power. The same thoughts arise in me when I read occult books or
converse with theosophists. But I believe most deeply that there can be a
new beauty in life itself and that the loss of the old culture is only
apparent, an effect of the limitation of our minds, because all beauty is
eternal and belongs to the deepest core of our being. The sadness that
weakens us must therefore be overcome. If it can be said as a penultimate
truth that the beauties of Botticelli and Leonardo will perish irrecover-
ably with the disappearance of the material plane of being on which they
were incarnated, then it must be added as a final truth that those beauties
have entered into eternal life, for they have always existed beyond the
insubstantial veil of the universe which we call materiality. But the new
creation will be of a different kind and will not be fettered by attraction to
the gravity of this world. Picasso is not a new creation; he is the end of the
old one.

From Nikolay Berdyaev, 'Picasso', *Sofya* no. 8, Moscow, 1914, pp. 57–8, 61–2;
translated from Russian by P. S. Falla.

Ivan Aksenov's book Picasso i okrestnosti, *written in 1915, was published in
Moscow by Centrifuge in 1917 with a cover designed by the Russian con-
structivist artist Alexandra Exter. The four main chapters of the book are
concerned primarily with aesthetics, while in a 'Polemical Supplement'
Aksenov examines paint layers, brushwork and compositional arrangement
of various works representing the major phases of Picasso's development to
that date. Following here is an excerpt from this Supplement concerning the
development of Cubism and the revolutionary concept of cubist space.
Aksenov's theories were reportedly known in Paris in the twenties (although
no translations have yet been found); a very recent French translation
appeared in* Cahiers du Musée National d'Art Moderne *no. 4, April–June
1980, pp. 319–22.*

Picasso's frequent changes of style indicate his dissatisfaction with the
solutions he had attempted. In the pictures which concluded each period
Picasso employed a graphic device, the use of the highlight with cross-
hatching. Much is explained if we remember that this device is character-
istic of the work of El Greco – those who wish may verify this in the
Munich *Laocoon*. The adoption of a schema which was not his own
testifies to a hidden crisis in his work; in his earlier periods of activity
Picasso had not succeeded in finding his own solutions to the problems
which he had set himself.

We have seen that finally he began to carry El Greco's device to
extremes – this was an attempt to individualize his fatal inheritance, an
attempt cut short by the artist's determination: he renounced the tools of
another and determined to create his own. This explains the temporary
conversion of the painter into a sculptor. At the time when he was
studying contour, he had turned to the most characterless of media, to
watercolour, and then he began to work with wax. The result was a cycle
of wax heads[1] and the paintings of 1909. In most cases these were also
heads and the colour chosen for them was the pale yellow of patinated
wax. The similarity of both cycles amounts almost to copying. Character-
istic of this new genre of painting is the assumption of an underlying
rectilinear solid form with insistently traced contours. There is rarely,
almost never, a break, and where one occurs the reason for it (this is
highly characteristic of Picasso) is a wish to increase the area of greatest
pictorial value. The brushstrokes are applied parallel to the most ex-
pressive boundary of the plane – a last and farewell *rapprochement* to
Cézanne.

The colourist rhythms of Delacroix's pupil are abandoned once and for
all, but geometrical simplification of the incidental elements of the pic-
ture is adopted and developed towards the goal of greatest possible
clarity. . . . Reproducing in paint the results of Picasso's sculptural
investigations, this series of paintings reduces the problem to the distri-
bution of light and of colour harmony. The heroic resolution, which must
be made, to break the contour has not been abandoned – it is put to one
side; traces of it can be seen in the displacement of the elements contained
within the contour. The subordination of painterly execution to plastic
problems confirms our opinion as to the preparatory nature of this cycle.
What was in preparation was a new expression of depth. This came to
dominate Picasso's work from 1911 onwards. The contours of objects
were moved apart, both in the interests of the expressive outline of each
articulation and with the aim of exploiting more fully the characterization
of the brushwork.

Volume is a sculptural concept; easel-painting has to do with the

flatness of a canvas. The expression of volume on a flat surface, the depth of a picture, is achieved chiefly by means of graphic perspective. Painting is subordinated to problems of graphics, creating an optical illusion which could be mistaken for a likeness. Artists who have wished to renounce the predominance of the graphic side of their art have sacrificed depth in their pictures. Picasso set himself the task of expressing the perspective of volume by primarily painterly means, refusing to reduce to an enclosed relief the planes which characterize an object. Every such plane came to be regarded as an independently valuable element, its place in the picture space being determined not by the obligation to reproduce nature photographically, but by its compositional link with the other elements of the picture. The space within the picture frame became a special world with its own laws. . . . Since the planes represented in the picture were component parts of one object and therefore were made of one material (and we know Picasso's love for material) so the colour of all of them was one and the same, differing only according to the distribution of light on them. If Neo-Impressionism was the analysis of light, then this period in Picasso's painting brought about the analysis of chiaroscuro. But, not limiting himself to the perspective of light, Picasso introduced the device of the so-called shifting plane – a transparent plane, through which are visible the other elements of the picture.

This device posed a new problem: the individual characterization of each of the planes which characterized the volume. The solution was demonstrated in two ways: in terms of graphics – in a complete freedom of choice of place for the plane and in turning it at the angle which most clearly revealed its distinctive features; and in terms of painting – in the individualization of the execution of each structural element. Thus the simplest of objects became an unfamiliar perspective made up of elements arranged in a hierarchical schema and the characteristics which define volume were on the verge of disappearing, becoming an indistinct gradation of a great number of elements in unlimited space. The way of avoiding this pitfall was suggested by a series of everyday observations of two very ordinary things – a shop-window and a poster.

Lettering on invisible glass framed by an aperture cuts across the object, which has been formally broken up into parts, and forms the foreground of the picture. The lettering on the poster, emerging from behind the object, establishes the background of the picture. The discovery of this new perspective should, it seems, have put an end to Picasso's searches: it seemed as if everything had been found, but in fact this achievement served as an impetus to new work on the problem of the plane.

We have seen that the individual characterization of planes was achieved by the individualization of their painterly execution, which demanded a great variety of technique within the limits of one picture. But though it may appear strange at first glance, this does not result in a seemingly inevitable thickening of the paint layer or a deliberate vir-

tuosity. This strange fact is explained by a particular treatment of the multi-layered structure: within the boundaries of one articulation several layers of paint are applied, but they cover one another only partially; the execution of each layer is different from the execution of the layer beneath it. Thus the possibility was realized of combining not only different types of brushwork, but also combinations of these types, which enormously increased the technical means of the artist, without destroying their unity. For example, if we have five different layers, we have $5! = 120$ different planes. Graphic devices have completely disappeared from Picasso's pictorial repertory – they reappear only in *L'Arlésienne*,[2] in the form of black hatching in the background, apparently applied with a pen, but this device is purely graphic, it does not attempt to pass for painting and, by the nature of its materials, is opposed to the earlier technique.

It is in the nature of a confrontation between the semi-graphic style of the past and the purely painterly style of the present. But graphics, banished outside the limits of the plane, continue to play a role on its boundary, defining with line the convexity or concavity of the articulation. In deciding to individualize the planes Picasso at the same time complicated his task by refusing to use linear relief. Now sections of a Euclidean plane with varying outlines appear as the component parts of a picture.

However, the exaggerated depth of the object does not disappear; the characterization of volume does not succeed in its purpose and the object loses its personal character, disintegrating into a series of elementary volumes. The characterizing element is no longer the plane, but a new volume. It is permissible to think that the cause of this at first eluded Picasso and he looked for it in graphic relief. The elimination of this cause did not change things – the elements of the picture continued to be volumes, stubbornly refusing to give up their third dimension to the will of the painter who created them. Picasso continued to increase the number of divisions, evidently supposing that if the curve of the object's surface were insufficiently broken up, then this would secretly show up in the elements of analysis. The increase in the number of planes caused an increase in the number of paint layers: in the most complicated composition, the *Poet* (1912),[3] in the most simply painted section, we can count up to eight layers and each section appears as a volume. It seems that lettering, introduced out of consideration of perspective, provided the solution. In introducing it into his compositions the artist was, in effect, repeating the device of his first Parisian studies: he was creating depth by introducing an element which in its colour and execution was foreign to the general composition of the picture.

The reproduction of the enamel shop-window signs was exact. Picasso stencilled them in lacquer and enamel – this arose also from the need for opacity. The technique brought about by the new materials differed essentially from the technique of oils; it represented one smooth layer – a device belonging to the canon of the house-painter. This lettering was

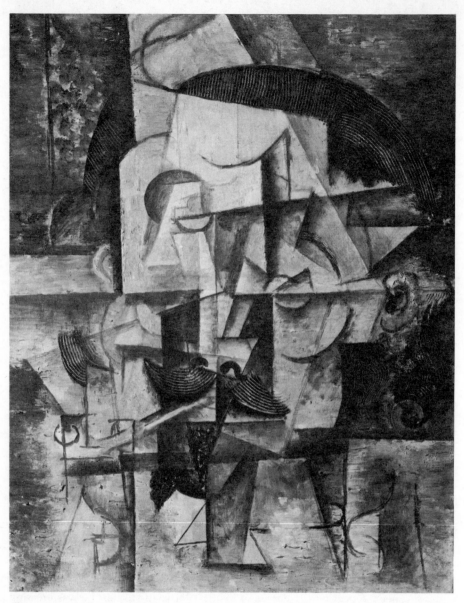

The Poet, 1912. Kunstmuseum, Basel.

absolutely flat. It then became clear that the apparent depth of the articulations resulted from his multi-layering technique: each sector represented not a 'surface', but a series of combined planes; absorbing light, each in its different way, they also gave a feeling of depth. The cause had been found and the struggle began.

Light-absorbing polyhedrons were replaced by light-reflecting ones: the smooth layer of lacquer and enamel no longer had a subsidiary function. With the simplification of execution the need arose for greater complexity of colour. The overall tone of the picture is broken up: pure white enamel appears side by side with black lacquer. The results produced by the structure of the paint layer had shown that he had not needed to repudiate the curved outline of segments. This came back. Besides, there only *seemed* to be a simplification of execution; devices changed according to the materials used. These new materials, introduced by the lettering, brought with them further attributes of the lettering itself. The letter represents an immutable visual impression. If the hieroglyph represents the most extreme generalization of the object depicted by it, then the letter – the surviving line of a hierogram which has been blown away – represents the canon of graphic devices. But absolute generalization is possible not only in the field of drawing: age-old representation of certain objects has created their organic synthesis and brought about the canonization of their colours in the field of decorative painting. This relates mainly to wood and marble.

Picasso used these devices to his own ends. In the *Poet*, not having the possibility (because of thematic considerations) of introducing the 'lettering' perspective, he gave the hair and moustache of his model a 'wood finish', working with a decorator's comb. A completely unexpected impression was produced, which was a revelation. What was important was not the novelty of the device (after all Pierre de Maré used a comb to paint the garments of Mary Magdalene at the foot of the cross in the *Crucifixion*) but the feeling of absolute certainty which was engendered by the most conventional of methods of representation. When we look at a cupboard with an oak finish, we gain the firm impression that the cupboard is made of anything but oak, and a wall with a marble finish will always be free from the suspicion that any marble is present in it. 'Oak' or 'ash' are contained only in the layer of paint applied by the decorator – this layer must be completely opaque so as to disguise the real material of the painted object. The appearance of painting belonging to the 'decorator's canon' evokes in the spectator a feeling of pure surface, of absolute flatness, devoid of the third dimension – devoid of depth.

Thus began the honeymoon with decorator's finishes – 'wood', 'marble', 'china' or 'clay' – which formed the basis of Picasso's new technique. To these finishes used singly or in combination he added the use of grey, by working the white surfaces with pencil lines, which acted as a transition from the smooth to the textured surface. Abstraction of style naturally brought about the abstraction of the whole linear and

colour composition, and their interaction led Picasso to a new series of investigations which form the basis of his present work. The eye soon becomes accustomed to recurring impressions and more so the professional, educated eye. The conventionality of the new devices ceased to satisfy the artist, apparently it left too much scope to his individual whim and was not absolutely conventional.

And Picasso once more abandoned painting: he glued to the picture pieces of 'marbled' paper, triangles of 'wood finish' panelling, replaced the 'pencil on white' with newspaper cuttings; these were absolutely flat surfaces which he sometimes united with a few lines of charcoal or chalk. [4] He fixed to a wooden panel all kinds of household rubbish: bits of box, ink-pots, visiting-cards, pieces of cardboard, rulers, fragments of violin, bound them with string, spiked them with nails, hung them on the wall; sometimes he summoned the photographer. The simplicity of outline, the limited number of constructive elements and of colour combinations allows us to see in this last phase of Picasso's work a new form of his experiences working with flat paint: the same close scrutiny of the material structure of the plane, the same closeness to the elements of everyday perception.

What will happen next? We shall see. At least we know that we shall not see anything that does not belong in the exclusively plastic nature of his creation – not mysticism, nor demonism, nor the fourth dimension were ever present in the work of Picasso, are not and will not be. Here we have surveyed Picasso's entire career and have found that the problems which determined its development were exclusively pictorial – the problems of the painter's craft. These problems are eternal, and eternal is the beauty of Picasso's work.

From Ivan Aksenov, 'Polemical supplement', *Picasso i okrestnosti*, Moscow, 1917, pp. 53–60; translated from Russian by Christine Thomas.

[1] e.g. *Head of a woman (Fernande)* (Spies 24)
[2] z. II. 356
[3] z. II. 313, reproduced in Aksenov's book.
[4] e.g. *Guitar and sheet of music* (z. II. 372), also reproduced in his book.

Picasso rarely travelled outside Spain and France, and his first trip to Italy, which was to have a notable impact on his work, was made for the purpose of collaborating on the ballet Parade *in 1917. The poet Jean Cocteau had originated the idea for this wartime theatrical event and had convinced Picasso to design sets and costumes, Erik Satie to compose the unusual score, Massine to choreograph, and Diaghilev's Russian Ballets to perform the work. In the following account, which was written and published in France in his book* Picasso *in 1923, and appeared the following year in English translation in the American journal* Arts & Decoration, *Cocteau acknowledges Picasso's particular talent for theatrical design. The poet's more familiar*

record of Parade *and the subsequent commotion it caused when performed at the Théâtre du Châtelet in Paris appeared in his book* Le Coq et l'Arlequin *in 1918.* Parade *was the first of a series of theatrical collaborations between Picasso and Diaghilev, which included* Le Tricorne *in 1919 and* Pulcinella *in 1920.*

Picasso's stay in Rome represented an intense period of activity; he wrote to Gertrude Stein from the Hotel Russie on the Via Babuino (letter of April 1917, Beinecke Library) that he worked all day, stayed up all night, and had met all the 'dames romaines' in town. He added that, in addition to making caricature portraits of his Ballets Russes *collaborators Diaghilev, Bakst and Massine (among others), he spent 'all day on my sets and costume designs and on two canvases that I've begun here and which I would like to finish before returning.'*

The 1917 visit also gave Picasso the opportunity to travel to Naples, visit museums, and to meet Italian artists such as Enrico Prampolini, then the director of the journal Noi. *Prampolini's account of Picasso's visit to him, included here, provides valuable documentation concerning meetings with avant-garde artists, whom Picasso had already heard about in Paris from Cocteau and the Italian Futurists Boccioni and Marinetti. Although this recollection was written in retrospect (in 1943), Prampolini gives important information concerning the immediate impact on Picasso's work of Italian Renaissance art.*

(1917) Jean Cocteau
Picasso in Rome

What concerns me is Picasso, the scenic artist, for I dragged him into it. His circle did not wish to believe that he would follow me. A dictatorship weighed upon Montmartre and Montparnasse. We were crossing the austere period of Cubism. The objects found upon a café table were, with the Spanish guitar, the only pleasures permitted. To paint a setting, and above all for the Russian Ballet (this devoted adolescence knew not Stravinsky), constituted a crime. M. Renan, in the wings, never scandalized the Sorbonne as much as Picasso did the café La Rotonde when he accepted my offer. The worst was that we had to rejoin Serge Diaghilev in Rome and the cubist code forbade all journeys except that from north to south between the place des Abbesses and the boulevard Raspail. Journey without a shadow, despite the absence of Satie. Satie does not like to shake his musical 'grand cru', he never leaves Arcueuil. We lived, we breathed. Picasso laughed to see the figures of our painters grow short behind the train.

(I except Braque and Juan Gris, who were anyway themselves to design décors for Diaghilev seven years later.)

We created *Parade* in a cellar in Rome, where the troupe was studying

Picasso with scene painters for drop curtain of *Parade*, Paris, 1917.

and which was called the Cave Taglioni; we walked by moonlight with dancing girls; we visited Naples and Pompeii. We came to know the gay Futurists.

Elsewhere one may find the consequences of this voyage *(Le Coq et l'Arlequin)*. It is useless to relate again the scandal occasioned by *Parade* in 1917, and its success in 1920. The important thing is to record the ease with which Picasso realized the theatre, as he had realized all the rest.

The characteristics which render him unsuited to the decorative style were to serve him on the boards. Indeed, if intense life is a fault in a setting in which one must live, this fault becomes a trump card when the setting of an evening must have life with the actors. In the theatre, the actors used to pass back and forth before dead drops, which were more or less picturesque and more or less rich. Picasso solved, at the first blow, one part of the problem.

I shall never forget the studio in Rome. A small box held the sketch for *Parade*; its fixtures, its trees, its barracks. On a table, opposite the Villa Medici, Picasso painted the Chinaman, the managers, the American woman, the horse of which Madame de Noailles wrote that one might think one saw a tree laugh, and the blue acrobats compared by Marcel Proust to the Dioscuri.

Parade united the frivolous troupe and Picasso in such a way that we were, shortly afterwards – Apollinaire, Max Jacob, and myself – witnesses of his marriage in the Russian church in the rue Daru, and that he executed the settings and costumes for *Tricorne, Pulcinella,* and *Cuadro Flamenco*. A misunderstanding of dates, a lack of conjunction between Massine, the ballet master, and the scenic artist, and a ballet directed in

Rome which had to be danced in Paris two days later, hindered Picasso from composing his set for *Pulcinella* with logic. He improvised costumes; but what are they worth in comparison to the costumes and the pantomime which he wanted, and for which the sketches exist? Neapolitan girls and yokels enact in it the old puppets, brought up to date, like the music of Pergolesi as transposed by Stravinsky. After about twenty paintings, in which the scene represents a theatre, with its lustre, its boxes, and its stage, Picasso's taste rose above such excess of research and furnished the entire actual scene with the setting of the miniature scene. One leaves the red velvet for towers of cards on a moonlit night in a street in Naples.

Do you remember the mysteries of childhood, the landscapes it discovers hiding in a dark spot, the views in the stereoscope of Vesuvius at night, fireplaces at Christmas, rooms looked into through a keyhole? Then you will understand the soul of this setting, which filled the frame of the stage at the Opéra with no other artifice than grey drops and a house of wise dogs.

On the eve of the dress-rehearsal of *Antigone*, in December 1922, we, actors and author, were seated in the hall of the studio, at Dullin's. A canvas of the same blue as washing balls formed a rocky background. There were openings to the left and right; in the middle, in the air, a hole behind which the role of the chorus was to be declaimed through a megaphone. Around this hole I had hung masks of women, boys and old men which Picasso had painted, or which I had caused to be executed after his models. Under the masks hung a white panel. The question was, how to catch on this surface the sense of a fortunate decoration, which would sacrifice exactitude and inexactitude, both equally costly, to the evocation of a hot day.

Picasso was walking up and down.

He began by rubbing a stick of red chalk on the board, which, because of the evenness of the wood, became marble. Then he took a bottle of ink and traced out several motifs, with masterly effect. All at once he blackened some empty spaces, and three columns appeared. The appearance of these columns was so sudden, so surprising, that we applauded.

Once in the street, I asked Picasso if he had been calculating their approach; if he had been going toward them, or if they had taken him by surprise. He answered that they had taken him by surprise, but that one is always calculating without knowing it; that the Doric column results, like the hexameter, from an operation of thought; and that he perhaps had only now invented this column, in the same way that the Greeks discovered it.

From Jean Cocteau, *Picasso*, Paris, 1923, reprinted in *Le Rappel à l'Ordre*, Paris, 1926, pp. 285–9; section translated from French by William Drake as 'Picasso, a Fantastic Modern Genius', *Arts & Decoration* vol. 22, New York, December 1924, pp. 73–4.

(1917) Enrico Prampolini
 Picasso in Rome

In February 1917 Picasso, Cocteau and Bakst were in Rome with Diag-
hilev for the Russian Ballet. I knew Cocteau, and it was he who in-
troduced me to Picasso and Bakst.

The three of them looked startled as they entered the little upstairs
room at 89, via Tanaro which served me as both a home and a studio. It
was also the editorial office of avant-garde newspapers and journals
(*Avanscoperta, Noi* etc.) and a clandestine meeting-place for revolution-
ary artists: it was here that the *Casa d'Arte Italiana* and Ricciardi's *Teatro
del Colore* were founded. Among those who frequented the place were
many artists and writers, Italian and foreign, who have since become
well-known.

It was a cramped little place, the walls covered with pictures of all sizes,
futuristic paintings and quantities of drawings. On every side were easels
and rickety furniture, pieces of sculpture, strange constructivist objects
and plastic combinations of many materials, while mysterious wire con-
traptions hung from the ceiling. Abstract shapes and violent polychrome
effects added to the general clutter: the walls, floor and ceiling were so
crowded with objects that it seemed as if they might burst at any moment.

'This isn't a studio, it's a conjuror's box,' said Cocteau, entering with
the springy step of a young man. Bakst, by contrast, was corpulent and
sedate, dressed in black, with a highly coloured scarf that half-hid his
kindly highly coloured face. He sat down at once and began looking round
with his clear eyes; he wore an old-fashioned pair of very thin gilt
spectacles.

Picasso at first remained standing by the door, with the searching
expression of a sentry. His thick-set, typically Spanish figure seemed to
be prolonged in space by the magic radiance of his incisive gaze, piercing
yet good-natured. His bright, darting eyes, their glance occasionally
veiled, expressed firmness of character. A lock of his very dark hair was
brushed sideways after the fashion of 1910. He looked about him in
astonished delight, like a child at a play, his expression at once question-
ing and affirming as he scrutinized each object in turn with the joy of one
experiencing a revelation.

His way of speaking – laconic, musical yet decisive – precisely matched
the synthesizing expression of his painting, with its abstract but clearly
defined style, and his silences called to mind the suggestive reticence of
his art.

As he remained motionless in the doorway Picasso seemed to be saying
sternly: 'Only those devoted to work may enter.' He instinctively appreci-
ated the efforts of a very young man who, in 1914, had caused a stir by
breaking with the scholastic teaching of the Rome Academia di Belle Arti
and embarking on the new course opened up by Futurism.

Picasso indeed felt at home in that tiny 'magic box', where everything aroused his delighted curiosity, especially the *polymaterial* constructions; in that strange atmosphere he could feel the stress and torment of heroic years of hard work, of research, discovery and plastic invention. He had just arrived from Paris, where Marinetti, Boccioni and Cocteau had told him of the youthful Italian painter thirsty for experiment and ready to dare everything for the evolution and future of art. It was an exploratory meeting rather than a mere visit or conversation; he asked me about Boccioni, the great friend who was no more, and the *traîtres*.

We all went out *en camarades* to the Caffè Greco where Armando Spadini and Léonide Massine were waiting; Cocteau, who never forgot his friends, made us sign a card to Erik Satie, on which he had drawn a heart in such a way that it was pierced by all our signatures. Satie was unwell and had remained at Arcueil, while Picasso and Cocteau, co-authors with him of the ballet *Parade*, had come to Rome with Massine to prepare for its first performance; for various reasons, however, this stormy event actually took place at the Théâtre du Châtelet in Paris.

THE LESSON OF ROME

Picasso's encounter with Raphael and Michelangelo at the Vatican in the spring of 1917 turned out to be an event of considerable importance in his life and in his kaleidoscopic evolution as a painter.

I remember the childlike delight, mingled with calm, reflective pleasure, with which he contemplated the Sistine frescoes and, still more, Raphael's *Stanze* and the Vatican museums of sculpture.

The enchantment of the subjective world, with the speculative relationships and transcendence of form in cubist technique, was disturbed and dimmed by the unexpected light of the Renaissance works with their irresistible humanistic power.

The unifying, summarizing power of the idea identified with form and colour, as we find it in Raphael and all the Renaissance masters, upset the revolutionary plans of the master from Málaga, who had been caught up by the cubist whirlwind north of the Alps. What happened was not so much a return as a recall to order; the concrete values of a real world, the discovery of plastic truths, decisive forms and images derived from his fascination with the world of antiquity, were sufficient to shake the fragile structure of Cubism that was still in its infancy.

In Easter week of 1917 Picasso, overwhelmed by Raphael's visions, showed me in his room at the Albergo di Russia in the Via del Babuino the first classicist drawings he had made in the serene, imposing, admonitory climate of Rome. From a 'naturalist portrait' of Cocteau,[1] the first of a series of similar drawings, to *Three Women*,[2] in which Raphael's influence was evident, Picasso candidly expressed his passionate adherence to the world of humanistic reality. The formative process of his artistry had been enriched by a new conceptual praxis that he would never discard.

The ardent, insatiable temperament of the Italo-Iberian painter showed itself in the desire to know, assimilate and exhaust everything that left its impression on him.

From Rome he went for a few days to Naples and Pompeii to see – and he knew how to see – the Roman painting and go back to its origins. He returned with syntheses of colour, form and space which proved his firm determination to find a new orientation in his painting: this was the so-called Classical or Antique period from 1917 to 1923, following Synthetic Cubism and preceding what some wrongly call his Surrealist period.

To the Classical period belong the famous large pastel heads of women, of Pompeian inspiration, which he exhibited in Rome in the foyer of the Costanzi theatre, now [1943] in the Massine collection, and the monumental figures often called *Les grosses femmes* and the *Baigneuses*.[3] These enormous works, intensely architectonic in conception, are among the most representative of Picasso's Classical period and are important evidence of the influence exerted by classical Roman art on the work and development of Pablo Picasso.

From 'Incontro con Picasso', *Cinquanta Disegni di Pablo Picasso (1905–1938)* con scritti di Carlo Carrà, Enrico Prampolini, Alberto Savinio, Gino Severini, Ardengo Soffici, Novara, 1943, pp. 11–13; translated from Italian by P. S. Falla.

[1] Z. III. 17
[2] Z. IV. 322
[3] e.g. *Large bather* (Z. IV. 329)

Bathers, 1918. Fogg Art Museum, Cambridge, Mass.

Accounts of visits by artists and writers to Picasso frequently serve as valuable descriptions of his studio and its contents, including a record of the paintings and objects in evidence, and the works that were in progress at the time of the visit. Axel Salto, who founded and published at his own expense the Danish art and literary journal Klingen, *visited Picasso at his studio in Montparnasse. Among the works by other artists he described was Henri Rousseau's 1907 painting* Les représentants des puissances étrangères venant saluer la République en signe de paix, *which Picasso probably acquired from Vollard in 1910 (see* Donation Picasso, *Paris, 1978, for this and other works in Picasso's personal collection).*

Salto pointed out that the controversial Demoiselles d'Avignon, *painted in 1907 (in which he describes four figures instead of five), was still hanging in the studio. (The painting first appeared in an exhibition in July that year at the Salon d'Antin, Paris, organized by André Salmon.) Salto also described Picasso's care with regard to light, materials and planar relationships in the assembly of a synthetic cubist construction, presumably in progress, that was hanging on the easel in the middle of the room on the day of his visit.*

Picasso's response to some of his visitors, such as the young Catalan painter Joan Miró, often reveals his sensitivity to or perception of the work of other artists. His comment that Miró's painting was 'poésie pure' suggests that from the beginning Picasso understood this concept later to be associated with Surrealism.

(1916) Axel Salto
Visiting Picasso in Paris

In the spring of 1916 I visited Pablo Picasso – creator and renewer, proclaimer of the latest artistic gospel – at his home in Paris, in the rue Schoelcher overlooking the Montparnasse cemetery. He had on a grass-green sweater and baggy trousers of brown velvet such as French artists still wear. He is small in stature and built like a bullfighter. His skin is sallow and his wicked black eyes are set close together; the mouth is strong and finely drawn. He reminded me of a racehorse, an Arab with a well-shaped neck. People said that he had secret powers and could kill a man by looking at him; they said other strange things too. There was something massive and supernatural about him. He was amiability itself, showing me all his possessions, including a peepshow where you looked through a glass and saw a starry sky with angels flying about. I saw Henri Rousseau's picture of the European potentates standing together under a canopy with the inscription 'Freedom, Equality and Work', also pictures by Derain and Matisse and watercolours by Cézanne. His own first work, which hung over the bed, was painted at the age of twelve: a picture of a golden-haired girl in a vermilion skirt.[1] The delicate features were finely

observed, and all the charm of youth was in the picture; it was shown with unmistakable pride. Picasso's early paintings of the Blue Period show an indissoluble blend of purity and vivid sensuality. His harlequins and youths are painted with an almost effeminate tenderness, but there is a mystic quality about them which brings to mind his Spanish origin. The later picture *Demoiselles d'Avignon* was hanging in the studio. This is a canvas the size of a wall, somewhat higher than it is broad: it shows three women standing and one seated, seen from behind; below on the left is some fruit. Tones of cobalt, brown, black and white are juxtaposed in a pure scale of colours such as you find, for instance, in primitive Peruvian pottery. The form is simplified, without appearing inorganic or degenerating into arabesques. The *Demoiselles d'Avignon* is related to Javanese stone reliefs and Negro carvings. Modern French art has turned towards these new forms (Maillol, Matisse) and the artists of other countries come to them indirectly, through the French.

On an easel in the middle of the room, among pots of Ripolin enamel paint, there hung a square box without a lid, containing some bits of wood fixed at an angle to the bottom and sides; another piece of wood, like the handle of an awl, was fastened so as to cast a shadow on the inside of the box. This produced an interplay of light and shade, angles and planes, in the little world within; here and there the effect was varied with stuck-on sand or bits of newspaper. This work had been created by Picasso with the utmost *objectivity*, taking precise account of the character of the materials and the balance of the planes in relation to one another. His method of work, in which German aestheticians are so interested, is marked by a determined attempt to establish as concretely as possible the extent of the decorative elements of a picture, their material value and location in space. He strives to reduce the 'picture' to its simplest forms. Such experiments have been taken up by grateful imitators and developed into a philosophy.

Picasso, who is 34, is said to have subsequently entered upon new phases of development, opening the way towards forms of art that cannot be predicted but only awaited with delight. One feels that the possibilities are as manifold as combinations on a chess-board.

From Axel Salto, 'Pablo Picasso', *Klingen* no. 2, Copenhagen, November 1917, unpaginated; translated from Danish by P. S. Falla.

[1] *Girl with bare feet* (z. I. 3)

(1919) Joan Miró
Visiting Picasso in Paris

When I went to Paris in 1919 I went to see Picasso. He said to me, 'Listen, I'd like to see what you are doing.' I said I would be delighted, and he

came to the wretched hotel where I was living in the boulevard Pasteur. He was very interested in what I was doing and said: 'Look here, you know, that's pure poetry.' I always remembered this remark. He was constantly wanting to advance beyond painting into poetry, music and other fields, not to remain stuck with pictorial art.

From an interview (1979) of Joan Miró with Perry Miller Adato for the film *Picasso: a painter's diary*, **1980.**

Apollinaire's death at the age of thirty-eight in November 1918 ended a deep friendship and an artistic exchange that had been a significant part of Picasso's life and work since the period of the saltimbanques of 1905, which Apollinaire discussed in two articles that year (see pp. 52–3). His ardent support for Picasso continued throughout the years of their friendship and the publication of The Cubist Painters *in 1913 still makes the study of Apollinaire an essential component of the cubist years.*

Wounded in the war, Apollinaire returned to Paris something of a hero, and dramatically reasserted his defence of the new art and Picasso in connection with the first performance of Parade *at the Théâtre du Châtelet in 1917. In the programme notes he claimed that a new alliance, among artists and the arts themselves, had led to 'the point of departure for a whole series of manifestations of the New Spirit that is making itself felt today and that will certainly appeal to our best minds.' (*Apollinaire on Art, *p. 452)*

In 1917 Apollinaire also first published his poetic portrait of Picasso in the little French journal SIC *in the May issue, which was dedicated to 'Ballets Russes: Cubistes et Futuristes'. The interest in typography and the conjunction of images relates this portrait to Picasso's own cubist work as well as Apollinaire's format of calligrams.*

The last major published article by Apollinaire concerning Picasso's work appeared as the preface to the catalogue for the Matisse-Picasso exhibition at the Paul Guillaume Gallery in January and February 1918. The discussion of Picasso as a 'lyric painter' is also alluded to in Apollinaire's letters to Picasso, written in September 1918, just one month before the poet's death. In the shorter letter (which is published here for the first time) Apollinaire suggested to Picasso that he make a large painting – something lyrical like Picasso's recent work based on Le Nain. Lyricism here undoubtedly refers to Picasso's return to figurative drawing. In the painting Picasso balanced the linear treatment of the figures with an overlay of divided brushstrokes and colours, reminiscent of a neo-impressionist canvas; this work is related to his painting of La Salchichona *done in similar manner the same year (*z. III. 45, Museo Picasso Barcelona*). In Apollinaire's letter of 4 September (the French original was published in* Cahiers d'Art *vol. 22, 1947, pp. 142–3), his own renewal of poetic tone in classic rhythm suggests that Apollinaire contemplated a comparable experiment in his own work at that time.*

PABLO PICASSO

```
See this painter he takes things with   their shadows too and with a sublimatory glance
Tears himself into harmonies deep and   pleasant to inhale such as the organ I love to hear
Harlequins are playing in the pink      and blues of a fair sky    That memory relives
the dreams     and the active hands     Orient full of glaciers    The winter is harsh
Lustres     gold irised canvas gold     law of fire streaks        melts with a murmur.
Blue       light     flame              silver  of  waves          blues after the great cry
Still            remaining              they play                  that    siren  violin
Fawns            heavy wings            incandesce                 a few strokes more
Bumblebees       streaked women         blaze of                   diamond - plunge
Harlequins    who resemble God          in variety              Distinguished as a lake
Flowers       shining like two          giant                   pearls    that    quiver
Lilies        circled with gold   I was not alone!              make regrets undulate
        New early morning world rising                          from the enormous sea
      The adventure of that old horse                                in        America
   On the night of the marvelous catch                              the mask's eye
   Airs on small violins in the depths of the                       angels lined up
   In the sunset then at the end of the                             year of the gods
   Look at the immense giant head                                   the green hand
   Silver will quickly be replaced by                               all    our   gold
   Dead woman hanging on the hook ... it is                         the blue dance
   The humid voice of the acrobats                                  of the houses
   Grimace amidst the attacks of the wind                           which    subsides
   Listen to the waves and the crash of a                           blue     woman
   At last the atmosphere of the grotto is gilded                   by       virtue
   That veined sapphire                                             makes one laugh!
   King of phosphorus        beneath the trees the ankle-boots between blue feathers
   The dance of the          ten flies     faces him when he thinks of you
   The blue   frame          while     the agile  air  also  opened  up
                             In the     midst of regrets in a vast grotto
                  Take the pink spiders             swimming
                  Regrets of invisible traps
                                                               the air
Peacefully arose but on the keyboard
                                                               melodies
Guitar-tempest
                                                        oh gay tremolo
Oh gay tremolo
                                                        oh gay tremolo
He laughs not
                                                        the artist-painter
Your poor
                                                       pale    sparkling
Nimble shadow
                                                     of a dying summer evening
Immense desire
                                    and dawn so luminous emerges from the waters
I saw our eyes
                             diamonds enclose the reflection of the green sky and
I heard his voice
                             which gilded the forests while you were weeping
The acrobat on horseback the mustachioed poet a dead bird and so many tearless children
Broken things some torn books some layers of dust and some dawns unfolding!
                                                    GUILLAUME APOLLINAIRE
```

Guillaume Apollinaire, 'Pablo Picasso', *SIC* no. 17, Paris, May 1917, unpaginated; reprinted in *Chroniques d'Art*, Paris, 1960; translated from French by Susan Suleiman in Leroy C. Breunig (ed.), *Apollinaire on Art; Essays and Reviews 1902–1918*, New York and London, 1972, p. 451.

1918 Guillaume Apollinaire
Preface to Matisse-Picasso exhibition, Paris

Picasso is the heir to all great artists and, having suddenly awakened to life, he sets out in a direction that none has taken before him.

He changes course, retraces his steps, sets out again more boldly, growing in stature every moment, drawing strength from his contact with the mysteries of nature or from comparison with his peers of the past.

All art contains a lyrical element, and Picasso is often a lyrical painter. He provides for meditation a thousand themes, animated by life and thought and glowing with a clear internal light, yet with an abyss of mysterious darkness at the heart.

In his work, talent is multiplied by will-power and patience, and every experience helps to liberate art from its fetters.

Is not this the greatest aesthetic effort known to us? He has vastly extended the realm of art in the most unexpected ways, where surprises bob up like a toy rabbit beating a drum in the middle of the highway.

And the proportions of this art of his become more and more majestic without any of its grace being lost.

Think of a fine pearl – and, Cleopatra, do not dissolve it in vinegar!

From Guillaume Apollinaire's Preface to *Catalogue de l'Exposition Matisse-Picasso*, Galerie Paul Guillaume, Paris, 23 January–15 February 1918; reprinted in *Chroniques d'Art*, Paris, 1960, pp. 430–1; translated from French by P. S. Falla.

1918 Guillaume Apollinaire
Letter (late summer) to Picasso

My dear Pablo,

I shall be returning to Paris in two days. I have taken some good trips. I am glad you are working. I am too, so that I can send you the poems before long, but it is very hot and I shan't do anything for these last two days of the holiday. We are in a farming village by the sea, and just now they are threshing, which is a fine sight. Serge has come, *L'Action Française* has done a good article on *Calligrammes*, so has *L'Europe Nouvelle*.

I am writing on this because I have run out of paper. Jacqueline will be writing to Olga.

La Publicidad (Madrid) published an interview with me. I read in *L'Instant*, the Franco-Catalan review, an interview with Sert which isn't bad:[1] he is in favour of the Jesuit, i.e. Baroque, style as a traditional one for Catalan artists. It's an idea. They are launching Carolus Duran in Paris. I would like you to paint big pictures like Poussin, something lyrical like your copy of Le Nain.[2]

Finally I expect a lot of good from your stay at Biarritz.

Your friend,

Guillaume Apollinaire

Thanks for your tobacco flower and our drink under the trellis.

Letter (late summer 1918) from Apollinaire to Picasso on Ministry notepaper; translated from French by P. S. Falla. Property of Picasso Estate.

[1] Litus [J. Perez-Jorba?], 'Un grand artiste catalan: J. M. Sert', *L'Instant* vol. I no. 2, Barcelona-Paris, August 1918, pp. 3–5.
[2] *The Peasants' Repast, after Le Nain* (z. III. 96)

1918 Guillaume Apollinaire
Letter (4 September) to Picasso

My dear Pablo,

I am very glad to hear you are working, so am I. I am now properly at *Excelsior* and I no longer go to *l'information* in the morning – that is really a relief. I shall have the ministry, but anyway it's a step forward. I shall send you *Perceval le Gallois* which I have published, a very fine old story. I am writing poems and will soon send you the first ones to engrave, but don't keep me waiting too long, you know that waiting is poison to me, that's the word. I hope your wife is well. Serge has become quite Tournairophile. The Tournaire family reconciled me with M. Seve – I am not

The Peasants' Repast, after Le Nain, 1917. Musée Picasso, Paris.

sorry, as I really like him very much. They are very nice too. So much for my news. I am very glad to hear you have decorated the Bitternois villa like that,[1] and am proud that my poems are there. The ones I am writing now will be more in keeping with your present concerns. I am trying to renew the poetic tone, but in a classical rhythm. I do not want to copy what Moréas has done. I am all the more entitled to do it as I have never abandoned rhythm, it is at the basis of all my poems and gives them a solid structure. On the other hand, I don't want to be retrograde and fall into pastiche. I could easily do so, I would only have to start reading the poets of a certain period, and I am not ignorant of the right periods. But I prefer to draw on my own resources and to put in so much thought that its value can't be denied, so that the people who are hardest to please, and who sometimes, indeed often, know best – though in general they don't know the things I have invented or maintained – will not be tempted to run down my work in comparison with the classics.

What work today is newer, more modern, more economical and full of richness than Pascal? I think you like him, and so you should.[2] He is a man we can love. He is more appealing than a Claudel, who only mixes some quite good romantic lyricism with theological commonplaces and politico-social truisms.

I don't see many people nowadays, as I have to work. We send our regards to you both, and please give mine to Mme Errazuriz. Your friend,

Guillaume Apollinaire

Letter (4 September 1918) from G. Apollinaire to Picasso; translated from French by P. S. Falla. Property of Picasso Estate.

[1] Apollinaire is referring to the interior wall decorations made for Mme Eugenia Errazuriz at her villa at La Mimoseraie in Biarritz, where Picasso and Olga spent their honeymoon that summer.

[2] Picasso did share Apollinaire's admiration for Pascal (see his letter to Jacinto Reventós, p. 51).

The editor of Le Nouveau Spectateur – *and likely author of this review – was the critic and poet Roger Allard, whose article, 'Au Salon d'Automne de Paris' for the November 1910 issue of* L'Art Libre *(Lyons) was his earliest defence of Cubism (reprinted in Fry, p. 62). The following review was probably based upon the Matisse–Picasso exhibition of 1918.*

1919 (Roger Allard)
Picasso's latest paintings

Picasso's career is a masterpiece – one of the few masterpieces of our time. So much patience combined with decisiveness, such elaborate care masquerading as nonchalant fantasy; calculated boldness, prudence and

volatility, freedom mixed with artifice and sobriety with excess – all this makes up a singularly attractive personality.

Picasso has managed to remain both mysterious and familiar, so that even in the most mechanical of his works there is a reflection of inner life. He owes a great deal to Montmartre. A Spaniard, whose blood is fired by oriental memories, he has yielded to the attraction of the Paris landscape, has felt profoundly the quality of the greys that hover between pink and blue, the tender greens, and the ashen light in which they are harmonized and which seems made to clothe, not the immobility of decorative forms, but rather the touching gestures and naïve attitudes of people and things. He was not tempted by the mirage of gaudy barbarity, because he already carried it in himself. He did not give in to oriental frenzy, but would rather have exclaimed with Jean Moréas: 'How much more I love you chestnut-trees of Paris, lit by a gas-lamp under a rainy sky!'

In M. Picasso's painting we may find traces of a dark nostalgia for sombre Spanish passions of intolerance, ferocity and mysticism. The intertwined bodies of lovers in his pictures of the Blue Period have the sickly, tortured air of El Greco figures. However, the melancholy airs learnt in Watteau's school do not prevent some recent harlequins from recalling the pallor of the *Garrotting* by Goya.

It may well be thought that the air of Paris has saved M. Picasso from the common fate of Spanish painters of his generation, who subsist as best they can on the appearance and outward form of a tradition no longer sustained by custom or belief. Our changing sky prompts him to change his own manner and style as often as necessary, while the clothing has never disguised the material quality of his temperament, which is of the highest order.

.

His latest paintings show his dark nostalgia, expressed in delicate nuances and lines which seem to say: 'This is what we might have done had the times and circumstances been different.' It is not by chance that so many of his compositions feature travelling circuses or street-singers with guitars. We seem to hear the agonized voice of the conquering cornet celebrated by Verlaine; we see the melancholy grin of these mountebanks, born to grace an illustrious stage, and all the sarcastic bitterness of the 'chastised clowns'.

A large *Harlequin*[1] seems to me the major work in this exhibition. The head is treated like an umbrella handle with a reminiscence of Negro masks, and it also makes us think of hat-stands in a dress-shop. Yet the canvas as a whole has a human expression, the suggestion of a face like those of the saltimbanques that the artist painted not long ago, whose cheeks, in the words of Apollinaire's poem, have 'the pink complexion of girls who are close to death'. Elsewhere a charming oval picture, with grey tints highlighted with touches of brown, with a pink tuft in the upper part and a bright red patch with sharp ridges below, achieves admirably the kind of effect dear to Whistler or Mallarmé, except that there is not the

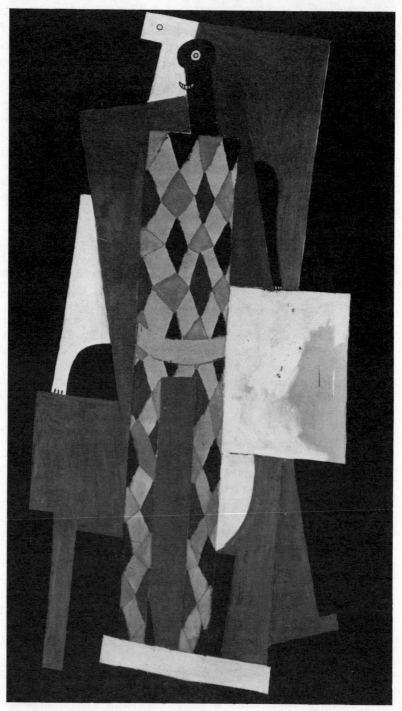

Harlequin, 1915; oil on canvas, 183.5 × 105.1cm. The Museum of Modern Art, New York.

slightest allusion to nature but only a very discreet invitation to pictorial reminiscences. We are insidiously led to discover unexpected yet inevitable analogies between the pleasure of the eyes and the memory of celebrated representations of nature. Such works thus appear remote from the spirit of our modern interiors in which everything accosts the spectator. They are blurred and enveloped by the reflection of all that surrounds them; they take on the harmonious tone of engravings so familiar that the subject-matter is merged in visual habit. It is a type of painting that goes ideally with any kind of furniture, except perhaps something too new or ostentatiously modern.

Despite the abstract forms, we can recognize pictures that belong to different classifications: genre scenes, boudoir or *trumeau* pictures, studio sketches, signboards, pictures of the auction-room-furnished-apartment type, exhibition or salon subjects, large collectors' pieces, small, highly typical signed works for connoisseurs, drawings in the style of 'Drawing taught by the Great Masters', album pages, and even witty imitations like the watercolour of a fruit dish which is more like Cézanne than that master's own work. Picasso nearly always avoids the unpleasing effect of a patchwork of marquetry and linoleum which makes certain cubist paintings impossible to look at for long. A figure of a woman in a range of white and grey tints is remarkable for its treatment of hair: let us hope that this motif of parallel undulations will not be systematically inflicted on us elsewhere. Among the many still lifes, real or supposed, there is a sentimental, wilting bouquet in a grey vase in front of a wallpaper with a garnet-red floral design, and another of a stuffed bird with an insect in its beak: these seem to me to have a pleasant, old-fashioned charm such as one finds in certain provincial chimneypiece ornaments. A lament, as of things out of their element, arises from the musical instruments whose grave volutes M. Picasso is fond of: 'In the empty musical void, a mandola sorrowfully sleeps.'

A brave plan has been formed to banish sadness from art and poetry. We are promised that there will be optimistic painting, but so far we only see it among children and savages. Happily, M. Picasso's paintings are different from these. His art respects in its metamorphoses the essential contours of life. It meditates, it remembers; it is a learned art and, whatever one may say, a melancholy art.

From 'Picasso' (attributed to Roger Allard), *Le Nouveau Spectateur* **no. 4, Paris, 25 June 1919, pp. 61–2, 68–70; translated from French by P. S. Falla.**

[1] z. II. 555

5.
The twenties

1920–1930

Following the end of the war, Picasso's life changed and so did his artistic pursuits. His marriage to Olga Koklova in 1918 and the birth of his first son Paulo in 1921 changed the nature of his home life. His work on Parade *had also introduced him to the world of theatre and ballet and led to collaborations on several other productions.* Mercure, *in 1924, was of particular interest to the Surrealists, including André Breton, whose first manifesto of Surrealism was issued that year. Although Picasso never officially joined the surrealist movement, his work was acclaimed by them and included in their Paris exhibition of 1925, and was often reproduced in their journals.*

Picasso exhibited widely in the twenties in Paris, Rome, Munich, Berlin, Prague, Chicago and New York. By this time he was the acknowledged master of Cubism and was considered as Cézanne's worthy successor. In some respects, however, Cubism in the twenties had entered into a phase that could be characterized as 'academic' or even 'classic', particularly the work of Braque and Metzinger, and to some degree Juan Gris. Moreover, Cubism began to serve as the foundation for new theoretical approaches to art, such as Ozenfant's 'purism', and later for some of the Bauhaus principles of design. Picasso, however, in a move that now seems consistent in his overall develop-ment, turned from Cubism to a style – a new kind of classicism – that seemed opposed to it, and for this reason, it caused a great deal of controversy among his critics. Radical artists and writers, such as the Russian poet Mayakovsky, feared Picasso might abandon the revolutionary direction his art had taken; others, such as the German Oskar Schürer or the Catalan Llorens Artigas, saw his classicism as evidence of a characteristic aspect of Picasso's art that could be traced throughout the different phases of his work.

In Schürer's essay that appeared in Die Kunst für Alle *in 1926, he claimed that as early as 1905 Picasso had attempted to 'clarify' his work, and in that sense this tendency constituted a classicizing principle in his work as a whole. In his Rose Period works, for example, contour had been the main expressive aspect of form, while the picture plane remained 'tranquil'. Cubism had expressed the struggle for the inner equilibrium of the two in Picasso's painting – that is, the struggle to balance line and space. After 1917, Schürer observed that line itself had become enriched with spatial values and charged with feeling; and, in turn, the plane was no longer tranquil, for it had*

attained its own inner rhythm and plasticity. Schürer concluded that by 1926 the new decorative tendency apparent in Picasso's work could also be considered as yet another step in his process of clarification.

Another aspect of criticism in the twenties that emerges from the general study of critical response to Picasso during that period, particularly among French authors, is reference to late nineteenth-century symbolism, which can also be tied to the developing surrealist movement – in certain ways an extension of the earlier movement, particularly in literature. Early in Picasso's career (and even to the present time) there was a tendency to interpret some of his work in terms of symbolist subject matter – death, illness, and inner feelings, for example. However, by the twenties, in an attempt to deal with cubist abstraction, the more abstract theory of correspondences among the arts and the importance of language, that were essential components of symbolist theory, began to be discussed anew in critical writing. André Salmon, for example, specifically begins his 1920 essay on Picasso with a reference to the symbolist poet Mallarmé; and Ozenfant, in the following year, discussed Picasso's abstract language of forms in terms of 'mots plastiques'.

Response to Picasso in eastern European countries, however, because of distance and separate historical traditions, seems somewhat more detached. Picasso's work had been exhibited in Prague, for example, as early as 1912 at the Mánes Association, and his works were being collected by individuals such as the art historian Vicenc Kramář. Prague itself was a culturally active centre and receptive to the new art, and the influence of Cubism on Czech artists was soon felt. Czech criticism in the twenties tended to discuss Picasso's work in a manner that in some ways resembles the Russian formalist approach and their receptiveness to new modes of expression. Václav Nebeský, for example, discussed Picasso's treatment of space in conceptual terms, based upon observations of the works themselves, and seems, like the Russians, to have been partial to the revolutionary significance of Cubism and of Picasso's role in its formulation.

1920 André Salmon
Picasso

Was Stéphane Mallarmé a symbolist? M. Lanson himself does not think so.

The writer of *Hérodiade* was led by his genius to discoveries that were to be the death of symbolism.

Thanks to the etherial Mallarmé, the symbolists, who were often successful poets, were poets with a system.

In our time the Academy, the eternal protectress of systems, set a seal upon the system of symbolism by electing M. Henri de Régnier, ten years after Mallarmé's death.

If, in its turn, the Académie des Beaux-Arts calls to its bosom one of the painters we have in mind, it may well be M. Georges Braque or M. Jean Metzinger. Certainly it can never be Picasso – the glory of being Spanish has nothing to do with this exclusion.

Picasso's whole system lies in his genius, although, as early as 1912, Maurice Raynal, with good logic, denied the existence of genius itself.

Picasso is a purveyor of Cubism but not its leader.

In relation to Picasso, and with the secret complicity of the poets of his circle, a charming phraseology of classification came into use.

There was the Period of the Saltimbanques, the Blue Period and the Rose Period, before Cubism.

There were even, for the subtle, sub-periods within these radiant Periods.

Thus, within the Blue Period, some distinguish the Period of the Crow and the Period of the Great Beggars.

What an enormous responsibility Picasso would have if each of these periods and sub-periods had a School attached to it, like Cubism!

But Picasso would smile, and that would relieve him of all responsibility.

Yet, although Picasso's art is not free from cruelty, he is not so cruel as to disavow or condemn Cubism, a movement which he dominates, which he made possible, but on which he is not dependent.

He is followed by a well-ordered group, who are free from any obligation of gratitude.

Indifferent as he is to the destiny of the School, Picasso, the inspirer of Cubism, egotistically defends it. One cannot fight for Picasso without supporting Cubism and the Cubists. But one may prefer Picasso and his art.

The Cubist School is a sharply defined one or 'Why Picasso the inspirer could not be the head of a school so dependent on his genius.'

One of our systematizers said recently to a capricious artist, a woman friend of Bonnard, Vuillard and the most sensitive *fauves* of Matisse's family: 'No doubt, Madame, this is the authentic abundance of grace; but

will there not be a day when the *caprice* that governs it all grows weary? And would you not then be very glad of our certainty?'

Picasso does not tie himself down. He is full of movement, more so than the *fauves*, who in their first triumph were threatened with formlessness, and whom his own art has condemned and done to death since 1906.

It would be purposeless, and unworthy of both sides, to draw up too precise a catalogue of all that has been bestowed on Art with such prodigality by this great egoist, this anti-social animator, who has not needed to be generous in order to enrich the community.

He has aroused powerful feelings of hatred, which make the sky more beautiful at the point where azure meets the desert of shadow, and where Praise shines with a lone white light.

When the Cubist era began Picasso was in an admirable position, his free genius flourishing as never before.

Whom did Guillaume Apollinaire have in mind when he wrote the opening words of one of the profoundest tales in his *Hérésiarque et Cie*: 'Situated at the extremity of life, on the confines of art, Justin Prérogue was a painter.'? And its conclusion, if that is not too radical a word: 'This St Veronica, with her fourfold gaze, commanded them to flee to the extreme limit of art, to the confines of life.'

This story by Apollinaire is the sacred history of Youth, martyred and wondrous: a history justifying the communal holding of property; one that will dazzle men of the future when Picasso's Harlequin comes to reopen the closed books.

Picasso had sought counsel of masters worthy to reign over minds that were, happily, ill-fitted to confuse repose with calm or thirst for knowledge with anxiety; minds that cannot be interpreted by jargon. He had questioned the sovereigns of souls imbued with fervour, from El Greco to Toulouse-Lautrec. Instructed by them, with the shining light of these 'beacons' warming his blood – with what coolness and passion, what prudence and playfulness! – he calculated, measured, cut and polished a mirror in which he could recognize himself. Having cultivated enough rigour to dismiss the matter from his thoughts, he abandoned himself to a vibrant fantasy that was both Shakespearean and Neo-Platonic, with all the gracefulness of an adolescence which could look forward to the reward of perpetual life.

Thus crowned, Picasso could go on living and working happily and with justified self-approbation. There was no reason to expect that any other effort would bring him more praise or the development of a more immediate fortune.

Nonetheless Picasso was in a state of torment as well as wretched anxiety.

He turned his canvases to the wall, abandoning that great work *Les Demoiselles d'Avignon* – a document to confound impostors and their train of over-credulous sceptics: a huge painting that was to be resumed and altered, that had not left the studio and perhaps never could, and that

was the very centre of his work, the ever-glowing crater from which the fire of contemporary art erupted.

He turned his canvases to the wall and threw away his brushes.

For long days and nights he continued drawing, turning abstractions into concrete form and reducing that form to essentials while at the same time enriching it. Never was labour less repaid with obvious joy, and it was without his earlier youthful enthusiasm that Picasso set about applying to the great nudes of the *Demoiselles d'Avignon*, begun in the spirit of the Rose Period, the first results of a research strictly dictated by the calm examination of all that had preceded it. There is never any break of continuity in Picasso's work, although a single moment in it was the signal for the Cubist revolution, which was a revolution indeed.

Picasso subjected his genius to the cold light of Reason.

When he gave it wings again, he stood immortal at the centre of a transfigured universe.

The Blue Period.

Cripples and vagabonds who made their homes in church porches, milkless mothers, the century-old Crow.

All the grief and all the prayer.

The saltimbanques.

The stout red man in the cap and bells, in the image of the man who has constructed the lyre for poets of the New Spirit;[1] the slim adolescent acrobats, the Harlequin-magician (Harlequin Trismegistus, O Guillaume!), the sad little bells on the comic hat and the funeral drum of tribes and the circus, which will roll for the death of the best one of whom St Veronica, on an ordinary towel, preserves the candid wisdom in her quadruple glance; the Girl with a Shawl and the White Horse of the eternal *manège*, celebrated twice more by Max Jacob, the first to thrill with hope at the 'discovery' of Picasso, as rich collectors call it.

The Rose Period.

All the mirrors, all the springs, all the panes of glass, all the nudes 'at the border of life, on the confines of art'.

Auto-da-fé.

Resurrection.

Those who resist the fiery friendship that attracts us to this painter spare themselves the baseness of disdain by confessing, at least, that he is our draughtsman.

After twenty years of work, of new departures or reworkings, twenty years of silence – when three works on Cubism had already appeared, one of them by two painters – Picasso made a selection of his finest drawings for a Paris gallery. The memory of this is preserved not only in the mind of that partisan of commonplace justice, M. Jacques-Emile Blanche, for whom the war itself was a revelation of the New Spirit, but to whom M. Jean Cocteau has not yet had leisure to introduce the tremendous shade of Guillaume Apollinaire.

This exhibition of Picasso's drawings aroused the trivial anger of critics who, the day before, had been publicists for the new busybodies of the press and for many who were inclined to speculate on a certain 'simplicity' – a somewhat novel vice. It is fair to say, too, that it enabled aestheticians and moralists with a love of order, from M. Jean-Louis Vaudoyer *(Echo de Paris)* to M. Henry Bidou *(Revue critique des Idées et des Livres)*, to represent Cubism as a classic quest at the time of the last Salon des Indépendants in 1920.

For my part, the exhibition prompts me to endeavour to describe the curve of Picasso's genius in a few words as follows.

Wide and white, the sleeves of Pierrot are not those of a conjuror.

They contain only two bare arms.

The queen of this opera of canvas, of which the arena is a projection of the world, throws herself back on her square chair and, her head tilted like a sphere, laughs at the mirror suspended between her uplifted arms. The mirror that absorbs and returns her image is at once heaven, light, air, water, fire and earth with its humanity, whose laughter and tears are sometimes as perfectly inimitable as the words LE JOURNAL, stereotyped in the furnace and reproduced in a million and a half copies that are never alike.

It is a scene from a village comedy, or the interval in a graceful ballet.

Nestling among the fat folds of the palm, the pipe-bowl warms the hand like a little bird. With the first quill that comes to hand, draw more precisely than with a drawing-pen a perfectly straight line along the stem whose heat teaches you restraint. Here is the guitar sonorous with all the recreated music, because what you call Harmony is as inimitable as the newspaper masthead.

Picasso is all alone between earth and heaven, followed by those to whom he showed the way and preceded by the man he used to be.

The life of this great artist will not be long enough for him to travel the whole distance illumined by his work.

Art present and Art to come derive from his beneficent tyranny.

Picasso has invented it all.

From such an imperious guide there is no refuge but in the past, in the grottoes of the past with their crystalline atmosphere. The slightest pause throws us back, and Picasso remains alone after bestowing new truths upon us; alone, preceded by that adolescent of former days, crowned with grace.

All the drawings collected are by that marvellous youth. But while, in the first days of that creation, the youth accumulated images and rejoiced to imitate God without even seeking the reality of the world, we now see him, freer but no less joyful, obedient to the second Picasso who has taken the measure of everything and who, it has sometimes seemed, could bring about a universal collapse by a concerted jest, face to face with numbers, those stars of the interior firmament.

Marcel Schwob succeeded in telling an ingenious tale. He understood nothing of the religion of Paolo Uccello, and spoiled with automatic humour whatever might have related to the work of faith. The exhibition of drawings cannot enable anyone to counterfeit the author of *Les vies imaginaires*.

Picasso promises no rest to our contradictory impatience. A master of forms, the man of a single truth situates them on justified planes as he pleases, just as did the youth of former times. But that youth now obeys the wisdom of one who, rich in the gifts of this world, has defined the oldest and newest, devoid of reflections and appearances, where imagination, no longer traditional, lay in gulfs of solitude and oceans of cold light.

The miracle is now fully accomplished. Picasso's drawings will be more to us than a justification, of which so great an artist has no need.

Here, opened for the first time, are the portfolios of the silent one – a mute St John of the Golden Mouth – by whom the Word of art was renewed according to its very essence.

Over Picasso's infinite work, and to enrich the most living work of our age, his pencil-strokes spread, broaden and dissolve into powerful waves like daylight, illuminating for our minds what his art reveals of a nature still full of concrete mysteries.

I have not had to choose, to prefer a haunting image. Picasso truly appears, his heart and mind full of dramatic wisdom, preceded on the road of eternal Discovery by his adolescent self, no less marvellous than Rimbaud – but 'despoiled' by a greater number of equal sacrifices no less perfectly agreed to – the adolescent who painted the saltimbanques before ordering the austere retreat, the great prayer amid sails heavy as storms, from the Blue Period and who pinned the scarves of the Rose Period to the rigorously calculated columns of the only sky without guile.

Picasso is the simplest man in the world. The gracious name of modesty takes on its full value when applied to this artist, who has every right to be proud and who is most endangered by untimely praise.

Because of his modesty Picasso, questioned so many times and challenged to justify himself, has answered with jests such as our youth, in its proudest days, put to a purpose 'useful to the promotion of the arts', but which are ill fitted to convey our thoughts to the multitude who only believe in newspaper columns.

The crowd has a feminine dislike of all that is not public. For the most part it only tolerates secrets that it is allowed to share.

Once again, why is it not understood that Picasso was indicating discreetly and modestly that he was the wrong person to question and that the proper guide to the labyrinth was to be found among the acknowledged Cubists? – either M. Georges Braque, the most robust and learned, or M. Jean Metzinger, the most happily eloquent, or M. Albert Gleizes, the most careful to be understood.

Picasso has just repeated his offence. When asked about Negro art he replied briefly 'Never heard of it,' – a retort likely to last as long as the good Paul Alexis's 'Naturalism not dead, letter follows,' and a much more eloquent one too.

I have said that there has never been any break of continuity in Picasso's art. Such a break would have been flagrant if the chance revelation of Negro art had caused him to stand the *Demoiselles d'Avignon* in a corner; but he did not subject it to that indignity.

The disturbance caused by Negro art was only part of a wider complex, preceding by a considerable time the abandonment of the Rose Period at a juncture when it was fading away spiritually, the right time if a 'period' becomes static instead of continuous.

If the right and the beautiful are one, if Ethics and Aesthetics merge into each other, I leave it to others to write about them. My lack of concern for the subject deprives me of a sense of hierarchic values. I would no longer write today that Picasso is the greatest painter of his time. I have no idea whether he is the greatest, or what one must do to deserve that title. I do not know whether 'the future belongs to him'. Others whom I could name, and whose origins are much the same as his, are beginning to have, or to regain, some of the influence over young people, newcomers and secondary minds that used to be all Picasso's, and their share in it increases daily. This does not signify a defeat, impossible in his case, since it is precisely he who safeguards the victory of his rivals and even of his equals. Let me explain. It is by Picasso – after Cézanne, of course, on whom both rivals and equals depend, and without whom present-day art would not exist – that everything has been fundamentally called in question. Matisse was an egoist, too human in his fury, and he sought the profits to be derived from teaching; Picasso, who embodied egoism to the point of cruelty, for that reason forebore to teach and instead set great Neronian examples. In his way he, the 'heartless one' (as Rimbaud used to call himself), allowed me in the past to compare him with Goethe, which so amused my friend Vauxcelles. As for André Derain, the other great solitary – to judge the position of that vanquished prince of darkness, the growth of whose prestige Picasso contemplates from a different height – ought we not to proceed by first examining the social fact? Let us not forget that it was the generation of 1900, all of them believers in art, who took offence at the naïve commotion of Dada and dared to 'murder artistic life'.

There was a lack, here and there, of views concerning André Derain, whom we behold today amid ruined walls. Could he be the Regulator? Picasso's revolution has presented Derain with subjects whom he did not aspire to govern, but whom he may reduce to order and harmony. The solitary one will hardly appreciate them, however; while Picasso, who never hankered after a world of disciples, already enjoys the return of a solitude that is his true kingdom, since he would not even prescribe laws for it. But memory will mar the perfection of this solitude. More than any

master at any time, Picasso has robbed a greater number of men of their acquired certainties, their sources of quiet reassurance; he has taken everything from them and left them gasping. The best of them have refashioned a certainty and laid the foundations of a school ruled by a different master on the basis of a single moment of Picasso, briefer than any of the previous 'periods'.

Of the three adventurers, it is the peripatetic Matisse who appears most glorious in the tradition of painting at its most painterly, the studio tradition – glorious, but deserted to the point of injustice. So we have Picasso and Derain face to face, with no certainty as to who will finally win over the lost and homeless to himself. Will it be Derain or Picasso again? And are they face to face as rivals, or as equals?

It would have seemed to me too summary and unfair to both sides to have simply noted the undoubted fact that, of all twentieth-century masters, it is Picasso who has caused the most soul-searching and whose name has been on most men's lips. One cannot even say – as the masters have not raised up a single disciple who might cause them to fear and rejoice beyond the limits of human vanity – that Picasso is a Lucifer and Derain an archangel. Picasso has refused many things and Derain promises nothing – he who exalts the moral 'drama' and who has just said of Raphael that we can only come to him after 'many disappointments' (*Le Matin*, 6 April 1920).

Is not all modern art – all the plastic work and poetry inspired by the 'new spirit' – a beautiful fruit of disappointment, still bitter though already ripe? Max Jacob, who has such good right to have his name coupled with Picasso's, is too much of a poet and too sophisticated to reduce anything to a trite formula, but did he not confess, secretly if I may so put it, that he had now and again practised the direct art of deception?

It would be unjust and dangerous to deny that, among painters, Picasso was the first master of the most terrible game, the most serious and fruitful and the one demanding most love. And therefore this permanent deception and the passionate care taken over it are, to his selfish profit, the pledge of an eternal promise.

André Salmon, 'Picasso', *L'Esprit Nouveau* no. 1, Paris, May 1920, pp. 61–80; translated from French by P. S. Falla.

[1] Salmon is referring to Picasso's depiction of Apollinaire as a saltimbanque in works from the Rose Period, such as the 1905 *Family of Saltimbanques* (z. 1. 285); for further discussion see E. A. Carmean, Jr., *Picasso: The Saltimbanques*, Washington, D.C., 1980; and for Apollinaire's related poetry concerning the 'arlequin trismégiste' (a line from his poem *Créspuscule* of 1909) see Marilyn McCully, 'Magic and Illusion in the Saltimbanques of Picasso and Apollinaire', *Art History* vol. 3 no. 4, London, December 1980, pp. 425–34.

Picasso is the paramount influence in modern painting – subject, of course, to the supreme influence of Cézanne. All the world over are students and young painters to whom his mere name is thrilling, to whom Picasso is the liberator. His influence is ubiquitous: even in England it is immense. Not only those who, for all their denials – denials that spring rather from ignorance than bad faith – owe almost all they have to the inventor of Cubism, but artists who float so far out of the main stream as the Spencers and the Nashes, Mr. Lamb and Mr. John, would all have painted differently had Picasso never existed.

Picasso is a born *chef d'école*. His is one of the most inventive minds in Europe. Invention is as clearly his supreme gift as sensibility is that of Matisse. His career has been a series of discoveries, each of which he has rapidly developed. A highly original and extremely happy conception enters his head, suggested, probably, by some odd thing he has seen. Forthwith he sets himself to analyse it and disentangle those principles that account for its peculiar happiness. He proceeds by experiment, applying his hypothesis in the most unlikely places. The significant elements of negro sculpture are found to repeat their success in the drawing of a lemon. Before long he has established what looks like an infallible method for producing an effect of which, a few months earlier, no one had so much as dreamed. . . .

And besides being extraordinarily inventive Picasso is what they call "an intellectual artist". Those who suppose that an intellectual artist is one who spends his time on his head mistake. Milton and Mantegna were intellectual artists: it may be doubted whether Caravaggio and Rostand were artists at all. An intellectual artist is one who feels first – a peculiar state of emotion being the point of departure for all works of art – and goes on to think.

Obviously, Picasso has a passionate sense of the significance of form; also, he can stand away from his passion and consider it; apparently in this detached mood it is that he works. In art the motive power is heat always; some drive their energies by means of boiling emotion, others by the incandescence of intellectual passion. These go forward by intense concentration on the problem; those swing with breathless precision from feeling to feeling. Sophocles, Masaccio and Bach are intellectuals in this sense, while Shakespeare, Correggio and Mozart trust their sensibility almost as a bird trusts its instinct.

From Clive Bell, 'Matisse and Picasso', *The Athenaeum* no. 4698, London, 14 May 1920, pp. 643–4; reprinted in *Since Cézanne*, London, 1922, and also in Chicago, The Art Institute Arts Club Exhibitions, *Catalogue of an Exhibition of Original Drawings by Pablo Picasso*, 20 March–22 April 1923.

Picasso's language

I have said that Picasso's art was always an art of expression. By this I meant that his successful works are deeply moving because the forms and colours are chosen not simply for the optical interest they present when combined together, but in the way one chooses words to express one's exact meaning: Picasso has the gift of being clear, precise, limpid and exact. When he paints a picture, he knows what he wants to say and what kind of picture will in fact say it: his forms and colours are judiciously chosen to achieve the desired end, and he uses them like the words of a vocabulary. The term 'vocabulary' must be properly understood: by suggesting that there are 'plastic words', I do not mean that they are descriptive. A bottle, a pipe, a guitar are not objects to be described, but physical organisms that trigger off certain well-defined emotions. The existence of this plastic vocabulary, and of the forms which are its words, can be perceived by experience; unfortunately there is no dictionary of them, and each painter must create his own language. Picasso is one of the few who has created a pure language of his own. In a picture of his it is rare to find associations of forms of a different nature to one another, or colours belonging to different scales.

Picasso handles the language of his creation with such assurance that today, having returned to the dangerous subject of the human figure, he has discovered a new terminology with which to express organic shapes and the emotions they arouse, with the result that he can depict a head, an eye, a torso or a body in such a way that these figures present themselves as quasi-entire creations. When Picasso confined himself to Cubism, that is to say to paintings in which forms and colours were associated with no constraint other than the painter's will, it could have been feared that he would be cramped by the fatal exigence of the human body, which does not tolerate dissociation but requires the continuity of organized forms. But we can now see that Picasso's plastic skill is so great that he was able to invent a system of forms based on organic elements with the same facility as he showed in still lifes. So fully is he in command of his means and ends that he can transcend the physical emotion aroused by a happy combination of forms and colours, and achieve expression even by means of representative forms.

For it must be recognized that the object of painting is to transmit what the artist feels, thinks and conceives, and that great art makes use of the physical and physiological means provided by forms and colours so as to put the spectator into whatever state its creator desires; the quality of that state determines the quality of the work of art.

Because Picasso nowadays paints both cubist and representational works, it has been falsely claimed that he is giving up Cubism: this has caused

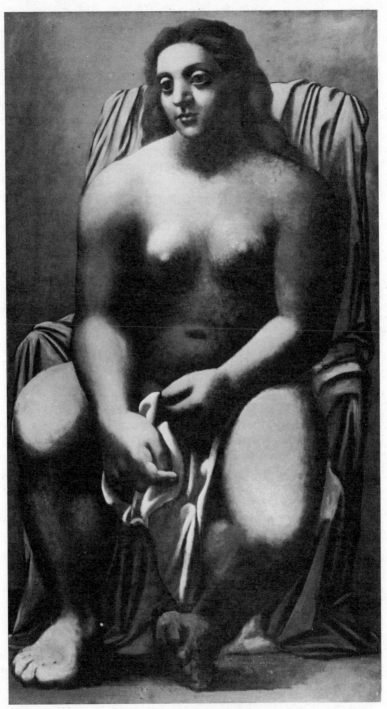

Large bather, 1921–2. Musée de l'Orangerie, Paris; Walter Guillaume Collection.

commotion in the studios and joy among diehards. Can such people not understand that Cubism and figurative painting are two different languages, and that a painter is free to choose either of them as he may judge it better suited to what he has to say?

The economy of means of expression is a sign of perfection in art as in everything else. Some things, for instance, are better expressed in algebraic than in geometrical terms, as the latter conform more neatly to this or that mode of thought. In the same way, and avoiding useless acrobatics, Picasso has created a language specially adapted to the emotions which can be transposed into delineations of the human body. Do we deny the value of algebra when we practise geometry? What matters is the thing to be expressed. The value of Cubism or of Picasso resides not so much in the means of expression as in the quality of what is expressed. To submit to the constraint of the human form is simply to introduce an intermediate stage. The language of Cubism, which organizes disorganized forms, has the advantage that it can act directly on our minds through our senses, without involving the sensations associated with the representation of human figures; and this perhaps makes it a better medium for speculative emotions. Nevertheless it is possible to introduce sufficient abstraction into figurative representations, and Picasso has proved this in his most recent figurative works.

From Vauvrecy (Amedée Ozenfant), 'Picasso et la Peinture d'Aujourd'hui', *L'Esprit Nouveau* no. 13, Paris, 1921, pp. 1492–3; translated by P. S. Falla.

The Mánes Association of Visual Artists held exhibitions in Prague that were something like the French Salons d'Automne, and had exhibited cubist works by Braque, Picasso and Gris in 1913 and 1914. The art historian Dr Vicenc Kramář, who wrote the preface to the catalogue of the 60th exhibition of the Mánes, held in 1922, was a collector of Picasso's work, which he bought from D. H. Kahnweiler, and also the author of a book on Cubism that was pubished in Prague in 1921.

The reception to Picasso by the Czech art world is here represented for the first time by Kramář and by Nebeský's article for the Prague journal Volné Směry (Free Directions).

1921 Václav Nebeský
The nature of space in Picasso's work

There was bound to come a moment in Picasso's life when, as with Cézanne, there would be a direct confrontation between space and outline. It was impossible for such solid, heavy, material, enduring bodies, into which he had succeeded in cramming the changeable appearances of

things, bodies so overcrowded with reality, to be abandoned within something as unreal to touch and vision as space. And yet this invisible and elusive element was everywhere, and all objects were in it. Picasso realized that a purely accidental relationship between two objects – their relative location or relocation – could not replace the absolute nature of space. He saw that the existence of those objects was determined by space, and that space was not determined by them: that they were in fact nothing but filled units of space. We shall probably never know what prompted his dangerous notion of materializing and representing that invisible, intangible all-and-nothing; the notion of linking visually two entities with a firm bond within a third, hitherto unknown, essence – so that the entities would integrate, but at the same time the essence would, as it were, differentiate itself into them as though into its limbs? Was it the single-mindedness of the technician and designer that made him pursue this dream? Or was it the mystic's soul that could not bear to contemplate two things not seen to be joined fraternally into one body? It was certainly not the barren abstract calculation of a philosopher, who would not even have conceived of doing anything so obviously impossible. Picasso's idea could have originated only in a mind by nature inclined to realize and carry through to conclusion every undertaking, the mind of Cézanne's heir and successor.

To a man of this nature this difficult task must have presented itself, from the moment he undertook it, in an entirely concrete form. Perhaps something like this: If in a desert I stand in front of a mound of sand, then the dome of the sky contains both of us – myself and the mound of sand. Wherever I may be, in a wood under trees or in a room under a ceiling, there is always something that contains me and the objects around me, and which, with regard to what it contains, appears to be empty. In the instance of the mound of sand in the desert it is the sky that contains that object; from the point of view of the object, however, this appears as an empty hemisphere viewed from within. Space is something that contains everything. Concrete space, which we are talking about here, is, in each given case, that which can be seen to contain everything and which, from the point of view of what it contains, appears empty. . . . What is the concrete link between the mound of sand and the empty hemisphere viewed from within? To illustrate this point let us imagine, as an example of volume, another hemispherical mound of sand, except that now this is viewed from outside and appears full. Concrete space now appears to us as an empty internal volume, and volume as a full external space. How can these finite magnitudes be reduced to the common denominator we are looking for? There were two roads leading to this goal: either by transforming the volume – the full external space – into an empty internal space, i.e. space in the proper meaning of the word, or by transforming space – the empty internal volume – into its own full volume.

When I begin a painting, that which will contain everything is a white canvas surface. If I now choose the first of the two methods, I shall adapt

everything I paint to the form of that internal empty space; in other words, I shall proceed planimetrically, i.e. in two-dimensional shapes. If I choose the second method, I shall, on the contrary, adapt the flat surface to the full shapes of the objects I intend painting; in other words, I shall proceed stereometrically, in three-dimensional shapes.

To prevent a complete conceptual fusion of volume and space, to ensure that one can merely see how volume enters into space and vice versa, it is necessary to combine both procedures for reconciling their antithesis. If I tend towards space, I shall adapt volume to space: in other words, if I proceed planimetrically, I must execute the flattening of the volume in such a way that the character of volume is fully preserved, so that all the visual indicators of its volume-quality remain visible. But to ensure that volume is preserved as three-dimensional volume even in its two-dimensional presentation, and in spite of that presentation, there is only one way: all the two-dimensional visual indicators of its volume-quality must be expressed alongside one another or after one another, so that they are all simultaneously visible. The object, in other words, will have to be taken apart. In this way I shall present its different aspects, visible only from different sides, in a single aspect, visible from one single viewing-point.

If I follow the other procedure, adapting space to volume, and therefore present space as fully three-dimensional, I must, in order to prevent a fusion of the two, conjure up the object two-dimensionally on the three-dimensional surface of space. But in order to conjure it up two-dimensionally as a three-dimensional object I must resort to the same dismantling and the same mode of expression as in the first case.

This brings us to the last of Picasso's great achievements, the dismantling of objects into visual signs which are significant to him. His efforts to resolve his struggle with volume, as much as the two roads chosen by him to attain that objective, characterize Picasso's work as a striving after a more complete and comprehensive realism. A real object which does not also contain in itself its ambience, the space that surrounds it and in which it stands, is not enough. The striving for complete realism is now marked also by the direction which governs the dismantling of an object and the enumeration of the visual signs of its physical nature. Picasso sweeps away the final inconsistency and dishonesty which has hitherto prevailed in the use of artistic methods. He deprives the picture of illusionism. At the same time he replaces the illusion of space created by linear, atmospheric or colour perspective with the realism of a material space; instead of the indirect transcription of an object by means of form-giving line, form-giving light and shade, and form-giving colour reflection, he gives us a direct transcription by means of pure line, flat surface and local colour.

Only one thing remains to ensure that the reality of a phenomenon is complete – namely an atmosphere, which is the mediator and confidant between object and object, between outline and space, belonging to the

world of sensual, optical and phenomenal reality. Picasso does not forget this, and he places light and shadow on the surface of reality, as if bestowing kisses on his beloved – reality, which under his hands becomes a monument more enduring than life itself. Reality has been achieved, the artist's work has been fully realized.

From Václav Nebeský, 'Pablo Picasso', *Volné Směry* no. 21, Prague, 1921–2, pp. 114–22; translated from Czech by Ewald Osers.

1922 Vicenc Kramář
Mánes Gallery exhibition, Prague

Objects as presented by Picasso are not to be found in nature – if only because they are not products of merely visual perception but of a great variety of experiences, in fact the whole human experience. These pictures, moreover, combine several aspects of an object in one entity and, most importantly, they destroy the spatial connection between objects by reducing them to their elements and recombining them into new entities, which reflect the lyrical mood of the artist's inner self, stirred by the beauty of shapes in the world.

Hence there is no imitation of objects and no imitation of space. Objects and space are created and are fused into one: on the one side, the objects seem to be the products of spatial relationships, and on the other, space achieves expression only through the objects. The pictorial construction is similarly based on objects. There is no fragmentation in the representation of objects or in the composition: objects and space are created by the very construction of the picture. The two are fused in one creative act.

The reality of this art is therefore not the accidental and transient reality of naturalism and its derivatives, but a compact enduring reality stemming from the laws governing our mental functions.

It was a long road that led Picasso to the complete clarification and embodiment of the new artistic view, and the works he created exhibit a colourful variety, even though they are linked by a strict line of development. This is what makes it impossible to speak of Picasso's work as a whole, except in very general terms.

To start with he followed in Cézanne's footsteps, used light as a shape-giving means and simplified objects to three-dimensional, visually clearly comprehensible, forms, by combining several angles of view (by abolishing a centralized perspective and thereby achieving a highly effective expressive deformation) and by subordinating every component to the construction of the picture. In this way he produced pictures which differed a great deal from the nature we know and which were undoubtedly strongly rooted in the mind – he was then under the influence

of the mystical realism of Negro sculpture and, equally, an admirer of the naïve primitivism of Henri Rousseau. Yet Picasso was himself clearly aware that he was still only halfway towards his goal so long as he assigned to light the modelling function it had in illusionist painting. He was not in fact creating three-dimensional work, but clinging to illusion, albeit of lop-sided or deformed elements; indeed the impression of deformation was in itself clear evidence that the ties with the ordinary world of phenomena had not yet been severed – in other words, these pictures with their relatively isolated objects were not yet devoid of that materiality which it was Picasso's aim to overcome. It was necessary to destroy the three-dimensional connection of objects, to break them up into their elements, and to exclude chiaroscuro. That was the direction of Picasso's efforts from mid-1910 to the end of 1912. In this way he arrived first at pure spatial constructions, which he gradually enriched with further characteristics of the objects, and finally, following the exclusion of chiaroscuro, he achieved the genuine creation of space and objects by means of coloured planes placed in front of each other or intersecting one another. At that time also, when he felt it was necessary, he used different materials and techniques in a single picture and heightened both the tension and the reality of the constructs of his mind by the inclusion of real elements: to him unity was neither in the technique nor in the material but in the concept.

In the pictures of his latest phase, which extends to the present time, we no longer find isolated objects. Absolute unity reigns in them, and the classically simplified shapes have an amazing purity and a truly crystal brightness which allow us to see these works as a modern form of French classicism, a period with which they are genuinely linked both in their intrinsic nature and in Picasso's development.

From the beginning of the war, however, Picasso greatly surprised a public that had been closely watching his development. In addition to those exceedingly inward and spiritual pictures, he began – as early as July 1914 – to draw, and presently to paint, in a manner which represented a return to integrated form in the traditional sense. In this way he produced work which beyond any doubt betrayed the influence of Ingres and later of Corot. Conservative and reactionary circles saw this as the end of the Cubism they hated: they failed to realize, or else they did not know, that these conservatively classical pieces represented merely a small fraction of Picasso's work at the time. If they still hold such views, they are overlooking the fact that this state of affairs has now persisted for eight years and that Picasso's cubist paintings reveal not the least retreat since then, but on the contrary tend towards greater simplification and spiritualization. We also know that there are cubist painters – in France primarily Braque – whose endeavours have not been in the least deflected during this period, but lead uninterruptedly towards further stages of the new art form. It would also seem that the reasons for this decidedly unusual phenomenon – an artist working simultaneously in two different

styles – are of a personal rather than an artistic nature, so that it is difficult to comment on them. Yet if we consider the ever-heightened spirituality of Picasso's contemporary cubist works we gain the impression that the painter may well need, if not repose after so much hard work and so little comprehension from the public, then at least some counterweight or supplement, some release in the form of powerfully modelled works which have no parallel in contemporary painting and which one could easily imagine translated into sculpture, in order eventually once again to devote himself with tranquility and with all his strength to the pioneer work of so powerfully re-evaluating our reality. It is, of course, possible that the phenomenon has other, deeper causes which we cannot as yet discern, but which will be revealed by the further development of this restless and richly creative spirit. Meanwhile, it is certain that Picasso has made the improbable possible and that we are witnessing the existence, concurrently, of two fully developed manifestations of ideas and expression with no interference from each other. If Picasso's most recent cubist works seem somewhat closer to conventional nature than the paintings of the preceding phase, this is a mere illusion. They are more 'legible' because they are simpler, more self-contained, and perhaps also because they frequently use silhouette – but they are in no way less spiritual or intimate than his earlier works. It would certainly be a complete misunderstanding to describe Picasso's new nudes as classicist and to present them as the most recent art form, or indeed as a signpost to a future development in opposition to his cubist works. In reality both groups of paintings belong to the same mainstream of his development, except that the cubist works represent his modern manner while those nudes are classicist in the conservative sense and, in their substance, approach closely to the old classicism.

From Vicenc Kramář, 'Pablo Picasso: 1906–1921', *60th Exhibition of the Mánes Association of Visual Artists*, Mánes Gallery, Prague, September 1922, pp. 1–2; translated from Czech by Ewald Osers.

In his 1922 record of a visit to Picasso's studio, the Russian revolutionary poet Mayakovsky is rather dogmatic, as would be expected at this date, in his insistence on the revolutionary role of art. Cubism had had an impact on the development of constructivist art, and in this connection Mayakovsky makes reference to the Russian artist Tatlin, whose visit to Picasso's studio in Paris in 1913 had inspired Tatlin's own corner reliefs and experiments in materials.

1922 Vladimir Mayakovsky
Picasso's studio

The first studio to be visited in Paris is, of course, that of Picasso. The range and importance of his work make him the greatest painter of the present day. A thick-set Spaniard with a sombre, energetic air, we find him in an apartment hung with paintings that have long been known to us from reproductions. Like the other artists I have met, he passionately admires Douanier Rousseau . . . One question interests me particularly, that of Picasso's return to classicism. Some Russian newspapers have reproduced his latest drawings with the label 'Back to classicism' and with absurd articles to the effect that, if an innovator like Picasso had given up his crazy ideas, why was it that some cranks in Russia were still interested in planes and colours instead of straightforwardly and honestly copying nature? Picasso showed me round his studio, and I can state that the fears are groundless: he is not returning to classicism. His studio is full of the most diverse things, from realistic blue and rose scenes in classical style, all the way to constructions of tin and wire – and all of it dating from the same year. Noticing, on a table, the catalogue of the Russian exhibition in Berlin, I asked if it made him happy to decompose, for the thousandth time, a violin into a tin violin that nobody would buy, that could not be played and only served to appeal to the eye of the artist. For a long time now, our own Tatlin has been saying that the important thing was not to make shiny objects of tin but to see to it that the metal, in which such tasteless constructions are now being made, should in the future be vitalized by artists. 'Why,' I asked him, 'do you not "transfer" your paintings, for instance to the side wall of the Chamber of Deputies' building? Seriously, Comrade Picasso, they would show up better.' He shook his head and was silent for a moment, then he said: 'It's all right for you, you don't have policemen or Monsieur Poincaré.' 'To hell with policemen,' I replied, 'Go along with a pot of paint one night and decorate the walls while they aren't looking. That's what we did with the Monastery of the Passion.' I saw a glint of alarm in Madame Picasso's eye, though she didn't seriously believe it could happen.

From *Maiakovski par lui-même* (ed. Claude Frioux), Paris, 1961, p. 180; translated from French by P. S. Falla.

Among Picasso's papers the following unpublished statement about art was written on a sheet of paper and kept with some sketchbooks dating from 1923–4. The artist's own notes about art are rare, and in fact this particular statement is a personal observation that theory derived solely from an intellectual process is not the conceptual source of his art.

Picasso
Statement about art

To seek to express an idea in the language of art is a highly unnecessary and roundabout process. It is part of the manner that I was criticizing just now, that of playing aimlessly with artistic resources. You can never produce a real work of art if its conception is based on pure ideas and nothing else.

It is easy to recognize that the conception has this hybrid origin: that is to say, it is born of pure ideas, so that the artist, before setting to work, is already capable of expressing precisely and in words the subject he intends to represent.

Handwritten statement by Picasso (undated, c.1923–4); translated from French by P. S. Falla. Property of Bernard Picasso, Picasso Estate carnet 214/8287.

Although Picasso worked independently from the Surrealists, he was claimed by André Breton as one of their own in the following excerpt from 'Le Surréalisme et la Peinture', which appeared in La Révolution Surréaliste *in 1925. Picasso's work was occasionally reproduced in surrealist journals, including the first Parisian publication of Picasso's* Demoiselles d'Avignon *in* La Révolution Surréaliste *no. 4, 15 July 1925. He was also included in the surrealist exhibition at the Galerie Pierre in 1925. Breton wrote about Picasso on several other occasions, including 'Picasso dans son élément', which appeared in the first issue of* Minotaure *in 1933, for which Picasso had designed the cover; 'Picasso poète',* Cahiers d'Art, *1935 (see pp. 197–9); and in 1961, 'Pablo Picasso: 80 carats . . . mais une ombre' (see pp. 243–4).*

1925 André Breton
Picasso and Surrealism

When we were children we had toys that would make us weep with pity and anger today. One day, perhaps, we shall see the toys of our whole life spread before us like those of our childhood. It was Picasso who put this idea into my mind (the *Woman in a chemise* of 1914,[1] and the still life in which the inscription 'VIVE LA' stands out boldly against a white vase above two crossed flags).[2] I never received this impression so strongly as on the occasion of the ballet *Mercure*,[3] a few years ago. We grow up until a certain age, it seems, and our playthings grow up with us. Playing a part in the drama whose only theatre is the mind, Picasso, creator of tragic toys for adults, has obliged man to grow up and, sometimes under the guise of exasperating him, has put an end to his puerile fidgeting.

For all these reasons, we claim him unhesitatingly as one of us, even though it is impossible and would, in any case, be impertinent to apply to his methods the rigorous system that we propose to institute in other directions. If surrealism ever comes to adopt a particular line of conduct, it has only to accept the discipline that Picasso has accepted and will continue to accept; in saying this, I hope I have shown how very exacting I am in my demands. I shall always oppose the absurdly restrictive sense that any label (even the 'surrealist' label) would inevitably impose on the activity of this man from whom we confidently expect great things. The 'cubist' label proved equally fallible a long time ago. However appropriate such terms may be in relation to the work of other artists, it seems to me imperative that Picasso and Braque should be exempted.

From André Breton, 'Le Surréalisme et la Peinture', *La Révolution Surréaliste* no. 4, 15 July 1925, pp. 29–30; translated from French by Simon Watson Taylor in A. Breton, *Surrealism and Painting*, London, 1972, pp. 6–7.

[1] *Woman in an armchair* (z. II. 522)
[2] *Still life with cards, glasses and bottle of rum ('Vive la France')* (z. II. 523)
[3] *Mercure* was Picasso's sixth ballet décor and last major work for the theatre; it was a collaboration with Massine and Satie and was first performed in June 1924.

During the 1920s the Catalan ceramist Josep Llorens Artigas was associated with avant-garde art in Barcelona, and he also collaborated with surrealists in Paris (Llorens Artigas actually appeared in a brief sequence of the film Le Chien Andalou, *1929, directed by Luis Buñuel with the assistance of Salvador Dalí).*

The magazine La mà trencada *was begun in 1924 under the direction of Joan Merli (who later wrote a monograph,* Picasso: El artista y la obra de nuestro tiempo, *Buenos Aires, 1942), and featured artists such as Xavier Nogués and Josep Obiols (associated with Catalan* noucentista *painting of the teens and twenties) and avant-garde writers such as Joan Salvat Papaseeit. In the featured article of the 31 January 1925 issue (no. 6) Llorens Artigas discussed Picasso's 'inconsistency', that is, his ability to shift from style to style and work among them at the same time, and his wide range of pictorial expression and technique that resulted in 'his style'. Furthermore the idea of clarity Llorens Artigas proposed as a link among the varying formats is similar to the idea of the 'classical' harmony Schürer (1926) traced throughout Picasso's work.*

To include Picasso in La mà trencada *was a deliberate effort on the part of the editors of the journal to associate Picasso's name (which they have given with a Catalan spelling Pau for Pablo) with the avant-garde work in the twenties in Catalonia. Picasso's international reputation and the 'modern sensibility' he represented complemented the aims of the generation of* La mà trencada.

1925 Josep Llorens Artigas
Pau Ruiz Picasso

All the characteristics that can in a world of ease smother the original temperament of the most highly defined personality come together in the painter Pau Ruiz Picasso: an innate virtuoso quality, spontaneous ease, and the capacity to assimilate other artists' works. The voices of mental comfort and of physical indolence could hope to find, from the very first, a sonorous and brilliant echo in the natural qualities of the artist. The painter Picasso could have closed his mind to all worries; he simply had to reach out with his arm, and from the tip of his pencil or from the brush held in his hand would come spontaneously a work of painting or, to put it more precisely, the visual appearance of a work of painting, the fruit of his extraordinary talent.

But Picasso's glory is the product of his reaction against his own facility, and of the application of his own extraordinary talents to the resolution of problems which no other artist would have dared to pose. The whole of his production, then, belongs within a heroic plan and one must respect it: for it is the performance of an extremely risky venture achieved by means of an inexhaustible range of extraordinary qualities.

From the very start Picasso refuses to take advantage of the pictorial achievements of every period which drop into his expert hands. He sets himself to paint as a primitive, with neither law nor system, and he adopts for each work original attitudes and solutions, thus creating that stylistic inconsistency which is the dominant note in his painting, we might say, 'his own style'.

He refuses to take the easy advantage these achievements would give him in order to gaze into wider horizons, the unexplored regions of modern sensibility, in which any other artist would faint away; to his exceptional temperament this becomes a field of unique experiences where his spirit blossoms.

His superior stance, his privileged situation, has converted Picasso's painting into the spiritual centre of the plastic arts, the centre of gravity of all modern aesthetic ideas, and it has given his work the unmistakable sign of his creative ability: clarity. This clarity, even though some French avant-garde intellectuals, upset by his versatility, have failed to recognize it, is (with the possible exception of a brief transitional period) one of the oustanding characteristics of his canvases, from the beginning until now.

If there is darkness in Picasso's work, if there is mystery, it lies not in the result but in the process of creation, which, like that of the divine work, eludes our perception; but his end-products are clear, even to the slowest of imaginations. The drawings and paintings of Picasso launch a direct attack upon the aesthetic sensibility of the spectator, and provoke understanding; for since his work is pure and concentrated, its author is not frightened that his audience's understanding might reveal any faults;

he rather desires and stimulates such an understanding in order to have his qualities recognized. The artist does not intend to put the spectator to sleep, but rather open his eyes. This noble courage has conquered for Picasso's work the respect of every artist.

In his most recent works his personality has become stronger and more complete. The fusion of colour with drawing, which, paradoxically, results from their dissociation, from their distinct functions in the work as a whole, has never before attained the lively intensity of his latest paintings. Here the artist achieves a wonderful balance and sustains, without violence or disintegration, the colour scheme over the incisive and steel-sharp line drawing.

Pau Ruiz Picasso, in the flower of his youth and at the height of his powers, has consolidated the development of his artistic life. He has given a positive effectiveness to the aesthetic revolution, which has been pro-voked by the force of his amazing activity combined with the introspec-tion of his personality, and he has united the diversity of the new truths; he has saved from the wreckage that he himself brought about those virtues which are still valuable to art.

His hands have touched every artistic achievement; his art is a living reworking of them. His immense prestige derives from the fact that through all these speculations and experiences, whether he works within classical norms or in the freest Cubism, he has always maintained at the highest artistic level the unmistakable stamp of his own personality.

Josep Llorens Artigas, 'Pau Ruiz Picasso', *La mà trencada* **vol. 2 no. 6, Barcelona, 31 January 1925, pp. 91–2; translated from Catalan by Miquel Sobré.**

The Armenian artist Yakulov published this brief commentary concerning Picasso in the Moscow journal Ogonek *along with a Russian translation by K. Mocholsky of a well-known letter attributed to Picasso. Although the authenticity of the 'Lettre sur l'art' is doubtful, it has been reprinted in several different publications (see Barr,* Picasso: Fifty Years of His Art, *New York, 1946, p. 286).*

1926 Georgy Yakulov
Picasso

For some twenty years past the attention of all art-lovers in Europe has been fixed on the Parisian painter Picasso. His works are a reflection of the whole culture of our time, in both its good and bad aspects.

Artistic creation in our time is composed of three elements: the physio-logical perception of things, the use of past experience, and the artist's personal temperament.

In Picasso's work we find a fully developed physiological sense of things, which has been called Cubism, and which may be considered Picasso's personal achievement. Picasso has found what painters have been searching for since the mid-nineteenth century and he has made this the purely physiological basis for a contemporary style.

Just as species of fish that live at different depths have differently formed eyes, so people of different periods have different visual perceptions. This, of course, is due to their different conditions of life. Present-day Europeans live in towns among houses with plenty of windows, where there is an abundance of reflected light; medieval men lived in towns that were like fortresses, where the houses were close together and had little light.

Perspective in itself is nothing but the unfolding of objects. The Middle Ages used a conventional flat perspective, the Renaissance a three-dimensional one, while nineteenth-century perspective was purely photographic. The problem confronting modern painters is to define and express the perspective of shifting objects, silhouettes and reliefs.

Oscar Wilde correctly wrote of Turner, the founder of Impressionism, that he created the London fog. Before Turner people lived in the fog, but did not notice it. In the same way modern painters who create a perspective of shifting objects make us really feel and see them, and Picasso's main achievement from a purely historical point of view is to have created a new perspective for our time.

So much for the first of the three elements of modern painting. We now come to the use of experience and the question of personal temperament. In Picasso's work we find a great awareness of artistic tradition, and he has made a detailed study of the Flemish, French and Italian masters.

So far I have indicated several positive aspects of Picasso's work; what are his shortcomings? He lacks, to begin with, what we Russians have to excess, namely content – not, however, in the sense of a plot or narrative, but in the sense of inner unity. Picasso is admirable at analysis but poor at synthesis. He has divined the visual mood of our time and its physiological nature, but he knows nothing of its psychological nature.

Picasso is undoubtedly the supreme master of our time, but as an analyst and not a synthesist. This, of course, is not Picasso's fault, but the fault of the European culture in which the great painter lives and which his works reflect. If he were to live and work in our country, his talent might develop even more comprehensively and extend to fields that are new even to him.

From Georgy Yakulov, 'Picasso', *Ogonek* no. 2, Moscow, 1926, unpaginated; translated from Russian by P. S. Falla.

Picasso's classicism

The topic chosen for this article makes it necessary to clarify two basic points. First: what do we mean by classicism in this context? Second: how does classicism, thus defined, fit into Picasso's work as a whole? The formulation of these questions alone makes it clear that the subject here is not the period of Picasso's work which is referred to in the contemporary literature of art as 'neoclassical' – the works with which from 1917 onwards the painter amazed even his own adherents. The answers to the questions will reveal that this is a principle which permeates the whole creative output of this painter, and which could not be explained without concurrent contemporary influences.

Classicism here should be taken to mean the clarifying principle to which art constantly returns after periods of agitation and obsessive idealism; whereby the return to traditional classical values provides a normalizing influence. This tendency appeared most strongly in the historical classicism of the period around 1800, when it grew into a style in its own right. Here, too, it becomes apparent that this clarification of form involves a return to a repertoire of natural forms, so that it is justifiable to speak of both a naturalistic and an idealistic component of classicism. There is in classicism the operation of an inner discipline, a principle of austerity, regulation, discrimination. From this all the distinguishing marks of classicism may easily be deduced.

How does classicism, thus defined, fit into Picasso's oeuvre? Let us take an overall view of that oeuvre. In it, three essential elements appear to coalesce into a unity (a unity that subsists in spite of all the sudden transformations that appear on the surface): a fundamental sense of decadence, which creates powerful expressive forms; a decorative impulse, which impels all forms into their most effective visual manifestation; and the classicism, which, in about 1917, seemed to absorb into itself the whole strength of his creativity. To reveal the artist in all his complexity it would be necessary to point out the ways in which these qualities mingle, reinforce and compensate each other. In addition, it would be necessary to shed some light on the curious refraction that each of these components undergoes in the depth of his Spanish-Moorish-Jewish blood. There could be material for a far-reaching analysis. Here all that can be done is to point to the constant influence of the classicizing elements in Picasso's makeup. Not least because it is classicism that expresses the essential Picasso: the promise that this great talent will expand, grow stronger, and attain a more than ephemeral influence.

Even if we did not know of Picasso's early classical leanings, from conversations and other records, it would be impossible to overlook its presence in the pictures painted in the years 1903–5. Space, in so far as it is perceived at all, is absorbed into a tranquil picture plane. And this plane

in turn concentrates its inner life in the contour which, as 'expressive line', becomes the main vehicle of the vision. A picture like the *Boy with a horse* (1905)[1] is highly characteristic of this form of moderated classicism. It is clear that Picasso is treading in Cézanne's footsteps. But perhaps it is his sense of decadence that softens the elemental vision of the Master of Aix into classicism. And the same softening also sets the work apart from Cézanne's polar opposite in volumetric perception, Marées, of whom one is reminded by the choice of subject, and whose spatial intensity, again, is neutralized here by a subtle decorative intention.

I have discussed elsewhere ('Neoclassicism in recent French painting', *Jahrbuch für Philologie*, Munich, 1925, pp. 427–33) how this tendency towards classicism works itself out in the cubist experiments. Classicism as the keynote of Cubism, an idea which initially seems paradoxical, becomes on closer study the most instructive relationship for the understanding of this movement and of this artist. Only the observer who has seen the Cubists' struggle for inner equilibrium as a kind of latent classicism can perceive, beneath the jolts and discontinuities of Picasso's development, the inner and necessary unity of an evolution.

In the present context there is little that needs to be added concerning the pictures of 1917–22. Their classicism is evident – almost defiantly so. Their almost literal borrowings of formal devices from the painting of late antiquity show that the description of this classicism as 'Ingrism' is, at the very least, one-sided. In retrospect it is, however, worth observing how this classicism has purified and cleansed itself in comparison with that first classicism of 1905 – principally as a result of the intervening baptism of fire that was Cubism. One sees how the line has been enriched by significant spatial values, and how it has become charged with feeling. And how, in spite of this enrichment, the line no longer drains away substance from the plane: the plane now takes its autonomous place alongside the line and fully conveys, through its own inner rhythm, the plasticity of the material substance. One sees, above all, how space now appears within the naturalistic pictorial context, clarified and reaffirmed, and asserts the reality inherent in the work. The juxtaposition of equal elements – line, plane, space, colour – is emphasized to the point of naïveté. At the same time, the clear process of classical formal creation is never interrupted.

In Picasso's current work, which has once more turned back to painting divorced from the object, the decorative elements are noticeably growing in importance. But they too incorporate a classicism which soothes the eye and satisfies the emotions, and which is the product of decades of effort. From the standpoint of the spectator's pleasure, it is perhaps regrettable that Picasso has once more left the path on which he seemed to have found the most direct and universal expression of his own complex nature and his own relationship to the outer world. By this we mean those experiments in the direction of a classically controlled realism that are adumbrated, for example, in the beautiful *Harlequin*[2] of 1923.

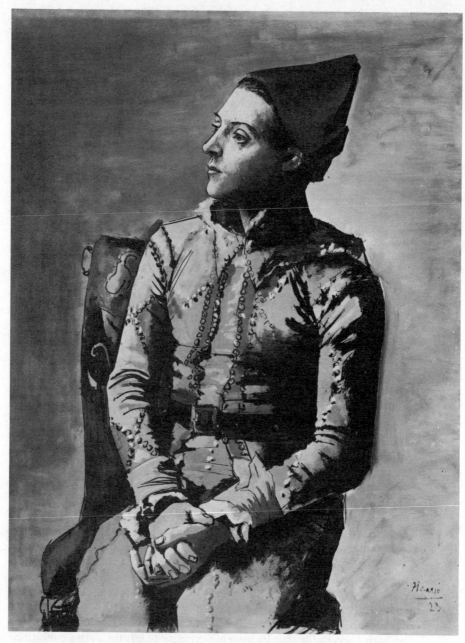

Seated Harlequin (portrait of the painter Jacinto Salvado), 1923. Kunstmuseum, Basel.

However, what has happened is surely inevitable, from the standpoint of a creative temperament which finds valid self-expression only in carrying each of the components of its nature to the extreme.

Oskar Schürer, 'Picassos Klassizismus', *Die Kunst für Alle 1925–26,* **Munich, 1926, pp. 202–7; translated from German by David Britt.**

[1] Z. I. 264
[2] Probably *Seated Harlequin (portrait of the painter Jacinto Salvado)* (Z. V. 23)

Christian Zervos founded Cahiers d'Art *in 1926, and illustrations by Picasso and articles concerning his work were often featured until the journal ceased publication in 1960. In the first issue of 1927, E. Tériade (the pseudonym of the Greek art critic and writer Efstratias Elestheriades) began what was intended to be a new series on modern artists with his article 'De la formation d'une plastique moderne', which follows. In that same year,* Cahiers d'Art *no. 6 included Max Jacob's 'Souvenirs sur Picasso' (see pp. 37–8, 54–5).*

1927 E. Tériade
Picasso's quest

Picasso takes as his starting point a new aspect of Cézanne's work. His concern is to transpose into plastic form intellectual truths that are valued by the free minds that surround him. In his work we recognize the simultaneity of certain needs of the time and certain profound requirements of painting, which through the Impressionist revolution had become a field of exploration with incalculable possibilities. He was aided by his extraordinary basic skill in plastic art and by certain resources that only come as the result of adventure, which is a continuous movement forward. He found certain things and used them to discover others. He observed, and used his observations to press onward. Eventually he sensed the existence of a new modern world that belonged to him and to his time. Then he plunged in, advancing from one discovery to another.

Day by day, year by year, he proceeded to establish modern painting and its aesthetic language, regardless of imitators, of inadequate or false interpreters, and of the misunderstandings caused by the interest taken in his work by some intellectuals. Compared with Picasso, Braque represents stability controlled by a sense of measure and confirmed by his innate capacity for realization.

Cubism, by which the interlude of Impressionism was brought to a close and the true essence of painting was rediscovered, went much too far to be capable of returning to rational notions and traditional feelings.

The leaders of the movement, who had endeavoured to paint pictures in accordance with a conscious system, using only plastic elements free from any anecdotal suggestion, suddenly became aware that they had advanced into regions that the artists of the Renaissance had not dared to enter. Having thus lost their mainstay in the past, they were obliged to seek a foothold in the present and, involuntarily, to anticipate the future.

The first period of Cubism – which may be called architectural, either on account of the predominance of constructional elements or because of the use that architects made of it – was born at the moment when Picasso realized that he was advancing joyously into the void of discovery and, with the superior strength of a man of destiny, resolved to put his trust in it.

This is the root of the matter. Picasso at that time was in what may be called the classical state of mind – an active state, which is the opposite of the spirit of imitation based on laws discovered from the study of classical works. Picasso, we may say, found himself, amid all his anxieties, obeying the same profound needs as the masters of antiquity and eager to solve the same problems as they.

If the feeling for construction and the desire for planar equilibrium were often stronger than respect for nature, this was due first to the violent response that Cubism offered at that time, and secondly to the factor of invention through which it succeeded in imposing plastic unity on a resistant world with all its impossibilities and apparent contradictions. But neither Picasso, nor above all Braque, ever let go of reality: there is always a basis of representation in their work. Picasso must have felt deeply the modern weakness which sometimes gave his work the false appearance of a system, when it was only the bare but necessary framework of a tremendous revival. The ancients had only to breathe the surrounding air, whereas Picasso needed oxygen tanks.

We are now at the end of the first cubist movement. The only survivors are the godlike heroes, those who had something to lose and took the risk of losing it. We might even date the end of this period from Picasso's last exhibition, when he made a profound appeal to those of his kind and, in his sublime maturity, inaugurated what may be called his poetic period. This, beyond all doubt, is to be the great immediate future of modern painting, a glorious renascence, if true painters respond to his appeal.

The first period of Cubism enriched young painters with magnificent materials, new forms of expression, a strong architectural discipline, and the possibility of a new poetic art to which Surrealism made its own contribution. During this period, painting was still heavily influenced by architecture. The latter art took advantage of this fact, taking back the elements that applied to itself. It was now time for painting to throw off constraints and reap the benefit of its achievement.

The period of pure invention was over: a new aesthetic had already taken shape.

As the means of reproduction become more and more varied and

perfected, modern man once again comes to realize more fully the true significance of art. He seeks to free it from false ideas of naturalism and, by isolating it in a plastic and abstract form, to rediscover the fresh, spontaneous, inventive poetry of the age of simplicity. All advanced civilization leads to simplicity, a goal to which poetry attains when it has completed the cycle of knowledge. Consequently, there exists today a living though schematized aesthetic based on the explorations of Cubism, and it is this which differentiates the present time from that of the first Cubists.

Picasso, as we said, started out from his awareness of a new aspect of Cézanne's work. Should we not then believe that artists of the future will start from an awareness of a new aspect of Picasso? For it is already possible to distinguish a new aspect and a profounder truth in his work, especially the most recent.

Liberated from architecture, which is now so deeply engrained in him; liberated from all the discoveries of his astonishing pictorial craftsmanship; having at his command wonderful means of expression, a language of colours and signs – Picasso gives free rein to poetry, the sources of which at a given time, as with every strong man, come from within.

But this does not last long. Picasso soon returns to his quest. He feels himself to be a man of destiny, the creator of a new language, the eternal inventor of plastic signs. Realization in itself is almost a weakness in him. His classical drawings, no less beautiful than those of classical artists, are the recreation of a man who has read, known and understood many things.

It is for the young to be singers, poets and above all painters. Let them see what has already been gained: poetic liberty in the conception of a picture, plastic liberty in its execution, the architectural value of a powerful, concentrated, vibrant equilibrium, answering to our present aesthetic needs and our thirst for poetry.

To concentrate the aesthetic, pictorial, architectural and poetic value of a Renaissance painting into the proportions of a modern one – such, whether consciously or not, is the aim we pursue.

From E. Tériade, 'Les Peintres Nouveaux: 1. De la formation d'une plastique moderne', *Cahiers d'Art* no. 1, Paris, 1927, pp. 30–1; translated from French by P. S. Falla.

Carl Einstein was a German critic and poet whose essays on Picasso were frequently translated and published in France, such as his article on Picasso's work of 1928 in Cahiers d'Art *(1929), and his article 'Picasso', which appeared in* Cahiers d'Art *in 1930, in which he attempted to explain Picasso's destruction of external reality in the light of his pursuit of self-knowledge and inner experience, which was manifested in geometric forms. Einstein also compiled a history of twentieth-century art (*Die Kunst des 20. Jahrhunderts, Berlin, 1931*) and his study there of Picasso's Dinard Bathers is translated in* Schiff, *pp. 71–74. In the selection that follows from an article in a Swiss journal, Einstein considered Picasso's work dating from 1917–27 with regard to his historical inheritance, in an attempt to explain his 'polyphony of styles'.*

1928 Carl Einstein
Picasso: the last decade

The years 1917–18 saw Picasso's unfinished portrait of his wife[1] and that of Madame R.[2] Then came the large figure paintings that followed a copy of Corot.[3] Picasso is intelligent enough to know the limitations of every style; he sets out to show that, while he is not derivative from any style, he is master of all. Some have spoken of 'Ingrism', others of the influence of the Baroque. There is no doubt that Picasso himself initiated, among his unacknowledged followers, the reaction against Cubism and return to neoclassicism. He knew that one single method was too restricting for him, and that it had to be complemented – and completed – by its antithesis. Artistic compulsion – daemonic compulsion, to use a much misused expression – is often hard to distinguish from sheer playfulness. Picasso knows the limitations of style and of individual form, which to him is more a means than an end. He is too open not to be sceptical about the idea of one solution only; ironically or despairingly, he displays the contrasting form, the 'other' style. He is a pluralistic spirit, who places no great reliance on clear formal causality. To him painting is a means, and he places high above it the human inventive intellect; whereas for Braque painting is everything and an end in itself. Braque is the Latin; hemmed in by self-imposed purist inhibitions, making a highly conscious sacrifice to the beauty of craftsmanship. An abnegation which may be nobler than heroism, but which cuts him off from a great deal of experience.

Classicism had been laid low; and with passionate curiosity Picasso tried his hand at an intensely personal trial of the very thing that had now been abolished: the classical norm. His portraits aim at a *soigné* objective realism, with a virtuoso use of local colour. He showed that he had mastered the whole sequence of French pictorial tradition; that he too can be an admired classic. Simultaneously, his abundance of new knowledge incited him to work from the motif as a starting-point.

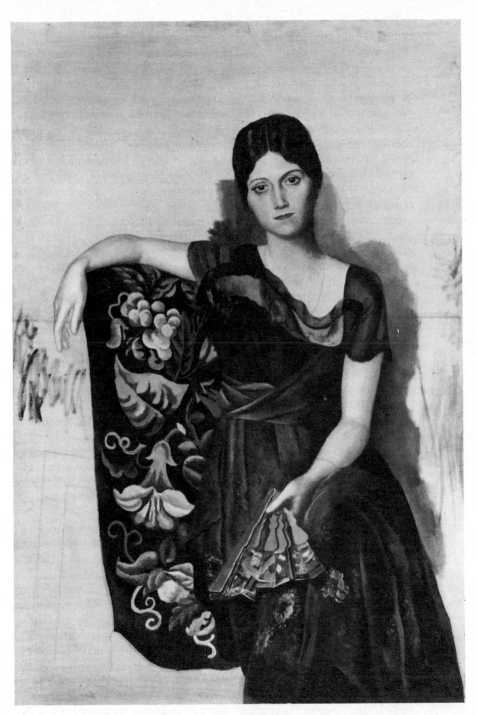

Olga Picasso in an armchair, 1917. Musée Picasso, Paris.

We have shown how Picasso lives in the tension between opposites and finds his own vital individuality and identity in the drama of antitheses. This sort of stylistic pluralism is not unusual in French painting and literature. We refer the reader to the attractive example of Mallarmé; or, in painting, there are the heroic and the sentimental compositions of Poussin. In Poussin, stylistic contrasts grow out of a moral differentiation: he is expressing a quasi-Christian dualism. Corot and Cézanne are other examples. With these masters, hindsight has much reduced the considerable differences once apparent between their attitudes. It is entirely understandable that richly endowed temperaments should chafe under the restrictions, the narrow bounds, of a work of art; especially as, in comparison to the old masters, the works of today are less complex.

No artist has drawn closer than Picasso to the elements of art. It is tragic that, in this age of triviality, elemental simplicity appears as a gratuitous act of blasphemy against the age's washed-out commonplaces, most of which have become untrue through over-use. Principles are ultimately established only through obsessive and arbitrary acts of will, and are intuitive things; seen in terms of the rational continuum, they appear extraordinary explosions of self-will. In their intuitive origins, art and science meet at one minute point, and this is the origin of some of their formal affinities, their wilful and obsessive natures.

Surely no painter today has so intensively communed with himself as has Picasso. Often the peripheral world has disappeared from his view altogether, but always he has extracted from his own obsessive state a scrap of form, with which to begin a specific reconstruction of the world around him. However far we move away from this world, we always remain a part of it – just as it exists, in another sense, as our imagination of it. This polar ambivalence makes it possible for formal and representational freedom to exist. The polar opposites depend on each other, and so even hallucinatory formal creations ultimately have a point of contact with external appearances. Form is the means of differentiation: through it character and classification are determined.

It is natural for an artist as self-absorbed as Picasso to have the idea of painting in a socially acceptable objective manner in order to prove to himself that he has a firm hold on his historical inheritance. Picasso wanted to master history in order to free himself from his isolation and from his confinement to a narrow but crucial Now. He wanted to grasp the whole range of the past, and perhaps to challenge comparison with the old masters. And so Picasso abandoned direct subjectivity, the pure dynamic of the isolated imagination. He painted his classical portraits, made austere drawings, pure and noble like the outlines on Greek vases. Now he pursues physical presence through modelling, makes forms stable in their solidity, draws subtle, sharp outlines, and beholds with epic detachment the tranquil grandeur of his almost proto-Greek figures.

With these works Picasso has mapped out for a new generation the

territory on which they have to work. His portraits and compositions once more show younger artists the way. Picasso has legitimized a return from exile: and classicism has become the object of major experimentation.

These works proclaim a titanic archaism. Picasso has carried Greekness far beyond Maillol into a realm of colossal myth. He rears up big-eyed, ponderous figures or conjures up fleet-footed dancers like those on painted vases. A heroic world opens before him, sometimes in idyllic repose, sometimes in powerful rhetoric. Through these figures Picasso has found his way back into history, and into what is quasi-officially designated as Nature. The world, as objectively assessed, had been conquered by the individual will, and Picasso has presented his own age with a new set of figurative images. In these works the painter has returned to the figure paintings of his youth. And yet here too he is accused of infidelity to his early self, while he gives a more powerful expression to the themes of his early period. The poor and the unimaginative always feel betrayed by youth and by riches.

Picasso has painted harlequins, still lifes, figures, both in an archaistic-classical and – concurrently – in a cubist style. Seeing the world from both its poles at once, dividing himself in two while trusting in his own enormous strength, seeking truth and plenitude in the tension between simultaneous opposites, placing no trust in the dogmatic truth of one style, sacrificing his own discoveries. All these psychological tendencies are constantly present in Picasso. The grand style is yet more forcefully articulated in the cubist works. The structure of the intersecting viewpoints is now calmer, grander and more significant. The delineation of objects is more curvilinear, simpler, but also more differentiated. The formal relationships flow evenly, with due emphasis. The colour is structurally organized. These works seem to the structural sense classically purified. They breathe an expansive structural tension; the visual sectors are simpler and broader. I am speaking here of the still lifes and figures; but let us refer also to the darkly menacing *natures mortes*,[4] whose burning, nocturnal intensity and severity recall the great Zurbarán. Great dark surfaces are enclosed by a thread-fine contour which oscillates chromatically, like a twanging bowstring. Interspersed among these things, like laments and cries of pain, are the prophetic sketches for a *Crucifixion*,[5] which will perhaps one day form the centre-point of his oeuvre: a theme which fits perfectly into the dynamic of Picasso's work.

In 1927 Picasso painted a number of particularly significant figures and heads. Here he uses the technique of dislocated formal contrasts even more extensively. Contrasted through colour, the viewpoints interlock and abut, setting up a swift, polyphonic, fugal interplay of layers of visual and mental form. Articulated by curves, the contrasting elements form wondrous harmonies, each in turn dominating the musical texture. The sense of contrast is wonderfully used. By the polyphonic law of opposites, every form signifies itself and yet simultaneously hurls us into its an-

tithesis. It is these paintings in particular that speak to us of the sense of simultaneity, with all its rich implications for the future, whereby a form or a sentence illuminates previously latent and unconscious antitheses or parts of a figure – and truth lies in the identity which underlies the tension between opposites.

Picasso plays back all these fugal contrasts within one picture. He encompasses the polyphony of styles. He hastens tirelessly from one formal creation to another; forms burn up and die within him, in the white heat of historical necessity. He is a man who has blown apart, as none other has, the limitations, the obsessional narrowness, of the practices of art.

From Carl Einstein, 'Picasso', *Neue Schweizer Rundschau* no. 4, Zurich, 1928, pp. 269–73; translated from German by David Britt.

[1] z. III. 83
[2] *Mme Rosenberg and her daughter* (z. III. 242)
[3] *L'Italienne* (z. III. 362)
[4] e.g. *Pitcher and compotier with apples* (z. III. 276)
[5] e.g. z. VII. 29 (1926)

The Catalan poet Sebastià Gasch wrote the following essay for the little literary-artistic magazine Gallo, *published in Granada. In the April 1928 issue, in which the article concerning Picasso appeared, a Spanish translation of the Catalan 'full groc' (yellow sheet), a spirited Dada-Surrealist manifesto issued in Barcelona on 28 March by Gasch, Salvador Dalí, and Lluís Montanyà is printed in its experimental typographic form. The manifesto ends with a list of modern masters (including painters, sculptors, writers and musicians), and Picasso's name is listed first. This issue also includes a short story* Encuentro *by the Granada poet and friend of Dalí, Federico Garcia Lorca.*

1928 Sebastià Gasch
Picasso

Picasso's art is undefinable and unclassifiable. There is nothing harder to classify or label than Picasso's art. Nothing so categorically refuses a critical definition as Picasso's art. The art of this great Andalusian is an uncontrollable art, an art made up of imponderables. An art steadfastly opposed to any analytical dissection by laboratory critics; it only accepts poetic criticism. The poet's commentary, pioneered by Salmon and invested with supreme authority by the Surrealists.

I was not born a poet, yet, invited to comment on Picasso's work by this admirable *Gallo* [rooster] – bravely ready to utter its manly crow in the

midst of the prudent dumbness of the times – I will attempt to write a few notes about the prodigious art of this Malagan genius, which demands passionate attention from today's best artists. Such an invitation cannot be refused.

Picasso's art is essentially soulful. Full of soul. For Picasso there is no other reality than his inner reality, and the movements of a soul – a tortured, restless, ardent, passionate soul – which the great painter portrays in his canvases, translates in his paintings. One can divine the mystery of the artist's inner world in any of Picasso's brushstrokes, in the simplest, most abstract stroke, free of any representational significance. Picasso's soul leaves an imprint in the least stroke and makes it tremble with a vital shudder as only the most intense and profound works can.

When Picasso abandons himself frenetically to his art he runs great risks, he is constantly stepping near the edge of the precipice over which others, with less talent, would already have fallen.

Let us take a look at these risks. First, the risk of abstraction, which has been the ruin of countless contemporary painters. The plastic abstraction of some Cubists and the mystical abstraction of some Surrealists. Yet Picasso's works are never abstract. On the contrary, they show a great realism, an astounding resemblance – not with the external look of objects but rather with their profound inner reality, with their surreality: in other words, with the spirit living within the matter, revealed only to the great. A spiritual resemblance, Picasso's. A spiritual rather than material likeness.

Another risk: going astray into literature. Picasso said to Christian Zervos, in a recent visit to a so-called avant-garde exhibition in Paris: 'To tell the truth, it has been useless for our generation to go to such pains when one sees these people stumble once more into literature and forget the most elementary plastic art.'

As opposed to all these artists who, pretending to be overwhelmed by emotion, give into unrestrained spontaneity with no concern for a supporting visual scaffolding, Picasso always respects the inescapable plastic laws. He has always respected them. From his Horta de Ebro landscapes, through his classicizing post-war subjects, to his present period, which is essentially poetic.

A poet, a true poet; and, also, a painter, a true painter, Picasso transforms everything he touches not only into poetry, but also into painting; he thus engenders his wonderful creations, which we could call plastic-poetic, and presides over modern painting with an authority and a prestige which nobody would dare deny.

Sebastià Gasch, 'Picasso', *Gallo: Revista de Granada* no. 2, Granada, April 1928, pp. 1–2; translated from Spanish by Miquel Sobré.

The art historian Max Friedländer was concerned in his writings to define the
fundamental concepts of art history. In his essay 'Stil und Manier', he
introduces the example of Picasso, drawing a comparison with the work of El
Greco. A short excerpt from this article was reprinted in French translation
in Documents *vol. 2 no. 3, 1930, p. 183, along with an excerpt from Wilhelm*
Bode's 'Die "Neue Kunst" der Futuristen und Kubisten', 1913 (see p. 100),
as examples of 'official opinions in Germany' on Picasso.

1929 Max J. Friedländer
 On style and manner

We need to describe the characteristics of a genuine work of art and to
define the difference between style and manner. Unity, integrity, self-
confidence, a flow that is swift and free, are looked for as signs of intuitive,
spontaneous creativity. However, these observations are deceptive, since
similar results can be achieved by the experience of cold-blooded con-
noisseurship or by creative power. Even the degree of variability can be
interpreted in either way. Certainly the mannerist is betrayed by his
inability to achieve his intention or to carry his efforts through to the end,
by his failure to realize what he intends with natural expressiveness, his
lack of discipline, his changes of plan; but a deviation of this kind is easy to
confuse with the change brought about by organic development and an
abundance of imaginative activity. What at a higher level means unity can
on a lower one betray pedantic monotony; the swift tempo which in one
case means a bursting imagination can in the other be evidence of super-
ficial routine; something strange and extraordinary may be the product
of the compulsive vision of a genius or it may come from a cynically
calculated craving for sensation and mania for innovation.

The level of quality is therefore what counts. But this introduces a
criterion from which the scientist shrinks in horror. The question of
quality is answered with one's feeling of conviction, according to the
depth of one's impression, the measure of aesthetic pleasure sensed. The
conclusion we reach about quality is spontaneous, depending on our
ability and our receptiveness, and we interpret a work's characteristics
according to this.

Judgment of the level of quality is subjective and it changes. Each
generation decides differently. Karl Justi called El Greco a mannerist.
Today we look on this Spanish painter as a naïve genius. The artistic
theory from which we have derived the distinction between style and
manner will not last for ever either; perhaps even today it is no longer
valid. The 'mannerist' label which has been applied to certain phen-
omena, people and periods still sticks to them after the judgment on
them has changed. So, someone may make the statement: 'El Greco is a
mannerist' – fine, then we will respect and emulate mannerism; and if his

art was wilful – right, then we shall dispute your theory and derive a new theory from his work. Picasso, to my eyes, shows the characteristics of unadulterated mannerism, and I am not so enthusiastic about him that I would set out to try to reinterpret these characteristics, let alone alter the theory of art on his account. Others will not share this view of Picasso.
.

The artist whose perception is out of the ordinary and peculiar to himself will give his work a stamp that appears to the normal eye as stylized. The mannerist, on the other hand, who is ambitious to use his expertise to offer more than he really has, and would like to appear to be more than he really is, despises his own vision, considers it banal, and therefore, rather than putting his own stamp on his work, seizes on what bears the stamp of another.

Whether the work looks naturalistic or non-naturalistic is immaterial: we can speak of style so long as we believe in compulsive vision, but of manner wherever the form does not seem to have been seen, but to have been drawn in from somewhere outside and somehow to have been put together out of vanity and a sense of inferiority.

From Max J. Friedländer, 'Stil und Manier', *Echt und Unecht: Aus der Erfahrungen des Kunstkenners*, **Berlin, 1929, pp. 57–61; translated from German by Michael Raeburn.**

In 1930, just one year before Picasso's fiftieth birthday, the magazine Documents *dedicated a special issue to Picasso. The journal, founded in 1929 by Georges Bataille, frequently published surrealist writers and poets, many of whom were outside Breton's circle. Articles by Bataille, Robert Desnos, Marcel Jouhandeau, Jacques Prévert and Georges Ribemont-Dessaignes from the Picasso issue have been translated in Porzio and Valsecchi, pp. 243–60. In the two articles that follow from this special* Documents *issue the influence of Surrealism can be detected. André Schaeffner, for example, discusses Picasso's arbitrary treatment of nature and the resulting mysterious imagery as an expression of unknown regions that are only reached through painting, as if painting were a primitive process closer to the senses than the intellectual problems of writing. Likewise in Pierre-Quint's review of the artist's career, the unexpected directions of Picasso's development, which usually separated him from other artists of his time, are explained as a series of personal metamorphoses, as if Picasso were alone on a primitive earth, and a study of his work thus reveals the dynamic relationship of man and nature.*

In spite of photography and in spite of Cubism, if not because of them, the fundamental problem of painting consists in its relationship with nature, which it is supposed to reproduce or interpret more or less freely – just as the central problem of music, perhaps, still lies in the relative recalcitrance of its formal materials to any infiltration of a psycho-physiological kind. These arts of imitation and expression, just because they were a meeting-ground between different techniques and were in contact with other arts, were caught up in the play of technique as such, and each of them fell into the habit of reciting a poem in praise of its own specific virtuosity. Despite constant appeals to follow 'higher' spiritual aims, these arts still remain attached to the vanity of each of the senses that it is their function to reach. And it is at the threshold of such vanity ('the vanity of painting') that power is given to man to threaten the world order. The revolt starts – if the whole of art is not a revolt – at the point where the vanity of reproduction ceases to find its material, where we are obliged to refer to a nature that is foreign to our own, although it emanates from it under the influence of dreams or madness. It is probable, indeed, that without painting we should never have known the world, and no image of other possible worlds could have been found and made fertile. A poet, even a visual one like Victor Hugo, could not have endowed the 'unknown presences' of which Jacques Rivière speaks, let alone the unknown aspect of presences all too familiar, with the precision and persuasive force that can be found in a line or a colour. The unexpected turns of painting seem to me to have taught us more about the forbidden regions of the universe than any accident of speech or sound.

I do not believe I am sufficiently equipped to define the exact status of a man like Pablo Picasso or to say whether the most disturbing aspects of his art cannot be found in different degrees among certain painters of the past – in other words, whether Picasso is the only painter who has exercised this power of deformation. I can, however, say that some few of his paintings are the only ones which have given me a real feeling of vertigo at the sight of so much unfamiliarity, of the *natural* in such monstrous liberties taken with nature, of such arbitrariness in art and in nature itself. At the same time I have felt moved at discovering some corner of reality left intact while the rest of the scene was thrown into confusion by unbridled fantasy (I remember a key left in a door, which apparently justified the mysterious presence of that door on the canvas), and I have felt the thrill of discerning the dividing-line between what the painter left unscathed and what he subjected to his destructive frenzy. Painting, it would seem, never imitates nature more closely than by renewing the arbitrary character of given forms – an arbitrariness which does not prevent their being 'viable', to borrow a happy expression from

an article by Michel Leiris on 'Recent Paintings by Picasso'.[1] And this leads me to think that music, compared to painting, is a desperately 'exact' form of art – as one speaks of 'exact sciences' – in that it can never escape its own kind of reality but is destined always to imitate itself, to go on fortifying the same frontiers. There is no music that could be called 'surrealistic'. And, while endorsing Michel Leiris's distinction between Picasso and the Surrealists, we can judge by this what a difference there must be between the missions, at the present time, of a Picasso and a Stravinsky.

André Schaeffner, 'L'homme à la clarinette', *Documents* vol. 2 no. 3, Paris, 1930, pp. 161–2; translated from French by P. S. Falla.

[1] 'Toiles récentes de Picasso', *Documents* vol. 2 no. 2, Paris, 1930, pp. 57–71.

1930 Léon Pierre-Quint
 Doubt and revelation in the work of Picasso

An artist like Picasso is concerned with something beyond painting, namely the direct relation between man and nature. What, in fact, is the environment in which we live? At times it appears to Picasso as a formidable seething mass, at other times as a collection of pure static images which can well be represented by traditional linear drawing. Then, once again, solid bodies take on infinite depths which he tries to enter, taking sections of the impenetrable, opaque matter so as to illuminate it from within. Then again the world suddenly seems to him a prey to huge savage gods like those of the Assyrians; men, and especially women, become heavy and monstrous; their cow-like eyes wander uncertainly; the air is torpid and full of brooding. Suddenly nature, reverting perhaps to a prehistoric state, spreads out before him without a living soul to be seen, like a huge, bare, arid field covered with tombs built of menhirs and dolmens, crude monuments that disintegrate and re-form as though they should eternally constitute the very substance of things. Thus the different periods of Picasso's painting each correspond to a particular compelling vision of the external world. It is as though Picasso had lost contact with other men and was alone on this primitive earth, which then imposed itself on him in a series of metamorphoses.

However, no intellectual problem, properly speaking, has been posed to him. His predicament is not that of a man trying one technique after another in order to find the best way of expressing himself. He has the techniques already, and he does not hesitate over means of expression. When he pioneers the use, one after the other, of *papier collé*, sand, corrugated iron and textiles, it is not a matter of inventing a perfect technique on each occasion but of giving adequate expression to a mo-

mentary apparition: for his real drama is the pursuit of this ever-fleeting vision.

.

Picasso's career does not consist of a series of long, well-defined stages; the periods overlap. He advances or retreats as the mystery dictates; an impulse greater than himself drives him from one type of expression to another. Of course he dominates these revelations and imposes them each time with almost perfect technical mastery. But that mastery is innate, and the canvases are never mere studies. Collected in the order in which they were produced, they form a dramatic record of the life of a haunted artist.

One of the essential features of Picasso's visions is that he does not dwell on them with complacency or enjoyment. Others may give their painting a more poignant quality, or make more play with the strangeness of their apparitions. Though less important than Picasso they may sometimes touch us more closely, like Baudelaire compared to Victor Hugo. We find it easier to discern an element of pure poetry in their pictures, though it often slips in by way of literature. With Picasso there is no literature and no intellectual abstraction. What makes his work great is the suddenness and brutality of the thing seen. It is a force sure of itself, like lightning or a thunderbolt, and yet to the attentive observer even the severest canvases – still lifes, views from windows, inanimate objects – are full of a controlled emotion that recalls the moving despair of the painter's young days.

It is not the least surprising fact of Picasso's career that he has become the head of a new school. A team formed around him; each of its members soon developed a trick of his own and began to turn out paintings according to a pleasant formula. Then the theorists came on the scene.

Cubism became a reaction of classical art against the sloppiness of Impressionism. A legend got about that Picasso had disavowed Cubism, that he did not want the credit for inventing it. In any case he is certainly pretty much of a stranger to that school.

No doubt he is a classicist by virtue of the spontaneous perfection of his technique. But the very root of his personality is that his painting springs from a tragic doubt as to the apparent reality of the universe of forms. Those who follow, criticize or blissfully admire him should not be too sure of themselves. In him as in every great artist the spirit of revolt is stronger than faith, his faith in the outside world. The liberty thus gained may lead Picasso much further in the direction of reversal and re-creation.

From Léon Pierre-Quint, 'Doute et révélation dans l'oeuvre de Picasso', *Documents* vol. 2 no. 3, Paris, 1930, pp. 134–7; translated from French by P. S. Falla.

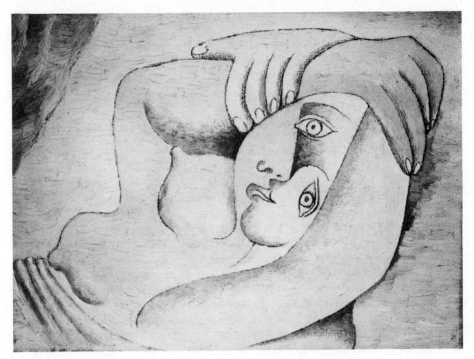

Reclining woman, 1929 (illustrated with Pierre-Quint's article). Marina Picasso
Foundation.

6.
The thirties

1931–1939

In 1931 Picasso was fifty years old and his life and work were once again in the process of change. His marriage with Olga was breaking up, there was a new woman in his life, Marie-Thérèse Walter, and his decision to take a large studio outside Paris in Boisgeloup that year led to a rich period of sculptural production. Picasso's return in the previous decade to a classicizing style was basically over, and his increasingly violent distorted forms were described by some critics, such as Waldemar George, as poetic statements that corresponded with modern neuroses. In fact, the Picasso myth had grown so large that much of early thirties' criticism tended to search for an explanation of his work by discussing his inner psyche in order to understand better the idea of the creative process in general. Jung's study of 1932 is, of course, one of the principal examples of this approach. In this connection, Picasso's restless creativity that was expressed in his many-sidedness was regarded in the thirties as more than formal experimentation, for in this continually changing evolution it was thought that he would open up new perspectives and unknown regions of artistic expression.

The 1930s also represented a period of political upheaval that directly affected Picasso and is expressed in his work and in critical response to it. Picasso's last trip to Spain was made in 1934, just two years prior to the outbreak of civil war in his native country, to which he would never return in person, although he did so often in his work. A renewed interest in Spanish types, such as bullfighters and Spanish majas, often combined with mythological minotaurs occurs in his paintings, prints and drawings. The minotaur, the figure created by the juxtaposition of the head of a bull (without human reason) and the body of a man (with all of man's physical desires) was also a favourite image among the Surrealists, for whom Picasso had designed the cover of the first issue of the journal called Minotaure in 1933.

When Picasso painted Guernica for the Spanish pavilion at the Paris International Exhibition of 1937, it was from his Spanish heritage that he drew his inspiration. In fact, his 1934 visit to Barcelona had included inspection of Catalan romanesque frescoes, and these should also be considered in connection with Guernica for the power of their flat, expressive design. Guernica, in turn, generated a great number of critical and poetic essays and many of these were published in Zervos's Cahiers d'Art in 1937.

Zervos's own article traces the development of the painting through stages just as Dora Maar had photographed them, as if to make a psychological study of the creative process itself.

Writers such as José Bergamin emphasized the artist's temperament in order to explain the expressive power of Guernica, but temperament in the sense of his cultural and artistic inheritance rather than his individuality. In this way Bergamin connects Picasso and Guernica to Goya and Madrid, The Third of May 1808, because both drew upon the 'Spanish fury' of their cultural background to express the rage of the Spanish people in civil war in compelling artistic form. In his essay of the following year Herbert Read attempted to explain the painting's universality of meaning as a monument of destruction, a cry of outrage 'amplified by the spirit of genius' echoing the shock of the world in modern terms.

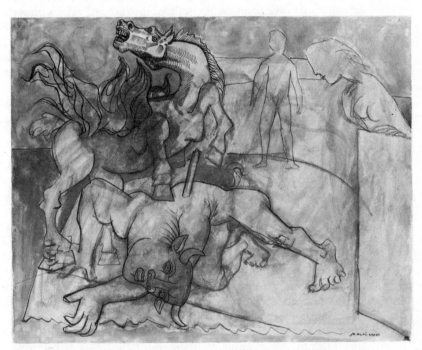

Composition with wounded minotaur, horse and couple, 1936. Musée Picasso, Paris.

1931 Waldemar George
Picasso's 50th birthday and the death of still life

The salient feature of modern art is the death of the world considered as a huge still life. This death seems irremediable. It is not a mere alarm or a fit of lethargy: it is the conclusion, the normal end of a cycle or period. And how lucky we are to be the grave-diggers of a genre so unworthy of Western man! For a still life is not a subject, it is the expression of a state of mind: the only religion to which an atheistic society has given birth. Although it has inspired masterpieces, still life is an admission of creative impotence. It purports to turn flowers and fruit, faces and localities into soulless objects and patches of colour. It is the direct expression of an attitude of mind which inverts the natural order. Man, incapable of articulating bodies and bringing them into action, prides himself on this inability to transmit sensations of life. Cubism, which was interpreted as a liberation, has served only to divorce man from the world. The truth of this is not invalidated by the experiments, the learned calculations and speculations of cubist painters in search of a law and a sacred measure. A law is an effect; it is never a cause or a point of departure.

In mid-crisis and as Pablo Picasso approaches his fiftieth birthday, we must put our cards on the table. Picasso, a figure-painter, has not always been a painter of repression. He has had other masters than the Scythian nomads. At twenty-four he realized the adolescent type, the type of perfect humanity, the physical and intellectual ideal of the Greeks and the Quattrocento. Amid the disarray of 'still-life-ism' he understood that man, the human being, was more than simply a ductile, malleable motif.

Twenty years later, in 1925, when he drew dancers at work, Picasso rediscovered the sense of gravity, dignity, rhythm and balanced power. But the humanistic vein is an exception, an obscure by-way in the life and work of this child of the age. Picasso withdraws into himself, pays heed to his voices, listens to the familiar demons that haunt him, and apparently no longer wishes to externalize his dreams or embody them in a universal shape – I mean 'universal', not 'generally known'. His demons are poetic facts that correspond to a collective reality of the moment, a modern neurosis, a thirst for mystery, an obscure escapism typical of a godless age. They are not dominants of an era or constants of European art, by which the white race ensures its historical survival and identity. The chimeras of Pablo Picasso are destined to be dumb still lifes, astoundingly impressive assemblages of form and colour, but not sources of energy or the foci of a Mediterranean civilization.

Picasso's geometrical style is the manifestation of a dualistic age oriented towards rationalism, making light of the affections of the heart but ravaged by a *horror vacui*. It is a transmissible style that spreads around the world like wildfire, culminating in industrial art and exhausting its possibilittities.

Picasso's monumental style, also called Roman or Michelangelesque, is too abstract a form not to engender an academic style. His ideography is as disquieting as a complex. But his tragic adolescents of the Rose Period, the only figures he has created that are full of life, extend a fraternal hand, through time, to the young men of today.

Waldemar George, 'Les cinquante ans de Picasso et la mort de la nature-morte', *Formes* **no. 14, Paris, April 1931, p. 56; translated from French by P. S. Falla.**

On the occasion of an exhibition of Picasso's works at the Kunsthaus, Zurich, in 1932, and at the invitation of the Neue Zürcher Zeitung *the Swiss psychiatrist Carl G. Jung devoted an article to the psychology of Picasso's art. Christian Zervos published the major part of that article in* Cahiers d'Art *in 1932 in French translation and added his own observations about Jung's essay, with which he took issue. His disagreement rested on Jung's methodology, which failed to take into account the formal evolution and the art-historical context of Picasso's art.*

Their arguments counter each other almost predictably throughout: Jung argues from the particular to the general: in the objective Blue Period pictures, such as Evocation *(z. 1. 55, which he describes on p. 138, but does not name, and which was in the Kunsthaus show in Zurich), he begins with the colour blue, and associates it with 'the blue of night' and 'the Egyptian underworld'. Death is represented by Picasso's soul (although this is an evocation of Casagemas) on horseback and a woman, who is day. Then Jung further generalizes: since night and day are, according to him, sides of the soul, Picasso thus demonstrates that he suffers the 'underworld fate' and is drawn into the dark following a 'demoniacal attraction of ugliness and evil'.*

Zervos, on the other hand, starts with the general: the subject matter of the Blue Period was fashionable in Barcelona among painters of that time, and Picasso worked from these and other art-historical influences to the particular work. Neither Zervos nor Jung mentions the very well-known personal sources for Evocation, *the death of his friend Casagemas, whose suicide was provoked by his failed love-affair (attributed to his impotence) with Germaine.*

The fascination during the 1930s with Freud, psychoanalysis, and interpretations of the subconscious and dream world makes Jung's contribution to Picasso bibliography certainly a timely one, for this attempt at psychological interpretation is characteristic of the period and enters into critical writing in general.

1932 Carl G. Jung
Picasso

Non-objective art draws its contents essentially from 'inside'. This 'inside' cannot correspond to consciousness, since consciousness contains images of objects as they are generally seen, and whose appearance must therefore necessarily conform to general expectations. Picasso's object, however, appears different from what is generally expected – so different that it no longer seems to refer to any object of outer experience at all. Taken chronologically, his works show a growing tendency to withdraw from the empirical objects, and an increase in those elements which do not correspond to any outer experience but come from an 'inside' situated behind consciousness – or at least behind that consciousness which, like a universal organ of perception set over and above the five senses, is orientated towards the outer world. Behind consciousness there lies not the absolute void but the unconscious psyche, which affects consciousness from behind and from inside, just as much as the outer world affects it from in front and from outside. Hence those pictorial elements which do not correspond to any 'outside' must originate from 'inside'.

As this 'inside' is invisible and cannot be imagined, even though it can affect consciousness in the most pronounced manner, I induce those of my patients who suffer mainly from the effects of this 'inside' to set them down in pictorial form as best they can. The aim of this method of expression is to make the unconscious contents accessible and so bring them closer to the patient's understanding. The therapeutic effect of this is to prevent a dangerous splitting-off of the unconscious processes from consciousness. In contrast to objective or 'conscious' representations, all pictorial representations of processes and effects in the psychic background are *symbolic*. They point, in a rough and approximate way, to a meaning that for the time being is unknown. It is, accordingly, altogether impossible to determine anything with any degree of certainty in a single, isolated instance. One only has the feeling of strangeness and of a confusing, incomprehensible jumble. One does not know what is actually meant or what is being represented. The possibility of understanding comes only from a comparative study of many such pictures. Because of their lack of artistic imagination, the pictures of patients are generally clearer and simpler, and therefore easier to understand, than those of modern artists.

Among patients, two groups may be distinguished: the *neurotics* and the *schizophrenics*. The first group produces pictures of a synthetic character, with a pervasive and unified feeling-tone. When they are completely abstract, and therefore lacking the element of feeling, they are at least definitely symmetrical or convey an unmistakable meaning. The second group, on the other hand, produces pictures which immediately reveal their alienation from feeling. At any rate they communicate no

unified, harmonious feeling-tone but, rather, contradictory feelings or even a complete lack of feeling. From a purely formal point of view, the main characteristic is one of fragmentation, which expresses itself in the so-called 'lines of fracture' – that is, a series of psychic 'faults' (in the geological sense) which run right through the picture. The picture leaves one cold, or disturbs one by its paradoxical, unfeeling, and grotesque unconcern for the beholder. This is the group to which Picasso belongs.

In spite of the obvious differences between the two groups, their productions have one thing in common: their *symbolic content*. In both cases the meaning is an implied one, but the neurotic searches for the meaning and for the feeling that corresponds to it, and takes pains to communicate it to the beholder. The schizophrenic hardly ever shows any such inclination; rather, it seems as though he were the victim of this meaning. It is as though he had been overwhelmed and swallowed up by it, and had been dissolved into all those elements which the neurotic at least tries to master. What I said about Joyce holds good for schizophrenic forms of expression too: nothing comes to meet the beholder, everything turns away from him; even an occasional touch of beauty seems only like an inexcusable delay in withdrawal. It is the ugly, the sick, the grotesque, the incomprehensible, the banal that are sought out – not for the purpose of expressing anything, but only in order to obscure; an obscurity, however, which has nothing to conceal, but spreads like a cold fog over desolate moors; the whole thing quite pointless, like a spectacle that can do without a spectator.

With the first group, one can divine what they are trying to express; with the second, what they are unable to express. In both cases, the content is full of secret meaning. A series of images of either kind, whether in drawn or written form, begins as a rule with the symbol of the Nekyia – the journey to Hades, the descent into the unconscious, and the leave-taking from the upper world. What happens afterwards, though it may still be expressed in the forms and figures of the day-world, gives intimations of a hidden meaning and is therefore symbolic in character. Thus Picasso starts with the still objective pictures of the Blue Period – the blue of night, of moonlight and water, the Tuat-blue of the Egyptian underworld. He dies, and his soul rides on horseback into the beyond. The day-life clings to him, and a woman with a child steps up to him warningly. As the day is woman to him, so is the night; psychologically speaking, they are the light and the dark soul (anima). The dark one sits waiting, expecting him in the blue twilight, and stirring up morbid presentiments. With the change of colour, we enter the underworld. The world of objects is death-struck, as the horrifying masterpiece of the syphilitic, tubercular, adolescent prostitute makes plain. The motif of the prostitute begins with the entry into the beyond, where he, as a departed soul, encounters a number of others of his kind. When I say 'he', I mean that personality in Picasso which suffers the underworld fate – the man in him who does not turn towards the day-world, but is fatefully drawn into

the dark; who follows not the accepted ideals of goodness and beauty, but the demoniacal attraction of ugliness and evil. It is these antichristian and Luciferian forces that well up in modern man and engender an all-pervading sense of doom, veiling the bright world of day with the mists of Hades, infecting it with deadly decay, and finally, like an earthquake, dissolving it into fragments, fractures, discarded remnants, debris, shreds, and disorganized units. Picasso and his exhibition are a sign of the times, just as much as the twenty-eight thousand people who came to look at his pictures.

When such a fate befalls a man who belongs to the neurotic group, he usually encounters the unconscious in the form of the 'Dark One', a Kundry of horribly grotesque, primeval ugliness or else of infernal beauty. In Faust's metamorphosis, Gretchen, Helen, Mary and the abstract 'Eternal Feminine' correspond to the four female figures of the Gnostic underworld, Eve, Helen, Mary and Sophia. And just as Faust is embroiled in murderous happenings and reappears in changed form, so Picasso changes shape and reappears in the underworld form of the tragic Harlequin – a motif that runs through numerous paintings. It may be remarked in passing that Harlequin is an ancient chthonic god.

The descent into ancient times has been associated ever since Homer's day with the Nekyia. Faust turns back to the crazy primitive world of the witches' sabbath and to a chimerical vision of classical antiquity. Picasso conjures up crude, earthy shapes, grotesque and primitive, and resurrects the soullessness of ancient Pompeii in a cold, glittering light – even Giulio Romano could not have done worse! Seldom or never have I had a patient who did not go back to neolithic art forms or revel in evocations of Dionysian orgies. Harlequin wanders like Faust through all these forms, though sometimes nothing betrays his presence but his wine, his lute, or the bright lozenges of his jester's costume. And what does he learn on his wild journey through man's millennial history? What quintessence will he distil from this accumulation of rubbish and decay, from these half-born or aborted possibilities of form and colour? What symbol will appear as the final cause and meaning of all this disintegration?

In view of the dazzling versatility of Picasso, one hardly dares to hazard a guess, so for the present I would rather speak of what I have found in my patients' material. The Nekyia is no aimless and purely destructive fall into the abyss, but a meaningful *katabasis eis antron*, a descent into the cave of initiation and secret knowledge. The journey through the psychic history of mankind has as its object the restoration of the whole man, by awakening the memories in the blood. The descent to the Mothers enabled Faust to raise up the sinfully whole human being – Paris united with Helen – that *homo totus* who was forgotten when contemporary man lost himself in one-sidedness. It is he who at all times of upheaval has caused the tremor of the upper world, and always will. This man stands opposed to the man of the present, because he is the one who ever is as he was, whereas the other is what he is only for the moment. With my

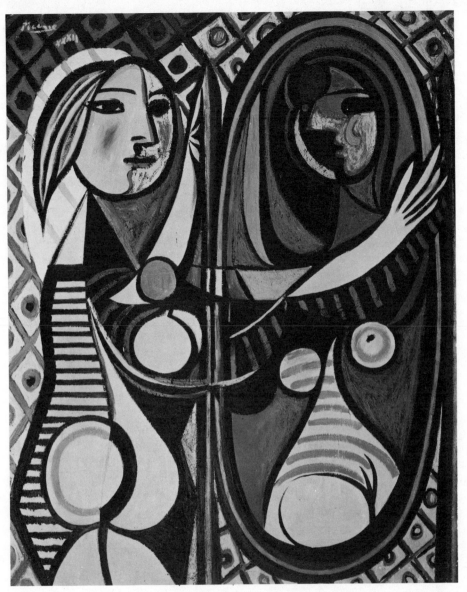

Girl before a mirror, 1932; oil on canvas, 162.3 × 130.2cm. The Museum of Modern Art, New York.

patients, accordingly, the *katabasis* and *katalysis* are followed by a recognition of the bipolarity of human nature and of the necessity of conflicting pairs of opposites. After the symbols of madness experienced during the period of disintegration there follow images which represent the coming together of the opposites: light/dark, above/below, white/black, male/female, etc. In Picasso's latest paintings, the motif of the union of opposites is seen very clearly in their direct juxtaposition. One painting (although traversed by numerous lines of fracture) even contains the conjunction of the light and dark anima. The strident, uncompromising, even brutal colours of the latest period reflect the tendency of the unconscious to master the conflict by violence (colour = feeling).

This state of things in the psychic development of a patient is neither the end nor the goal. It represents only a broadening of his outlook, which now embraces the whole of man's moral, bestial, and spiritual nature without as yet shaping it into a living unity. Picasso's *drame intérieur* has developed up to this last point before the dénouement. As to the future Picasso, I would rather not try my hand at prophecy, for this inner adventure is a hazardous affair and can lead at any moment to a standstill or to a catastrophic bursting asunder of the conjoined opposites. Harlequin is a tragically ambiguous figure, even though – as the initiated may discern – he already bears on his costume the symbols of the next stage of development. He is indeed the hero who must pass through the perils of Hades, but will he succeed? That is a question I cannot answer. Harlequin gives me the creeps – he is too reminiscent of that 'motley fellow, like a buffoon' in *Zarathustra*, who jumped over the unsuspecting rope-dancer (another Pagliacci) and thereby brought about his death. Zarathustra then spoke the words that were to prove so horrifyingly true of Nietzsche himself: 'Your soul will be dead even sooner than your body: fear nothing more!' Who the buffoon is, is made plain as he cries out to the rope-dancer, his weaker *alter ego*: 'To one better than yourself you bar the way!' He is the greater personality who bursts the shell, and this shell is sometimes – the brain.

Carl G. Jung, 'Picasso', *Neue Zürcher Zeitung* CLIII:2, Zurich, 13 November 1932; translated in vol. 15 of Jung's *Collected Works*, London and New York, 1966, pp. 136–41.

1932 Will Grohmann
Dialectic and transcendence in Picasso's work

Even in works that do not yield up their meaning at first glance, Picasso's art remains alive and rich in resonance. At every level of its evolution it has remained precise and full of significance. A fact and a cipher. This is as true of individual works as it is of the oeuvre as a whole. Picasso's stance

is that of a man who consciously makes every step in his development his own; who draws no conclusions from the situation which prevails at a given moment but freely, responsibly and consciously decides on his own next step. His artistic consciousness is constantly stimulated by what he himself knows of that same consciousness. This restless state of mind divides him, pits him constantly against himself and against the world, forces him to see and to create in antitheses, in pursuit of a goal which remains unknown both to him and to us. The painter attaches no importance to concealing this dialectic; on the contrary, to him constant tension is a source of total freedom, which enables him to escape the peril of compulsiveness or predictability, and to keep his vision clear for the transcendent reality which, like every great artist, he seeks to evoke.

Picasso does not rest content with seeing an entity as a whole from outside; or even with the ability to generalize from partial insights: he stays in suspense, and carries every creative act through to the point where it tips over into its opposite. Hence the many-sidedness and the contrasts of his development; which can be seen as random only by those who fail to recognize the nature of his basic artistic stance.

These antitheses can be traced, from craftsmanship, by way of the intellectual, to the transcendental; with the result that the Picasso phenomenon takes on no finished shape but constantly opens up perspectives which hint at what might be. In the first ten years of his evolution the antitheses followed one another in slow successive phases; later he progressively emancipated himself from time, so that by the 1920s the process can be observed in operation from one picture to the next.

Painterly quality is carried to a pitch of technical perfection, which then leads to its antithesis in the emphatic materiality of *papiers collés* and tactile surfaces; and this structure in turn is refined until planar representation gives way to an extreme degree of sculptural modelling. The object swings between utter concrete reality (not imitation), at one extreme, and the role of a function of consciousness, at the other. The form oscillates between delineation and action. The opposition of concept and percept, reason and instinct, within the individual work, is not an oscillation between two poles but an acknowledgment of the true purpose of man's intellectual and creative powers: constantly to put himself and his world to the test; not to use antitheses to arrive at a comfortable synthesis, but to abandon the quest for a definitive resolution in favour of a truth which cannot be grasped but only intuited. To ask what abstract art means is self-contradictory: the abstract, like the concrete, is the absolutization of randomness. And so are the poetic and the prosaic, the mathematical and the human. Seen in this light, all Picasso's contradictions are resolved into the most perfect unity and the most disciplined liberty.

In art, we do not customarily find the twin poles, inner and outer, set so far apart; still less are we used to seeing their antithetical nature positively stressed. In this respect, also, Picasso appears as a rare exception. But if one recognizes the true basis of his artistic life, this painter's work

becomes an almost limitless reservoir of artistic possibilities. We behold something that is more than we ourselves are.

Picasso once made the much misunderstood statement that art is a lie which makes it possible to recognize the truth. By this he meant that it is a hypothesis directed at knowing the nature of the world: not the real world but the super-real or surreal world; as art is always a cipher for what transcends sensory perception. Picasso does not rest content with polarity but transforms it into tension: into a state in which decisions can be freely made; a state from which he transcends himself and the world. Each one of his pictures is a cipher born of an intuitive comprehension of the world order. As this cipher has as yet no place in the harmonic scheme of a consensus view of the world, its form as a sign seems to us at times confused and hard to understand. We are at a point in evolution which compels us to eschew definitive formulations; to wait and watch to see whether, from decisions taken moment by moment, a more valid and absolute decision will grow. What is transcendental in our time is not to be grasped in purely religious, or in purely philosophical, or in purely artistic terms. All that is certain is that man is seeking to break out of the mental space in which he has lived for a century; that he seeks to transcend himself in the sense of which Nietzsche and Kierkegaard speak; and that he has the desire to make his own decisions, at every instant, for himself and for the world in which he lives. Picasso has so succeeded in conveying this transcendental idea, in gaining credence for it, and in adapting his own means of expression to it, that he is understood all over the world and has enjoyed a public response such as few painters have ever had. One is tempted to surmise that, out of the prevailing chaos of today's world, there has grown a desire for a concensus concerning things of a higher order.

For the time being, it remains a mystery how, in spite of a multiplicity of problems of detail, Picasso has achieved so clear and so comprehensive a result. Comprehensiveness and clarity balance each other: the complexity of his statements never detracts from their uncompromising firmness; and their clarity is never obtained at the expense of oversimplification. It used to be possible to speak at times of a 'simultaneity' of optical impressions in a picture; there is now a simultaneity of all mental powers – including those that are directed towards the beyond.

Will Grohmann 'Dialektik und Transzendenz im Schaffen Picassos', *Cahiers d'Art* **vol. 7 no. 3–5, Paris, 1932, p. 156; translated from German by David Britt.**

Carles Capdevila
Picasso at the Barcelona Museum

We are not referring to new acquisitions nor to the works of the famous painter now in the catalogue of the municipal collection, but to the man, to the flesh-and-blood Picasso who visited the galleries of the Museum which are to be opened next month. Since Picasso and his family are in Barcelona for a few days, the directors of the Museum have invited him to visit the new installations in the National Palace where the municipal holdings have been considerably increased with the acquisition of the Plandiura collection.

The insipid and banal architecture of the halls of the enormous Palace has been cleverly disguised by the placement of the romanesque frescoes and genuine architectural fragments, so that one would need a guidebook to make out the original structure of those rooms. The whole first floor, transformed in this way, is devoted to painting and sculpture from the primitive period to the beginning of the Baroque: from the impressive romanesque frescoes it goes chronologically up to the Catalan eighteenth century. The second floor will be devoted to modern Catalan painting from the early nineteenth century to the present; Picasso will be very well represented here with pre-cubist works.

From one room to the next, Picasso, looking at those incomparable fragments of primitive Catalan art, admired their strength, their intensity, their mastery; their firmness of vision and execution: the daring and conviction with which the hand of the unknown artists had expressed on those walls the ideas and feelings of their spirit. Picasso was sure that our romanesque museum would be unique in the world, essential for those who want to understand the origins of Western art, an invaluable lesson for the moderns.

Picasso's visit has also, unexpectedly, shown a different aspect of the man; we have come into contact with a much more human Picasso, quite different from the enigmatic and elusive man he is reputed to be. Picasso is undoubtedly one of the most exceptional and complex figures in contemporary world art. One automatically imagines him always armed with cautious discretion, always ready to launch into subtle aggression or to protect himself with deliberate aloofness. Fame, when given so liberally to a man, has these turns. Much literature has been created around his personality; people's imagination, provoked by envy or by self-interest, has worked over the details of his life and his views on art so much that it is now difficult to approach him without prejudice. It is not his fault if there have been many misunderstandings about him; no doubt it has often happened that he has been surprised and embarrassed by the tone of conversation around him.

The Picasso of two days ago was such an accessible and cordial Picasso, so ready for friendly discussion that we talked for hours unaware of the

time. The Museum had proved an admirable go-between; Picasso had been so deeply touched by it that he talked freely about the memories of his youth in Barcelona. An antique door installed in a small room, a fragment of painting he happened to see, the retable of the Virgin of the Councillors . . . recalled to him his Barcelona years. A sketch by Martí i Alzina made in a studio on Riera de Sant Joan reminded him that he too had worked in that studio and had also sketched the terraces and bell towers of old Barcelona. Casas's collection of charcoal portraits brought back to him many friends and acquaintances from the city, and many episodes and anecdotes. None was more touching than his own portrait, as a bohemian barely past adolescence, drawn by Casas with rare fidelity more than thirty years ago.

At lunch, using a mixture of Catalan, French, and Spanish, which lent an improvisatory tone to the dialogue, Picasso continued his reminiscences of those times, when as a young prodigy he first found friends and admirers. Luckily there was no reference to aesthetic theories or artistic problems, which would not have suited the Mediterranean splendour of the afternoon. We spoke of people, of friends, of Catalans now scattered around the world who long for home, of those who had died and those who remain. And with the warmth of those memories, it seemed as if the cosmopolitan painter, admired throughout the world, had come home.

Without our noticing it the conversation turned to the lucidity that painters acquire with age. We mentioned 'papa' Corot, Harpigny, Renoir – all models of fruitful old age – and Degas, who died virtually the day he was forced to move. In Picasso's calm and assured voice, in his thick-set appearance, in the tone of his words as he described his cottage in Normandy, one sensed a silent, fertile promise. As he left he told us that he was going home the next day. He had taken a month's vacation to tour the north of Spain in his 'Hispano'.

'I have to go home;' he said, 'I must work.'

And as his car sped away, I thought that the word 'work' had acquired a special meaning. The final note of the conversation, the tone of the painter's warm, human observations suggested to me that Picasso had undergone a profound change. I may have been the unconscious victim of the charm of those unforgettable hours – I don't know – but for a while I had the impression that the great restless man had laid down Yorick's skull for ever, having brooded over it with such care, and he now faced the world with joyous humility, guided by that lucidity which is only granted after long, fruitful years. I have always said that Picasso has not yet spoken his last word. The energy and vitality, the self-confidence and the spiritual calm which pervade his whole personality ensure that his talent still has in store works which will increase the honour of his name. Barcelona will keep the works of this universal painter among those of its most outstanding artists. It would have been a mistake and an injustice to exclude him from our family of artists, for Picasso has not forgotten that Barcelona was the home of his artistic youth, and he has now confirmed

this memory with unforgettable generosity. Barcelona sincerely wishes to return this generosity, and its inhabitants are happy and honoured to devote some space to the works of the great artist; we would be happy, however, to see a larger sample of the works of the Picasso of the present and the Picasso of the future.

Carles Capdevila, 'Picasso, al Museu', La Publicitat, Barcelona, 6 September 1934, p. 1; translated from Catalan by Miquel Sobré.

A special issue of Cahiers d'Art *dated 1935 (which actually came out in 1936) was dedicated to Picasso and coincided with the first major show of his works held in Spain since his earliest exhibitions in Barcelona in 1900, 1901 and 1912. The show was organized by ADLAN (Amics de l'Art Nou) and held at the Sala Esteve in Barcelona. One of the organizers, the Catalan architect Josep Lluís Sert, stated in an interview that appeared in the Barcelona newspaper* La Noche *(17 January 1936) that the primary goal of ADLAN had been to introduce Picasso to Barcelona in his role as a revolutionary in art: 'If Picasso is a revolutionary,' Sert explained, 'his aim has been to undermine painting which is moulded and created according to bourgeois taste. . . . Picasso's painting is an attack, a rebellion against what is accepted – in technique, in subject matter, and in its goals.'*

Salvador Dalí's contribution to the Cahiers d'Art *issue included the following invitation to the exhibition, in addition to an article entitled 'Les Pantoufles de Picasso'. Paul Eluard's 'Je parle de ce qui est bien', which also follows, had originally been presented as a speech in Barcelona, Madrid and Bilbao, in connection with the ADLAN exhibition.*

1935 Salvador Dalí
Invitation to the Picasso exhibition, Barcelona

Salvador Dalí is pleased to invite all unburied rotting corpses, all painters of crooked trees, in the more or less rural tradition, all the members and patrons of the Catalan Choral Society to visit the *Picasso* exhibition.

The *Picasso* exhibition will be the extravagant station where we shall see for the first time the arrival in our country of the express train – first class only – of the Iberian intelligentsia and genius, thirty years late. Responsibility for this phenomenal delay lies mainly with the exquisite corpses of the local intellectuals and artists, exquisitely leaning on the railings of their manorial balconies from which, as we all know, one can see nothing but the overwhelming monotony of our succulent, high-class, countryside, full of manure, with an occasional cow, perfectly blind,[1] totally infamous.

(One hears the deep sadness of the cow's moan.)

It is very possible that the local critics and 'good-for-nothings' may want to explain to you that Picasso's painting is some magnificent bunch of flowers: amiable, elegant, decorative, definitively incorporated in the 'point de vue de "Vogue" '. Don't you believe them. Picasso's sensational painting is closer to a rabid fighting bull, colossally putrid and realistic, the symbol, essence, and substance of all that is darkest and most turbulent, in the deepest and most delicate roots of the human spirit, 'subconscious thought', and you may be sure that, in this case, Cubism is nothing more than the very bone of this putrid bull, the impeccably white bone, the bone you see, the bone you know, from the very tip of his big toe! . . .

It is equally possible that they may want to explain to you that the extravagant paintings by *Picasso* are just a sort of measles 'which will go away' or perhaps the subtle product of a refined and special 'humour'; but when they tell you about *Picasso*'s humour remember that it is rather the very white bone, the terrible bone, the bone you know – in the tip – of his big – toe!

> (The sound of a fierce north wind
> is heard that lasts until the end of the poem.)
>
> In Cap de Creus there is also a putrid ass!
> But that one
> Presents a different form and aspect,
> The Cap de Creus putrid ass
> Looks like an immense and very ancient automobile
> Carved in pink marble
> At the edge of a bluff,
> Hanging on the abyss
> With the pose
> Of the Samothrace Victory;
> From one of the cracks of the autofossil
> An inexhaustible fountain of milk
> Pours forever on the sea,
> And this milk
> Is nothing but
> The horrific and very white bone,
> The bone you know,
> The bone you know – at the tip – of his big,
> Big toe!
> Listen to the sweeter than honey music
> Coming from . . . Picasso's imaginative machine gun.

Untitled (signed Salvador Dalí), from *Cahiers d'Art* vol. 10 no. 7–10, Paris, 1935, pp. 187–8; translated from Catalan by Miquel Sobré.

[1] Allusion to Joan Maragall's *modernista* poem 'La vaca cega', The Blind Cow.

Picasso had first met the Catalan sculptor Juli González at Els Quatre Gats in Barcelona in 1902. Their renewed friendship, beginning in 1928, was a significant factor in Picasso's experimentation with welded sculpture, on which he worked in González's studio on rue de Médéah.

1935 Juli González
From Paris

A most commendable initiative has been taken by the ADLAN group to acquaint the public with the best works of great artists, who deserve to be considered among the most distinguished in Modern Art.

This group had the good fortune to begin with the works of our own genius, Picasso; we are sorry to learn that, in his own country, none of his canvases has been officially purchased by any museum.

Picasso was one of the first who in Paris, some thirty years ago, began the bitter fight – along with other artists of that time – to break with routine and empty traditions and to oppose the old theories with new ideas.

The struggle that took him to his goal was almost heroic. Picasso, with his inventiveness and with his brilliant solutions to all sorts of problems, was from the start considered the leader of that innovative group.

I have no doubt that this present show of art will be most valuable for artists and will ultimately benefit Catalan art.

The whole world admires Picasso, everybody wants him for himself. They all want to give him a mother country. Some, because of his background, make him French. Others, because of his psychology, make him German. Because of his imagination, others want him to be Spanish. Picasso listens to all this and says: 'They can say what they want.'

Yes, our Picasso's art deserves to be claimed by every country. Picasso may be influenced by a thousand things, but what is interesting in him, what characterizes him, what characterizes a Greek, Italian, Chinese or Negro artist is almost inevitably the influence of the milieu of his formative years, the influence of the place where he spent his youth.

I have known Picasso for more than thirty years, and whenever I have seen him and talked to him – which has happened often – we have talked about Catalans, and he has spoken nostalgically of Barcelona, of Perpignan. He remembers their festivals, their traditions, *sardana* dancing, fairs, demonstrations, and all kinds of events, and he remembers things in great detail. Everything Catalan is of interest to him. He is 'ours'. A ribbon-size Catalan flag which he keeps religiously in his pocket will convey to you the profound love he feels for the Catalan country, for the country of his youth.

So many fond memories, so many beautiful thoughts, so many yearnings to see you again, when I hear him say: 'Only "in that place" would

one be happy. . . .' Such love, such affection, such nostalgia pervading his life, will they not lend a particular character to the works of the artist? Why should this place not be his mother country rather than all the other ones that people want to impose on him? Is it not precisely in his works where the characteristics of a school or of a country are found? . . . And do we not detect in the background of some of his works, even recent ones, a tragedy – the tragedy of life, and also – why not – the tragedy of his own country and of Catalan art?

It gives me great pleasure, by right of good fellowship and grateful admiration, to bring you his message, to be able to tell you, with noble pride: Here is our Picasso.

Juli González, 'Desde Paris', *Cahiers d'Art* vol. 10 no. 7–10, Paris, 1935, p. 242; translated from Catalan by Miquel Sobré.

1935 Paul Eluard
I speak of what is right

There are men who have fully proved themselves in their lives and of whom one need only say that they have been in the world to feel that they are here to stay. Of these Pablo Picasso is one of the greatest. Having conquered the world he had the courage to turn it against him, being certain, not of victory, but of encountering a worthy opponent. 'When I have no blue, I use red,' he used to say. Instead of a single straight line or a curve, he shattered a thousand lines that found in him their unity and their truth. Flaunting conventional ideas of objective reality, he re-established contact between the object and the spectator, who sees and therefore conceives it: in the boldest and most sublime manner, he restored to us the inseparable proofs of the existence of mankind and of the world.
.
The irrational, having wandered for all time in dark or dazzling chambers of the mind, has at last taken its first rational step in those of Picasso's paintings that are absurdly called cubist; and that step has at last given it its *raison d'être*.

Picasso has created fetishes, but these fetishes have a life of their own. They are not only signs of intercession, but signs in motion, and that motion gives them concrete reality once more. These geometrical figures and cabalistic signs representing men, women, statues, tables and guitars once again become men, women, statues, tables and guitars – more familiar than before, because they are now comprehensible, accessible to the mind as well as to the senses. What is called the magic of colour and design returns to nourish all that surrounds us, and ourselves as well.

It has been said that using things and their relationships in order to study the world scientifically is not only our right but our duty. To this it should be added that this duty is the duty of living – not after the manner of those who carry their death about with them and are already no more than a wall or a vacuum, but living as an integral part of the universe, a universe in a state of motion and development. Thought should not regard itself merely as a process of scrutiny or reflection but as a motive, panic, universal element, the relationships among things being infinite in number.

Picasso seeks after truth. Not that fictive truth that will always leave Galatea inert and lifeless, but an all-embracing truth that unites imagination with nature, considers everything real, moves incessantly from the particular to the universal and back again, and accommodates itself to all varieties of existence and of change provided only that they are new and fruitful.

Only when things are grasped in their complication do they cease to be indescribable. Picasso painted the simplest objects in such a way as to make everyone who saw his work both capable and desirous of describing them. For the artist as for primitive man, there are no concrete and no abstract forms: there is only communication between what sees and what is seen, an effort of understanding and relating, and sometimes of determination and creation. To see is to understand, judge, distort, imagine, forget or forget oneself, be or disappear.

I call to mind Picasso's famous *Woman in an armchair*,[1] which I have known for nearly twenty years and which has always seemed to me so elementary and so extraordinary. The huge, sculptural mass of the woman in her armchair, her head as big as the Sphinx's, her breasts as if riveted to her chest, form a marvellous contrast – never thought of by the Egyptians, the Greeks, or any other artist before Picasso – with the delicate features of the face, the wavy hair, the delightful armpit, the prominent ribs, the vaporous garment, the soft, comfortable armchair and the daily paper.

I think of the pictures called *Ma Jolie*,[2] as devoid of colour as things are which one knows well and is used to seeing. They do not arise out of space, they themselves are space, contained by the limits of the painting, like the curls of smoke filling the whole room, limitless and precise. Neither the limits of the painting nor those of the room set bounds to my fancy – the whole world is there, composing, decomposing and recomposing. O memory, vague but essential, I know what the night outside contains, what the invisible groups together, what forms it envelops; it is within me, light or peremptory. I see into myself – Picasso has extracted the crystal from its matrix.

In *Surrealism and Painting*, André Breton wrote of Picasso: 'It was due to

a lack of will on this man's part that the game we are playing ended in a draw if not a loss.' Yes, for this man held in his hand the fragile key to the problem of reality. His aim was to see that which sees, to liberate vision and achieve clairvoyance, and in this aim he was successful.

Language is a social phenomenon; may we not hope that drawing, like language and writing, will one day become a social phenomenon too, and that all these will be not only social but universal? All men will communicate with one another by means of their vision of things, and that vision will express what they have in common among themselves, what is common to them and to things, to them as things, to things as people. When that happens, true clairvoyance will have integrated the universe with man, that is to say man with the universe.

From Paul Eluard, 'Je parle de ce qui est bien', *Cahiers d'Art* **vol. 10 no. 7–10, Paris, 1935, pp. 165, 168; translated from French by P. S. Falla.**

[1] Z. II. 522
[2] e.g. Z. II. 244 (1911–12) and Z. II. 525 (1914)

Picasso once told a friend that long after his death his writing would gain recognition and encyclopedias would say: 'Picasso, Pablo Ruiz – Spanish poet who dabbled in painting, drawing and sculpture' (Miguel Acoca, 'Picasso Turns a Busy 90 today', International Herald Tribune, *25 October 1971).*

Picasso began to write poetry in the thirties, and examples of his surrealist-influenced style were first published in Breton's article in Cahiers d'Art *in 1935, a portion of which follows. In the next year, Picasso's poems were included in a special issue of* Gaceta de Arte *(Santa Cruz de Tenerife), and since that time his poems have appeared in various publications, including* Poemas y Declaraciones, *Mexico, 1944; 'Textes de Picasso',* Cahiers d'Art, *no. 23, 1948, pp. 50–60;* Papeles de son Armadans, *Málaga, 1961;* Dibujos y escritos *and* Trozo de piel, *Faro de Cullera, 1968.*

Picasso also wrote and published plays, including Le désir attrapé par la queue *(1941; first performed at the apartment of Michel Leiris in Paris in 1944);* Les quatre petites filles *(1947–8, see p. 240); and* El entierro del Conde de Orgaz *(1957–9).*

Breton's essay concerning the early poetry preceded by one year Clive Bell's comments on poetry in 'Picasso', New Statesman and Nation, *30 May 1936, reprinted in Schiff, pp. 86–7.*

Picasso's obsession with colour never ceases, above all in his early poems, and in his manuscripts words, phrases or whole pages appear in bright variegated hues like parrots' feathers. But that is not all: colour asserts itself a great deal further; sometimes it appears to absorb the whole poem, and to throw its name to all the echoes:

> in the corner a purple sword the bells the folds of paper a metal sheep life lengthening the page a rifle-shot the paper sings the canaries in the white almost pink shadow a river in the empty white in the light blue shadow lilac colours a hand beside the shadow casts a shadow on the hand a very pink grasshopper a root lifts its head a nail the black of trees without anything a fish a nest the heat in full light looks at a parasol of light the fingers in the light the white of the paper the sun alight in the white cuts out a shining wolf the sun its light the sun very white the sun intensely white.

> listen in your childhood to the hour that white in the blue memory borders white in her eyes deep blue and patch of indigo of silver sky the glances white traverse cobalt the white paper that the blue ink tears out bluish its ultramarine descends that white enjoys blue repose agitated in the dark green wall green that its pleasure writes rain light green swimming green yellow in clear oblivion at the edge of her foot green the sand earth song sand of the earth afternoon sand earth

The play of light and shadow has never been observed more tenderly or interpreted more subtly and lucidly; it keeps the poem within the bounds of the present moment, of the breath of eternity which that moment at its most fugitive contains within itself. Nothing is more characteristic of this than the care Picasso has taken to indicate in the text of several of these verse or prose poems the place, day and hour at which they were composed. We have the impression of being in the presence of an intimate journal, both of the feelings and of the senses, such as has never been kept before; and this impression is so lively and disturbing that it is doubtless not by chance that I have omitted to copy a typical poem which is exactly so titled. But I cannot emphasize enough the way in which any poem in the collection gives the impression of something caught on the wing and reproduced without deliberation. A few seconds later the same subject would have presented itself differently; this Picasso seeks to bring out by making the poem pivot on itself, as it were, as one may turn a cup to and fro in one's hands (let us never lose sight here of the inductive object within easy reach):

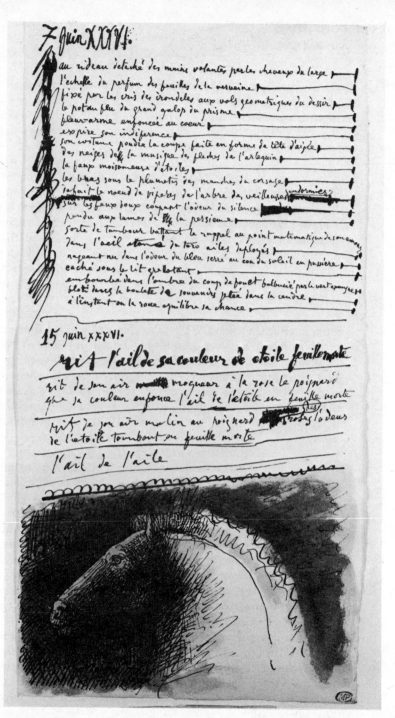

Poems and horse's head, 1934 (poems dated June 1936). Musée Picasso, Paris.

the wing twists corrupts and makes eternal the cup of coffee whose harmonium of timidity caresses the whiteness the window covers the shoulder of the bedroom of the wing-beats of goldfinches dying in the air which embraces in its veins the aroma which to the ear does not sound and runs sings laughs in its sleighs the little grains of sand

shutter rattling in the wind kills the flying goldfinches blows stain with blood the shoulder of the room hear the whiteness of silence passing death bears in its mouth the harmonium's aroma its wing pulls the well-rope

shutter rattling in the wind kills the flying goldfinches sends them to strike and stain with blood the shoulder of the room hear passing the whiteness of silence death carries off in its mouth the harmonium's aroma and its wing pulls the well-rope

the goldfinches are the aroma that strikes with its wing the coffee that reflects the shutter at the bottom of the well and hears the air passing in the silence of the whiteness of the cup

the aroma hears passing the reflections that the goldfinch strikes in the well and effaces in the silence of the coffee the whiteness of the wing

The process of simplification, purification and, so to speak, decanting observable in the five 'states' of the poem quoted must not be hastily taken for a compositional device systematically used by Picasso, to the premature delight of 'classically' minded critics. It would seem to be the haunting image of perfume, and that alone, which here justifies the quantitative reduction of words for the sake of a certain quality of expression, in which the abruptest ellipses are permitted. The position is quite different, for instance, with the poems consisting of words that seem to have been thrown on to the page without any preconceived links, and that Picasso has joined together by red, yellow and blue lines in such a way that they can be read in various directions and that the handwritten page looks like a dew-laden spider's web under the first rays of the morning sun. Is it not thus that we interrogate the skies, beginning with no matter which constellation, and, if we have time, seek to read human destiny in the stars? I emphasize especially the fact that this is *contradictorily* the case with all the poems in the collection that are embellished from day to day with greater abundance and even profusion, so that each version, in relation to the next, serves as a background on which the author's latest emotions can be imprinted.

From André Breton, 'Picasso Poète', *Cahiers d'Art* vol. 10 no. 7–10, Paris, 1935, pp. 187–8; translated from French by P. S. Falla.

Eugeni d'Ors, a prominent Catalan essayist before the Spanish Civil War, wrote a well-known monograph, Pablo Picasso, *in 1930, that was translated into English and French in that same year. D'Ors's 'open letter' to Picasso from the Catalan journal* D'Aci i D'Alla, *written in the year before Guernica was painted, calls for a masterpiece from the artist.*

1936 Eugeni d'Ors
Open letter to Picasso

You, Picasso, are lucky, who, in life and legend, have flourished at the time of the social meteors most favourable for your art! If, at the same time, the aesthetic climate was becoming harder than ever is another question. . . . But who will fail to admire the miracle of this great wave of public favour which painting now enjoys, at the moment known as 'the post-war'; when it has replaced literature in the eyes of the people? We might even say this is one of the most curious phenomena in the history of culture.

In what other epoch – do tell me, please – had the personality of each one of the artists so much interested their contemporaries? Did it ever happen before that the smallest fragment coming from their hands would see itself, as it does today, recorded, commented upon, appreciated, complimented, disseminated to the minds of multitudes? In the past, even in Paris, one used not to talk about painting except in the spring, when the Salon was open. Once the Salon closed down, that was it; the subject was not mentioned until the new season. Yet everybody paid constant attention, in the interim, to poets, playwrights, novelists, even one or two philosophers – an especially reactionary or a sceptical one; all this according to changing fashion. The cosmopolitans of the time never ceased praising them; parents mentioned them to their children, to better their education. Now, however, it is a sure bet that the name of the Douanier Rousseau is infinitely more frequently mentioned in current conversation than, say, that of Jules Laforgue. And if the story were told today of the childhood friendship of Emile Zola and Paul Cézanne, broken as their lives grew apart, in all probability Zola not Cézanne would be seen as the victim.

But we two are preserved from such fates; we did not share a desk in an Aix-en-Provence *lycée*, but a table at the Quatre Gats tavern, where the Barcelona of the beginning of the twentieth century opened its eyes to new revelations, its nostrils to new drugs. We were hardly grown up, but we already respected each other a great deal. Such 'respect' – it is your word – sprang from the seriousness we each sensed in our cameraderie, before and after drinking. We knew that we were both heirs to age-old tradition, in the realm of beauty, in the realm of thought. For there is a very great distance between that which you really are and the instinctive

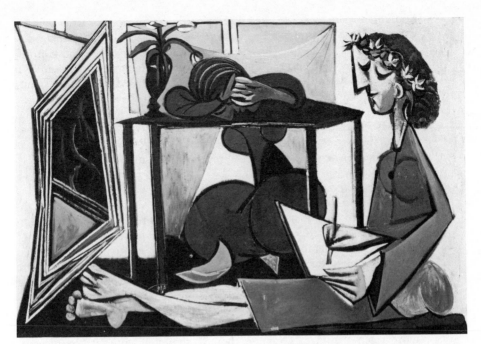

Interior with a girl drawing, 1935; oil on canvas, 130 × 195cm (illustrated with d'Ors's article).
The Museum of Modern Art, New York.

being, tamed by the dynamics of the subconscious. For so many have imagined just such tameness hidden behind the fiery secret of your eager eyes. I have certainly not forgotten that, in our first conversation, as a response to a page written by a mutual friend, we spoke of the Centaurs. Likewise, recently, just a few weeks ago, our last conversation turned to the subject of the Minotaur. We had always been obsessed, in the time between, by Antiquity and Mythology.

The same was true with the problems of pure form – the object, for one, of continued and fertile creativity, for the other, of austere study. Every line in your drawings has had for me the value of a Sign. And for you too, as you drew it. Later, when planning your show – as you are by nature introverted – you paid no attention to people's comments, and you amused yourself – you amused yourself too much – to the point of provoking those comments which you have always liked to hear without letting it go to your head. Whether, in fact, an Italian, or a Malagan or a Catalan, you are in every way a pure Mediterranean, a relative of Ulysses, fertile in cunning. A relative of the man who would not stop his ears to the sirens' song, but made quite sure that his body was tied to the ship's mast, and thus united prudence and reason to the delicious inebriation the song produced.
.

Some five years ago, I begged and begged you to produce works which would belong – without calling on association of ideas – to a normal, safe, quiet kind of work, like those time-honoured masterpieces now in the best galleries of the best museums. The five years have passed in vain. We still have to be content with your 'almost-masterpiece'. . . . My friend, my friend, we belong to a generation which, under God knows what law of nature, seems destined – and it is a relevant detail that we have no one country, no one milieu, no one métier – for the glory of the athlete who, having jumped the hurdles, stumbles and loses time and distance just at the moment when he was about to reach the finishing line.
.

I had better stop now, and I'll summarize all I want to say in a kind of shout to encourage and urge you on like the shouts of the bullfight *aficionados* to their matadors. Catalan would not really be appropriate to convey that shout. I shall have to take recourse to yet another mode of expression. Remember old Carolus Duran, that carnival character who taught our own Ramon Casas in Paris and who ended up in Rome, at the French Academy at the Villa Medici: 'Monsieur', Carolus Duran would order a newcomer, 'faites un chef-d'oeuvre!' [Sir, produce a master-piece!]. . . When he said that at the Villa Medici it was just a carnival jest. But in the tradition of the Quatre Gats and amongst us it is better than the most solemn advice. Gravely, then, I shall tell you: 'Pablo Picasso, produce a masterpiece!' Believe me, it is high time. It will not now be long for either of us before, sad to confess, any masterpiece of ours will remain as an unfinished entry in the account book of our conscience.

From Eugeni d'Ors, 'Epístola a Picasso', *D'Aci i D'Alla*, Barcelona, Summer 1936, unpaginated; translated from Catalan by Miquel Sobré.

1937 Christian Zervos
On *Guernica*

More than any other of his works, *Guernica*[1] illustrates the constant oscillation that is his true character. He is both a romantic and a classicist, but a romantic who resists analysis and a classicist of an unusual kind, opposed to strict rules and devoted heart and soul to the metamorphoses of reality; one who refuses to interpret life by syllogism alone, acknowl-edges its many riddles and mysteries, and, for all his classicism, is capable of adopting simultaneously a multitude of different perspectives.

The first state of the picture was conceived in a mood of exaltation: no affective element was spared, no emotion left unexpressed. But the very next day, with a reaction typical of this artist, in whose work everything is combined with its opposite, he set about breaking the most sensitive connections and giving up the pleasure to be had from them, for fear of

falling into sentimentality. It must also be said that he felt compelled to take an intellectual stance, even though this compulsion is not expressly reflected after the first state of the picture, as the artist judged by then that there was no reason to submit to such discipline. He was not likely to forget that it is one thing to feel an emotion and another thing to express it as felt. But the fearful drama which he was a witness could not be contained, and it would be naïve to suppose that so passionate a work could be handled on a basis of mere calculation. Every artistic image, after all, is the resonance of an emotion and derives its essential quality from that fact; and if there is any artist who puts the whole of himself into his work so that it can be felt to vibrate with his mind, that artist is certainly Picasso. Whenever he makes use of the resources of his art – and he is familiar with them all – he does so in such a way that they accompany and strengthen the emotion, so that its magic is not broken and the source of his inspiration remains fully alive.

Seeing this man reacting constantly against his impressions suggested to me the idea of retracing the successive experiments by which his vision was steadily broadened and amplified, so as to give an idea of his thought processes and, by examining the series of studies that preceded the final picture, to show how mistaken are those who speak of Picasso's facile improvisation.

If the reader were to study the different states of the picture in detail he would make some remarkable discoveries. He would gain an idea of how a work by Picasso comes into being and how the interplay of opposites serves to nourish its vital force and free it from all constraints. For antithesis springs naturally from the conjunction of events which brings into conflict the emotions and thought of an exceptional genius.

The magic power of this painting should not be diluted in explanations. I do not wish therefore to go into technical details, especially as the reader can form an idea of them from the different states. I shall confine myself to saying that the freedom of composition of the first state, when at the beginning the artist gave into a flood of emotion, was transformed as the work proceeded. At each succeeding stage the picture becomes more economical in structure until it reaches absolute clarity. The figures, like the rest, change their expression completely. Represented at first in violent movement, they gradually become freer of the effects of shock and accident that were impressed on their forms and make broader, more synthetic movements. Looking at these figures, whose brusque unconventionality may cause them to be wrongly taken for neologisms, we realize that only by forms of this kind was it possible to achieve the effect of overwhelming pain that they express, to define the ambiguous situation of each of them and to present to the spectator the outward aspect of an emotion, the depths of which will be revealed in time to come.

No one will deny that Picasso has achieved the miracle of turning emotion into a true image, without indulging in expressionism. His figures – terror-stricken, fleeing in a nightmare of desperation, racked

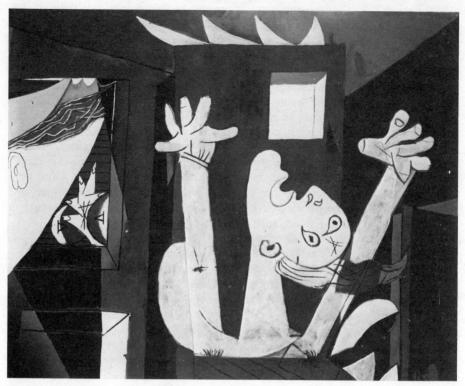

Detail from *Guernica*, 1937; oil on canvas, 350 × 782cm. On extended loan to the Museum of Modern Art, New York, from the artist.

with grief, physically tortured or put to death – are never over-stressed in an artistic sense. On the contrary, his women – overcome by disaster, their sad fate marked in the hollow of their hands, caught between nothingness and eternity, driven alternately by fear and hope, and only attached to the world by the miracle of a precarious chance – nonetheless play a purifying role and appear as a source of energy that refuses to yield even to inexorable fate: a significance emphasized by the presence of the bull. It is one of Picasso's finest achievements that in the shock of passion, at the rhetorical climax of the work, an animal figure presents itself to our gaze freed from the complications of thought – a perfect figure of power delivered from death, in full command of time and destiny, from which the dawn will spring that is always hoped for by those in distress.

At the same time as he transcended aesthetic emotion in order to present the great, obscure mass of people whose griefs, sacrifices and hopes give life its holiness, Picasso changed the scene of action and confined it to a narrower space. In the first states of the picture the drama was enacted in the open air; but the work, permeated as it is by dreams, was better suited to an indoor atmosphere. Is it not much more effective for the tragedy to be deployed on the narrow stage of a humble interior, which thus becomes the altar of sacrifice and purification with its mystical virtues?

The implacable sense of the dramatic event also called for a closely related treatment of colour, imposing on it austerity and severe restraint. The lack of colour thus gives full value to the affective quality of the figures. Expression and colour are closely related: sadness, like all the great abstractions, is severely simple and is expressed in no other tones but black, white and grey. There could be no better way of emphasizing the tension of these figures and the heroism of their grief. When the artist began the picture he had not yet decided on his final choice of tones, but these three imposed themselves as the drama gradually took possession of his mind. We may note that as the work went on he was at pains to make sure that he was obeying a profound instinct in this respect and not merely a sentimental impulse. For this purpose he introduced patches of vibrant colour, provided by wallpaper – but in every case these experiments, which can be seen in certain states, were rejected and the colours were finally kept to the sober range of white, black and grey, heightened here and there by small black dots which enhanced their resonance.

At first sight this sobriety may disconcert an eye accustomed to bright colours, but the careful spectator will perceive what marvellous use Picasso made of the dullest tints; from these he drew infinite subtleties, attacking the eye by means of a small number of skilfully calculated effects. The harmony of these silent tones is achieved by a combination of rhythms, complex in interrelation but clear in purpose, which do not resolve themselves into a single chord but, on the contrary, form a dissonance that is appropriate to the figures and emphasizes their desperate condition.

The greatness of this picture in fact lies in the artist's skilful handling of dissonances. By simplifications of form and abbreviations of design, by the use of evocative signs, and by representing objects not as in reality but by the shock they produce (eyes flower-shaped, as if made with nails, or tears so sharply drawn that the spectator feels gripped and tortured), Picasso enhances his power to violate and so dominate our kinaesthetic sense. These visionary forms, far more powerfully evocative than meticulously detailed ones, impel us to understand their acts and to see them as they really are. Like instruments of witchcraft, they call forth germs of pestilence to attack the leaders whom Picasso has sentenced to death.

A man's ability to extend his power at will, to set in motion forces of incalculable range at a moment of his own choosing, to translate those forces into fiery symbols – all this is a supernatural gift which has nothing to do with normal conditions. It explains the demonic side of Picasso and the greatness of his work.

From Christian Zervos, 'Histoire d'un tableau de Picasso', *Cahiers d'Art* vol. 12 no. 4–5, Paris, 1937, pp. 109–11; translated from French by P. S. Falla.

¹ z. ix. 65

1937 José Bergamin
The Mystery Trembles: Picasso Furioso

'Is the fury then so great?'
(Lope de Vega)

I have often mentioned the importance of what used to be called in the seventeenth century the 'Spanish fury', and have recalled the words which a Valencian writer used to describe this peculiarly Spanish way of motivating will-power by impatience or intensifying thought to the point of anger. Referring to the essentially visual approach which makes Spaniards better at understanding art than history, this writer remarked that 'Spanish fury has more in common with painting than with history, for a panel or a canvas immediately reveals what it has to say, while history presents more of an obstacle to understanding.'

The Spaniard's impatience, the 'fury of a grave Spaniard', which inspired the dramatic poetry of Lope de Vega – this is what roused us, an act whose significance is expressed in Goya's paintings. This was when the Spanish people took up arms in earnest, arising in fury to defend its independence and freedom, its will to exist.

'Is the fury then so great?' So great was this Spanish fury and so great is it still today, that the clear, simple manifestation of it in painting pierces our eyes like a dagger. This dramatic living axiom, this tragic evidence is

called Madrid 1808 and Madrid 1936. It is called Goya, and it is called Picasso.

In putting these two names together we do not intend to suggest any artistic kinship between them. There is no analogy, no direct, pictorial, aesthetic equivalence between the two styles of painting. If we mention Goya and Picasso in the same breath it is because their works are a response to the same original shock – because there surges up in them the same anger, the same furious will to assert their being, which is purely Spanish and purely of the people.

What is repeated in these canvases is not painting but history.

Goya and Picasso do not see the *Disasters of War* from the same point of view, but they both express the heart and understanding of the Spanish people, the attitude of mind which prefers painting to history 'because it says all it has to say at once' – the kind of understanding which 'enters the eyes' as we say in Spain.

The Spanish fury expressed in this painting is so intense that, in entering our eyes, it fills us with stormy rapture, making us follow its images to their extreme perspective of horror. It is a purging, a purification, a powerful cleansing of the spirit. No one can think or feel in a confused way in front of this violently pure and lucid painting by Pablo Picasso. Guernica means Madrid, it means Spain and the fury of the Spanish people.

We might say, with deference to Lope, that painting and poetry 'can be just the same thing'. Painting can be a kind of utterance, a language of fire and blood. Painting becomes word, poetry, in Picasso, as poetry and the creative word became a pictorial, plastic work of imagination in Cervantes. This is because of the same necessity, the same inner urge to express his thrill, his trembling with fury, his impatient will to live – a furious affirmation of life against the dark ring of death that imprisons it, but at the same time affirms it and expresses it even while it seeks to imprison and destroy it. As I once wrote, all poetry and all poetic arts are arts of 'trembling', like that art of fear that the simpleton in the fairy tale wanted to learn. And all simpletons tell this story without understanding it, without learning the art of fear, the art of trembling. But this mysterious thrill of the living mystery of man is his thought itself. That is why, when Spanish people get angry, they use the expression 'the mystery trembles', meaning by that the mystery of the Trinity, of the Word itself. Human speech, sombre and luminous, is a divine mysterious trembling, like that of the divine fury. Man feels this divine trembling in the face of creation because he feels himself alone, and his trembling expresses itself in the creative word, the mute or sonorous image of thought. To think means to tremble mysteriously in this way, for it means being aware of our solitude in the face of death. It means feeling ourselves luminously inflamed by our trembling, which is the effect of fury rather than fear, for it is a desire for life, a throbbing of the blood that aspires to break out of the dark circle of death that expresses us. Human fury is the

most godlike expression of our will to exist in the face of death. It is man's social mode of expression: by it he relates his solitude to the plenitude of human solitude, and himself to all men. By the language of fury, by the word or the voice of all, of the people in person, he makes himself one of the people. And this word, this language, this cry of the blood – that is what this painting means, and that is why it *coincides* with history. For the history that is a revolutionary movement, that is man's awareness of his existence, is engendered in divine wrath. In the end, the fury of God engenders justice. There is no other truth than justice; or, as Unamuno used to say to me, 'There is no justice but truth.' Justice and truth are the serene and sure expression of that mysterious divine trembling which is the living thought of man. The Spanish fury which, in Picasso's painting, expresses itself so marvellously that it 'enters our eyes' is the living word of the Spanish people, that of its truth and justice: the purest and clearest truth of our 'independent, revolutionary people'. It is that of a people creating a new life – not the slave of its history, but liberating history by means of its poetry. A people which does what it says it will do. The Spanish people that speaks in its fury to us in this canvas is truer than its history: in its true fury, it is the voice and the word of God. The mystery trembles by reason of the furious truth of the justice it demands. For true justice is the point of balance between a final Yes and a final No: in the last resort it is nothing else, no other ideal, no other reality, than the human affirmation of life in opposition to the negation of death, the plenitude of being against nothingness.

.

Poetry and painting express this people, seem to predict its history, and it is a single true people, whole and unique – which is alone, absolutely alone with its own truth. A people that lives and dies, truthfully and completely. This is why I would rather that this extreme work by Picasso, in which the yes and the no of life, in all their truth and justice, are made evident to us to the point of exhaustion, to the point of death, should bear the name of what it historically is, although it did not appear to be – in its reality and not its representation: the miracle of Madrid. Seen and not seen. The mystery triumphant. The trembling mystery given life by the fury of the Spanish people, seized like its fire amid its shadows. For fire appears amid shadows in this truly immortal painting.

From José Bergamin, 'Le mystère tremble: Picasso furioso'; translated by Jean Cassou in *Cahiers d'Art* vol. 12 no. 4–5, Paris, 1937, pp. 137–9; translated from French by P. S. Falla.

Art long ago ceased to be monumental. To be monumental, as the art of Michelangelo or Rubens was monumental, the age must have a sense of glory. The artist must have some faith in his fellow men, and some confidence in the civilization to which he belongs. Such an attitude is not possible in the modern world – at least, not in our Western European world. We have lived through the greatest war in history, but we find it celebrated in thousands of mean, false and essentially unheroic monuments. Ten million men killed, but no breath of inspiration from their dead bodies. Just a scramble for contracts and fees, and an unconcealed desire to make the most utilitarian use of the fruits of heroism.

Monumental art is inspired by creative actions. It may be that sometimes the artist is deceived, but he shares his illusion with his age. He lives in a state of faith, of creative and optimistic faith. But in our age even an illusion is not tenable. When it is given out that a great Christian hero is leading a new crusade for the faith, even his followers are not deceived. A Christian crusade is not fought with the aid of infidel Moors, nor with fascist bombs and tanks. And when a Republic announces that it is fighting to defend liberty and equality, we are compelled to doubt whether these values will survive the autocratic methods adopted to establish them. The artist, at the lowest level of prestige and authority he has ever reached in the history of civilization, is compelled to doubt those who despise him.

The only logical monument would be some sort of negative monument. A monument to disillusion, to despair, to destruction. It was inevitable that the greatest artist of our time should be driven to this conclusion. Frustrated in his creative affirmations, limited in scope and scale by the timidities and customs of the age, he can at best make a monument to the vast forces of evil which seek to control our lives: a monument of protestation. When those forces invade his native land, and destroy with calculated brutality a shrine peculiarly invested with the sense of glory, then the impulse to protest takes on a monumental grandeur. Picasso's great fresco is a monument to destruction, a cry of outrage and horror amplified by the spirit of genius.

It has been said that this painting is obscure – that it cannot appeal to the soldier of the republic, to the man in the street, to the communist in his cell; but actually its elements are clear and openly symbolical. The light of day and night reveals a scene of horror and destruction: the eviscerated horse, the writhing bodies of men and women, betray the passage of the infuriated bull, who turns triumphantly in the background, tense with lust and stupid power; whilst from the window Truth, whose features are the tragic mask in all its classical purity, extends her lamp over the carnage. The great canvas is flooded with pity and terror, but

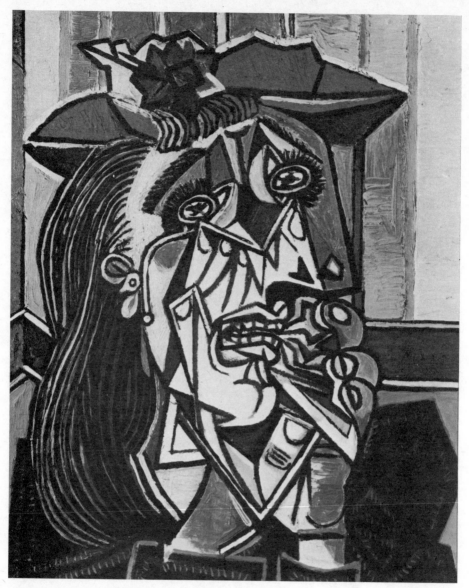

The Woman Weeping, 1937. Private collection, England.

over it all is imposed that nameless grace which arises from their cathartic equilibrium.

Not only Guernica, but Spain; not only Spain, but Europe, is symbolized in this allegory. It is the modern Calvary, the agony in the bomb-shattered ruins of human tenderness and faith. It is a religious picture, painted, not with the same kind, but with the same degree of fervour that inspired Grünewald and the Master of the Avignon Pietà, Van Eyck and Bellini. It is not sufficient to compare the Picasso of this painting with the Goya of the *Desastres*. Goya, too, was a great artist, and a great humanist; but his reactions were individualistic – his instruments irony, satire, ridicule. Picasso is more universal: his symbols are banal, like the symbols of Homer, Dante, Cervantes. For it is only when the widest commonplace is infused with the intensest passion that a great work of art, transcending all schools and categories, is born; and being born, lives immortally.

Herbert Read, 'Picasso's "Guernica" ', *London Bulletin* no. 6, London, October 1938, p. 6.

(1937) Roland Penrose
The Woman Weeping

In the autumn of the year in which *Guernica* had been painted I paid Picasso a visit one morning with Paul Eluard. When he showed us into his studio we were both astonished at the captivating power of a small newly painted canvas placed on an easel as though he were still at work on it. *The Woman Weeping* had been finished on the day after his fifty-sixth birthday in October 1937. It came as a postscript to the great mural and contained an account of the agony caused by fascist aggression on humanity. The sombre monochrome of *Guernica* had given place to brilliant contrasts of red, blue, green and yellow in a highly disconcerting way. It was as though this girl, seen in profile but with both the dark passionate eyes of Dora Maar, dressed as for a fête, had found herself suddenly faced by heartrending disaster. For a while the impact of this small brilliant canvas left us speechless and after a few enthusiastic exclamations I heard myself say to Picasso 'Oh! may I buy that from you?' and heard in a daze his answer 'And why not?'. There followed the exchange of a cheque for £250 for one of the masterpieces of this century. Paul I noticed often had the effect of bringing out both the most animated and amiable side of Picasso, which meant that the usual practice of passing on any business of this kind to his dealer was once more ignored. I was overwhelmed at my good fortune as we left with the painting on which the paint was scarcely dry.

From Roland Penrose, *Scrap Book*, London, 1981.

Picasso's last exhibition in Paris before France entered the war was held at Paul Rosenberg's gallery in January 1939. The painter André Lhote's review, which follows, suggests that even among informed artists at that time there was still hostility towards Picasso's art and his newest developments, and to an extent Lhote reflects the general philistine view of certain critics. Lhote does attempt, however, to connect Picasso's method of juxtaposing formal elements to the work of the sixteenth-century Italian painter Arcimboldo, who was popular in the thirties and forties among Surrealists such as Breton and Dalí, to whom his work seemed to exemplify the principles of his 'paranoiac-critical method'.

1939 André Lhote
Picasso's reputation

Picasso's immense talent as a painter and draughtsman is undeniable, even if we feel that his recognized critics have gone overboard. Picasso literature is certainly incomparably rich in incongruous praise, in more or less hysterical ecstasy. The monograph recently published by Floury begins with the amazingly pretentious statement by Mme Gertrude Stein that, if world painting in the nineteenth century was the work of Frenchmen in France, in the twentieth it is the work, in France, of the Spaniard Picasso. This is perhaps the most humorously absurd of the exaggerations that are encouraged, if I may so put it, by our unsmiling prince.

I prefer to this kind of criticism the remark made to me by a talented young painter who was much excited by the exhibition: 'Picasso is a toreador – brilliant, alert, skilful; he kills a new bull with every stroke. It is a wonderful performance, but if a Frenchman tried to do it he would break his back.' This was very well said: the French temperament is not suited to such conjuring tricks. He is slower, more painstaking and cautious than the Spaniard, and, to use a dangerous word, more respectful towards reality and towards the spectator. The Frenchman values coherence and consistency, and does not like to compromise himself in reckless impulses.

The drawbacks of this attitude have been emphasized often enough. They are responsible for the Prix de Rome, the Salon des Artistes Français, and, amongst the so-called avant-garde, the most lamentable reworkings of Ingres and Corot. The virtues of French painters are highly dangerous, but we know that they go very deep.

By a symbolic coincidence I have just received the latest numbers of *Cahiers d'Art* and *Verve*, the former devoted to Picasso and the latter almost entirely to French miniaturists. *Cahiers d'Art*[1] reproduces Picasso's most bewildering variations on three themes: women beside beach-cabins, a woman in an armchair, several figures clustered around a

lollipop. Picasso twists and turns about these subjects, practising one feint after another and weaving arabesques in the most agile and unexpected way. Constantly on his guard against the onslaught of reality, he evades it with marvellous skill, teasing it with mocking interpretations and in a few days running through all the plastic resources at his command. Eluding the sentimental snares presented by the tenderest object he hovers over it like a god of irreverence and instability, an incorruptible workman who is never taken unawares.

But this craftsman's flights of fancy do not have their origin solely in the unconscious, as his usual interpreters – who are sometimes of astounding credulity – would have us believe. His mind is a prodigious reservoir of already invented forms, an encyclopedia kept carefully up to date, and it feeds his inexhaustible invention with reminiscences of the most famous historical creations, from the Altamira caves to the studio of Arcimboldo.

The public has recently been acquainted with this fantastical Italian painter who used fruit, foliage and ornamental devices in profusion in an attempt to revive the baroque energy of the Middle Ages. Arcimboldo constructed his figures by juxtaposing fruit, flowers, shells and vegetables; and when we look at the *Woman in an armchair*[2] reproduced in *Cahiers d'Art* we see her face as a housebreaker's yard in which fragments of arches, pillars and staircases suggest the eyes, nose, mouth and ears of this devastated creature who may well be taken for an image of the modern world.

Picasso is too close for us to gauge the exact import of his message. How, in any case, could we recognize it amid the deafening racket of praise, in which the whistle of the surrealist poet competes with the art critic's trumpet and the big drum of the advertiser-in-chief? Never before has a living artist been the subject of such a hullabaloo, in which painting is the very last thing to be discussed. Nonetheless, it will not be absurd to venture the opinion that Picasso is the true portrayer of the absurd and fabulous times in which we live. A creator, an assembler and a destroyer, his genius blends and confuses all values, upsets the normal order of things, jeers at logic and offers each day a fresh symbol of universal decomposition.

From André Lhote, 'Les Arts: Picasso', *La Nouvelle Revue Française* **no. 306, Paris, 1 March 1939, pp. 530–1; translated from French by P. S. Falla.**

[1] *Cahiers d'Art* vol.13, no. 3–10, 1938, pp. 73–80.
[2] Z. II. 522

7.
World War II and after

1940–1952

During the period from approximately 1938 through the mid-forties, Picasso, living a restricted life because of the war, painted a large number of portraits. Although his other wartime paintings tended to be sombre, in these works he used the techniques of cubist fragmentation and reassembly, the gestural expression and distortion of Guernica *and related work, and a lively palette which reintroduced colour and decorative elements, to unite psychological and physical characteristics with the overall expressive qualities of form and composition. The accounts that are included in this section refer specifically to the 1939 portrait (Z. IX. 366) of Sabartés (who had returned from South America to France in 1935), and the portraits of the photographer Dora Maar, whom Picasso had met in 1936 and who was his mistress until the mid-1940s, and of the painter Françoise Gilot, whom Picasso began to live with in 1946.*

After the liberation Picasso's studio was opened to many visitors, and reports about his wartime activities were described by the friends, artists and critics who went to see him. In this period, Picasso, who was now in his sixties, began to enjoy a more general acceptance, and much of the polemical writing that had existed before the war virtually disappeared. In fact, writing about Picasso became more lyrical, accepting, and to some extent anecdotal. Because of his age, enormous reputation and popularity, friends and visitors to his studio began to record many details of his everyday life and expressed an even greater curiosity about the working methods of the 'master'.

After 1944 Picasso resumed exhibiting his work, which included, in addition to painting, some of his new efforts in sculpture, lithography, and ceramics. Although Picasso had worked in sculpture practically all his life, his work in the medium had remained comparatively unnoticed by critics until the forties. One of his lithographs, made during this period, representing a dove (B. 583), became known all over the world in the late forties as a symbol of peace, further popularizing Picasso's name. Three different comments on the origins and effectiveness of that particular image are included here, by Picasso's friend, the poet Louis Aragon, the Russian writer Ilya Ehrenburg, and André Breton, who in 1961 expressed his disappointment with the artist (whose political attitudes he did not share), whom the Surrealists had once claimed as their own.

The following article by the English writer Wyndham Lewis appeared in the
literary journal The Kenyon Review *in 1940, and was prompted by the*
exhibition of Guernica *in the Picasso retrospective at the Museum of Modern*
Art that had opened in New York in 1939. Although Lewis credited Picasso
earlier in the article with 'an originality of a technical order', here he finds
praise for Picasso's work as revolutionary undeserved. This review contrasts
with Lewis's better known first article on Picasso, which took the form of a
*spirited manifesto 'Relativism and Picasso's Latest Work' (*Blast, London,
1914; reprinted in Schiff, pp. 53–5). In the 1914 article Lewis claimed that
Picasso had created 'mysterious machines of modern art' and, although these
machines were useless and had no life of their own, Picasso had succeeded in
revolutionizing the artistic process, for he no longer interpreted nature, but
made it. The 1940 article takes into account Picasso's extraordinary repu-
tation in the intervening years, which had by virtue of its capitalistic support
discounted any claim that Picasso be considered revolutionary either in
politics or in the making of art.

1940 Wyndham Lewis
On *Guernica*

It will be profitable to examine one aspect of such a programme as
Picasso's: namely, is it, as often we hear it described, a *revolutionary*
programme? And if so, in what way is it revolutionary?

First of all, it should be plain to everybody that in a revolutionary
society – in a socialist, or a communist, society – such a phenomenon as
Pablo Picasso could not come into existence: or if already it existed, it
could not flourish. Picasso, regarded as a social phenomenon (and the
same applies to surrealism) provides the barbaric – the 'revolutionary' –
thrill to the wealthy 'socialite' of a capitalist society. He would have no
meaning for, and evoke no response in, the newly conscious masses of a
revolutionary society. I am not registering this against him, perhaps I
should remark. I am merely establishing the facts.

Corbusier, the famous 'revolutionary' architect, has remarked upon
the rapidity with which a revolutionary society like the Russian or the
German tires of 'revolutionary' art, and turns its back on it. It was only in
the very old societies, such as the English, that the 'new' architecture
could hope to find a home. If it did not find one there, then it could shut
up shop. America, Corbusier said, was quite hopeless. It was too new!

As a *destructive* force, of course – as a 'decadent' principle, to promote
decay – Picasso, and his fellow Catalan Dalí, have some meaning. And
who would care to assert that our society, as it stands at present, is
something that we should religiously conserve? Who would shed a tear if,
rotted from within, it were swept away?

But that decadent principle, that social dissolvent, is not art. It is

politics. If Picasso ought really to be regarded politically – as a rat, or as a termite – and not as an artist (in the same sense as Raphael, or Dürer, or Ingres) at all – if that is the case, then it may be very bad politics for me to be analyzing him as now I am doing, though it might be very good art.

But the corruption has gone so far that the social aspect of the matter surely can be left to look after itself. Our society is so visibly dropping to pieces beneath our eyes, that destructive agents have lost their point. We, as artists (however revolutionary we may be), can look after *ourselves* for a change. We can turn away from politics, and back to the preservation of this great human function – artistic expression. For whatever we may think of contemporary society, *that* is worth preserving: it would be a pity if the artistic faculty became atrophied: if we came to live in a world of Men Without Art. So we can leave politics out of the picture for the moment – whether we are parlour pinks, or true-blue Republicans or what not – and give our undivided attention to art and its more specialist problems.

Having disposed of Picasso's 'revolutionary' claim, and having discounted his further usefulness as a reagent of social disintegration (if such he be or ever were) we may turn our attention exclusively to Picasso the artist.
.

The set piece of the exhibition at the Museum of Modern Art – the big *Guernica* – is not a success, it seems to me. It is a big, highly intellectual poster, uninteresting in colour, and having no relation to the political event that was supposed to have provoked it. . . . The inalterable 'intellectuality' – the frigidity, the desiccation – of Picasso is demonstrated more forcibly by this largest of his canvases than anything else could have done.

From **Wyndham Lewis, 'Picasso',** *The Kenyon Review* **vol. II no. 2, Kenyon College, Ohio, Spring 1940, pp. 202–4.**

(1939) Jaime Sabartés
A new portrait

'The portrait which I am going to do next will be bigger', he said, 'a full portrait, in oil, to season up that escarolle of the collar with salt and pepper and all the dressings which please your palate, as well as the nude woman, the hound, and the full regalia which you used to wear when you strutted proudly through the corridors of the Escorial. A long time has gone by, but still we have not forgotten.'

'What I don't understand is why every time we speak about this, you insist upon having a nude woman beside me.'

'Because the idea of the Escorial makes me shiver, man.'

'One more reason for dressing her up. . . .'

'It is I who feel the cold; but it concerns you and not her. . . .'

'People will think she stands for Truth. . . .'

'That wouldn't be so bad because no one will be able to recognize her in her altogether. When the picture is ready we'll put it in a German "frame"[1] and hang it on the Paseo del Prado.'

From Jaime Sabartés, 'With Picasso, 1935–41: Studio at Royan', *Picasso: An Intimate Portrait,* **New York, 1948, and London, 1949, p. 202; translated from Spanish by Angel Flores.**

[1] Play on words: *marco* means 'frame' as well as 'mark'.

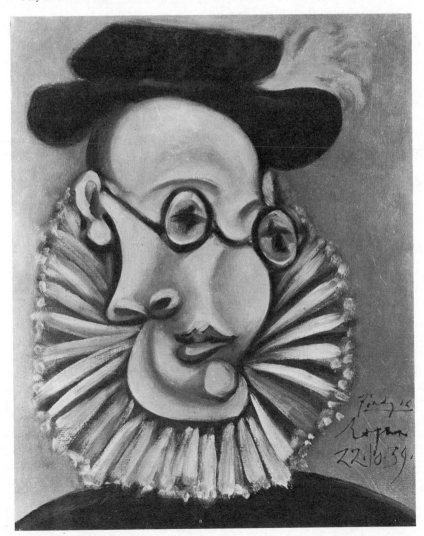

Portrait of Sabartés, 1939. Museo Picasso, Barcelona.

(1939) Brassaï
On Sabartés' portrait

I look at the painting he [Sabartés] is holding out to me: Sabartés costumed as a Spanish grandee, with a fluted ruff like those worn by men of the sixteenth and seventeenth centuries around his neck, and a curious cap of black velvet, ornamented with a little blue plume.[1] The portrait is a really astonishing likeness, although Picasso has completely rearranged the face, fixing the eye in the usual location of the ear and an ear at the base of the nose, and carrying audacity to the extent of depicting the familiar eyeglasses upside down. The odd costume astonishes me, and I ask Sabartés the reason for it.

 Sabartés: 'It was my idea. It was a whim. I had always dreamed of being painted by Picasso as a sixteenth-century nobleman – the period of Philip II and the way he would have dressed at the Escorial. . . . And when you mention that sort of whim to Picasso, it's not as if you were talking to a deaf man. . . . He made some sketches first – in 1938, at the rue La Boëtie – and that collar with the starched ruff amused him. He was planning to paint a full-length, life-size portrait in this costume of a grandee of Spain. . . . I thought he had forgotten about it, though, and then one day in Royan he surprised me with this. Did you notice that he has used the colourings of the Spanish paintings of that period?'

From Brassaï (Gyula Halász), *Conversations avec Picasso,* **Paris, 1964; translated by Francis Price as** *Picasso and Company,* **Garden City, N.Y., 1966, p. 96.**

[1] z. IX. 366

(1942) Harriet and Sidney Janis
On Dora Maar's portrait

In his portraits, no matter how far removed they may be from photographic likeness, the head and all of the features, however reshaped and displaced, are invariably present. On a face the eyes may be horizontal and vertical respectively, and these may either be presented on the same profile, or opposite profiles may be designated for the nose and for the mouth. These, again, may be transformed into masks or skulls, and sometimes into both, but invariably all of the facial features will be indicated. The displacements, having psychological as well as plastic value, create a diverse and keenly observed portrait of the personality. 'Portraits should possess,' in the words of Picasso, 'not physical, not spiritual, but psychological likeness.'

 Reproductions of six progressively abstract portraits of Miss Dora Maar[1] show how the artist alters his approach to his subject, retaining the

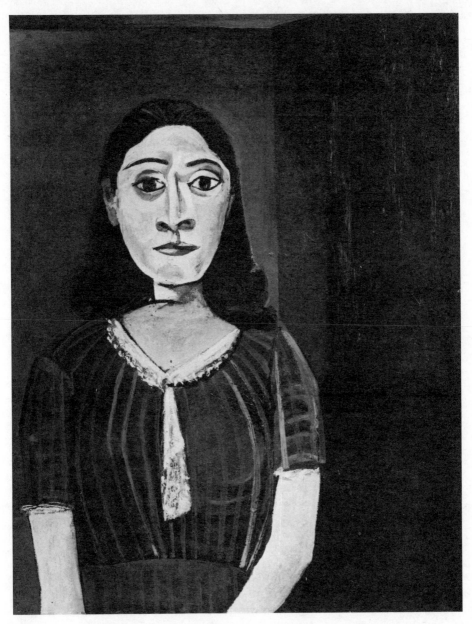

Portrait of Dora Maar, 1942. Collection Stephen Hahn, New York.

essential resemblance to the original model, but also conveying in varying degrees of subtlety and penetration a representation of the qualities of outer composure and inner intensity which are so characteristic of Miss Maar as a person.

From Harriet and Sidney Janis, *Picasso: The Recent Years, 1939–46*, Garden City, N.Y., 1946, p. 27.

[1] One of these is *Portrait of Dora Maar*, 9 October 1942 (z. XII. 154), which was painted over a period of weeks shortly before the death of Dora Maar's mother.

Brassaï's recollections and notes of visits to Picasso during the 1940s are a rich source of information concerning many aspects of Picasso's life and work. In particular, the following two statements concern the importance of materials for the artist: on the one hand, the significance of the quality of the paper itself to the resulting imagery (in this case, voluptuous nudes correspond to the sensual Japanese paper Picasso showed to Brassaï); and Picasso's attitudes towards appropriate sculptural materials and life forms. Curiously his fantasy about casting popular life in Paris predicts environmental sculptures of the 1960s by the American artist George Segal.

(1943) Brassaï
Conversations with Picasso

Tuesday, 19 October 1943

Christian Zervos, the publisher of *Cahiers d'Art*, comes in. For some time he has been fascinated with Picasso's magnificent drawings, and wants to publish an album of them. Picasso opens the heavy, Cordovan leather portfolio, embossed with corners, studded with nails, like the portal of a cathedral, and brings out his drawings, one by one.

Picasso: 'I was lucky – I managed to get my hands on a supply of splendid Japanese paper. It cost me the eyes of the head! But without it, I would never have done these drawings. The paper seduced me. It's so thick that, even when you scratch deep into it, you barely touch the inner layers.' . . .

And it was, really, the voluptuous quality of this paper that had conjured up in his mind these undulent, supple, passionate women. . . . The seductive quality of basic matter has always played an important part in his work.

Having gone through all of the drawings with Zervos, Picasso said to him, 'You want to publish these? It's a very good idea. But you would have to publish the entire series, without leaving any of them out. And I would think they should be reproduced just as they are, in the same size. Then they could make a wonderful album – don't you think so?'

Zervos wants to take the whole series of drawings with him. Picasso doesn't want to let it go just yet. He is always a little reluctant to part with his work. In any event, they count and recount the drawings. According to Zervos, there are a hundred and twenty; according to Picasso a hundred and twenty-one. His count is correct.

Wednesday, 20 October 1943
Picasso: 'It seems strange to me that we ever arrived at the idea of making statues from marble. I understand how you can see something in the root of a tree, a crevice in a wall, a corroded bit of stone, or a pebble. . . . But marble? It stands there like a block, suggesting no form or image. It doesn't inspire. How could Michelangelo have seen his *David* in a block of marble? If it occurred to man to create his own images, it's because he discovered them all around him, almost formed, already within his grasp. He saw them in a bone, in the irregular surfaces of cavern walls, in a piece of wood. . . . One form might suggest a woman, another a bison, and still another the head of a demon.'

.

Myself: 'An excavation always gives me the impression of a mould that is being broken so the sculpture inside can be taken out. At Pompeii, it was Vesuvius that did the work of making the mould. Houses, men and women, animals – they were all caught instantaneously in that boiling matrix. There is nothing quite so startling as the sight of those contorted bodies, caught forever in the moment of death. I saw them, in the glass cases they've preserved them in at Pompeii and Naples.'

Picasso: 'Dalí was obsessed with the idea of monstrous castings of that kind; of that instantaneous end of all life because of a cataclysm. He talked to me about a mould of the Place de l'Opéra, with the Opéra, the Café de la Paix, the chic prostitutes, the automobiles, the pedestrians, the cops, the news stands, the flower stalls, the street lights, the big clock still marking the time. . . . Imagine that in plaster or bronze, life-size. . . . What a nightmare! For myself, if I could do such a thing, I would rather do Saint-Germain-des-Prés, with the Café de Flore, the Brasserie Lipp, the Deux-Magots, Jean-Paul Sartre, the waiters Jean and Pascal, Monsieur Boubal, the cat, and the blond cashier. . . . What a marvellous, monstrous casting that would make!'

From Brassaï (Gyula Halász), *Conversations avec Picasso*, Paris, 1964; translated by Francis Price as *Picasso and Company*, Garden City, N.Y., 1966, pp. 66–7.

The 1944 Salon d'Automne, 'Salon de la Libération', opened in Paris just one day after the announcement that Picasso had joined the Communist Party. As a result, demonstrations against Picasso's political stand took place in the special gallery that had been set aside for his paintings and sculpture. Art critics, such as Georges Limbour, however, disregarded Picasso's politics and favourably reviewed the show.

1944 Georges Limbour
Picasso at the Autumn Salon

The canvases painted by Picasso in the last five or six years and exhibited at the Autumn Salon are as violent a shock to the visitor as any artistic spectacle could be. These intensely precise forms, aggressively strange, larger than life, weighing on the soul like objects of a greater density than is known on earth, whether of lead, china, wood or bone, plunge us at first sight into a strange but fascinating disquiet, until we recover our balance in the special atmosphere in which they exist. They oppress and haunt us until we have fathomed the multiple meanings that they bear. This is the effect not only of the forms but of the colours and paint that are inseparable from them, and which are of such richness and variety that each painting is a perpetual reinvention and the occasion for a new technique. When we have been right around the room we have the impression that every known colour has been lavished on hats, dresses, children and objects. The striking feature of this painting is indeed its universal quality: issuing from reality, it re-creates a complete universe with every form, living and inanimate, expressed in its true essence. (We are a long way from the austere colours of Cubism, and in this or that portrait of a woman the painter's knife has carved deep incisions, multicoloured and dazzling. A universal sap springs upward in this enchanted garden.) Some of the paintings await us like magnificent sphinxes, haughty and indifferent, which do not ask any riddle that we can fully understand or that is exactly translatable into our language – but is it not rather we who ask them questions that are sometimes idle and indiscreet? They guard the portals of a fantastic world governed by the often blasphemous pride of the rebel angels, a world full of pain, cruelty, humour, the drunken delirium of creation, fantasy that is full of charm, and even, perhaps reluctantly, an occasional touch of tenderness.

This kind of painting is certainly accessible to only a rather small number of spectators, for it requires boldness and courage to enter into it, unless we do so lightly or pretend to be under its spell in order to conform to a prevailing fashion. For five wartime years the Nazis forbade any exhibition of Picasso's work, realizing that his world was unalterably hostile and fatal to them. When a wide public had a chance of seeing it, cowards and fools recoiled at the first glance and burst out laughing to

conceal their terror. Was not this painting an affront to human dignity, an insult to the beauty of the most noble and harmonious of God's creatures? – always recalling that the most coarse and brutish human beings are those most aware of the greatness of the species.

Artists are giving up portrait-painting, which has become an unpopular genre. Except for earlier cubist portraits, a human face plays no more important part than a fruit-dish, and expression plays no part at all. Picasso, however, has restored its expressive importance and at the same time given it a new meaning. His gallery of portraits transports us into a world at once of devils and fairies which, with all due allowances, calls to mind the dreamland full of poetry and not always free of wickedness that fascinated us as children when we discovered it in a huge ball of silvered glass on an iron tripod in the middle of the lawn, in the garden of an old gentleman we were taken to see every Thursday during the summer. What joy it was to look at our distorted faces, carried far away from us by this magic air-balloon, among minute flower-bushes whose colours took on an extraordinary intensity on the silvery surface! (Sometimes the ball was partially darkened by a dull storm-cloud, and this colour is often seen in Picasso's portraits, contrasting with the cheerful greenery of an indoor plant or the pink of a bodice.) There was another small boy whom we couldn't stand; the ball twisted his silly grin still further and inflated his stupidity. Yet through these deformations it showed us the way to a distant enchanted region where we again wore our true faces, restored and purified.

Reclining woman, 1941 (illustrated with Limbour's article). Galerie Louise Leiris, Paris.

I have felt the same wonderment at these portraits, though they have many other meanings too; for Picasso's genius, and the dream through which he sees human faces, have other depths, resources and distorting properties than the crystal ball of those childhood days. If a real face looks like a firm oval bud which cannot blossom properly in this cold world, how well Picasso knows how to open it and make it bloom! The petals (or, as some would say in more technical language, the planes) start to unfold, we see the profile and the full face, finally the countenance as a whole. Then the universe, like a whimsical *modiste*, adds its own riches, providing headgear in the shape of a still life, a bit of garden, a fish, even a fork and spoon. Humour may here be mingled with a wholly legitimate anger, leading the artist to poke fun at the Creator's sacred work by putting a human face on a cow's head or replacing the nose by a small proboscis.
.

When I think of the destiny of Picasso's work I remember the proud opening words of Jean-Jacques's *Confessions*: 'I have resolved on an enterprise which has no precedent and which will have no imitator.' The artist's work is in fact bound up with the realization of a universe so personall as to exexclude the possibility of others sharing it; there is no question of Picasso founding a school. Except for discreditable pastiches, do we not see younger painters embarking on a different course? Picasso is on too high a plane to be imitated, and it is part of his greatness to remain unique.

From Georges Limbour, 'Picasso au Salon d'Automne', *Le Spectateur des Arts* no. 1, Paris, December 1944, pp. 4–6,8; translated from French by P. S. Falla.

(1944) Harriet and Sidney Janis
Picasso's studio

When Picasso opened his studio in liberated Paris to the GI's and others, his first inquiries were concerning the artists in exile: Duchamp, Breton, Dali, Masson, and many others. He disclosed to his questioners that German officers repeatedly had tried to buy his pictures only to be categorically rejected. When, on the other hand, some German privates risked orders to visit him, he gave them a few small sketches, a gesture that in itself indicates the simple, basic democracy of his character. He explained how he had been able to work in the face of Nazi occupation and the party's antagonism to all forms of modern art, saying: 'It was not a time for the creative man to fail, to shrink, to stop working,' and 'there was nothing else to do but work seriously and devotedly, struggle for food, see friends quietly, and look forward to freedom.' In actuality, however, his activity carried considerably further than this explanation would imply. 'Work', for example, included surreptitiously casting in

forbidden, strategic metals the plasters he made during the war as well as most of the earlier plaster sculpture of the thirties. This feat he had accomplished with the aid of Resistance friends, who made frequent nightly trips between his studio and the underground foundry. The plasters and bronzes were transported under the very noses of the Nazis, cleverly concealed in wheelbarrows and carts ostensibly filled with rubbish – a nice diversion to constructive purposes of metals earmarked for destructive enemy use.

From Harriet and Sidney Janis, *Picasso: The Recent Years, 1939–46*, Garden City, N.Y., 1946, pp. 4–5.

1944 John Pudney
Picasso – A Glimpse in Sunlight

When the firing died down and one wept less often at the singing of the Marseillaise and less champagne was forced across one's altogether willing palate in the name of liberation, I went to see Pablo Picasso.
.
There was a hall littered with books. Then came the large room, 'a little of a factory and something of a studio'. Picasso pointed with his foot lightly towards a Matisse, then with his hand to another Matisse half hidden among the bronzes and *objets d'art* – to use a rare but strictly accurate phrase. There were other pictures belonging to my host, a superb Douanier Rousseau for example. There were no works by Picasso.

But at last we began to talk about the closed years: and Picasso's fine hands with the long regular finger-nails smiled with his eyes. He turned from the works of other men and beckoned me to follow him up one more staircase. 'I have worked on,' he said. 'They would not let me exhibit but I worked and all my work is here.' We came into a working studio perched amid the Montparnasse roofs, so recently – and still occasionally – battlegrounds for snipers. This studio was packed with the four years' work of Picasso.

I forget how it was ranged, how one looked at it. There was no order just a sufficient orderliness. During all the closed years Picasso has never ceased to work, in this studio. As the horror once seen at Guernica extended over the face of the earth, Picasso has worked with undiminished zeal. He believes that outside events caused him to seek a greater objectivity. He said that the tendency in the creative artist is to stabilize mankind on the verge of chaos. These are the sort of things we talked about, not using many words, but referring from time to time to the collection of pictures not yet enjoyed by the critics of a free world. There was a series of brilliantly coloured and comparatively objective paintings of the Seine round the Ile St. Louis – nearly the most hackneyed land-

scape in Paris.[1] There were four very exact likenesses of a boy drawn during the summer of war.[2] There were a number of drawings of the pot of growing tomatoes which stood in the window and at least two finished paintings clung round those same tomatoes as a central theme.[3] 'A more disciplined art, less constrained freedom, in a time like this is the artist's defence and guard,' Picasso said. 'Very likely for the poet it is a time to write sonnets. Most certainly it is not a time for the creative man to fail, to shrink, to stop working. Think of the great poets and painters of the Middle Ages.'

We looked at larger canvases, at painting lighter, gayer but as strong and free as the pre-war works I had known. Not being competent to write of painting I have no words either in French or English with which to praise or to examine such things. Picasso showed me the more recent, and he pointed out the significance of the dates. There stood the big picture finished on August 19 when the fighting started. There were sketches dated day by day during the Battle of Paris. On August 24 when Tiger tanks were fighting round the corner in the Boul Mich, when Germans and the French fascists were fortified in the Luxembourg, when the Prefecture just across the river on the Ile de la Cité was a strong point, Picasso glanced at a work by Poussin. As the windows rattled with the fighting he began copying Poussin's design. 'It was an exercise, a self-discipline, a healthy fascination. . . .' He worked at it throughout the loud, angry day of the liberation on August 25.[4]

Now the sun shines in upon the much-painted tomato plant and Paris is quiet. Cocteau is on the telephone. One must see the rest of the studio apartment, the cool Spanish tiled floor of the bedroom, the bathroom with twin wash-hand basins, 'either a hand in each or an intelligent conversation with a friend while you wash.' The little man is vivid, simple, twenty years younger in vitality than the disciples who move about these roomy quarters to do honour to the work and admire the master.

In the littered hall again, Picasso displayed the savage literature of the enemy. He has quietly collected the Nazi and collaborationist periodicals in which his work has been attacked. His quick remarkable hands turned over the pages which reproduced his work. *Picasso the Jew . . . the decadent Pablo Picasso . . . the obscene pornographer . . .* went the captions. 'And now, at least, that is at an end,' he said, simply allowing for one moment the relief which all intellectual Paris is expressing to show itself in his own face.

From John Pudney, 'Picasso – A Glimpse in Sunlight', *The New Statesman and Nation,* **London, 16 September 1944, pp. 182–3.**

[1] e.g. *Le Vert Galant* (z. XIII. 64)
[2] *Head of a young boy* (z. XIV. 30–33)
[3] Drawings, z. XIV. 13–16; paintings, z. XIV. 21–29
[4] *The triumph of Pan* (z. XIV. 35)

Up to the time France entered the war there were no echoes in Picasso's painting of the furious protest that had produced *Guernica*. Then came France's military disaster and her humiliating occupation by the Germans. Nasty stories circulated about Picasso. That he was living well in Paris under the Germans; that he played ball with the Gestapo, which in return permitted him to paint unmolested. That he was selling the Nazis fakes – works he signed, but which were actually painted by his students. Still another that he was dead. From 1940 until the liberation of Paris, Picasso remained a figure completely surrounded by mystery and obscurity. Then in October following the liberation came the electrifying news that Picasso had joined the Communist Party.

In that same month liberated Paris held a gigantic exhibition of contemporary French art, one room of which was especially devoted to Picasso – seventy-four paintings and five sculptures, most of them executed during the occupation. The exhibition startled me. It was the Picasso of the *Guernica*, painting powerfully, painting beautifully, painting of life and hope.

I was so excited by Picasso's work I determined to see him.
.

You enter directly into one of the studios, a room with several easels, paintings, books – without order. As I waited I noticed one of his recent paintings on an easel, of a metal pitcher on a table. Tacked above the painting was a small pencil sketch of the composition, which the painting duplicated down to the last line and detail. Though it was only a quick sketch, he had followed it so closely that when he crossed lines at the corner of the table he also crossed them in the painting.

I asked his secretary if Picasso had had trouble with the Germans. 'Like everyone,' he said, 'we had hard times.' Picasso was not permitted to exhibit. Once the Gestapo came and accused Picasso of being in reality a man called Leipzig. Picasso simply insisted, 'No, I am Picasso, that's all.' The Germans did not bother him after that, but they kept a close watch on him at all times. Nevertheless, Picasso maintained a close contact with the underground resistance movement. After about ten minutes Picasso came down from the upstairs studio, and approached me directly. . . .

I described my interpretation of his painting, *The Sailor*,[1] which I had seen at the Liberation Salon. I said I thought it to be a self-portrait – the sailor's suit, the net, the red butterfly showing Picasso as a person seeking a solution to the problem of the times, trying to find a better world – the sailor's garb being an indication of an active participation in this effort. He listened intently and finally said, 'Yes, it's me, but I did not mean it to have any political significance at all.'

I asked why he painted himself as a sailor. 'Because,' he answered, 'I

always wear a sailor shirt. See?' He opened up his shirt and pulled his underwear – it was white with blue stripes!

'But what of the red butterfly?' I asked. 'Didn't you deliberately make it red because of its political significance?'

'Not particularly,' he replied. 'If it has any, it was in my subconscious!'

'But,' I insisted, 'it must have a definite meaning for you whether you say so or not. What's in your subconscious is a result of your conscious thinking. There's no escape from reality.'

He looked at me for a second and said, 'Yes, it's possible and normal.'
.

'My work is not symbolic. . . . only the *Guernica* mural is symbolic. But in the case of the mural, that is allegoric. That's the reason I've used the horse, the bull and so on. The mural is for the definite expression and solution of a problem and that is why I used symbolism.'

'Some people,' he continued, 'call my work for a period "surrealism". I am not a surrealist. I have never been out of reality. If someone wished to express war it might be more elegant and literary to make a bow and arrow because that is more aesthetic, but for me, if I want to express war, I'll use a machine gun! Now is the time in this period of changes and revolution to use a revolutionary manner of painting and not to paint like before.' He then stared straight into my eyes and asked, '*Vous me croirez?*'

I told him I understood many of his paintings at the exhibition, but that quite a few I could not figure out for myself at all. I turned to a painting of a nude and a musician that had been in the October Salon, set up against the wall to my left. It was a large distorted canvas, about five by seven feet.[2] 'For instance this,' I said, 'I can't understand at all.'

'It's simply a nude and a musician,' he replied. 'I painted it for myself. When you look at a nude made by someone else, he uses the traditional manner to express the form, and for the people that represents a nude. But for me, I use a revolutionary expression. In this painting there is no abstract significance. It's simply a nude and a musician.'

I asked 'Why do you paint in such a way that expression is so difficult for people to understand?'

'I paint this way,' he replied, 'because it's a result of my thought. I have worked for years to obtain this result and if I make a step backwards, it will be an offence to people because that is a result of my thought. I can't have the satisfaction of being understood. I don't want to go down to a lower level.'

'You're a painter,' he continued; 'you understand it's quite impossible to explain why you do this or that. I express myself through painting and I can't explain it through words. . . .'

From Jerome Seckler, 'Picasso Explains', *New Masses*, New York, 13 March 1945, pp. 4–7.

[1] *Self-portrait in sailor shirt* (z. XIII. 167)
[2] *The Aubade* (z. XII. 69)

Françoise Gilot
On *La Femme Fleur*

He began to paint the portrait of me that has come to be called *La Femme Fleur*.[1] I asked him if it would bother him to have me watch him as he worked on it.

'By no means,' he said. 'In fact I'm sure it will help me, even though I don't need you to pose.'

Over the next month I watched him paint, alternating between that portrait and several still lifes. He used no palette. At his right was a small table covered with newspapers and three or four large cans filled with brushes standing in turpentine. Every time he took a brush he wiped it off on the newspapers, which were a jungle of coloured smudges and slashes. Whenever he wanted pure colour, he squeezed some from a tube on to the newspaper. From time to time he would mix small quantities of colour on the paper. At his feet and around the base of the easel were cans – mostly tomato cans of various sizes – that held greys and neutral tones and other colours which he had previously mixed.

He stood before the canvas for three or four hours at a stretch. He made almost no superfluous gestures. I asked him if it didn't tire him to stand so long in one spot. He shook his head.

'No,' he said. 'That's why painters live so long. While I work I leave my body outside the door, the way Moslems take off their shoes before entering the mosque.'

Occasionally he walked to the other end of the atelier and sat in a wicker armchair with a high Gothic back that appears in many of his paintings. He would cross his legs, plant one elbow on his knee and, resting his chin on his fist, the other hand behind, would stay there studying the painting without speaking for as long as an hour. After that he would generally go back to work on the portrait. Sometimes he would say, 'I can't carry that plastic idea any further today,' and then begin work on another painting. He always had several half-dry unfinished canvases to choose from. He worked like that from two in the afternoon until eleven in the evening before stopping to eat.

There was total silence in the atelier, broken only by Pablo's monologues or an occasional conversation; never an interruption from the world outside. When daylight began to fade from the canvas, he switched on two spotlights and everything but the picture surface fell away into the shadows.

'There must be darkness everywhere except on the canvas, so that the painter becomes hypnotized by his own work and paints almost as though he were in a trance,' he said. 'He must stay as close as possible to his own inner world if he wants to transcend the limitations his reason is always trying to impose on him.'

Originally, *La Femme Fleur* was a fairly realistic portrait of a seated

La Femme Fleur, May 1946. Collection Françoise Gilot.

woman. You can still see the underpainting of that form beneath the final version. I was sitting on a long, curved African tabouret shaped something like a conch shell and Pablo painted me there in a generally realistic manner. After working a while he said, 'No it's just not your style. A realistic portrait wouldn't represent you at all.' Then he tried to do the tabouret in another rhythm, since it was curved, but that didn't work out either. 'I don't see you seated,' he said. 'You're not at all the passive type. I only see you standing,' and he began to simplify my figure by making it longer. Suddenly he remembered that Matisse had spoken of doing my portrait with green hair and he fell in with that suggestion. 'Matisse isn't the only one who can paint you with green hair,' he said. From that point the hair developed into a leaf form and once he had done that, the portrait resolved itself in a symbolic floral pattern. He worked in the breasts with the same curving rhythm.

The face had remained quite realistic all during these phases. It seemed out of character with the rest. He studied it for a moment. 'I have to bring in the face on the basis of another idea,' he said, 'not by continuing the lines of the forms that are already there and the space around them. Even though you have a fairly long oval face, what I need, in order to show its light and its expression, is to make a wide oval. I'll compensate for the length by making it a cold colour – blue. It will be like a little blue moon.'

He painted a sheet of paper sky-blue and began to cut out oval shapes corresponding in varying degrees to this concept of my head: first, two that were perfectly round, then three or four more based on his idea of doing it in width. When he had finished cutting them out, he drew in, on each of them, little signs for the eyes, nose, and mouth. Then he pinned them on to the canvas, one after another, moving each one a little to the left or right, up or down, as it suited him. None seemed really appropriate until he reached the last one. Having tried all the others in various spots, he knew where he wanted it, and when he applied it to the canvas, the form seemed exactly right just where he put it. It was completely convincing. He stuck it to the damp canvas, stood aside and said, 'Now it's your portrait.' He marked the contour lightly in charcoal, took off the paper, then painted in, slowly and carefully, exactly what was drawn on the paper. When that was finished, he didn't touch the head again. From there he was carried along by the mood of the situation to feel that the torso itself could be much smaller than he had first made it. He covered the original torso by a second one, narrow and stemlike, as a kind of imaginative fantasy that would lead one to believe that this woman might be ever so much smaller than most.

He had painted my right hand holding a circular form cut by a horizontal line. He pointed to it and said, 'That hand holds the earth, half-land, half-water, in the tradition of classical paintings in which the subject is holding or handling a globe. I put that in to rhyme with the two circles of the breasts. Of course, the breasts are not symmetrical; nothing ever is. Every woman has two arms, two legs, two breasts, which may in real life

be more or less symmetrical, but in painting, they shouldn't be shown to have any similarity. In a naturalistic painting, it's the gesture that one arm or the other makes that differentiates them. They're drawn according to what they're doing. I individualize them by the different forms I give them, so that there often seems to be no relationship between them. From these differing forms one can infer that there is a gesture. But it isn't the gesture that determines the form. The form exists in its own right. Here I've made a circle for the end of the right arm, because the left arm ends in a triangle and a right arm is completely different from a left arm, just as a circle is different from a triangle. And the circle in the right hand rhymes with the circular form of the breast. In real life one arm bears more relation to the other arm than it does to a breast, but that has nothing to do with painting.'

Originally the left arm was much larger and had more of a leaf shape, but Pablo found it too heavy and decided it couldn't stay that way. The right arm first came out of the hair, as though it were falling. After studying it for a while, he said, 'A falling form is never beautiful. Besides, it isn't in harmony with the rhythm of your nature. I need to find something that stays up in the air.' Then he drew the arm extended from the centre of the body stem, ending in a circle. As he did it, he said, half-facetiously, lest I take him too seriously, 'You see now, a woman holds the whole world – heaven and earth – in her hand.' I noticed often at that period that his pictorial decisions were made half for plastic reasons, half for symbolic ones. Or sometimes for plastic reasons that stemmed from symbolic ones, rather hidden, but accessible once you understood his humour.

In the beginning the hair was divided in a more evenly balanced way, with a large bun hanging down on the right side. He removed that because he found it too symmetrical. 'I want an equilibrium you can grab for and catch hold of, not one that sits there, ready-made, waiting for you. I want to get it just the way a juggler reaches out for a ball,' he said. 'I like nature, but I want her proportions to be supple and free, not fixed. When I was a child, I often had a dream that used to frighten me greatly. I dreamed that my legs and arms grew to an enormous size and then shrank back just as much in the other direction. And all around me, in my dream, I saw other people going through the same transformations, getting huge or very tiny. I felt terribly anguished every time I dreamed about that.' When he told me that, I understood the origin of those many paintings and drawings he did in the early 1920s, which show women with huge hands and legs and sometimes very small heads: nudes, bathers, maternity scenes, draped women sitting in armchairs or running on the beach, and occasionally male figures and gigantic infants. They had started through the recollection of those dreams and been carried on as a means of breaking the monotony of classical body forms.

When Pablo had finished the portrait he seemed satisfied. 'We're all animals, more or less,' he said, 'and about three-quarters of the human

race look like animals. But you don't. You're like a growing plant and I'd been wondering how I could get across the idea that you belong to the vegetable kingdom rather than the animal. I've never felt impelled to portray anyone else this way. It's strange, isn't it? I think it's just right, though. It represents *you*.'

From Françoise Gilot (with Carlton Lake), *Life with Picasso*, New York–Toronto–London, 1964, pp. 116–9.

[1] Z. XIV. 167

Tristan Tzara had first become acquainted with Picasso's work at the celebrated Cabaret Voltaire in Zurich in 1916, and from that time into the thirties Tzara was an outspoken participant in Dada and Surrealist activities. In his later years he helped organize exhibitions of a less radical nature and wrote occasional essays on aspects of contemporary art.

The following discussion was one of the first examples of Picasso criticism in the forties to renew the discussion of the parallel between painting and thought processes, which had been fundamental to Surrealism over twenty years before. Tzara's discussion of Picasso in this context is of particular interest because of the connection which was being made between painters and automatism in the post-war period.

1947–8 Tristan Tzara
Picasso and the knowledge of space

If the act of painting is a way of living, the finished work occupies a definite place in that creation which is constituted by the artist's life as a whole. Whether it be forms, colours, volumes, sounds or words that act as a medium for the realization of the thing to be signified, it is by denying their specific nature that the artist activates them in a world where they will belong according to the new, more general, nature that from now on attaches to them.

With Picasso it is as if he had retraced the whole process of the invention of plastic forms, from anonymous arts to the sophistication of the present day. In reconsidering the means by which man has sought throughout the ages to synthesize his representation of the world, Picasso has denied not only the object of this representation but also the interpretive schemata that have crystallized in different ages and under different skies. Thus by Picasso's denial of history this negation of the negation of the pictorial object here succeeds in attaining to a particular knowledge of the world of forms. A real set of axioms is placed at the painter's command, a compendium of all the ways of translating the data

of immediate reality into plastic language. Each of his creations presents afresh the whole problem of painting and its radiation throughout human affairs.

As Picasso approaches his canvases – and each one of them must be seen as the starting-point of a period or cycle that concludes only when its possibilities are exhausted – he re-invents the art of painting by calling in question the central principles of technique and cognitive content, the two being interdependent and inseparable. In Picasso's universe every plastic experience leads to exhaustive amplification; despite the diversity of means employed, it would be easy to relate them all to a necessity of expression in pursuit of a common end, that of reaching the heart of the structure of objective vision and the understanding of nature by means of that instrument which man has been given, the faculty of sight and touch. Whether on flat surfaces or in sculpture, tactile sensation is located both in the outer edge of the skin and in the structure of the eye, to which it may be transferred; just as space, to be perceived, requires both the visual and the tactile element. The world of physical objects, where the plastic arts are situated, demands the intervention of movement around those objects, for a static perception would rob them of the attribute of volume which is not only their constitutive reason but also their definition. Space is movement, a function of sight and contact, and demands to be lived in order to assert itself to its full effective measure.

.

The objective of the plastic arts has always been, if not to represent the spontaneity of nature in its full freshness – which would be an absurd pretension – at least to create its correspondence within a privileged milieu. Human contact is here transferred to a plane where the artist condenses his own emotion more or less directly, and where, for want of real space, the demands of movement are circumscribed by the fact that the canvas itself is immersed in space and framed by it. The initial state of thought, suspended, as it were, prior to its realization, and fixed in that phase by line and colour, corresponds to what is produced in the theatre by the creation of feeling in its emotional purity. The effort of abstraction required of the spectator is not of the same kind as at the cinema, where the use of images of physical reality create an easily acceptable but superficial convention for the senses, for it appeals to their automatism, whereas in the case of a painting it takes second place to an intensive operation, a recapitulation of the very process of the painter's art.

What we have to do is not to explain Picasso's painting, but to fit it into a system of relations that match the spirit of the time. The spectator only comes to appreciate the subtlety of a painting in so far as he has a more or less accurate sense of the evolution of the painter's thought and feeling. If a community accepts an art as public property, thanks to changes of taste and habit, this is as a rule due to a generalized *simulation* of the creative act. This shows how reluctant the mind is to accept new functional modes in the sphere of behaviour. Nonetheless, there comes into being an

average measure of collective comprehension which gives each period its proper shape both from the point of view of its stylized aspect and of the education of the senses.

Picasso's work has done a very great deal to give our age the particular character that history, with its schematization of appearances, will not fail to bring out of the confusion and contradictions that at present seem to be a significant feature of modern times.

From Tristan Tzara, 'Picasso et la connaissance de l'espace', *Artès* no. 3–4, Antwerp, 1947–8, pp. 3–5; translated from French by P. S. Falla.

1947–8 René Gaffé
Picasso a sculptor?

How many in fact know him as such? Yet his *Woman's head*[1] dates from as long ago as 1909, when his inventiveness (working together with Braque, it is true) gave birth to Cubism, which was to revolutionize the art of painting and shake the world for a long time afterwards.

Picasso sought within himself the substance of his sculptural creation. It is not that his works in this medium are very numerous or are all successful with the kind of perfection to which the Greeks have accustomed us, but they all bear witness, without apparent effort, to his inward anxiety and to his perseverance in using clay to express what he thought needed saying. There is nothing about this extraordinarily spirited man that can be ignored by those who are not bound by small-minded prejudice. The choice of medium does not matter to him. In sculpture he is interested only in the form which he subdues to his demonic fantasy – a form which is sometimes anguished but always powerful and intensely personal, a multiple form which he understands how to exploit to the full in order to suggest ideas and strike the imagination, to establish new canons and, as he did in painting, to find an enormous number of strangely effective modes of expression. He will not be called an inspired sculptor. I do not believe in his inspiration as a sculptor, but this man of genius has such resources of invention and such sharpness of vision that he cannot exhaust them with the brush alone. When he sets a reversed pair of handlebars on a bicycle saddle to make a modern Minotaur,[2] or ties a supple thread around pins stuck into a table, or crumples a flower and tears off its petals, or extends in space the slim body of an ephebe, or bends violently a Venus with bulging eyes – each of these is a success. As we wait patiently, he renews our vision every time. We are a long way here from the tender figures who stand beneath the placid sky of the Acropolis!

Picasso renews every material that he touches. Whereas, with professional sculptors who are only professionals, the external forms of their work appeal especially to the eye, with Picasso they violently excite our

235

minds. He always opens up new horizons to many hostile critics because he achieves a perfectly valid re-creation of purely plastic modes of expression. Geometrical elements have kept all their intensity without being tied down by pure intellectual abstraction. Picasso has not forgotten that in sculpture, unlike painting, form is not a mere support but must of itself delimit figures extended in space and reduce them to contours without ornament. He does not, however, isolate any important specific element, but he intensifies his forms, enriches their content and increases their density. In this manner, in a domain which is not properly his (but this prodigious sorcerer is at home everywhere), he has played his part in revolutionizing the art of sculpture. Many painters had tried to do so before him – Degas, Renoir, Modigliani, Matisse – but Picasso's turbulence renovates and rejuvenates the ancient art which, in various ways, had been saved from repetitiveness by Laurens, Lipchitz, Brancusi and Zadkine.

René Gaffé, 'Sculpteur, Picasso?', *Artès* no. 3–4, Antwerp, 1947–8, pp. 36–7; translated from French by P. S. Falla.

[1] *Head of a woman (Fernande)* (Spies 24)
[2] *Head of a bull* (Spies 240)

1947–8 Willy Boers
Lithographs by Picasso

Picasso, who is regarded by his supporters and even by his opponents as the most original of living painters, has been causing a stir in the art world for the past forty years or so. His perpetual self-renewal reduces imitators to despair, but his works exercise a tremendous attraction on young people in many lands, not only in Europe but especially in North and South America.

This great creative artist has already used several media and expressed his feelings in a wide variety of techniques, including sculpture, woodcuts and etchings. He has done many illustrations and even written a surrealist play entitled *Le diable* [sic] *attrapé par la queue*.

He now surprises us once again with a little-known aspect of his talent in the form of a series of drawings on the lithographic stone.

As in Picasso's most recent paintings, we are struck by his power to see reality in several different ways. This, in my opinion, is Picasso's secret; he is after all not a young man, but remains perpetually vital and makes us think of him as a member of the younger generation. He is indeed younger in spirit than many of his juniors, who instead of developing have become imprisoned in dogma. Thanks to his great vitality Picasso finds points of contact everywhere, both with contemporaries and with cultures of the distant past. It is a distinguishing mark of genius to perceive and connect

Owl on a chair, 1947.

ideas that seem remote and even opposed to one another. We find this in Shakespeare and Rembrandt, and also in the whole of Picasso's work.

This series of lithographs once again shows his many-sidedness. In every case he uses subjects perceived in the world about him. Thus, for instance, in a series representing a young owl that Picasso found in his garden at Antibes and lovingly brought up in his studio, he endeavours in different ways to express the wonder of the creature. Naturalistic studies of animal heads are varied with metamorphoses of the head of a woman. Some still lifes with flowers and the customary fruit-dish make a painterly impression by their fluidity of touch. Some sheets are inspired by the amazing animal paintings of the Altamira caves, and others by Bushman drawings.

The whole collection gives us the impression of having looked through a sketch-book of Picasso's. The works do not appear, however, to be sketches in the usual sense, but studies that make us see how these experiments could be developed. The sheets are not finished works such as the public generally expects to be shown, but stimuli for later generations of artists.

Willy Boers, 'Lithos van Picasso', *Artès* no. 3–4, Antwerp, 1947–8, pp. 38–40; translated from Dutch by P. S. Falla.

(1948) Daniel-Henry Kahnweiler
Talking to Picasso

Vallauris, 'La Galloise', 28 June 1948

At 10 I drove up with Marcel to La Galloise. It was impossible to bathe in the Golfe, so we talked. We were joined by Adam the sculptor and Picasso's son Paulo, who had both arrived overnight by motorcycle.

Picasso spoke again of a subject that had been occupying his thoughts, namely that artists in the past had been craftsmen, and only now were they free to be truly artists. Adam and I agreed. I said to Françoise that the troubles of Rembrandt, for instance, were due to the fact that he did not want to be just a craftsman. He was commissioned to paint a portrait, and the customer found himself confronted by a picture where there was a lot of chiaroscuro, study of light and even psychology, but in which he did not recognize his own portrait. And the *Conspiracy of the Batavians* was so far removed from the 'honest' pictures of a painter like Van der Helst. Altogether, in those days people expected of a painter what today they expect from a photographer.

P.: 'They commissioned work, of course, didn't they?'

You could hear in these words the horror of commissions which always prevented Picasso from executing any.

K.: 'A commission obliges the artist, or the artisan, to set himself a

Still life on a ball, 1948 (illustrated with Kahnweiler's article). Galerie Louise Leiris, Paris.

specific aim. He has to foresee and plan what his picture will look like, and that rules out the freedom of "perpetual creation".'

P.: 'Another result of craftsmanship is "rules", geometrical methods, the golden section.'

Adam: 'The spectator must be able to find these proportions in the finished work, but the artist shouldn't think about them while he's painting.'

K.: 'I think you can find them in all pictures. There's a bit of cheating when the diagonal doesn't pass across the sitter's mouth, and we say that the painter ran it through his ear instead.'

P.: 'Cézanne's "Poussin after nature" is another mistake of the same kind. It's all wrong to approach nature with the deliberate intention of violating it. You cut off a branch here and there to throw it into a basket, you shift a tree from one place to another – what a mistake it all is!'

K.: 'Yes, you think it goes against the naïveté that you are practising just now, the "absence of style" which you do in fact achieve.'

Adam: 'To achieve that freedom has taken many centuries – and above all it needed you, Picasso.'

K.: 'I agree.'

29 bis, rue d'Astorg, 8 July 1948

Picasso came round to show us his new car. He found Laurens in the office and they had a talk.

P.: 'You ought to go in for pottery, it's magnificent. [To me]: The head's fired already. [To Laurens]: I've done a head, and whichever angle you look at it from, it's flat. Of course it's the painting – I painted it specially to make it look like that. In a picture you look for depth and as much space as possible, but with a sculpture you try to make it look flat from every direction. I did something else too: I painted on curved surfaces, balls for instance. It's amazing, you paint a bottle and it runs away from you, it slips round the ball.'

Later, seeing one his *papiers collés* of 1914, he said: 'What idiots or cowards we must have been to have given that up! We had marvellous means at our disposal. You see how beautiful it is – not because it's mine,

of course – but we used to have *that*, and then I went back to oils and you to marble. It's crazy!'

Léger arrived, and we talked of Picasso's play.[1] Léger said we ought to act it, and somebody remarked that Léger himself would be fine as a girl.

P.: 'Yes, I had in mind tall, beautiful children [indicating the height of a grown-up person].'

From Daniel-Henry Kahnweiler, 'Entretiens avec Picasso', *Quadrum* no. 2, Brussels, November 1956, pp. 75–6; translated from French by P. S. Falla.

[1] Picasso's second play, *Four Little Girls*.

(1949) Françoise Gilot
Aragon and the *Dove*

In his aviary, in company with many exotic birds, Matisse had four large Milanese pigeons. Their feet were not bare like most pigeons. They had feathers right down to the ground covering their claws; it was just as though the feet had white gaiters on them. One day he said to Pablo, 'I ought to give these to you because they look like some you've already painted.' We took them back to Vallauris with us. One of them had a very distinguished artistic and political career. Early in 1949 Pablo made a lithograph of it which turned out to be a brilliant technical success. In lithography one can get an absolute black quite easily, but since lithographic ink has wax in it, when you dilute it with water to make a light-grey wash, the lithographic stone does not take the wash very evenly. That makes what is called in French *la peau de crapaud*, a surface mottled like a toad's skin. But in this lithograph Pablo had succeeded in making a wash that gave the impression of an extremely transparent grey, with gradations that were an amazing *tour de force*.

About a month later, the poet and novelist Louis Aragon, who served as a kind of intellectual wheelhorse for the French Communist Party, came to the studio in the rue des Grands-Augustins to prod Pablo into giving him a sketch he had promised him for the poster advertising the Communist-sponsored World Peace Congress soon to be held at the Salle Pleyel. Aragon looked through a folder of recent lithographs, and when he saw that one, the pigeon looked so much like a dove to him that he had the idea of making it the symbol of the congress. Pablo agreed and by the end of the day the poster and the 'dove' had already begun to appear on Paris walls. In its countless printings and reprintings, first as an original lithograph and later in reproduction, the poster went around the world in the cause – or at least in the name – of peace.

From Françoise Gilot (with Carlton Lake), *Life with Picasso*, New York-Toronto-London, 1964, pp. 255–6.

Ilya Ehrenburg
Picasso and peace

Some authors who have written about Picasso have tried to represent his interest in politics as something accidental, a whim: he is an eccentric, he likes bullfighting, and for some reason he has become a Communist. Picasso has always treated his political choice very seriously. I remember a dinner at his studio on the day the Paris Peace Congress opened. That day a daughter was born to Picasso, whom he called Paloma, 'dove'. There were three of us at the table: Picasso, Paul Eluard and I. At first we talked about pigeons. Pablo told us how his father, a painter, who often drew pigeons, would allow him as a boy to draw the pigeons' feet, of which he himself had grown tired. Then we spoke about pigeons and doves in general. Picasso likes them and always keeps some; laughing, he said that pigeons were greedy and cantankerous birds; he could not understand why they had been made into a symbol of peace. Then he turned to his peace doves and showed us a hundred drawings for the congress poster – he knew that his dove was destined to fly over the whole world. He talked about the congress, about war and politics. I remember one sentence: 'Communism for me is intimately bound up with my whole life as an artist.' The enemies of Communism do not give this bond any thought: sometimes it puzzles certain Communists.

Later, Picasso drew several more doves for the Warsaw and Vienna Congresses. Hundreds of millions of people know and love Picasso only through the doves. The snobs sneer at those people. Picasso's detractors accuse him of having sought an easy success. Yet the peace doves are closely connected with all the rest of his work, the minotaurs and the goats, the old men and the girls. Of course his dove is only a single particle in the wealth of his creation. But how many people knew and admired Raphael through the reproduction of a single picture, the Sistine Madonna? How many millions know and admire Chopin only because he composed a piece of music they hear at funerals? The snobs do wrong to laugh. Of course it is impossible to know Picasso by the dove alone, but one has to be a Picasso to make such a dove.

Picasso himself, far from being offended by the love of simple people for his peace dove and for him, is infinitely touched by it. In 1949 the World Peace Committee met in Rome. After an open-air meeting held in a large square we walked along a street in a working-class district; some passers-by recognized him, took him to a small *trattoria*, gave him wine and embraced him; women asked him to hold their babies for a few minutes. It was an expression of the kind of love that cannot be simulated. Of course those people had not seen Picasso's paintings, and would not have understood many of them had they seen them; but they knew that he, a great artist, was for them and with them, and that is why they embraced him.

At the congresses – in Wroclaw, in Paris – he always sat with his earphones on, listening attentively. Several times I was obliged to ask him for favours: it nearly always turned out at the last moment that a Picasso drawing would be essential for the success of a congress or of some local peace campaign. And, however busy he was with other work, he always complied. From time to time people on the same side as himself politically would condemn or reject his works. He received this with a certain bitterness but calmly, saying 'there are always quarrels within a family.'

He knew that his pictures adorn many American museums, and he knew, too, that when he wanted to go to the United States with a World Peace Council delegation he was refused a visa. But he also knew something else: in the country he loved and believed in there was a negative attitude to his work for a long time. When we met once he said, laughing: 'You and I are in trouble again.' Shortly beforehand I had written an article in *Literaturnaya Gazeta*, not, of course, on art but on the struggle for peace (this was in 1949); in it I said that the best minds in the West were with us, and mentioned Picasso among others. The editorial board printed a footnote expressing regret that I had failed to criticize the formalist elements in Picasso's work. Naturally the anti-Soviet press in France quoted, not my article, but the footnote. Pablo only laughed, saying that it was not worthwhile getting upset: Rome wasn't built in a day.

Nothing could shake his confidence in the Soviet Union. In 1956 some of his friends, a prey to doubts, appealed to him to sign various protests, declarations and statements. Picasso refused.[1]

His exhibition in Moscow was a great joy for me. Too many people came to the opening: the organizers, afraid that there would be too few, had sent out too many invitations. The crowd broke the barriers. Everyone was afraid they might not get in. The director of the museum, white in the face, came running to me: 'Try to calm them, I'm afraid there'll be a stampede.' I said into a microphone: 'Comrades, you have waited twenty-five years for this exhibition, you can wait quietly for another twenty-five minutes.' Three thousand people laughed and order was restored. I was supposed to open the exhibition on behalf of the 'Friends of French Culture'. Normally these ceremonies strike me as boring or ludicrous, but on that day I was as excited as a schoolboy. They gave me a pair of scissors and I felt as though I were about to sunder, not a ribbon, but a curtain behind which stood Pablo.

Naturally enough, people at the exhibition argued. That is always the way at Picasso exhibitions: he delights, outrages, amuses, gives pleasure; no one is left indifferent.

From Ilya Ehrenburg, *People, Years, Life* **vol. I, London, 1961, pp. 213–5; translated from Russian by A. Bostock and Y. Kapp.**

[1] On 22 November 1956 Picasso, along with Edouard Pignon, Hélène Parmelin and seven others, protested at Russian intervention in the Hungarian revolt, and their letter to the Central Committee of the French Communist Party appeared in *Le Monde*.

1961 André Breton
80 carats . . . with a single flaw

I, for one, will never forget the number of *treats* he has given me. He alone, time after time, has made my eyes sparkle with his fireworks. I rediscover my youthful vision when I call to mind my first encounter with Picasso's work, at second hand, through an issue of Apollinaire's *Soirées de Paris* which included rather hazy reproductions of five of his latest still lifes (the date was 1913). Four of them were composed of an assemblage of materials of a residual nature such as slats, spools, discarded fragments of linoleum, lengths of string, all borrowed from everyday life. The initial shock provoked by an entirely new visual experience was succeeded by an awareness of the incomparable balance achieved by these works, which were thus endowed, willy-nilly, with an organic life that justified the necessity of their existence. Since then, nearly half a century has gone by. I gather, from what Picasso said to me one day, that these early constructions have long since been dismembered, but the image that remains of them suffices to demonstrate to what a degree they anticipate those forms of expression today which are most convinced of their own daring. To what a degree, too, most often, they tower above these later forms through the sheer authority they radiate, an authority which immediately dispels the slightest suspicion of gratuitousness.

On the artistic level, the attitude of surrealism towards Picasso has always been extremely deferential, and on many occasions his new proposals and discoveries have recharged the magnet which has drawn us towards him. What has exempted him, in our eyes, from the category of those so-called 'cubist' painters who were of no interest whatsoever to us, is the *lyricism* which allowed him, very early on, to take great liberties with the strict concepts that he and his fellow-enthusiasts of the moment had imposed on themselves. The secret lay in the fact that once the principles of a new means of representation had been established, his temperament permitted him to be the only one to go beyond those principles by refusing to shield them against the violent impulsions of passion that his life might experience. This in itself was sufficient to ensure him the immediate and lasting respect of all true poets. In his case, the rigid scaffolding of so-called 'analytical' cubism was very soon seen to be rocked by high winds, to be *haunted*. In this period of his work, which I consider to be the most fascinating of all, the power of incantation shows no signs whatsoever of diminishing. Even if his original intention had been no more than to refurbish the tarnished figurative image, the fact remains that in the end he had turned it upside down and reconstructed it in absolutely revolutionary fashion. A titanic operation, to be sure.

Later on, Picasso moved voluntarily in the direction of surrealism and made every effort to meet it half-way; and the good luck that his gesture brought us should make us careful, at this distance, not to minimize its

importance at the time. The proof of his adherence lies in part of his artistic output during 1923 and 1924, a number of the works he produced from 1928 to 1930, the metallic constructions of 1933, the semi-automatic poems of 1935 and, more recently, his 1943 play *Desire Caught by the Tail*. What has proved to be a lasting obstacle in the way of a more complete identification of his viewpoint with our own is his indefectible allegiance to the external world (of the 'object') and the blindness on the oneiric and imaginative level to which that predisposition has led. Even so, his whole body of work, with its roots buried in the last century, by virtue of its historical situation and the lengthy period it covers with an absolutely unwavering luxuriance, by virtue, too, of its inimitable semi-playful, semi-dramatic character, remains alive and youthful. The liveliness and youthfulness of his work is proved, additionally, by the controversies it continues to stir up, and by the fact that it is powerful enough to justify the unprecedented fame it enjoys.

Picasso a 'distinguished visitor'? I wish it were as simple as that. The fact remains that, today more than ever before, a body of work of such immense scope must inevitably be affected, in any final evaluation of it, by the behaviour of its author after being carried to the pinnacle of power by the accumulation of material goods, especially when this behaviour involves a flagrant contradiction with the message emanating from the work in question. For, in my view, this message, which is primarily one of freedom, is rendered nugatory by the toleration, at the price of very specific compromises, of party slogans, especially that of so-called 'socialist realism' with its notoriously indigent content and the coercive means employed to enforce it. This message, which is also one of truth, a truth filtered (as the artist has suggested often enough) through the prism of love, is equally flouted by the unremitting attentions of the Stalinist leaders who have continued to use Picasso for their own ends, not only during the lifetime of the dictator but even after Budapest as well. Has his courage perhaps failed him? It is almost incredible that, faced with their incorrigible servility, and in full knowledge of the crimes of which their masters are guilty, he has nevertheless yielded to their entreaties and peopled their atomic skies with so many fallacious, anaemic doves.

That is the single step which is missing each time I dream of climbing Picasso's staircase, my heart beating with the old excitement.

From André Breton, '80 carats . . . mais une ombre', *Le Surréalisme et la Peinture*, Paris, 1965, pp. 116–8; translated from French by Simon Watson Taylor as *Surrealism and Painting*, London, 1972.

A special issue of the magazine Le Point *was dedicated to Picasso in October 1952, following celebrations of Picasso's seventieth birthday the previous year. Contributors included Maurice Raynal (a selection of his panoramic view of the artist's half-century of work follows); D. H. Kahnweiler (these interviews are translated in Boeck and Sabartés, pp. 505–6); Pierre Reverdy (see Porzio and Valsecchi, pp. 257–8); as well as articles and recollections by Georges Besson, Tristan Tzara, Paul Gay, Edouard Pignon and Claude Roy.*

Maurice Raynal's quite lengthy article is an overview of the artist's life, which precedes his well-known 1953 study of the artist, and was written thirty years after his first monograph concerning Picasso had appeared in Paris in 1922. Raynal is primarily concerned here with tracing the connections between the various stylistic periods of Picasso's oeuvre, and he sees Picasso's Spanish heritage as the major linking factor, writing of Picasso's 'constant dissatisfaction, a never-ending torment, a constant search for something better, typical Spanish melancholy – a little of all this, no doubt, but above all the revolutionary spirit that has marked all Spain's greatest sons.'

The following selection is Raynal's conclusion; the works he refers to as the 'monstrous compositions of living figures' undoubtedly refer to Picasso's Dinard Bathers *of the late 1920s (e.g. Z. VII. 209).*

1952 Maurice Raynal
 Picasso's revelation

From each work another has arisen that inaugurated a new period, to the despair of logical classification. New forms of syntax are created for 'new thoughts'. Surely Picasso will reach the point of composing a new 'anatomy'. All plastic and graphic methods make their contribution. Oils, watercolours, engraving, drawing, lithography, sculpture – all are pushed to their limits, not out of curiosity or dilettantism but out of restlessness; each method is calculated as a dangerous weapon. If Picasso smiles mockingly before attempting the feat, it is because he is not always quite certain of success – for which we can hardly blame him. Thus we come to understand the athlete's wry smile before the *salto mortale*, or Picasso's sigh: 'You can't invent something new every day.'

But when he does succeed! – then all our wretched little human troubles disappear. The most powerful means are employed: the sensual and the cerebral unite; despair and confidence, tragedy and burlesque, irony and tenderness, the true and the improbable, doubt and faith combat each other or join forces. Figures, bodies and objects crack at the seams, break their fetters, burst out of their limits. Stifled and lost in this world of which we know nothing, the great artist's imagination strives to free itself from its obsession by means of a physical intoxication that transcends human measure and rises to superhuman heights. Yet nothing

human is lost, least of all the laws of an intuitive measure whereby the value of lines and volumes conforms to rhythms whose solidity defies time, whereas the little tonal combinations of colour, subject as it is to decay, are most often neglected or reduced to essentials. Literature cannot fully correspond with plastic lyricism, and one is in danger of using exaggerated language. But how else can we say that, having advanced beyond known limits, Picasso has now succeeded, for the edification of his world, in fusing the microcosm and the macrocosm of ancient metaphysics, to produce effects of strange blossoming, unexpected turgescence, incredible distension, prodigious efflorescence – shrill, frenzied, impetuous and desperate.

This is above all true of the 'monstrous' compositions either formed of crude living figures or made up of constructive elements, living themselves. I am reminded of the engineers' word for struts, *jambes de force*. Here Picasso touches the most secret fibres of life, the very heart of beings and of things. A whole world of joy, grief, cruelty, death and sensuality lays bare the mysteries of a life whose secrets have been violated by the crudest vivisection. A tear-stained face, a sleeping figure, a person dying, men and woman frolicking on a beach, a bird on a branch, a dance, a mad bull, the massacre of Guernica – all are brought to life with such elements as mouths, teeth, eyes, hands, legs or various other objects, exorcized of their appearances, seen in terms of their original mechanical functions, considered as essential materials directed toward verification, above all towards distinguishing their intended purpose in making the most profound revelation of a real world, as real as the vibrations of truth that the power of genius can send pulsing through our veins.

Thus, despite the practice of a science, almost forgotten because it is intuitive, Picasso's art is reunited with the childish scribbles from that period of life when drawing is not yet a language. This time Picasso's work is no longer the effect of language alone, that is to say a translation of an expressive need. It is the object itself, spontaneously created by exclamation and onomatopoeia, before translation-treason, inadequate as it always is, comes to obscure and distort the pure aspiration; its spirituality inexorably outrun by its sensory expression.

I have used the term 'apocalyptic' of Picasso's works of the last twenty years. If we re-read the Apocalypse of St John I think we shall find many resemblances between the two, and above all the idea of revelation that they have in common, which is the highest and most powerful human expression of the lyrical spirit.

From Maurice Raynal, 'Panorama de l'Oeuvre de Picasso', *Le Point* XLII, Souillac (Lot)-Mulhouse, October 1952, pp. 16–17; translated from French by P. S. Falla.

8.
The last twenty years

1953–1973

The glorification of the Picasso myth, which had begun after World War II, in the last twenty years of his life grew until his work, in a sense, had become beyond criticism. Few attacked him, with the exception, perhaps, of John Berger, who in The Success and Failure of Picasso *(1965) questioned Picasso's economic motives and his public reception in his later period in particular. Otherwise, it was Picasso's enormous output in a variety of techniques (with exceptional numbers of prints and drawings) that prompted his name to be discussed among critics, even though his work seemed at the time to be far from mainstream, non-figurative art. Picasso, on the other hand, continually worked with figurative imagery to the point of developing a kind of internal narrative in the numerous variations within a series that characterized his working methods of the late years.*

One of Picasso's favourite thematic departures in the late work was the history of art, and in his many prints, drawings and paintings of that period, reference is made to artists such as Altdorfer, Manet, Rembrandt, Delacroix, Courbet and Velázquez. In a sense, Picasso was writing himself into the history of art, by virtue of his choice of association with his predecessors. Of particular significance, however, are the specific works that interested him, for they reveal that Picasso often personally identified with the work or the artist. After seeing Manet's Lola de Valence *exhibited in Nice, he made at least one drawing of Jacqueline as* Lola de Valence *(z. XVI. 479). He was also attracted to Delacroix's* Femmes d'Alger *because of the resemblance of the figure on the right to his wife. More importantly, he seemed challenged to rework the complex pictorial problems the older artist had originally set for himself. In the case of* Las Meninas, *for example, the scene is not merely the artist Velázquez in his studio, but it is the mature artist (a fellow Spaniard) whose life is his work, and who is, like Picasso, tied to the studio in late life (when Velázquez was exclusively working at the court). The intricate and subtle problems of light, spatial relationships and colour, and above all, the whole game of seeing, of illusion and reality, that occur in Velázquez's work, are given new life in Picasso's inventive variations.*

In his later years Picasso exhibited a renewed sense of freedom and play — everything he touched seemed to turn into art. Picasso himself behaved like a conjuror, performing with light before a camera in Henri-Georges Clouzot's

film Le Mystère Picasso *(1955)*, *or transforming playful paper cut-outs into monumental sculptural form. And, finally, just as he returned to the subjects of the history of art, he set about to redo his own subjects – the circus and the artist's studio become stages once again for the performance of his characters, among whom he portrayed himself as an old acrobat or king.*

In the last Avignon exhibition, the fresh paint surfaces and child-like scrawls which covered the canvases he himself had selected for that show conveyed the energy of creation that still provoked critical response. Once again his work was explained in contemporary terms, and thus in 1973 Pierre Daix, for example, referred to the impact of the world of mass media and technology on the artist in his nineties.

Drawing after Altdorfer, 1953, which Picasso signed with the artist's name (one of two drawings illustrated with Rosamond Bernier's article).

Rosamond Bernier
Picasso on Altdorfer

It is not generally known that Picasso is passionately fond of exercising his style by copying and interpreting the works of great painters of the past. In 1949 he made drawings and lithographs after Cranach and at present he is working on a whole series of pictures based on his recollection of Delacroix's *Femmes d'Alger*, which he has not seen for fifteen years.

One of the painters in whom he took an interest was Altdorfer, three of whose drawings Picasso worked from, as shown for the first time in the accompanying illustrations. Daniel-Henry Kahnweiler, who for the past thirty years has kept a note of his conversations with Picasso, relates how his friend got to know the Bavarian master:

'Calling on Picasso one day in the autumn of 1953, I happened to have with me Benesch's book on Altdorfer. Picasso, who was curious about everything to do with art, asked to see it; he became enthusiastic, and I gave him the book. A few days later we had the following conversation:

29 bis, rue d'Astorg, 18.11.53, 5 p.m.
Picasso came to sign some lithographs, and we had a chat. Beaudin joined us, and asked Picasso what work he had been doing. Picasso said none. "What about the lithographs?" I put in.

' "No," said Picasso, "I've been copying Altdorfer. It's really fine work! There's everything there – a little leaf on the ground, one cracked brick different from the others. There's a picture with a sort of little closed balcony – the closet, I call it. All the details are integrated. It's beautiful. We lost all that, later on. We've come all the way to Matisse – colour. It may be progress but it's something different. These things ought to be copied as they were in the past, but I know no one would understand." '

Rosamond Bernier, 'Altdorfer vu par Picasso', *L'Oeil* no. 5, Paris, 15 May 1955, p. 37; translated from French by P. S. Falla.

(1955) Hélène Parmelin
Concerning *Lola de Valence*

One summer's day at La Californie, Picasso announced a great piece of news: *Lola de Valence* had arrived in Nice.

The way Picasso announced the news it might have been a Lola of flesh and blood, some eminent person, a visitor from the moon arriving at the airfield, Sabartés or even some children or other.

Lola de Valence had come to Nice with a few other canvases of the same period for an exhibition in one of the town's museums.

It never, or scarcely ever, happens that a canvas takes the trouble to make the journey itself.

We could talk of nothing else but of the beautiful and magnificent *Lola de Valence*. Picasso and Pignon were in the studio. Manet was clearly the only painter in the world and they discussed all his canvases. They talked about him for an hour. They turned the pages of a book in which there were reproductions of Manets, talking delightedly all the time. Only Cézanne and Van Gogh emerged triumphant from the arena. All the rest was tripe. This was always happening, but Cézanne and Van Gogh never changed. On the other hand, the hero of the day, the starred painter who was momentarily in the ascendant was continually being replaced. He might cease to be tripe one morning only to become so again the next.

For the moment, the supreme painter was Manet.

And what a wonderful title for a canvas . . .

'Shall we go and visit Lola de Valence?' said Picasso.

We went off, all four of us [Picasso, Jacqueline, Parmelin and Pignon] as if we were going to see the queen on Republic Day in Paris. We lauded the beauty of Lola de Valence all the twenty-five kilometres that separated Cannes from Nice, where she was. We found the Museum, full of Napoleonic relics and very pretty. We hurried up the steps. It would be splendid, Picasso said, if we saw her come to the top of the steps to receive us, as at a ball, with her mantilla and her fan, like an ambassador's wife. . . . And with Manet on her arm. I'm putting myself out to look at him, he certainly owes me that much. . . .

We were all alone in the Museum, calling Lola de Valence from room to room. And there she was.

Picasso and Pignon stood in front of Lola de Valence, talking little of their impressions, the tips of their fingers skimming over the surface without touching it in the usual painter's gesture. There was a guard wandering about, with an air of wondering what we were up to.

Then we left. That's the whole story. Lola de Valence was as beautiful as the day. But, at the first glance, she had dissipated the clouds of our over-excited imaginations. She was magnificent. But simply herself. A magnificent canvas.

Our exaltation had lapsed. But it was renewed in the restaurant, where Lola de Valence became herself again, not as in the Museum, but in the little or big museum each of us carried in his head: the beautiful, the incomparable, the unique Lola de Valence.

To Lola de Valence's health!

The real one: the one one thinks of when one does think of her, 'the unexpected charm of a pink and black jewel'. Manet's.

From Hélène Parmelin, *Picasso sur la place*, Paris, 1959; translated by Humphrey Hare as *Picasso Plain*, London, 1963, pp. 120–1.

In 1954–5, Picasso worked on the theme of Delacroix's Femmes d'Alger *and made fifteen paintings (e.g. Z. XVI. 360, the final version), numerous drawings and a set of lithographs. For the most complete analysis of this project, see Leo Steinberg, 'The Algerian Women and Picasso at Large', Other Criteria, New York, 1972, pp. 125–234.*

(1955) Daniel-Henry Kahnweiler
Conversations about the *Femmes d'Alger*

Rue des Grands-Augustins, 14.1.55

Picasso took me up to the attic once again with his nephew Fin to look at the pictures after Delacroix's *Femmes d'Alger*, on which he was working.

Picasso: 'I wonder what Delacroix would say if he saw these pictures.'

I replied that I thought he would understand.

P.: 'Yes, I think so. I would say to him: "You had Rubens in mind, and painted a Delacroix. I paint them with you in mind, and make something different again." '

Somehow we began to talk of El Greco.

P.: 'What I really like in his work are the portraits, all those gentlemen with pointed beards. His religious pictures, the Trinity, the Virgin and so on – all that is Italian, decorative. But the portraits! That, too, is why I prefer the Germans to the Italians. They, at least, were realists. The painter you gave me a book about. . . .'

K.: 'Altdorfer. Yes, you did a whole series of copies of his work – magnificent drawings.'

P.: 'Yes, Altdorfer. How beautiful it is! That's realism. While the Italians, even the greatest of them, are just decorative. And they keep harking back to antiquity.'

K.: 'What about your enemy Caravaggio? Isn't he a realist?'

P.: 'That's fake realism – stagy, make-believe. Like Feyder's films. "Put one reflector on the right, another on the left!" '

K.: 'But his treatment of biblical subjects, for instance St Matthew in the inn?'

P.: 'No, no! He sees the daughter of his concierge, paints her portrait and there you have Bacchus! But look at Rembrandt – he wanted to do Bathsheba, but his servant-girl who was the model interested him much more, and so he painted her portrait.'

One may see here the contradictions in Picasso that made him a 'man for all seasons', always free to take a fresh view. Two days earlier he had attacked me violently for criticizing 'abstract art'. I am convinced that he did so out of a spirit of contradiction and that he showed his true feelings in praising realism.

Les Femmes d'Alger, after Delacroix (final version), 1955. Collection Mr and Mrs Victor W. Ganz.

Rue des Grands-Augustins, 25.1.55

Picasso took me up to see a large canvas in the *Femmes d'Alger* series, which he had just begun. We spoke of this new series and of its colour.

P.: 'I sometimes say to myself that perhaps this is an inheritance from Matisse. Why shouldn't we inherit from our friends, after all?'

Lejard said that a friend of his had been very much struck by Picasso's remark long ago: 'I don't seek, I find.'

P.: 'You never know how your work will turn out. You start a picture, and it becomes something quite different. It's strange how little the artist's intention counts for. It's really tiresome: you always have a critic at your elbow saying "I don't like that" or "It ought to be different." He grabs at your brushes, and they become as heavy as lead. He doesn't know what he is talking about, but he's always there. Rimbaud was right when he said "I is someone else." '

Picasso had never talked to me before about this kind of split personality.

For the first time in several weeks, a lot of people had been admitted, and when I arrived Sabartés told me that everybody was upstairs. Picasso was showing them his *Femmes d'Alger*. Tzara, Gant and Lejard were there; Maya arrived a little later, and Sabartés introduced young Flinker.

Picasso again spoke of his inheritance from Matisse. Then we talked seriously about the pictures and their novelty.

P.: 'Basically, all my pictures were like that at first, but they changed afterwards. The bright colours get buried beneath others, and even the subject often changes, a figure advancing from right to left or vice versa.'

For some days past Picasso had been telling me that he always thought about the following day's picture in the *Femmes d'Alger* series and wondered what it would be like. He repeated: 'You see, it's not "time regained", but "time for discovery".'

Rue des Grands-Augustins, 7.2.55

When I arrived, only Fin was there. After a few minutes Picasso told me he had painted another picture in the *Femmes d'Alger* series, and took us up to see it. It was a big painting, about 100 by 160 cm, and quite different from all the previous ones. Instead of being brightly coloured it was in black and white, and it did not look like some of the studies belonging to the series, which were done in a kind of oil wash. This one was entirely a matter of drawing, and for lack of a better word I would call it cubist.

I told Picasso how fine I thought it.

P.: 'My feeling is that nobody will like it any more.'

I said I was convinced that they would.

P.: 'Yes, it was all right in the old days before 1914, when you used to buy these things. But afterwards we ourselves, that is Braque and I, led people astray by what we did.'

I replied that Picasso was certainly responsible for much of the confusion; he agreed, but claimed that Braque was still more so, with his 'well-made' pictures. 'Besides,' he said, 'you yourself, if you had to choose between this picture and more finished ones, you would prefer the others. Oh, I can quite understand it, from the business point of view you'd be right.'

I protested – and I really meant it sincerely. Picasso went on: 'Of course collectors will always prefer pictures with plenty of paint on them.' I replied that we must remember that nowadays collectors don't buy pictures out of pocket-money and that they must remember they may have to resell one day – and, of course, at the Hôtel Drouot, for example, a picture with plenty of finish will command a higher price.

P.: 'Yes, that's true. I bought the L'Estaque picture by Cézanne, although I don't like it as much as my other paintings by him, or even some watercolours that are scarcely touched, but I bought it because I wanted to have a Cézanne of that kind. And I know it will always fetch the highest price. But it seems to me that people don't understand intentions

any more. They have forgotten how to appreciate the quality of a line that curves away as it meets another.'

K.: 'You are quite right, but I think it has always been so. And is it really necessary for collectors to understand this? What counts, it seems to me, is their love for a picture. If they like it, if it moves them, surely that is what matters.'

P.: 'Anyway, it is by one's works that one is understood. We must work and keep on working.'

Then he spoke of the difficulty of inventing – even inventing a new subject. 'There are very few subjects when you get down to it, and people repeat them. Venus and Cupid turn into a Virgin and Child or a maternity, but it's the same subject each time. It's wonderful to invent new subjects. Van Gogh for instance, with his shapeless potatoes and old shoes – it's marvellous to have painted those!'

Rue des Grands-Augustins, 4.3.55

Upstairs with Picasso and Sabartés, I noticed that two of the cubist *Femmes d'Alger* had changed a lot: the canvas was much more covered, and the colour had been reinforced.

P.: 'Yes, I started to work on it, and when I change some little thing I have to change everything. It's strange, isn't it, since I think a philosopher can change one word without having to change everything.'

K.: 'Yes, I think that's true, but I suppose a poet is in the same situation as a painter.'

I talked to Picasso about *Gestalt* theory and said how impressed I was by the fact that this theory had asserted the primacy of the whole over its parts at the very moment when the Cubists were insisting that the details of a picture should be dictated by the overall composition, showing that this was a trend not confined to painting, but permeating the whole of intellectual life.

Daniel-Henry Kahnweiler, 'Entretiens avec Picasso au sujet des Femmes d'Alger', *Aujourd'hui* no. 4, Boulogne-sur-Seine, September 1955, pp. 12-13; translated from French by P. S. Falla.

In 1957 Picasso produced a series of paintings (Z. XVII. 351 etc.) based upon a reproduction of Velázquez's seventeenth-century painting Las Meninas *(located in the Prado Museum, Madrid; Picasso last saw the work in 1937 in Switzerland, where it was held for safekeeping during the Spanish Civil War). At the same time Picasso painted several views of his studio, especially the window and balcony where pigeons roosted and where he could look over the sea. It is as if Picasso had opened the light-filled rear door in Velázquez's painting, or turned to the light-source at the right and showed us what we could not see in the* Velázquez, *the view beyond the limits of the studio. In all there are 58 canvases, 44 of which were inspired by Velázquez's painting;*

nine are views of the Bay of Cannes seen through the balcony window of Picasso's residence, La Californie; three are landscapes, one a work entitled Le Piano; *and Picasso finished with a portrait of his wife Jacqueline, who was a silent observer during the process of making the whole series. In the game of sight, of illusion and reality, which is at the heart of Velázquez's complex composition, Picasso had the last word.*

1959 Michel Leiris
Picasso and *Las Meninas* by Velázquez

When we look at *Las Meninas* by Velázquez, we are not looking at the maids of honour themselves: we are looking at a picture by Velázquez, or, to be more precise, the *meninas* as he saw and described them.

When we look at the figure of Velázquez on the left-hand side of the painting, where the artist has portrayed himself facing frontally and painting the portrait of the royal couple in a room where the little infanta is attended by her retinue, we are no longer looking at Velázquez but a character painted by Velázquez, or, to be exact, the character that Velázquez became in 1656, when in order to paint himself while painting Philip IV and his consort, Velázquez looked at himself in fact or in imagination. This character is looking out towards us, because the royal couple, according to the logic of the painting, are considered to be occupying the position where the spectator stands.

Although we may not necessarily have happened to see this famous work, but only know it from reproductions or have simply heard of it, *Las Meninas* – even if they are removed from us by the foreignness of their title – are among those things whose existence, on a cultural level, we do not doubt to be a fact of some importance. So what exactly are these *Meninas* whose glorious existence we would be ashamed to call into question? What if not phantoms of maids of honour and the phantom of Velázquez, or, more faithfully, phantoms of phantoms, since even when the artist and his models, the maids of honour, were alive, the Velázquez and the maids of honour of the painting were no more than effigies, among other effigies projected on to the white of his canvas by the man whose name was 'Velázquez' and who, like the maids of honour, no longer has in our twentieth century any traceable existence other than that of a phantom lying in wait in one of the innumerable corridors of the palace of history. A subtle system of reflections and of reflections of reflections, with which the mirror painted in the picture – the mirror in which the images of the king and queen are framed, and not ours as they should be – seems to invite us to play everlastingly, as if the Velázquez whom we see depicted palette and brushes in hand had put it there, not to introduce the royal presence obliquely, but to fulfil the role of a trap or snare.

This game in which the work of Velázquez seems today to want to

Las Meninas, after Velázquez, 2 October 1957. Museo Picasso, Barcelona.

involve whoever looks at it – would we dream, even so, of playing it ourselves, did there not exist, for some eighteen months now – another kind of mirror to engage us – other *Meninas* by Velázquez: the series of paintings inspired by the *Meninas* which Picasso carried out in his villa in Cannes between 17 August and 30 December 1957, *Meninas* as it were raised to the power of two, which are to the old masterpiece what the *Meninas* of the Prado in Madrid were to the maids of honour of the Spanish court and who are neither the *Meninas* by Velázquez, nor those by Picasso, but *Las Meninas by Velázquez* by Picasso, a work with a false base, which – when we examine it – leads us to discover that the object to which it applies also has a false base, so that these *Meninas* displaced by three centuries are revealed finally as an object with three bases, or even an indefinite number of bases.

Effigies of phantoms or phantoms of phantoms, this is what *Las Meninas* became, after first being mere effigies or phantoms. Effigies of these effigies, empty phantoms of what were already doubly phantoms – such would the new *Meninas* be if the new Velázquez had confined himself to rejuvenating the first masterpiece by a process of stylistic grafting, instead of doing what he has done: to treat it with as much freedom as any other motif, in other words to engage it in an unforseen succession of formal adventures, treating it both as a given fact of nature and in Picasso's own manner; for Picasso's paintings, drawings and sculpture only occasionally imitate the appearances of life and are things that seem to have a life of their own – things which are themselves the life led by real or ideal models in terms of painting, drawing or sculpture – rather than being effigies of any kind.

Remade by Picasso (who recaptures them sometimes wholesale and sometimes in details) *Las Meninas* by Velázquez admit new characters, who, quite naturally, take the place of the old ones: the impressive pedigree dog painted by the master from Seville is replaced by a basset-hound reminiscent – though not an exact image – of the one that was part of Picasso's household, just as the other dog apparently lived at the court. The chronology of the *Meninas* series shows that this low-slung mammal made its appearance in the very first picture, and does not this show that from the outset it was understood that Picasso would 'make himself at home', as the saying goes, when he moved in with Velázquez.

Making oneself at home means in these circumstances not altering and correcting in a meddlesome way as if you are finding fault with your landlord, but – in all simplicity – furnishing the place to make it cosier and more congenial to your own habits and tastes, hanging up family mementoes and not hesitating to rearrange things whenever it seems necessary or you feel like doing so. This is the way that Picasso moved into the interior that Velázquez had arranged, letting his life as well as his art settle down in it with all their belongings and opening the windows wide to let in air healthier than the museum atmosphere where the masterpiece was languishing.

The same vital need for freedom which makes Picasso relax when he comes to camp with Velázquez also makes him take a relaxed attitude towards his own work: as if he felt the need from time to time not for interruption but to take a breath of fresh air while engaged on a work in which he cannot allow himself to be shut up. He paints in the margin of the *Meninas* the pigeons that live on the terrace outside his studio window, and continues the review of his immediate surroundings with landscapes and figures. Thus motifs from nature provide a cheerful contrast to the cultural motif which the illustrious *Meninas* represent, without there being any hiatus between the canvases which have no other source than Picasso's life and those born of his conversation with Velázquez: fresh, lively colours already appeared on the latter works before 6 September, when the first window bursts on the scene, full of pigeons and looking on to the sunlit seashore; the transition from the infanta of 17 November to the palm trees of the three landscapes that appear towards the end is also completely smooth.

When we look at *Las Meninas* by Velázquez, a rendezvous of phantoms with the spectator apparently invited to be counted among them, we are looking at one of the greatest and most extraordinary masterpieces that our culture has produced.

When we look at Picasso's *Las Meninas by Velázquez* and the other paintings, which are like leaves of a keepsake that attain a monumental quality whatever their size, we are again looking at the products of culture, but both sets of paintings are endowed with the capacity of being there like living beings. If the familiar pigeons, landscapes and figures tend to merge with the variations on *Las Meninas* in the same way as the infanta, the dwarf and the duenna of Velázquez turn into '*meninas*' in the mind of the present-day spectator, and if the whole ensemble, created in the space of a few months, as if canvases of this sort could only be a sudden manifestation, strikes us as directly as a spectacle of nature, is this not because Picasso has embodied himself in it so deeply that we are tempted to define it more strictly as '*Picasso* by the Meninas of Velázquez', the realistic antithesis of a creation of the imagination '*Velázquez* by the Meninas of Picasso'? For *Las Meninas* of long ago allowed the pictorial advance to get under way through which, once again, Picasso reveals himself to the very depths of his human essence, and does so as if it were no more than a game.

Michel Leiris, 'Picasso et les Ménines de Velasquez', *Picasso: Les Ménines 1957*, Galerie Louise Leiris, Paris, 1959, unpaginated; translated from French by Marilyn McCully and Michael Raeburn.

It was as a result of a walk that I took with him and Jacqueline at Vallauris on 23 November 1960 that Picasso decided to start work on a series of sculptures consisting of folded and cut-out sheet-metal. I had taken them to see the factory where we made metal tubes, and Picasso asked if we would like to work for him; at the same time he warned me of the difficulties and troubles that this might entail.

I agreed to his request with ill-concealed joy, thinking what luck it was and what a pleasure it would be to see Picasso every day.

Next day he sent us a first paper form in the shape of a superb-looking eagle. We executed the sculpture immediately, and following that, every day, other subjects were born of his magic scissors and his inexhaustible imagination.

In fact, it was nothing new for Picasso to cut paper into any desired shape. Jaime Sabartés tells us in his *Iconography* that in 1888, when the painter was a boy of seven, he used his aunt Eloisa's embroidery scissors to cut little figures out of a sheet of paper for his own amusement. Instead of making pencil drawings he skilfully cut out forms of animals, flowers, mysterious garlands and combinations of figures. At first he chose his own subjects, but later it amused him to execute the orders of his cousins Concha and Maria: 'Make us a portrait of Doña Tola Calderón's New-foundland dog.' Or they asked him to cut out the cock they had just been sent. Picasso, wanting to please his cousins, did as they asked. 'What shall I do now? Where would you like me to begin?' 'Start with its feet,' the elder girl would say, and Pablo was quite happy to begin either at the bottom or at the top. Afterwards he never stopped cutting out silhouettes from paper.

I am sure it is true that he never stopped doing this, but now, as he told me, 'I am fulfilling an ambition I have had for a long time, to give a permanent shape to all these bits of paper that were lying around.' When Picasso invented this new kind of sculpture, however, he did not hunt for old models but designed and cut out new paper shapes every day, in such quantity that it was hard to keep up with him. Yet on each occasion when I brought along the work executed on the previous day he was surprised and happy to see, in a tangible form, the silhouettes that had been no more than fragile bits of paper quivering at the slightest breath of air.

How does Picasso work? I am not giving away any secrets, for it is not really very hard to imagine.

In the first place he thinks of a subject, the sculpture just as it will be in its final form. That, no doubt, is the most difficult part; the rest is merely skill, talent, genius.

On a table covered with the most varied and unexpected objects there are also pencils, sheets of paper and cardboard, a knife, a pair of scissors,

La chaise, 1961. Musée Picasso, Paris.

pincers, a hammer and so on. Picasso seldom makes a drawing, but simply takes the paper in one hand and the scissors in the other, and begins to cut. Bits of paper fall to the ground, revealing the subject in a two-dimensional form. Picasso looks at it, and at that point a decision has to be made with no mistake; then the most important task, the folding begins: the folding is what produces the play of light in the finished sculpture.

Grasping the paper with a steady and skilful hand, Picasso marks it with curves and straight folds. Then he stands the paper subject up; it is fragile, but normally does not need any support.

He gives me the model, and then our workshop reproduces it in sheet-metal of the desired thickness. Picasso will not accept any imperfection in the work, and it makes him furious at times that he cannot himself work at the forge or with a cutting-torch.

If the sculpture is too shiny he paints it, usually white, and stands it in the sun so that the least defects can be seen. At other times the sculptures are polychromed or decorated with a grease pencil on a matt Ripolin background. Sometimes, too, soldering-lines on the metal reproduce lines drawn by Picasso to give the subject more life or emphasize the three-dimensional effect.

.

Going to see Picasso one day, I found him lying in his bedroom; in front of him, by the window, was a large plywood panel with a huge piece of wrapping paper fastened to it. On this paper, before he had cut it out, he had drawn a strange form, spread out like an octopus with immobile tentacles.

'That's a chair,' said Picasso, 'and, do you see, it's an explanation of Cubism. If you imagine a chair that's been under a steamroller, it would look pretty much like that.'

The chair could certainly be seen. In its decomposed form it was more like a star than a piece of furniture, but a chair created by the brush of Van Gogh or by the spirit of Picasso is not a representation of a piece of furniture but a starting-point for thought. This chair was to become very popular.

After cutting along the lines marked in charcoal Picasso began to fold and curl the paper in such a way that it became vibrant – the *Chair*[1] was being born. Every day, and often several times a day, I brought along the finished pieces to show him and take note of Picasso's corrections. Finally, after much manipulation the *Chair* was ready – I should call it '*Our Chair*', for, although it was Picasso's brain-child, we had helped to bring it into the world, and I believe it will be regarded as a landmark in Picasso's sculptural career.

From Lionel Prejger, 'Picasso découpe le fer', *L'Oeil* no. 82, Paris, October 1961, pp. 28–32; translated from French by P. S. Falla.

[1] Spies 592

'The cinema –' Picasso said to me one day, 'I was interested in it even before the war in 1914. I used to go often with Guillaume Apollinaire, without thinking of anything in particular, just as we would drop into a café. And then one day I saw a film (it may have been *Mysteries of New York*)[1] where there was a little funny man who made me laugh a lot. I told everybody about him, and everybody else talked about him as well – it was Charlie Chaplin at the start of his career, before any of us knew him by name.'

Perhaps Apollinaire was thinking of all the evenings spent at the cinema with his friend when he wrote the lines in *Les Mamelles de Tirésias*:

We hear from Montrouge
That our friend Picasso
Is making a moving picture
Just like this cradle.

'A moving picture' – a plastic art using movement and time as well as forms and colours. Perhaps twentieth-century arts are evolving in this direction. In any case, in the summer of 1950 Picasso began to produce paintings and sculptures which 'moved', and for some weeks he actually was a film director, using a camera instead of a brush or chisel.

For two or three sunny days in September I was lucky enough to assist him in this work. There had been a special festival at Antibes organized by Henri Langlois, the founder of the Cinémathèque française, who persuaded Picasso to direct a picture: he provided him with a camera, some reels of 16-millimetre film, a cameraman named Jean Gonnet and an assistant called Frédéric, who afterwards became well-known on television.

The film was shot on a kind of waste ground adjoining the former perfume factory at Vallauris where Picasso has his studio. He had a collection of junk – rocks, potsherds and old iron – which had been the raw material of his sculpture *The Goat*.[2] The latter was just finished and had not yet been cast in bronze. Under its plaster epidermis you could discern tins of polish, palm-ribs, logs, mattress-springs, bits of wire and pottery – a weird mixture of objects with which he 'made fun of' sculpture, in the same way as he had treated the art of painting with his *papiers collés* in 1911.

Picasso had already taken part in two or three films, but, if I may so put it, as an actor, for instance in Nicole Védrès's documentary *Life begins tomorrow*.[3] For that production he had used one of his ceramic plaques as a mask. He did so again at Vallauris, brandishing a dead branch and draping himself in crumpled wrapping paper. He soon abandoned this,

however, and fetched some pieces of pottery and sculpture which he placed on a rotating table. He married these to the sky, to some foliage or a ripe cluster of berries, made them spin round and modulated them with shifting tawny colours, using a sheet of copper as a reflector.

Picasso was only half satisfied. Next day he talked of his childhood, when he used to draw little figures on his sisters' arms, or related how as a young man he painted a curly head of hair on the bald pate of his friend Manuel de Falla.

Picasso and André Gide during filming of *La Vie commence demain*, 1949.

The curve of a leg no doubt reminded him of the amphorae that he was then using as a ceramist. A young woman served him as a model. With a few strokes of the brush he turned her legs into a couple of urchins, the calves forming their bodies and the knees their faces, which bore a remarkable resemblance to Guillaume Apollinaire. Under a rolled-up pair of trousers two little turbaned Turks moved towards the camera and away again, like two Siamese twins whom the magic of art had conjured out of a woman's body.

Then Picasso cast a covetous eye on Frédéric's lofty forehead. He painted on it another face in black and ochre, with black eyebrows and a white nose; then he painted eyes on Frédéric's closed eyelids and teeth on his lips. His face thus became a living sculpture, an animated gallows, a Homeric shield or, better still, one of those four-eyed masks from Africa or New Mecklenburg that are associated with music and dancing and derive their true meaning from movement.

What a splendid Picasso that face had turned into! And what price would it have fetched in the auction-room? But the masterpiece was soon removed with soap and water.

Was it, I wonder, that episode of the film (of which I published some stills at the time) that gave an American science-fiction writer the idea for a story that recently appeared in *L'Express*: a tourist, meeting Picasso on a deserted beach, watches with horror as the rising tide destroys a set of enormous frescoes that the artist had been drawing on the sand for his own amusement, and that would have been worth millions?

Together with Paul Eluard, Elsa Triolet, Aragon and some others, I was one of the few who actually saw Picasso's film, which was finished and edited at the beginning of 1951. This 'moving picture' for which he had created objects specially designed for film, and which he then had to destroy, like that bullring in cut paper painted with watercolour in which the light animated different silhouettes.

Owing to various circumstances the film found its way into the Aladdin's cave where Picasso keeps the treasures wrought by his own hand, and it is still there. Let us hope that, some day soon, it can at last be shown to the public, for in my opinion it marks an important stage in his career as a creative artist.

Georges Sadoul, 'Picasso Cinéaste', *Les Lettres Françaises* **no. 898, Paris, 26 October 1961, p. 8; translated from French by P. S. Falla.**

[1] According to Georges Sadoul in *Histoire du Cinéma Mondial: Des Origines à Nos Jours* (Paris, 1949, p. 12) *Les Mystères de New York* was a Pearl White film serial made in association with a Frenchman, Louis Gasnier, in about 1914. Chaplin, however, did not appear in the series.

[2] Spies 409

[3] *La Vie commence demain* was made by Nicole Védrès in 1949 and featured interviews with André Gide, Jean-Paul Sartre, Le Corbusier and Picasso, among others. In addition to a survey of present civilization, the possibility of communication with other planets was discussed.

(1963) Roland Penrose
A monument for Chicago

It was late one evening in the spring of 1963 that I received a 'phone call from a friend in Chicago who wished to introduce the architect William Hartmann. They told me they had a great project in hand for a monument they wished to place in the centre of the plaza in the new high-rise civic centre already in course of construction in the heart of their city. The architects for whom Hartmann was the spokesman wanted an introduction to Picasso so that they could persuade him to design a maquette which could be enlarged to gigantic proportions. During these years I had frequent demands which I had difficulty in refusing from people who imagined that I could influence Picasso, but I knew well enough how obstinate Don Pablo could be and how he systematically turned down any proposals that meant accepting a commission. In this case, however, realizing the importance of the project, I reluctantly accepted the difficult task of helping the Chicago architects to gain Picasso's interest.

In 1960 Picasso at last decided to move from La Californie, which was becoming increasingly untenable owing to the encroachment of high-rise apartment buildings that overlooked his garden, although he still kept it as a storehouse for a great quantity of work from which he did not want to part. He had found an attractive house with a large garden close to Mougins, on a hillside just below an ancient shrine, suitably called Notre-Dame-de-Vie, and was already comfortably installed and working hard on paintings and sculpture when the eager envoys from Chicago arrived.

A long and delicate process then began, in which I had the awkward task of trying in the first place to make the delegation acceptable and persuading Picasso to receive them. They had arrived at Mougins with full documentation of their plans and a large model of the site, which was good, but they were bold enough to insist that he should offer them an original piece designed specially for the project, refusing to be fobbed off with an existing sculpture, however attractive, that he had hoped they would accept.

In spite of this, when they met, Picasso began to warm to the idea. He told the delegation that he was honoured that Chicago, like Marseilles, two cities famous for their gangsters, should both have asked him for a monument, and the architects after their short visit left with no assurance that their hopes would be fulfilled but with the knowledge that their project, perhaps because of its formidable proportions, had been taken seriously.

More than six months passed without any sign that Don Pablo had had further thoughts about Chicago. On each visit to Notre-Dame-de-Vie I searched among the usual incredible output of paintings, drawings, engravings and ceramics without finding any new sculpture which could conceivably be intended as a study for the great monument. In fact it was

Maquette for Chicago Civic Center, 1965. The Art Institute of Chicago.

nearly a year later that suddenly I found two versions of a large head made of sheet iron and rods,[1] unlike anything I had seen around before. I at once asked Don Pablo if he had Chicago in mind and received an enigmatic reply which was however sufficiently reassuring for me to cable the architects.

The response was immediate. Five architects arrived by plane in great excitement. I had been careful to warn them that contacts with Picasso were always as unpredictable as stalking big game and so it was on this occasion. He was not in a mood to see anyone, however important, and with the exception of the patient Hartmann the architects were all obliged sadly but respectfully to return home, one of them saying 'Well, supposing I had come to see Michelangelo and he had said "No, I don't want to see you," I would have said "Okay Michelangelo, I'll come back another day." ' However when Lee Miller, Hartmann and I called again a week later the atmosphere had changed completely and it soon became clear that there was a good chance that the new sculpture might become the great fifty-foot monument. We left elated but still with no assurances that our hopes would be fulfilled.

Another year passed and the head remained untouched, becoming increasingly hidden behind new paintings and sculptures, but when I arranged another visit with Hartmann to my surprise we were well received and serious progress in the complicated transformation of the head from maquette to monument began. The maquette then left for Chicago and was placed in the hands of skilled engineers. In the summer of 1967 the great sculpture in cor-ten steel was unveiled by the Mayor of Chicago attended by the massed bands of the fire brigades and a vast crowd. Picasso was not present at this ceremony nor was I, but Hartmann asked me later to accompany him on a visit to Mougins to thank Don Pablo in the name of the citizens of Chicago. There had been some embarrassment in deciding how to offer an adequate fee to Picasso. From the start he had refused to discuss payment in any form but Hartmann this time conveying the enthusiasm of his friends brought with him a cheque for $100,000 which he presented to Picasso as a token of their gratitude. This Don Pablo refused categorically saying he wished the sculpture to be his gift to the people of Chicago. It will in this way remain dominating the great central plaza, a unique monument to his genius and his generosity.

From Roland Penrose, *Scrap Book*, London, 1981.

[1] Spies 643

Drawing, to Picasso, means living, with a special kind of life that is often self-sufficient: it is not, as with other artists, a preparatory exercise for a further work in a different technique. When he draws, Picasso is surrounded by a multitude of figures that have been his familiars for years. They present themselves, demand his attention and then play a charade for his amusement, and incidentally our own.

Some years ago Picasso showed me a large drawing in which the members of a family were assembled who had come straight out of Balzac; I noticed with surprise that Jean Cocteau had slipped in among them. 'Yes,' said Picasso, 'I don't know how he got there. I didn't invite him, he came in without being asked.' I had recognized Cocteau, but I could not put a name to the other figures, though I realized they were characters who had long inhabited Picasso's personal universe.

And it is always like that. The inhabitants of Picasso's drawings live somewhere in our memory like faces to which we cannot put a name. There are fauns, musketeers, farmhands, old bearded shepherds, lawyers, clowns and especially women, in their splendid nudity. Often a bright-eyed little figure stands to one side observing the scene. It is never the same one: sometimes it is old and wrinkled, sometimes young and malicious. Its constant appearance suggests that it represents the painter's presence among his intimates and that, for that reason, it changes its form as often as Picasso's mind itself. This heterogeneous mixture of figures with their accompanying birds and animals constitutes Picasso's mythology. He has chosen and taken possession of them to make them his demigods and his furies. Their games and cares have become his pleasures, his sufferings and ours, although in recent drawings the pleasure, which is often exuberant, outweighs the melancholy. It is as if Picasso were carried away by a wave of hedonism, his cares dispelled by an ardent or absurd *joie de vivre*. If we compare these drawings with older ones, for instance those of the Minotaur (1936–7) or the *The painter and his model* (1953–4), we find humour in the latter too, but it is a black humour reflecting a mood of doubt and despair.

It would be no use looking for a similar drama in the recent drawings. These mythical beings arise from a world which embraces the whole life of the imagination, and this remains lively and faithful thanks to the unequalled sureness of Picasso's memory. By rediscovering the value of myth in an age of technology, we return to a memory of this kind, a memory that fastens not only on details but on a general design. In this sense Picasso provides an answer to a universal need, but it is generally by his dazzling visual inventions, of form and light rather than rich subject-matter, that his message takes on its full meaning. And it is his memory that enables him to bring into play new methods that originated in

Cubism. There are nudes which, by a supple twisting of the body, miraculously present to us feminine charms from the front and back simultaneously. There are heads constructed from a series of profiles superimposed like the contours of a map. There are faces within faces, which move as the eye travels from one to another. There are transparences and ambiguities in which the basic structure disappears under the appearance of volume, and in a still more powerful evocation of the form of the living flesh, by the sensitivity and delicacy of line. In the wealth and variety of means used by Picasso, it is often surprising how inconsequential his methods seem to be. Where in the same drawing he changes abruptly his treatment of figures, the result is delightful rather than disconcerting. No system or formula impairs the spontaneity of expression. The drawing does not tell a conventional story: its eloquence derives from the facial expressions, an art that Picasso practised with enjoyment at a time when other artists were neglecting it. The ease and economy with which he handles key features, eyes for instance, are a complement to the charm and wit of the delicate floral arabesques which he uses to represent sexual organs.

The vigour of Picasso's imagination, the sharpness of his humour and the authority of his line are undiminished in these recent drawings. What they show in a higher degree than all his previous ones is variety and

Faun, nude woman and musketeer, 1967. Marlborough Fine Art, London.

stylistic freedom. Once again we salute his indefatigable genius and the way in which he shows us the permanent value of life.

Roland Penrose, 'Dessins recents de Picasso', *L'Oeil* no. 157, Paris, January 1968, pp. 19–21; translated from French by P. S. Falla.

(1968) Roberto Otero
On *Suite 347*

20 May 1968

Picasso is showing a handful of engravings done during April and May. There are large ones and small ones, splattered with the most far-fetched characters: saltimbanques, musketeers, Moors from Rif – according to Picasso's description – and women, children and old men.

As usually happens, one engraving in particular attracts our attention and we linger over it, studying it longer than we have the previous ones. Alert as ever to the smallest detail, Picasso comes over to us and laughs, a roguish look in his eye as he puts his index finger on a character at the lower edge of the picture.

'You see, that's La Celestina. She has fallen on the floor and lost her money. Do you see those scrawls here?'

'Well, those are the coins she's lost.'

'Of course, one never knows what's going to come out, but as soon as the drawing gets underway, a story or an idea is born, and that's it. Then the story grows, like theatre or life – and the drawing is turned into other drawings, a real novel. It's great fun, believe me. At least, I enjoy myself no end inventing these stories, and I spend hour after hour while I draw, observing my creatures and thinking about the mad things they're up to, basically, it's my way of writing fiction.'

From Roberto Otero, *Forever Picasso: An Intimate Look at his Last Years*, New York, 1974, p. 170; translated by Elaine Kerrigan.

1971 Brassaï
The master at 90

He and his wife Jacqueline are waiting for my wife and me at the door, and he throws his arms around us, kissing us repeatedly on the cheeks; not just formal pecks, but sensual, very Spanish kisses. Standing slightly apart, waiting to greet us in more reserved fashion, is the tall, elegant figure of Albert Skira, the Swiss publisher and old friend of both Picasso and myself.

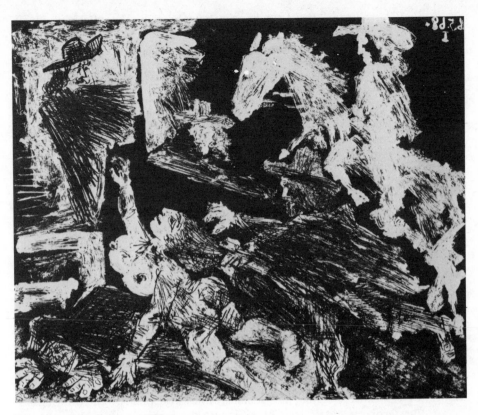

Plate no. 92 from *Suite 347*, 1968.

'You see!' Picasso exclaims triumphantly, 'Here we are again – the original crew of *Minotaure,* forty years later. We could start all over. I'm sure I could even find my trumpet.'

So he remembers even that! In that long-ago year of 1932, when *Minotaure,* 'the most beautiful art review in the world', was born, Picasso had lived at 23 rue La Boëtie, in Paris, and Skira had a tiny office at No 25, just next door. Picasso was working on a series of etchings to illustrate the *Metamorphoses* of Ovid, and as soon as he completed each of the plates he would lean out of his window and blow a discordant fanfare on his trumpet. Skira waited for the sound of that trumpet far more eagerly than he ever awaited a telephone call.

'It was just forty years ago,' Skira says, 'that I came to him with the idea of illustrating the *Metamorphoses* of Ovid.' He turns to me. 'Do you remember? I had a terrible time selling all of the copies of that album, and now they are collectors' items. So – for his ninetieth birthday [25 October] I am going to publish a new album and call it *The Metamorphoses of Picasso.*'

Picasso laughs, and I can imagine what he is thinking. Perhaps now it will be easier to sell.

He is dressed today with the sort of refined whimsy that often governs his choice of clothes. There has always been an element of the Renaissance dandy slumbering in him, and now he feels free to indulge whatever fancy may strike him. The last time I saw him, he had resembled a standard-bearer in some Uccello fresco: he was wearing velvet trousers of which one leg was blue and the other scarlet.

'A tailor made him a gift of a dozen pairs of the same kind, but of different colours,' Jacqueline had told me. 'He can change them to suit his mood – one day green and yellow, the next day violet and orange.'

Knowing his tendency toward such flights of sartorial elegance, tailors deluge him with gifts and constantly propose all kinds of innovations in materials, in cut and in colours. Today, he is wearing paint-spattered moccasins, trousers of varying tones of brown in a bold plaid, and a Scandinavian T-shirt printed with an enormous heraldic lion. Despite the ever-present threat of the builders outside his walls, he is in an excellent mood. His energy seems inexhaustible.

'After a period of doing only drawings,' he tells me, 'I've started again on a series of etchings. Wait, I want to show you something.'

He disappears into a cavern somewhere beyond the room in which we are gathered, and when he returns he is carrying an elaborately framed Degas monotype depicting a scene in a brothel. The girls, clad only in long midnight blue stockings, are clustered around their madam, an old harridan dressed entirely in black, embracing her and kissing her cheeks.

'It's called *La Fête de Madame*,' Picasso explains. 'One of Degas's masterpieces, don't you think? It was the inspiration for the series of etchings I'm working on now.'

At the age of ninety, Picasso is returning to the theme of *Les Demoiselles d'Avignon*! In 1907, that painting had changed the whole course of modern art. And its theme was also a scene in a brothel – not in Avignon as its misleading title would seem to indicate, but on the Carrer d'Avinyo, a street in Barcelona named for the old French city of the Popes.

Such a flowering of creative energy would be astonishing enough in a man who has already lived longer than many of the great artists of history, but in Picasso's case there is an even more astonishing factor: instead of bringing with it a slackening of his physical ardour, his great age seems only to stir up the demons within and heighten the intensity of his erotic imaginings. The sensuality which impregnates the drawings, etchings and paintings of these last years, the multitude of lustful attitudes, the flood of carnal embraces will probably reach its culminating point in this new series of etchings. From what he has shown me of them already, they seem to border on lechery. He makes a laughing attempt at explanation: 'Whenever I see you, my first impulse is to reach in my pocket to offer you a cigarette, even though I know very well that neither of us smokes any longer. Age has forced us to give it up, but the desire remains. It's the

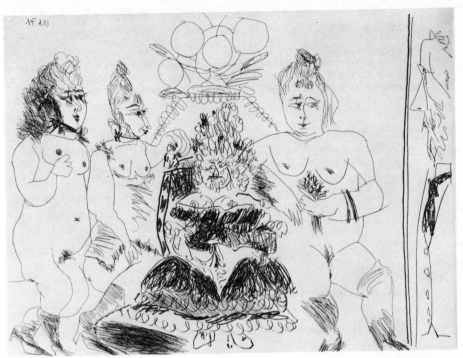

La Fête de Madame, after Degas, from *156 Gravures,* 13 June 1971. Galerie Louise Leiris, Paris.

same thing with making love. We don't do it any more, but the desire for it is still with us!'

.

Before we leave, I show him a copy of a new translation of my book, *Conversations avec Picasso,* and he immediately decides to do a drawing on the flyleaf.

'Rembrandt and his model . . . Would you like that? But have you ever noticed – whenever someone paints *The artist and his model* he almost always places them much too close together. In reality, there is always considerable distance between them. So, I'll put Rembrandt on the left-hand page and the model on the right. That will give more air, more space.'

He concentrates on his work like a matador on the bull. The drawing is superb, but when he puts down the pen he says: 'It isn't finished,' and goes out to the terrace, returning in a moment with the petals of some flowers and a few green leaves. Before I can fully grasp what he is doing he has begun to rub the drawing with the colours from this living palette. He disappears again, looking for some yellow flowers, to tint in a golden light around the head of Rembrandt.

'The finest colours imaginable!' he exclaims, delighting in our astonishment. 'Guaranteed pure! Completely natural! Solid! Stable!'

In a few seconds, the drawing has been transformed into a painting in delicate tones of violet and rose, yellows and blues and greens. . . .

From Brassaï (Gyula Halász), 'The master at 90 – Picasso's Great Age seems only to stir up the Demons within', *The New York Times Magazine*, New York, 24 October 1971, pp. 31, 46, 104–5; translated from French by Francis Price.

As Daix notes in the introduction to this article, Picasso's 1973 Avignon exhibition of 201 paintings, made from September 1970 to June 1972, was the last exhibition Picasso chose and decided on himself. His other activity from the last years of his life was represented in the show of 172 drawings exhibited at the Louise Leiris Gallery in Paris, and in January 1973 156 engravings were shown at the same gallery. The three exhibitions together basically reconstituted Picasso's creative activity from 1970 to mid-August 1972.

1973 Pierre Daix
The last exhibition at Avignon

Even in 1973 the works in this exhibition are liable to cause puzzlement and misunderstanding. Some, indeed, are clearly triumphs of figurative art, like *The Young Painter*,[1] which was used for the exhibition poster, but others are of such extreme simplicity that they almost look unfinished: the greater part of the canvas is left blank, as though the artist had begun a sketch and grown tired of it. But if we look at these works closely we shall see that his carelessness was intentional: in them he repudiates not only the need for 'finish' but traditional craftsmanship in general. This practice began ten years earlier with the series *The painter and his model*, where we find strokes of colour radiating over the bare priming of the canvas, while a painting like *Landscape at Mougins*[2] is full of technical flaws, with daubs and drips of paint and a single unvarying blue from which, through these different forms of maltreatment, the winter landscape is formed, almost devoid of light, where mountains, sea and sky are mingled. In the works we are now considering Picasso goes to the extreme limit in dismantling the language of pictorial representation. He thus returns, sixty years later, to a problem set by his first *papiers collés*: in what way exactly does the process of painting impart significance to a canvas?

We find the same problem in other works like the *Seated man*[3] or the *Head*,[4] in which Picasso scoops out furrows in the paint with apparently naïve clumsiness, filling them with coloured chalk if necessary and juxtaposing them with pencil lines on the paint. The effrontery (and virtuosity) that thus combines noble techniques with the incongruous methods of spontaneity is, in my opinion, a reflection of the idea that ob-

sessed Picasso in his last years, that the art of painting is still in its infancy and has a whole future of unpredictable development before it. All the knowledge and the diverse experiments of his long life as a painter led him into regions where, as he put it, 'painting is stronger than I am, it makes me do what it wants.' This, however, is not to be understood as a surrender to 'inspiration': on the contrary, it shows profound humility before the material laws of painting, and recognition on the artist's part that he can only command it by obeying it.

If the free application of paint produces both the tenderness of the *Young painter* and the pathos of the old men's heads, which derive from the scraping and rubbing techniques of Picasso's engravings of the same period and of some of his wash drawings, the emphasis on drawing and the simplification of painting range from an awkwardness (that almost recalls Dubuffet) to some cubist structures that are among the most powerful in all Picasso's work. . . .

We come here to the canvases that I have not yet mentioned, but which must number about half those exhibited and were the first to catch the visitor's eye in the great chapel at Avignon: those in which colour was allowed to exercise its full effect. These pictures represent the oldest part of the exhibition, being directly related to the 1970 Avignon exhibition and its paintings on corrugated cardboard, but they also punctuate the artist's subsequent activity. The chromatic oppositions, emphasized by the whole range of brushstrokes, of impasto, of his linear and free manner, create every kind of stylistic confrontation: the geometrical hardness of Cubism with the supple delicacy of organic forms. Beside brutal simplifications we find minuteness of detail, the three-dimensional treatment of a matador's brocaded costume, the furrows of a seamed face or the extravagant beard of a musketeer. Picasso does not shun either sentiment or exuberance. Whereas the previous Avignon exhibition concentrated on personal relationships, with its multiplicity of *Kisses* and *Embraces,* this one mostly presents close-ups of faces, men's busts and women by themselves. Many of the male figures, whether matadors or musketeers, seem to belong to the time of Velázquez. In every case they fill the whole canvas, and this time attention fastens overwhelmingly on their gaze, which seems to bore through the canvas, rather than on their limbs, on objects or on the elements of the setting. The whole science of disproportion, which he acquired after the end of Cubism and developed in the expressionism of the work that followed *Guernica,* has recently been taken further with his observation of television and its techniques of framing and foreshortening. He uses this to bring us right up against these faces and to abolish all distance between us and them, as if the artist were simply an interpreter bringing about this instant communication.

There is never anything gloomy or anguished about this insistence: such a mood is only felt in some later drawings. Picasso seems merely to be telling us that we do not take enough trouble to examine our fellow-creatures, to look them straight in the eye. Painting, we are made to see,

has the extraordinary enlarging power of television, but it can use it to much more and much better effect as a springboard – in the same way as the Impressionists used photography – so as to explore further the expressive force of forms and colours and set free the lyricism at the heart of painting.

At a superficial glance, this might seem backward-looking. But the extraordinary thing about this last exhibition is that there is no sign of complacency or concession to facility. With the utmost ease Picasso transcends the old – and false – opposition between the figurative and the abstract, because the spatial aspect of his figures has integrated the cubist framework no less than the contrasts and signs of abstract space. Thus Picasso is free to accept the transformation of our visual experience by the optical effects of contemporary cinema and television, putting it to artistic use as Manet did with the daguerreotype. Thus he writes a history in which the avant-garde is not governed by avant-garde tradition but by the modifications of our experience of reality and our understanding of vision, which it is the painter's mission to confront and to dominate.

I am writing this in the summer after Picasso's death. It is typical of him, to my mind, that his last exhibition should have been so disconcerting and disturbing to the conventions even of our own day. It also bears

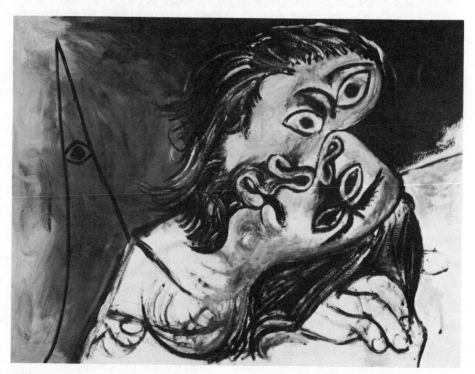

Baiser, 1969. The Pace Gallery, New York.

276

witness to the continuity of his life as a painter, in which successive reassessments were integrated into the unceasing battle with every kind of material which might, in two or in three dimensions, preserve the imprint of the form imposed on it by the act of creation. It seems to me one of Picasso's most decisive achievements to have brought about this generalization of craftsmanship whereby personal and impersonal painting, assemblage, collage, sculpture, and all the resources of drawing and engraving become so many elements of a single plastic language, equally capable of humour and of monumental effects, of lyricism and irony, of virtuosity and the extremes of poverty and vulgarity. We shall be better aware of this achievement of the materialist conception of painting when we have really taken stock of the tremendous bequest he has left to us. As yet we scarcely know more than a small, superficial part of it, and we may look forward to some fine surprises.

From Pierre Daix, 'L'arrière-saison de Picasso ou l'art de rester à l'avant-garde', *XXe Siècle* no. 41, Paris, December 1973, pp. 13–16; translated from French by P. S. Falla.

[1] Z. XXXIII. 350
[2] Z. XXXIII. 331
[3] Z. XXXIII. 288
[4] Z. XXXIII. 105

Brassaï and Edouard Pignon
Picasso on death

Brassaï was asked why Picasso did not attend Matisse's funeral:
 'Because he didn't like death. He didn't like thinking about death. He didn't like going to the cemetery and to church and all that. And he thought that if he stopped working, that was death. So, that's why until his death he worked every day.'

Pignon was asked what was Picasso's attitude towards death:
 'He certainly thought about it, as all men who live to a very advanced age do. But he never spoke about it. He used to say to me from time to time, "You'll see, you'll see. Once you're older you'll see." But having said that, until his death, he had the desire to work. He used to say "I don't go out any longer in the car because some imbecile will overtake me, he'll run into me and I have still got a lot of paintings to do." That's basically it. He wanted to work more and more and you can sense that in the last canvases he did, in the four or five years before his death.'

From interviews (1979) by Brassaï and Edouard Pignon with Perry Miller Adato for the film *Picasso: a painter's diary*, 1980.

Postscript

1980 John Richardson
Picasso: a retrospective view

Some twenty-five years ago, Picasso had the contents of his Paris studio shipped to the villa he had recently bought at Cannes. Among the treasures, household goods, and accumulated rubbish – the artist was a compulsive hoarder – were seventy portfolios. The day Picasso decided to go through these, I happened to be present. Few had been opened since 1939, some not since 1914. Although Picasso was vague about what was in the portfolios, there was reason to believe that they contained most of the works on paper that he had kept for himself, because they were too precious, personal, exploratory, or else too scabrous to exhibit, let alone put on the market. And here we should bear in mind that, as he grew older, Picasso retained much of his best work, drawings especially. So it was with the trepidation felt by Howard Carter when the first pick-axe probed Tutankhamen's burial chamber that we watched Picasso fiddle tantalizingly with the knots.

Picture our dismay when the artist threw open a bulging portfolio and gleefully showed us sheet after sheet of paper, some of it to be sure emanating from eighteenth-century Italy or nineteenth-century Japan, but all uniformly blank. 'Far too good to use' – the artist knew he could count on our emphatic denials. Was Picasso up to one of his celebrated teases? Was he perhaps re-enacting the *Chef-d'oeuvre inconnu*? No, the next portfolio contained Ingresque portrait drawings, many of them unpublished, of family and friends; another disgorged *papiers collés*, some not even glued together, and so forth. Sometimes there would be a disappointment – reams of identical posters, old newspapers – more often surprises: one of Rimbaud's exercise books, numerous lithographs by that rare print-maker, Rodolphe Bresdin, quantities of Picasso's poems (why haven't more of these been published?), and some puzzling water-colours of large heads. Early Marie Laurencins? Wrong, they were the amateurish oeuvre, what little remained of it, of Picasso's first *maîtresse en titre*, Fernande Olivier. 'No worse than any other woman painter,' Picasso said.

As Picasso scanned his own drawings, I could not help being struck by his total concentration, at the same time scary detachment about himself. It was as if he were examining work he had never seen before by an artist

quite unknown to him. '*Je est un autre*': Rimbaud's disturbing line came forcibly to mind. 'Not bad,' he could comment, but more in the spirit of a teacher going over a student's work than in pride of execution or ownership. 'Wouldn't the Museum of Modern Art like to get their hands on all this for their up-and-coming show?' (this was in 1956), Picasso grinned malevolently. 'This is what *I* call a retrospective,' and all of a sudden he made a great to-do about locking everything away.

Twenty-three years passed before Picasso was to have *his* retrospective – at the Grand Palais in Paris last summer. It consisted of all the paintings and sculpture and the best of the drawings and prints (roughly a quarter of the artist's estate) which the French government had accepted in lieu of taxes, and was a most moving exhibition. . . . The great exhibition that fills the entire exhibition space of The Museum of Modern Art is a far, far grander affair – a retrospective to end all retrospectives. It is of course big, but not that much bigger than the Paris show in 1966–7. The difference is that it is much more discriminatingly chosen and much more handsomely installed. For once full justice has been done to the variety of genres, styles, media, and techniques that makes Picasso the most prodigious and versatile artist of all time. . . .

The facts of his life have more bearing on Picasso's art than is the case with any other great artist, except perhaps Van Gogh. The more we know about his day-to-day existence and particularly his domestic arrangements, the easier it is to unravel the mysteries and metamorphoses of Picasso's development. This is especially true after 1918, when abrupt changes in style imply that one wife or mistress has been substituted for another. Thus the pattern of stylistic infidelity can be said to follow the pattern of amorous infidelity. So long as the artist was alive, a biographer – especially one as loyal as Roland Penrose – was unable to delve deeply enough into Picasso's private affairs to be able to perceive the ramifications of this pattern with any clarity. Now, however, that the artist is dead, every crumb of information should be gathered while there is time. In no other great life are the minutiae of gossip so potentially significant.

Dora Maar, probably the most perceptive of the artist's companions, once told me that at any given period of the artist's post-cubist life there were five factors that determined his way of life and likewise his style: the woman with whom he was in love; the poet, or poets, who served as a catalyst; the place where he lived; the circle of friends who provided the admiration and understanding of which he never had enough; and the dog who was his inseparable companion and sometimes figured in the iconography of his work. On occasion these factors overlapped: Jaime Sabartés, Picasso's secretary, survived four different régimes. But as a rule, when the wife or mistress changed, virtually everything else changed.

Max Jacob is of course the poet whom we associate with Picasso's early years in Paris and Apollinaire with Cubism. Later, if we are to go along with Dora Maar's theory, we should see Cocteau as a catalyst for the

neoclassic period presided over by the artist's first wife, Olga; Breton and the Surrealists for the 'Metamorphic' period presided over by Marie-Thérèse; Eluard for *l'époque Dora* (1936–45); Eluard and Aragon for *l'époque Françoise* (1945–53); and, despite Picasso's malicious comments about his shady war record, Cocteau again from the mid-fifties until his death, for *l'époque Jacqueline*.

For such a lightweight, Cocteau had a tremendous impact on Picasso, his influence persisting from 1916 into the twenties. Thanks to Cocteau, Picasso embarked on an association with Diaghilev (beginning with his décor for the ballet *Parade*) and met his first wife, the ravishing Russian dancer, Olga. Thanks largely to Cocteau, he moved to a smart apartment and took to frequenting the Proustian world of *'le tout Paris.'* But above all the poet confirmed the artist in his budding taste for neoclassicism. This phenomenon, whose glacial embrace so many Parisian artists, musicians and writers were to experience, should be seen in part at least as a reaction against the disorder of the First World War. One of its attractions for Picasso was that it represented the very antithesis of Synthetic Cubism. For a time the two-dimensional cut-outs of Synthetic Cubism exist side by side with the gigantic bathers, pneumatic ballerinas, and galumphing nymphs of neoclassicism, but after 1920 the latter gradually take over.

However, besides reflecting the modish dictates of Cocteau's manifesto, *Le Rappel á l'Ordre*, Picasso's adoption of this new style reflects the *embourgeoisement* brought about by marriage to a woman who, besides being silly and irredeemably square, was infatuated and jealous to the point of insanity. The reaction against a life of first nights followed by nice little dinners followed by hysterical scenes was not long in coming. Just as Picasso's love for his wife paralleled his adoption of neoclassicism, so did his subsequent hatred of her parallel his rejection of it. Not that this was by any means the last time Picasso expressed his feelings about women in neoclassic terms.

The failure of Picasso's marriage and the demise of the backward-looking style that it engendered are proclaimed by the cacophony, the metamorphic contortions of *La Danse* (1925).[1] Part Dionysiac Charleston, part *in memoriam*, this is the most forward-looking of Picasso's post-cubist works and in the artist's opinion (as he told Roland Penrose) 'a finer work than *Guernica*' – partly I suspect by virtue of its not being an official commission, which was something the artist had always been at pains to avoid. That *La Danse* stands in relation to the second half of the artist's development much as the *Demoiselles d'Avignon* does to the first half is too often overlooked, though not by John Golding, who has reminded us that both these paintings were featured in the same number of *La Révolution surréaliste* (1925).

Besides *La Danse*, a chance meeting with a seventeen-year-old blonde, Marie-Thérèse Walter, outside the Galeries Lafayette (January 1927) opened the way for the next set of stylistic developments. Within a few

months of this pick-up, Picasso's work betrayed the otherwise well-kept secret that he had a new companion. Not that he did portraits of Marie-Thérèse; what gave the show away was the frenzied sexuality and voluptuous forms of the new paintings and, a bit later, monumental sculptures that the tiny artist took to doing. The fact that Marie-Thérèse was a sleepy, easy-going girl who loved swimming and was often to be found in the company of a sister, on the beach or at Picasso's new house (château de Boisgeloup) – all this can be deduced from paintings of mammoth women, asleep or reading, by the sea or in a garden. Monsters of sex-appeal! Once again a new style had evolved under the influence of the mistress's persona, or rather Picasso's perception of it.

The extent to which Marie-Thérèse's sexuality pervades Picasso's work of the early thirties can be appreciated as never before in the spectacular group of paintings and sculptures of the late 1920s and early 1930s, which Rubin has arranged to such telling effect. Has sheer physical passion ever been made so palpable in paint or bronze? And yet for all their raunchiness, these Marie-Thérèses have a tenderness and warmth that make Matisse's girls of the same period seem cold and contrived and, in the same way, the mountainous Jacquelines of Picasso's old age look frustrated and menacing.

The switch from voluptuousness to violence in the mid-thirties has its roots in an unhappy combination of events: more out of thwarted love than greed, Picasso's estranged wife tried to appropriate half his property (including the studio contents); at the same time Marie-Thérèse became pregnant. In the face of these worries, Picasso abandoned painting for poetry (February 1935). Further problems lay ahead: not long after Marie-Thérèse gave birth, Picasso fell for a beautiful young photographer and painter, Dora Maar, whom he had met through Eluard. Meanwhile civil war was boiling up in Spain.

The fallow period – almost a year – paid off. When Picasso resumed painting, his work was heavily influenced by surrealist poetry. Melancholy allegories feature mortally wounded Picassos in the form of bulls, bullfighters, and Minotaurs confronted by Marie-Thérèses in the form of gored horses or classical nymphs crowned with wreaths; there is even a lot of the blue that self-pity brings out. And then all of a sudden, thanks partly to the advent of Dora, Picasso is back at his Dionysiac best. The series of women's heads – all to some extent portraits – which continue for the next eight years constitute the artist's most sustained achievement since Cubism.

But first came *Guernica*. This huge polemical panel in which Picasso pits himself against Goya (specifically *The Third of May 1808*, soon to be *Guernica*'s neighbour in the Prado) is permeated by Dora's presence. She not only photographed it at different stages of completion, but she actually painted part of it, and the figure holding a lamp is unquestionably a likeness of Dora. (So far as I know, nobody has published the fact that Dora Maar worked on *Guernica*. Many of the vertical strokes on the

horse's body were painted by her.) Moreover, she was an important link with Surrealists like Eluard who supported the Popular Front against Franco and whose ideas may well have played a part in the gestation of *Guernica*.

Dora was a formidable muse. Even in the earliest portraits of her one senses that a struggle to the death has broken out between this highly strung intellectual beauty and her demonic lover. Once again Picasso's manipulation of his mistress's life parallels his manipulation and redistribution of her features. Thus for Dora he contrived a supple new style that could express a range of emotions from rapture through tenderness and grief to loathing in contortions that are sometimes lyrical but more often monstrous. Meanwhile Picasso continued to paint Marie-Thérèse. Sometimes he would portray both women on the same day in the same pose but each in a different morphology (Dora angular; Marie-Thérèse all curves). Sometimes he would paint one mistress in ways that recalled the other; or he would do a painting in which the blonde Marie-Thérèse could see tell-tale traces of the flamboyantly smart Dora – dark hair in a snood, heavily made-up eyes – cropping up in what was otherwise a likeness of her. Was Marie-Thérèse being supplanted? Yes. 'These facts betray themselves in my work,' Picasso said. 'It must be painful for a girl to see in a painting that she is on the way out.' How heartless and brutal! Yet Picasso was also capable of the utmost tenderness toward the women in his life, as well as much kindness and generosity toward his friends. To dismiss him as a fiend is as misguided as promoting him as a saint.

While consummating his passions in paint, Picasso likewise consummated feelings of guilt and hatred in diabolical portraits of his vengeful wife. One of these is in the MOMA show, although it is not identified as such (*Lady in a Straw Hat*, catalogue page 331). The contrast between this obscene yenta, crowned by a grotesquely dainty hat, and the ideal beauty which the artist portrayed so affectionately in the early years of marriage is a chastening one.

Do not, however, imagine that the number of people present in these distorted 'portraits' is limited to one or two. On his summer visits to Mougins in 1937 and 1938 the artist was accompanied not only by Dora Maar but by Paul Eluard and his wife, Nusch. He also saw a lot of Lee Miller (Penrose), the American photographer, and of Ines (subsequently his housekeeper) and her two sisters. Picasso did separate portraits of all these women; he likewise did composite portraits, ones in which the features of three or even four people blend into a single image. In other works of the period Picasso arbitrarily manipulates the sex of one of his friends: Eluard gets a coif and is transformed into an *Arlésienne*, also into a Provençal peasant woman suckling a kitten.[2]

One more bizarre element must be taken into account, if we want fully to understand these paintings. Picasso had recently acquired an Afghan dog, Kazbek, and he often grafted the elongated muzzle and floppy ears of

this animal on to the face of Dora – a comment, he claimed, on 'the animal nature of women'.[3]

Staying on in Paris after it was occupied, Picasso made no overt references to the war in his work, but he painted some of the grimness of it into his portraits of Dora, particularly the agonized, skull-like heads he executed in 1943. These paintings can have left Dora in no doubt that love had soured into rage. 'She always frightened me,' Picasso said much later of the highly strung woman cooped up with him by the Occupation. Poor Dora! When Picasso left her, she suffered a nervous collapse and had to be entrusted to Dr Jacques Lacan's care; she subsequently became a recluse. But by that time paintings of a fresh young face free of angst reveal that Picasso had taken a new mistress: Françoise Gilot.

Once again everything changed. Picasso and Françoise set up house on the French Riviera; he fathered two children, took a more active part in politics, acquired a new dog, and adopted a simple new style – spare, serene, optimistic – in keeping with this idyllic new relationship. He also experimented to brilliant effect with a new medium (lithography) and a new craft (pottery). All went well until the artist discovered that, unlike her predecessors, Françoise resented being manipulated. As she has recorded in her book, *Life with Picasso*, she was exasperated by Picasso's view that women were 'either goddesses or doormats'. And so, after eight years, she left the artist, but not before the tensions between them had manifested themselves in some grim paintings of domestic life.

Françoise's departure (1953) was followed by an uneasy interim period. Once again Picasso expressed his sorrows in allegory; the so-called *Verve* series of drawings that bear witness to the dilemma of an old man confronted by desirable young models. At the same time, contrary to his usual custom, Picasso devoted some forty paintings and drawings to a beautiful girl, Sylvette David, who was not his mistress. The absence of emotional involvement is immediately apparent in the lack of tension and expressiveness – presumably why this corny series has been excluded from the present show. Meanwhile Picasso continued to pay court to three different women in three different parts of France, until, in the summer of 1954, his choice finally settled on a young divorcée, Jacqueline Roque (subsequently his wife), who had come to Cannes to work for her cousins – Picasso's potters.

Picasso lost no time in reverting to his old habit and soon contrived a new style with which to express the allure of his new mistress. But how unlike, how inappropriate the first portraits of Jacqueline seemed! It was difficult to equate such a demure girl with such a dramatic, such an intense air; and a long neck was not her most conspicuous feature. But once again Picasso's insight was born out by events; within a few months his mistress came to resemble the portraits in personality and even looks – Dorian Gray in reverse!

The old manipulator always prided himself on the premonitory powers of his portraits, often in the way they foretold unfortunate developments

in the life or character of his female companion. Especially eerie are some of Picasso's later portraits of Jacqueline, which predict the unhappy widow who was later to emerge in all her malevolence after the artist's death. Yet other portraits include presentiments of a different kind. In the early years of the affair Jacqueline's health was poor – 'Women's ills are always their fault,' Picasso used to say – and the artist swore that some of his more anguished portraits anticipated Jacqueline's bouts of sickness by a few days. More to do with her response to psychosomatic suggestion than with the painter's prophetic powers, I always felt.

As Picasso entered his ninth decade, his imagination flagged, not, however, his energy. With time running out, he jettisoned more and more – virtually all considerations of colour, structure, *facture,* finish, and style – in his race to summarize, in shorthand if need be, the black thoughts and jokes and sexual pangs that still preyed on his mind. Consequently many of the late paintings, less so the drawings, are helter-skelter to the point of sloppiness – speed painting. Time and again the artist would adumbrate an ambitious composition, then optimistically conclude it with a signature, long before any valid pictorial solution was in sight. Sad! And yet the best of these monstrous figures, all gaping eyes and banana fingers, pack such a punch that it would be dangerous to write them off as mere reprises. Like it or not, a painting like *The Young Bather with Sand Shovel* (1971)[4] has the impact of a Mack truck. Up to the day of Picasso's death in 1973 the power was never switched off.

All the same, a sad end. Of course it would have been more dignified if the great man could have died in the odour of artistic sanctity, like Titian or Rembrandt or Cézanne. But, let us face it, Picasso's vision had reached its apogee in his thirties. By his eighties let alone nineties, fear of death overshadowed everything else in life and made inward looks unthinkable. To believe Picasso, he had no faith of any kind; to believe Jacqueline, he was capable of being *'plus catholique que le pape'*. Either way, he was addicted to superstitions of the blackest sort. As his daughter said, it was all very Spanish. And so for this other Faust there could be no peace of mind, no great late works, no *Saintes-Victoires.*

From John Richardson, 'Your Show of Shows', *The New York Review of Books* vol. XXVII no. 12, New York, 17 July 1980, pp. 16–24.

[1] z. v. 426
[2] z. VIII. 370–2 (*L'Arlésienne*) and z. VIII. 373
[3] z. IX. 228
[4] z. XXXIII. 229

Abbreviations

The following abbreviations have been used for works cited in the text:

Apollinaire on Art
: *Leroy C. Breunig (ed.)*, Apollinaire on Art; Essays and Reviews 1902–1918, *New York and London, 1972*

Boeck and Sabartés
: *Wilhelm Boeck and Jaime Sabartés*, Picasso, *New York and London, 1955*

Daix
: *Pierre Daix*, Picasso: The Blue and Rose Periods, *London and Greenwich, Conn., 1966*

Fry
: *Edward Fry*, Cubism, *New York, Toronto and London, 1966*

MOMA catalogue
: *Catalogue of the Museum of Modern Art exhibition* Pablo Picasso: A Retrospective, *New York, 1980*

Palau i Fabre
: *Josep Palau i Fabre*, Picasso Vivent (1881–1907), *Barcelona, 1980*

Porzio and Valsecchi
: *Domenico Porzio and Marco Valsecchi*, Picasso: His Life, His Art, *London, 1974*

Schiff
: *Gert Schiff*, Picasso in Perspective, *Englewood Cliffs, N.J., 1976*

Illustrations are identified by numbers from the following catalogues:

B.
: *Georges Bloch*, Pablo Picasso; Catalogue de l'oeuvre gravé et lithographié, *Berne, 1968 &c*

G.
: *Bernhard Geiser*, Picasso Peintre-Graveur, *Berne, 1933 &c*

Spies
: *Werner Spies*, Sculpture by Picasso, with a Catalogue of the Works, *New York and London, 1971*

Z.
: *Christian Zervos*, Picasso: Oeuvres, *Paris, 1932 &c*

Index

References in **bold** type are to authors and subjects of the articles. References in *italics* are to illustrations.